CIRCLE THINKING

STUDIES OF RELIGION IN AFRICA

SUPPLEMENTS TO THE JOURNAL OF RELIGION IN AFRICA

EDITED BY

Paul Gifford (School of Oriental and African Studies, London)
Marc R. Spindler (University of Leiden)

DEPUTY EDITOR

Ingrid Lawrie (University of Leeds)

XXV

CIRCLE THINKING

African Women Theologians in Dialogue with the West

BY

CARRIE PEMBERTON

BRILL

LEIDEN · BOSTON

2003

This book is printed on acid-free paper.

BR
1430
.P46
2002

Die Deutsche Bibliothek - CIP-Einheitsaufnahme

Bibliographic information published by Die Deutsche Bibliothek
Die Deutsche Bibliothek lists this publication in the Deutsche
Nationalbibliografie ; detailed bibliographic data are
available in the Internet at http://dnb.ddb.de.

Library of Congress Cataloging-in-Publication Data

Library of Congress Cataloging-in-Publication Data is also available

ISSN 0169-9814
ISBN 90 04 12441 1

To
Archbishop Janani Luwum
Martyred 16th February 1977

His widow, children and children's children

and

Phebe Cave-Brown-Cave

CMS Missionary and Educator
(Uganda 1929–1967)

CONTENTS

Chapter 5 VIOLENCE AGAINST WOMEN:
CIRCLE WOMEN RESPOND

Chapter 6 MULTIPLE IDENTITIES IN-DEPENDENCY:
THE CHALLENGE AND CONTEXT OF THE CIRCLE
OF CONCERNED AFRICAN WOMEN THEOLOGIANS

ACKNOWLEDGEMENTS

Any substantial undertaking in life is dependent on more than the principal actor. So it is with this book, conceived out of my friendship with women in Bunia in the North East of the Democratic Republic of the Congo, during my sojourn there in the late 1980s as a theological educator at the Institut Supérieur Théologique Anglican. I owe them, and in particular Mugisa Kahwa, President of the Mother's Union and wife of the present Anglican Bishop of Katanga, more than they can know, for all the ways in which they enriched my life and the lives of my three children with generosity and eucharistic celebration in the midst of brewing civil war and general hardship.

The focus on the Circle of Concerned African Women Theologians first arose for me when I read *The Will to Arise: Women, Tradition and the Church in Africa* in the Henry Martyn Library, an independent Cambridge library committed to understanding the mission history of the worldwide church, particularly in the last three centuries. The will to undertake the study arose from a host of academic mentors who encouraged me to undertake research and to publish the voices I discovered in listening. Amongst these are Professor Haddon Willmer (Leeds University), Dr Carolyn Baylies (Leeds University), the Revd Dr Charles Elliott, Dr John Lonsdale (Cambridge University), Professor Marilyn Strathern (Cambridge University), Dr Louise Pirouet (Cambridge University), the Rt Revd Professor Stephen Sykes (Durham University) and countless others in the Faculties of Divinity in the Universities of Durham, Leeds and Cambridge, whose seminars, lectures and informal conversations have helped form my academic mind and shaped some of the theological desires of my heart. Particular thanks are due to the Revd Professor Nicholas Sagovsky and the Revd Dr Kevin Ward who examined the thesis which forms the vertebrae of this book, and to the late Revd Professor Adrian Hastings and Paul Gifford who, as Editors of the *Studies of Religion in Africa* series, encouraged me to bring my research work to publication.

On the journey that represents the eight years during which this book gestated, there have been many supportive midwives and places of rest. Amongst these have been the organisers of the South African

Academy of Religion whose conference I attended in 1996, and the Ecumenical Institute at Bossey, whose mid-decade conference on the decade of the churches' support for women was so instrumental in introducing me for the first time to the leadership of the emerging Circle of Concerned African Women Theologians. This initial introduction developed into the opportunity to establish some friendships and share time with many of those who have given generously of themselves in interviews and correspondence to enlighten me as to the intentions and achievements of the network of women theologians explored in this study. Amongst these I would like to particularly express my thanks to Ms Brigalia Hlophe Bam, Dr Musimbi Kanyoro, Dr Elizabeth Amoah, Revd Dr Nyambura Njoroge, Dr Mercy Oduyoye, Mrs Lloydda Fanusie, Dr Teresia Hinga, Sr Dr Bernadette Mbuy-Beya, Sr Professor Teresa Okure, Dr Faluta Lusungu Moyo, Dr Daisy Nwachuku, Dr Hannah Kinoti, Mrs Laetitia Adu-Ampoma, Miss Justine Kahungu Mbwiti, Dr Nokusola Mndende, Ms Musa Dube, Dr Ncumisa Manona, Ms Esther Acloatse-Kumi, Revd Grace Ndyabahika, Dr Wedad Abbas, Revd Martha Ngugi, Revd Grace Kinya Imathiu, Mrs Madeleine Mboute, Ms Eva Benedito Pedro Gomez, Ms Eunice Ekundayo, Ms Faith Lugazia, Ms Helen Mbenda Ngo Yinda, Ms Fatimatu N-Eyare Sulemanu, Mrs Sidomie Swana Tangiza Tenda, Revd Edith Nkoki Njiri, Dr Vibali Vuadi, Mrs Philomena Njeri Mwaura, Professor Christina Landman, Revd Edith Semmambo, Dr Rabiatu Ammah, Dr Titilayo Mary Dipe, Revd Sr Mary Juliana Ada, Professor Ebele Eko, Mrs Akintunde Dorcas Olubanke, Revd Marguerite Fassinou and Sr Dr Anne Nasimuye-Wasike. I look forward to the continuation of the lively dialogue and discussions that started in conversations enjoyed in Nairobi, Johannesburg, Geneva, Oxford and Cambridge.

As I was a full-time researcher and mother of five lively pre-school and school-age children during the time when the bulk of the work was undertaken, there were certain practical arrangements which had to be in place and without which completion of this work would have proved impossible. My thanks are due first to Dr Onora O'Neill, Principal of Newnham College, Cambridge, whose 2002 Reith Lectures, *A Question of Trust*, have received wide interest and acclaim. Her trust in my ability to research and write, even while I was nursing my fifth child, was expressed by providing a subsidised study in Newnham for three important years of the research enterprise. This, alongside the final retreat provided by family friend Mrs Janet Cronk, who in

so doing underlined Virginia Woolf's plea for a room of one's own in order to write and create, has been invaluable for the production of the work you are about to read.

I must also thank the ranks of social sisters, mothers and grand-mothers without whose help I would never have completed the first, let alone the last, chapter of this book. Children are indeed a bless-ing from God, and fortunate is she who has her quiver full. However, without those ready to collect from school, feed, care for, educate and play with our children when my husband was unable to be present, and when libraries, seminars and field-work spelt my absence, the book you are now holding would have foundered. The roll of hon-our in some of the co-parenting of these last few years includes Annie Davenport, Chris Thompson, Joan Reynolds, Alison Newson, Penny Jacques, Jean Peacey, Hilary Gretton, Alison Wareham, Jenny Crow, Gillian Macnamee, Mandy Owen, Jill Lewis, Xanthe Rees-Howell and Wendy Park. Thank you to each one for such sisterly solidarity.

The research for this book was financed by a range of individuals and academic trusts and bursaries. A British Academy grant funded the first three years of the research; a most generous grant from the Pew Charitable Trusts furnished my field work in South Africa and Kenya; Virginia Theological Seminary, Newnham College and various Church of England trust funds enabled participation in a wide range of conferences and further research opportunities. Personal friends Nicholas and Linda Tavener, Ruth and John Honey, Viscount and Viscountess Brentford and Nigel and Judy Pearson were unstinting in their practical support for this project until it realised publication. I owe each one of them profound thanks. Thank you.

To those who have read, commented, edited and reflected on the proofs of the book as it moved towards publication, my greatest thanks. From Brill's initial reader, Dr Leny Lagerwerf, to Ingrid Lawrie, who tirelessly harried and corrected the flaws in the script until all was ready for the release of this work, to the comments, rebuffs and constructive engagement of the readership it will enjoy, my gratitude. Needless to say, any enduring faults in texts or pre-sentation of ideas are entirely the fault of the stumbling author.

Penultimately, I must acknowledge my children's good-natured acceptance of these years of research and the affliction of preparing the work for publication. It has undoubtedly consumed large tracts of my time and energy, resulting in a dearth of long lazy evenings in the company of their mother. I bequeath this book to them, in

the hope that they too would be inspired to search for justice, peace, friendship and communion with the Divine, aspirations which underscore the purpose of this study, if not perfected in its execution. Finally, to my husband Jeremy, who has accompanied me down many of the paths that have made up the journey to publication, I am thankful for your companionship, dedication and faith in the final realisation of this project. Your support and attentiveness during this latest birth has surpassed all that went before.

INTRODUCTION

This book is an examination of the history and concerns of a contemporary network of African women theologians known as the Circle of Concerned African Women Theologians. It is, as far as I am aware, the first time that the production of the Circle has been critically explored, though Mercy Oduyoye herself has recently published an introduction to African Women's Theologies (Oduyoye 2001), and it has been an enormous privilege to be part of the European interface on an African movement. I have placed their work in both an historical and a contemporary context, with the requisite sensitivities deployed to cultural, gendered and racial meaning. In historical terms, the point of departure is the current of ideas and interventions, which have been a part of the continent's life since the Western missionary intrusion of the high imperial era (1880–1930). Such is the transnational nature of the insertion of Christianity into the African continent that I believe the presence of this part of Africa's history is sufficiently replete with ambiguity and latent disease both within and without the continent that I urge the reader to attend to that context in the reading of what follows.

The origins of the Circle and its continuing sources of sustenance are hybrid and international. They are the fruit not only of the struggle for political, cultural and religious independence which has engaged African academics for the last half-century, but also of a modern 'hybridisation' of the academy. This process has been well identified by Jan Nederveen Pieterse as the evolution of multiple dependencies generated in the modern world economy through increased 'globalisation' (Pieterse 1994). The result has been to develop a 'translocal *mélange*' of cultures. In this mixture, certain ideological motifs of the dominant world economy have been absorbed by national leaders to reconstruct their identities with cross-cutting alliances and separations, designed to create the possibility of a new concordat within the global and the local.

The Circle's relationship to the struggle within Western feminism

is a case in point. They have absorbed certain ideals of white North American feminism, in particular the strategy of 'legal feminism', fighting for equal rights and opportunities through State legislatures, the Supreme Court and latterly the UN itself. At the same time, dissident voices of black women caught in middle-class 'racially oppressive feminism' began to emerge in the mid-1980s (Hooks 1984). Womanism, which 'critiques white feminist participation in the perpetuation of white supremacy and . . . is organically related to black male liberation', has been of profound importance and has been absorbed into the Circle's project (Williams 1993: xiv). Yet womanism was a reaction against white liberal hegemony of feminist discourse, which had been the carrier for ideals of equality and justice for women.

Meanwhile, in Africa, the theological project of cultural recovery, pursued by male African theologians since the 1950s and outlined helpfully by Aylward Shorter and John Pobee in their recent works, has been another pattern in the quilt (Shorter 1988; Pobee 1992; Shorter 1994). Inculturation is used in this book to designate, with more breadth than is often granted, the variety of ways in which theologians have sought to make Christianity at home within culture. It is a term originally exploited by the Jesuit, Fr Joseph Masson SJ, whilst at the Gregorian University in Rome, just before the Second Vatican Council in 1962; he called for Catholicism to become 'inculturated in a variety of forms' (Masson 1962: 1038). Aylward Shorter calls the process one where 'a human culture is enlivened by the Gospel from within, a stage which presupposes a measure of reformulation or, more accurately, reinterpretation' (Shorter 1988: 12).

In many of the new two-thirds world 'identity' theologies which are under construction we are witnessing not the creation of in-house cultural theologies but new forms of supranational theology, which are beyond strict accountability to particular churches or classically conceived local communities. New forms of community are created by the shrinking of time and space through jet travel and electronic media (including the internet) as means of sustaining 'non-territorial communities' (Yuval-Davis 1997: 65). These are in a melting pot of late enlightenment idealism, post-modern commitments and neo-historicist scripts. Their bouquet is indeed complex. In this new world of theological production contextuality is claimed as a main ingredient. However, the 'homeland', 'people', or 'oppressed', lives in the imagination, non-localised and unverifiable, whilst many other ingredients of these theologies remain undisclosed.

The exposure of many of the key Circle writers to North American tertiary education and the idea of a global black diaspora has been very influential (Senghor 1964). Likewise the non-governmental forums of the World Council of Churches (WCC), the UN World Conferences on women, the Lutheran World Federation (LWF), post-Second Vatican Council synods in the Roman Catholic church and the Ecumenical Association of Third World Theologians (EATWOT) have all fermented the theological brew which the Circle women have created.

The historical roots of women's activism in Christian discourse lead the enquirer into disputed and uncertain terrain. There is a form of feminist solidarity between female missionary agents of the high imperial era and the contemporary aims of Circle members, but the connections are highly contested and problematic. There is apparent a certain congruence of a theological ethic of passion and compassion, an ethic reasserted in the publication by the same name produced by the EATWOT Women's Commission (EWC) in 1993 (Fabella 1993). There is a common attention to the liberating practice of Christ rather than Christian dogmatics, a shared commitment to literacy and education for women, and a similar advocacy on behalf of the 'burdened' mothers of Africa, albeit from a different vantage. The assertion of such commonality is unappetising, not only because post-colonial and racial consciousness has made such connections politically undesirable, but also because the hagiographic nature of much of the record masks the activity of indigenous agency.

There has been a marked process of differentiation from the ideological conditions in which missionary endeavour in the high imperial age was undertaken. The 'occidental absolute', which secured the 'logic of empire', was sustained by a variety of means: military force, economic opportunity, religious narratives of enlightenment and the delivery of effective health care (Gibellini 1994: 4). This absolute has been eroded by strong post-colonial national identities, in an age where the old economic and political centre has crumbled and those on the erstwhile margins are re-imagining themselves as new actors on the African and world stage. As part of this process Circle members deploy in the main a strategic use of theology and church history, which defines itself over and against 'missionary' engagement with Africa, invariably presumed as white, and posit a liberation paradigm for the present over and against the strictures of the imperial mission of the past.

There remains the challenge for anyone approaching contempo-
rary African theology of providing a sensible account of the accep-
tance and co-operation of African disciples, evangelists and apostles,
in the high imperial project which resulted by the close of the twen-
tieth century in Africa's substantial conversion to Christianity. Moreover,
the continued transformation of Africa's religious landscape to include
vibrant and growing churches demands a coherent basis within his-
tory which is not sustainable on a reductionist binary of missionary
exploitation and alienated black communities. This work is under
way in a variety of new church history projects being undertaken in
the North as well as the South. The ground on which the Circle
writers stand is soft. As an educated élite, they critique their cultures,
church praxis, mission history and society whilst manacled, by impli-
cation, to them. They are, after all, beneficiaries of the western edu-
cational project undertaken in the main by the mission churches. To
state this is not to deny their entitlement to speak, but to mark the
ambiguities of both their own positionality and the mixed nature of
the entire imperial/church, mission/state, black/white history. To
unravel this history is the task of all implicated parties, both Africans
and those from the North. Joint projects between universities of the
North and the South are called for in the creation of histories which
can be accepted as truthful stories, by Northern and Southern audi-
ences alike, with the alienations of power being acknowledged but
not given reductionist privilege in the struggle for human community
which featured in the Christian mission of the high imperial era.

The importance of story making has been taken as one of the
points of departure for the Circle of Concerned African Women the-
ologians. For Circle co-ordinator Dr Musimbi Kanyoro, now General
Secretary of the Young Women's Christian Association, African
'women [have received] an imperative call, to remember and to
name their experiences by articulating their stories of faith and life'
(Kanyoro 1996b: 4). This activity and the emergence of a network
to sustain the story-telling represents 'a pearl of great price' which
Kanyoro hopes will enrich the Church in Africa (Kanyoro 1996b: 4).
Certainly this organisation of African women who are international,
inter-faith and academically equipped to research and publish their
findings on the relationship of religion and culture is novel. Their
decision to privilege women's experience and advocate the dignity and
'rights' of African women is not entirely new, as the work of Hugo
Hinfelaar on Bemba women in the early twentieth century shows us

(Hinfelaar 1994). There is a sense of crusading zeal in the work of the Circle which often privileges the present over some of the mixed gains of the past. According to Kanyoro, now is the time for 'African women' to either 'speak out in protest or keep silent in protest. Either way, their cry is for the power to participate with dignity, the power to name themselves, the power to celebrate true partnership in society and in the ecclesia' (Kanyoro 1992b: 28). Throughout the Circle's production there is a sense of crisis which requires a prophetic word or action from women to bring in liberation and freedom, justice and peace for a troubled continent. This is not a theology from a continent at peace, but rather in turmoil, troubled by the labour pangs of bringing in something new for the worldwide Church and for a bleeding land. It is an unsettling perspective, but a consistent strand in their work. It forms a theology which is politically involved and realist. The kingdom of God is situated in our world here and now, with its deep economic and political divisions, its ethnic cleansing and genocides, its brutality and injustice.

It has been exceedingly difficult to engage in a critical discussion with Circle theologians about the nature of their work because of their commitment to a form of African existentialism. However, my inspiration to continue in what was frequently a most difficult and edgy dialogue was the call to *koinonia* in the Eucharist (1 Corinthians 10: 14–22; 2 Corinthians 1: 7) and the gift of the Holy Spirit (Hebrews 3: 14, 6: 4) echoed by Circle theologians, who constantly invites us into a relationship of mutual accountability, reciprocity and enrichment (Kanyoro 1996a). The entanglement of the West with Africa has been two-way, even if the power relations have been clearly asymmetrical. Moreover, the call to undermine binary divisions, whether they be those of the Pauline mission with Jew posited against Gentile, slave against free, male against female or those of modernity's racial, gendered and fiscal economies of privilege, is a powerful theme in Christian theological reflection and action, and has sustained the conversations which have delivered this book. Nevertheless, the theological and missionary activity of the last century has been embedded in wider political, social and gendered struggles for identity and power within Africa, whilst the presence of 'missionaries' and their organisational infrastructure financed from the North has manifestly operated within inequalities of power and resources in a faith community whose paradigm is radical equality. Such are the inescapable ambiguities and unsatisfactory circumstances of Africa's churches.

The Circle of Concerned African Women Theologians is a con-
temporary network of women from across Africa and in diaspora in
Europe and North America and the Caribbean. The network was
formally launched in 1989, with the inauguration of the Biennial
Institute of African Women in Religion and Culture in Legon, Accra.
However, the Circle was initially conceived by five women in the
alpine air of the Château de Bossey, Geneva. The Circle's incep-
tion in European climes reveals something of the problematic of indi-
genisation and representation which has been raised by globalisation.
For the genesis of this movement which seeks to represent African
women was facilitated by separation from the continent. Fresh con-
nections and communication are frequently easier outside the con-
tinent than within it. Such is the anomaly of contemporary Africa
and her logistical and political challenges.

The foundational meeting at the Château de Bossey was convened
by Brigalia Bam to encourage women in theological training. Bam,
later to become President of the South African Council of Churches,
was then the Director of the Education and Renewal Unit of the
WCC. According to Mercy Oduyoye (until 1997 the principal con-
venor of the continental Circle), 'five African women covenanted' to
make it possible for other African women who have had theologi-
cal education 'to discover one another and to seek how they can be
a source of inspiration and encouragement to one another and to
be an asset to both Church and society' (Oduyoye 1990f: 27). The
five set out to discover 'the sisters' and began to build a register of
committed women. In 1980, thirty women, a 'minority of minori-
ties' convened in Ibadan with the blessing of West African theolo-
gian, Dr Bolaji Idowu, to evaluate the role and contribution of
women theologians in 'religious institutions, family life and in national
development' (Oduyoye 1990f: 28). The inner Circle had begun.

The Circle currently numbers over five hundred members who
attend regional meetings in Africa and in diaspora in Europe and
America. Most of their work takes place in regional meetings. The
two intracontinental meetings have been separated by a symbolically
significant seven years. Over one hundred and twenty delegates gath-
ered in Nairobi in August 1996. This meeting was originally con-
ceived as ending the 'isolation and marginalisation of African women'
in the study of 'religious-cultural factors which mitigate the devel-
opment of women' and to encourage the generation of 'proposals

for national projects on women, religion and culture' (Oduyoye and Kanyoro 1990: 2, 4).

Women join from a variety of professions; by no means are all professional theologians, indeed, that situation would fly in the face of the intentions of this concerned network of African women theologians. Mercy Oduyoye has described typical members as those who 'earn [their] living in a variety of ways—teaching of religion and other humanities. Women from all levels of education, pastors of churches, executives in church organisations, heads of women's convents . . . owners of businesses' (Oduyoye and Kanyoro 1990: 19). Hannah Kinoti, a lecturer in the Department of Religious Studies at the University of Nairobi, comments that many of the 'mothers and sisters' of Circle women are from the countryside and townships. Like their female relatives, she comments, 'Circle women are overworked and must, out of necessity, combine several jobs to fulfil themselves and to make ends meet' (Kinoti, 1996b 1466: xi).

The Circle at present has no paid staff or research officers, and only limited access to funds. Finance and moral support have been secured in particular from the Programme for Theological Education, a department within the WCC. The Programme has been directed by a compatriot of Oduyoye's, university professor John Pobee (Oduyoye and Kanyoro 1990: 6; Pobee 1997). The Circle is a voluntary solidarity movement, which follows a long tradition in African societies of such organisations securing women's participation in decision-making in clan and village, in trade and politics. Such solidarities are, however, not simple, nor are they confined to Africa.

In a continent where a large percentage of women are illiterate, and with substantially restricted freedom of movement, the Circle membership represents an élite, in terms of both church membership and society in general. The background of the majority of women interviewed during the course of this research was mission-church: Anglican, Lutheran, Roman Catholic, Methodist and Reformed. Although there were women from African Traditional Religions (ATR) and African Initiated Churches (AICs) (notably from Nigeria), they were in the minority at both the 1989 and subsequent pan-African conference of 1996. They have similarly limited representation in Circle publications.

The Circle has connections with both African-American women and their theological themes and concerns. One of America's pioneers in African womanist theology, Katie Cannon, contributed the foreword

to the Circle's book of essays from the first biennial institute in 1992, *The Will to Arise* (Kanyoro and Oduyoye 1992). Others have been present at intervening national conferences; however, their precise theoretical relation to the issues of women, religion and culture and the development of an African feminist theology awaits articulation.

The impetus for the creation of the Circle came from women who were pioneers in the tertiary teaching of Religious Studies in their national universities or at theological seminaries. The importance of creating a national and pan-African network of support and common field of discourse is acknowledged in the introduction to the Circle published in *Talitha, Qumi!*, a record of the Proceedings of the 1989 Convocation of African Women Theologians. It has been confirmed in the author's interviews with Dr Musimbi Kanyoro, Professor Elizabeth Amoah, Professor Mercy Oduyoye and Dr John Pobee.

The Circle is a loose federation of women held together by their conviction that religion is important to their own personal and professional lives, and potentially revolutionary to the situation of women in their church and communities. From the outset, Mercy Oduyoye has argued that the Circle was 'not creating an association: [but] searching for kindred spirits'. What was critical has been to 'get a women's caucus of whatever existing Theological Associations' going and 'get a couple of people who will make things happen in the countries represented here' (Oduyoye and Kanyoro 1990: 18). These countries included Nigeria, the Democratic Republic of Congo (the former Zaïre), Tanzania, Malawi, Kenya, Swaziland, Zambia, South Africa, Cameroon, Namibia, Sierra Leone and Lesotho. Travel costs are always a difficulty in arranging international conferences in Africa. It is not surprising, then, that twenty out of the sixty-nine delegates noted in the official listings at the 1989 Accra conference were from Ghana.

The Circle's federated structure divides Africa into regional zones in much the same way as did the imperial powers. National Circle groups meet in the well-worn regional divisions of West Africa, East Africa, Southern Africa and Diaspora. So far the Circle has not established a forum north of the Sahara. This is hardly surprising since the majority religion for North Africa is Islam. The Circle, for all its insistence on openness to other religions, is overwhelmingly an initiative of Christian women who are involved in education in Church or society. Here, as indicated previously, important concealed continuities surface between the missionary vision of education, development and civilisation and Circle ambitions. Nearly two

hundred years later African women are seeking routes similar to their missionary foremothers for the transformation of their societies.

The network's information nerve centre has been Geneva. Mercy Amba Oduyoye was formerly one of the eight Vice-Presidents of the WCC; Musimbi Kanyoro and Nyambura Njoroge until 1997 were in charge of the women's desks at the Lutheran World Federation (LWF) and the World Alliance of Reformed Churches; both of these have their offices in WCC headquarters. In February 1998, Dr Kanyoro became General Secretary of the Young Women's Christian Association (YWCA), but has retained her commitment to the Circle as one of her key priorities. The Circle is not a movement that churches in Africa would necessarily recognise, as Musimbi Kanyoro acknowledges (Kanyoro 1994d). It is a movement of theological exploration, but most of all it is at present a movement of the theologically literate.

The Circle's principal agenda is to develop women's theological contribution in the churches, homes, universities, seminaries and political forums of Africa. In seeking to achieve this the Circle has prioritised publication, but pursues other forms of advocacy as well. As Mercy Amba Oduyoye, the recognised founder of the movement, puts it:

> I'm working with these women so that the isolation which I felt, nobody else will live that. That they will feel supported, that they will feel that they have a right to be where they are and (make) their contribution as women. As women we have a theological contribution to make to the theological development in Africa, to our churches, to our families, to our homes, and we have both a right and a duty, and it should be our joy, to make that contribution' (Oduyoye 1994e).

For the Circle leadership, the secular arena is just as important as the Church's. As early as 1989 Mercy Oduyoye challenged the Circle's delegates to profile the struggle for full and democratic rights for all, economic equality and the securing of women's rights in marriage, revised inheritance laws and the removal of violence against women; all issues which tax contemporary political and professional women's groups in Nigeria, Ghana and Kenya (Dolphyne 1991; Osakue, Okojie et al. 1992; Albert 1996). Circle members were charged as advocates for change in both customary and modern legislation. This demanded a reconsideration of what constituted 'fairness' for the African woman, and a reflection on whether a man 'should claim ownership of everything in his house including the woman he is married to?' (Oduyoye and Kanyoro 1990: 31). At

Accra, the Circle associated itself with the aims of the South African
United Women's Organisation, to unite women in common action
for the removal of 'laws, regulations, conventions and customs that
discriminate against... women and deprive us in any way of our
inherent right to all advantages and opportunities that society offers'
(Oduyoye 1990f: 20). The Circle's theology is praxiological and polit-
ical, its focus is centred on the condition of the ordinary African
woman, and it demands answers in the present, both within and out-
side the boundaries of the continent (Oduyoye and Kanyoro 1990: 31).

The Circle is a prophetic movement in the mission churches of
Africa. Mercy Oduyoye argues that these churches have suppressed
the traditional power of women within religion and culture, and
obliged them to adopt the false consciousness of the white colonial
centres. Rachel Etrue Tetteh, one of the first women to be ordained
in the Ghanaian Methodist Church, referred to the incorporation of
women in major decision-making and leadership roles by 'mainline
mission churches' as 'mere tokenism' at the 1989 inaugural confer-
ence (Tetteh 1990: 155). She continued, 'we know that women have
contributed a lot to the growth of the Church: women form the
majority of the congregations; they contribute towards the upkeep
of the church and give reliable and constant support to all church
programmes' and yet women's equal status is denied, 'discrimination
and sexism' prevail, and seminaries and other church institutions
have neither the will nor 'the facilities for the preparation of women
for church work' (Tetteh 1990: 159, 163).

Independent churches are the focus of some rather wistful research
and promotion by Circle theologians, who affirm their liberating
potential for women as leaders, their sustenance of traditional cul-
tural wisdom and the freedoms they create for women in prayer and
ecstatic religious practice (Zoé-Obianga 1992: 91; Hinga 1992b;
Nasimiyu-Wasike 1993a). However, many AICs manifest the entrap-
ments of patriarchal culture albeit in a mode different from that
of the mainline mission denominations. As Alina Maente Machema
asserted in her presentation at the Circle's inaugural meeting:

> Daughters of Africa need to rise and move forward from where they
> are locked up by culture and customs and do something... though
> Christianity has long been experienced in Africa and has preached
> that Jesus Christ came to liberate everybody irrespective of sex, race,
> strength or financial status. African women have been locked up in a
> safe compartment, along with their good ideas (Machema 1990: 131)

In their desire to establish a common agenda and identity there could be a danger in suppressing the plurality of views present in the Circle network. In my conversations and research the difference became most apparent between the Roman Catholic members with their allegiance to formal church structures and dogmas and the views of the Circle's mother, Mercy Oduyoye. However, as with any loose federation there is a genuine range of opinion across the Circle members' writings and personal testimony, generated by divisions of churchmanship, and the multiple variations of clan, locality, mission history, economic organisation, religious plurality, the struggle for independence, location of author/speaker and the recurring theme of motherhood. This makes their production a fertile seed-bed for creative future theological production and critical energy. Two things sustain their joint enterprise beyond gender. These are the paradigm of culture and religion as inextricably linked in the making of women's lives in Africa, and their perception of the failure of Christian or development agencies to render it of account in their activities or critiques (Oduyoye and Kanyoro 1990: 1).

Attention to religious and cultural practices by African theologians becomes a significant means of incorporating liberation theology motifs, and forwarding feminist and enlightenment goals of justice for women on their continent, without necessarily engaging in Latin American-style political action. Mercy Oduyoye has declared 'the religious burdens laid upon African people [as unimaginable] by the West', and *The Will to Arise* explores the implications of the ubiquitous 'child factor', widowhood rituals, women's 'martyr complex', 'ritual blood taboos' and menstrual impurity, polygyny, levirate marriage and the 'cultural manipulation of the female sexual organ' (Oduyoye and Kanyoro 1990: 44, 107, 190, 14). Thus the Circle's first article of faith is that they 'believe' religion and culture to be 'key' factors in the liberation of the 'humanity' of women in the land of Africa.

The logo for the Circle is an African woman at prayer in the process of 'responding to the call to arise' (Oduyoye and Kanyoro 1990: 18). In this gendered closure of the group, the Circle is rooted in traditions of organisation for action and support by women for women, whilst women performing a priestly prophetic function within their clans and families over Africa's long pre-colonial history has had important gains in research over the last decade (Hinfelaar 1994, Hoehler-Fatton 1996). The last two decades have seen urban academics reassessing the importance and variety of these women's groups

in the promotion of social, economic, religious and political well-being in their localities. The works of western social science researchers, frequently writing with African colleagues, mean that the North can no longer slide into simple colonially driven categories of women's historical disempowerment across the continent (Lebeuf 1963; Wipper 1975; Caplan and Bujra 1978; Obbo 1980; MacGaffey 1987; Berger 1992; Anyanwu 1993; Wipper 1995; Moore 1999). Gwendollyn Mikell, in *African Feminism: Towards a New Politics of Representation*, sees a resurgence of African women solidarity groupings as a marker of new democratic confidence after the disruption of colonialism and the suppression of alternative sources of political mobilisation during years of African military dictatorships (Mikell 1992). This may well be the case, but women's solidarities were important nodes of resistance during the years of colonial rule in Kenya and Nigeria, as the work of Tabitha Kanogo and Judith van Allen has clearly shown (van Allen 1976; Kanogo 1987).

Significantly, these women's solidarities are structured within wider co-operative ventures with men, which provide a different referential grid for their societal vision from those in which Western feminist solidarities have been placed. This is a point of resistance to any globalising vision from Western feminism. 'In mother-centred community men are precious as the male-aspect of life that we need to make us the carriers of life and whose responsibility is to be spirit protectors of the lives we bring into being. They are partners, not bosses' (Oduyoye and Kanyoro 1990: 44). The Circle is undertaking a feminist theological project which uses many of the theological tools supplied by Western feminist analysis, but has chosen alliances other than white sisterhood for pragmatic solidarities with men to secure an African future. However, in certain of their theoretical models, particularly their deployment of the notion of patriarchy and their analysis of male violence against women, their practical alliance with African men in the project of inculturating a liberating faith for Africa is potentially jeopardised.

The immediate priority of the Circle, however, is not political revolution but the production of theological literature (Oduyoye 1990f: 18). All members of the Circle from 1989 onwards were invited to publish at least two articles a year (Kanyoro 1990b: 5). In the light of the costs entailed in publishing in Africa, many of the Circle find publication only in newspaper articles, internal university papers and church literature. Orbis, the American-based publishing arm of the

Maryknoll Fathers, has provided the funding for the first four publications of foundational importance in the primary literature of the Circle. These are the conference papers of the EATWOT Women's Commission (EWC), *With Passion and Compassion*, the conference papers of the first biennial conference of the Circle, *The Will to Arise: Tradition and the Church in Africa*, and two theological studies by Mercy Oduyoye, *Hearing and Knowing* and *Daughters of Anowa: African Women and Patriarchy*. The Maryknoll Fathers, an association predominantly of American priests, have developed a significant presence in Africa, and committed themselves over the last thirty years to the promotion of liberation theology and Third World theologians. Nevertheless their publishing advocacy has made these seminal works more accessible to Western (specifically American) academic institutions and theologians than to the churches and seminaries of Africa, although subsidies for the Third World exist.

This raises important questions, recognised by the Circle, as to how to make their discussions accessible for African consumption. Orbis, despite generous subsidies, has been unable to reduce the prices of these imprints to make them accessible for a buying public in Africa. Those bought by university and seminary libraries in Africa were substantially achieved through European and American grants. The first publication of *Talitha, Qumi!* (later to evolve into *The Will to Arise*) was through the Daystar Press, Ibadan, where Mercy Oduyoye's Nigerian husband is the managing editor. The initial modest print run was sold through conference delegates in Accra. Since then an East African publishing house, Acton Publishers in Nairobi, has been established by Professor Jesse Mugambi, and has published two edited collections for the Circle. *Groaning in Faith: African Women in the Household of God*, and *Violence against Women* were published in 1996, the outcome of regional and national conferences of the Eastern and Southern African Circle, and the Kenyan Circle respectively. A concerted effort to secure African publication has recently realised the publication of the 1996 pan-African conference by Sam Woode publications as *Transforming Power*. *Groaning in Faith* and *Violence against Women* were intended to be 'authentic African theology . . . meeting people in their daily lives', using 'intensive fieldwork: listening and capturing what is said in songs, proverbs, sermons, narratives and the like, as people share their communities of faith' (Kanyoro and Njoroge 1996: xii). Their authenticity was seen to be preserved by African publication.

Building viable African publishing houses should be seen as part
of the quest for inculturation. The need to develop a vigorous unin-
hibited theological discourse in Africa has been well served by new
Catholic-funded presses across the continent. Paulines Publications
in Kampala and Nairobi, the Catholic Institute of West Africa (CIWA)
Press in Port Harcourt and Gaba Publications in Kenya are part of
a vigorous Catholic response to the need to develop an indigenous
publishing industry. The importance of autochthonous publishing
houses disseminating ideas free from the commercial sieving of 'New
York, London, Paris or Brussels', was noted nearly thirty years ago
as a significant part of decolonisation by the Publishing Director of
the East African Publishing House, John Nottingham (Nottingham
1969: 139). A robust African publishing industry liberated from
Western editorial control is an imperative for African theological
maturity. Otherwise what we see is the transmutation of *Talitha, Qumi!*
into *The Will to Arise*, with the loss of most of the original conference
material, and the capture and repackaging by Robert Schreiter of the
first publication of the Ecumenical Colloquium of East African Theo-
logians' (CEAT) symposium, *Jesus in African Christianity*, which became
Faces of Jesus in Africa and erased the contributions of Circle members
Judith Bahemuka and Hannah Kinoti (Mugambi 1989; Schreiter 1991).

The prioritisation of the Word in nineteenth-century Protestant
mission, with the introduction of printing presses for the distribution
of tracts, Scripture portions, other spiritual classics and newspapers
by the missionaries, gave literature and literacy a high profile in the
conversion of Africans. Modernity was Christianity and literacy. This
finds its modern analogue in the commitment to education, publication
and the academic location of the Circle's founder members. The
commitment to writing on the generic 'African women's experience',
and the problematic of distance from so many African women's lives,
is one which invites further empirical research. It should serve as a
warning to all theological projects of advocacy and representation. Such
theology will be judged by adequacy of representation rather than by
inner theological coherence or response to the divine word, cate-
gories which earlier Western engagements with Africa have preferred.

A significant proportion of Circle members who have tertiary
degrees and doctorates have studied and taught in America. Less
than a handful of Circle academics have secured funds for doctoral
studies in Britain. Europe has been host to some including Sr
Bernadette Mbuy-Beya and Dr Rose Zoé-Obianga. Of the central

organising caucus of Musimbi Kanyoro, Mercy Oduyoye, Nyambura Njoroge, Mary Getui, Anne Nasimiyu-Wasike, Teresia Hinga, Teresa Okure, Rosemary Edet, Rose Zoé-Obianga and Elizabeth Amoah, only Dr Getui and Professor Amoah completed their doctoral studies in Africa. The University of Lancaster awarded Teresia Hinga her doctorate in 1990, and Mercy Oduyoye obtained her masters' degree from Cambridge in 1969.

The academic habitat of many Circle authors now, therefore, includes some of the intellectual material of the United States as well as that of post-colonial consciousness. The women have been exposed to the language, symbols and concepts of post-civil rights America. Their vocabulary is the vocabulary of 'minority rights', 'racism', 'positionality', 'womanism' and the 'white superiority complex'. Black studies were born out of the bitter experience of slavery and the acknowledged failure of integration within education. This source of radicalisation for some of the Circle's core thinkers and writers, touched by the heat of America's race and gender struggles, suggests that there could be some difference in approach between Africa's indigenously trained theologians and those exposed to the seismic pressures of the United States.

The variables of the historical background of each of the nation states represented, the diverse church backgrounds and the personality of those interviewed present a formidable range of complexity which would need dedicated quantitative research to reveal more than hints and hunches as to the sources of the various discourses. However, there are significant connections with American feminist and womanist theologians, whose ideas enjoy favoured status amongst certain Circle authors. There is a general preference for themes of liberation, empowerment, black identity and the idea of the 'diaspora' by many of the transatlantically trained theologians (Kanyoro 1990b; Oduyoye and Kanyoro 1990: 23; Cohen 1997: 39–42; Yuval-Davis 1997: 65–66). There is a notion of sisterhood which creates potential counter-hierarchies based on colour against the perceived economic and ideological dominance of whiteness (Friedman 1995). This racial privileging seriously undermines the global sisterhood which had been part of liberal feminism's project on both sides of the Atlantic up to the mid-1980s, when dissonant voices from the 'underside' of the colour divide went into print and broke up what was perceived as a cosy transatlantic tea party (Hooks 1981; Hooks 1984). The Circle's cosmopolitan development is nothing startlingly

new. Africa's history has been entangled with America since the cre-
ation of the first indigenous church in Sierra Leone (Walls 1970;
Maimela and Hopkins 1989; Walls 1996).

Global feminist discourse and concerns have been developed through
Circle members' participation in the four UN world conferences on
women, from Mexico City in 1975 to Beijing in 1995. They have
been some of the 60,000 representatives of non-governmental organ-
isations, from one hundred and eighty nine countries. Whilst com-
mon concern for women's rights has been expressed by largely
conforming to the Universal Declaration of Human Rights of 1948,
there have been other coalitions of concern created within these
forums based on colour, religion and political geography. Cross-
alliances based on colour and anti-colonial rhetoric have flourished
amongst women's groups over the last decade, shattering Western
feminism's ideas of unitary oppression, and requiring more sophisti-
cated analysis to recover any common programme. We explore this
theme in chapter five with attention to the UN's recent prioritisa-
tion of the girl-child. Moreover, Islam has joined the Catholic, UN
and WCC debate on human rights with the promulgation of the
Universal Islamic Declaration of Human Rights (Islamic Council 1980).
This has helped pave the way for significant inter-faith dialogue within
the Circle membership.

The research realised in this publication has taken place in a
highly charged arena. There is constant jockeying for a place in the
sun of Africa's future by groups defined by gender, religion, ethnic
grouping or relation with the metropole. No forum is immune to
this contemporary task, not even the cloisters of theology. The old
sites of authority, village council, kinship and affine relationships—
already in some measure of crisis through missionary and colonial
interventions before independence—are, under the pressure of rapid
urbanisation, imploding. The strength of women's groups too is under
transformation. Women's membership of church groups such as the
Mothers' Union, the Anglican Women's Fellowship, the *Manyanos* (the
original term for Methodist women's groups in South Africa with
variations across Bantu languages) and the *Rukwadzano* (a women's
movement with a sub-text of European domestication developed by
women missionaries in southern Rhodesia at the turn of the nine-
teenth century, but now a means of continuing in Christian guise
the important separate sex organisation of Shona culture), are part
of a new positioning in Africa's social economies (Brandel-Syrier
1962; Muzorewa 1975; Schmidt 1992: 145 ff.).

It is widely recognised as a truism that 'women are the majority in the pews but virtually absent in clerical leadership' (Amoah 1997). Traditional collective work projects based on *harambee* harnessed by essentially conservative movements, such as the *Maendeleo ya Wanawake* (Development of Women) in Kenya, have, along with UN commissions on development and women, alerted non-governmental organisations and women politicians to the instrumental importance of women in sustaining rural economies and feeding Africa's fluctuating population. The UN Decade for Women registered an important shift in perception with its programmes for development registering the fundamental paradigm of 'the full participation of women' (UN 1996: 37). This added much needed external support to tertiary educated women's perception of their reduced role within both Church and nation. These women are renegotiating the spoils of leadership in many African institutions, with their colonially inherited male bureaucracies and hierarchies.

Mission churches, although frequently started by women missionaries and African women catechists and Sunday school teachers, were not able to transcend the gendered ecclesial economy from which they came (Gaitskell 1998; Pirouet 1982: 232; Robert 1998). The ordained power and religious authority within mission churches systematically devolved eventually onto local men, and resisted women's inclusion (Phiri 1997b; Landau 1995: 93). Moreover, as the Christian scriptures were translated into the vernacular, the NT proscriptions against women's full participation in the cult, teaching and leadership were absorbed into a new gendered partitioning of the religious imagination. The mixed nature of Christianity's impact on the gendered economy of an enormously disparate set of peoples and cultures, however, means that no single account of empowerment or destruction can be read without a close examination of the specific encounter. Where women had significantly participated in the religious realm within their clans and communities, this space was frequently problematised by the patriarchal remit of much missionary and colonial activity. However the map has not yet been finally filled in, and it is necessary to follow the contours of this troubled history with care. Counter-narratives emerge in close historical attention to the phases of societal change occurring in the history of Africa before the missionaries arrived. As Isabel Phiri alerts us in her doctoral exploration of the religious experience of Chewa women in Central Malawi, new female freedom and powers related to older overlaid traditions were sometimes unwittingly provoked by the presence of

female missionaries (Phiri 1997b: 39–55). Moreover, the provision of
western education set within the European patriarchal order intro-
duced African women to the possibilities of other identities beyond
the local; these were to include most powerfully the experience of
other African gender configurations (Hinfelaar 1994: xi; Dawson
1930; Labode 1993). However, it is beyond the scope of this pre-
sent study to do more than note the continued repercussions of the
age of flag and Bible in the orientation of much Circle discourse.

Finally, we come to the ambivalent category of motherhood, one
which both facilitates inculturation and discourages women's radical
autonomy within society. Motherhood was a metaphor adopted by
the imperial agents of state and mission in their imaginative orien-
tation towards the land which they were to conquer. There was a
colonial infantilisation of Africa, with the brief that the colonial/mis-
sion infrastructure was there to raise the child of Africa to full matu-
rity and 'manhood', which attempted to transcend the problematic
of race through the categories of maternal care, with the emphasis
of relationship over material exploitation. This deceitful metaphor,
experienced on the underside as the oppression of a step-mother
and not the nurturance of a mother or indeed, preferably, a sibling,
informs some of contemporary Africa's reluctance to trust relations
with Northern institutions today. Moreover, with motherhood as the
prevailing category for womanhood and entitlement in both Church
and society, members of the Circle are divided within their own net-
work as to their place in this dominant economy.

Some are mothers, some are without partners, some have their
religious vocation as their sphere of fertility and some are without
hope of biological reproductiveness. The place of motherhood as the
defining moment of women's legitimation in the African societal
economy is therefore contested. How is the centrality of the cultural
good of motherhood to be reconfigured in a socio-sexual and ethi-
cal economy of religious discourse and local practice that does not
privilege some women over others? Happily, the manner in which
fecundity is realised for Africa is through the active participation of
all her women, which renders motherhood not the narrow definition
of biological motherhood as in the classic Victorian formulary of the
bourgeois North, but the mythic centre of a woman's identity and
orientation towards her community, herself and the divine. The pro-
found implications of this insight are only just being explored by
African women theologians and their Northern counterparts. I hope

the discussion of the thought of both Mercy Oduyoye and African Catholic religious in chapters three and four will help our thinking on these matters to be not only better informed but given another dimension of the value of mother talents which are undermined in modernity's vaunting of technology and independence.

As publications are the Circle's top priority, part of the interest of this book is the working bibliography of books and papers both published and unpublished which I have been privileged to assemble over the course of writing. Hence a substantial section of this publication has been dedicated to bibliography. The four main collections of Circle literature used in the book are *Talitha, Qumi! Proceedings of the Convocation of African Women Theologians 1989; The Will to Arise: Women, Tradition and the Church in Africa; Violence Against Women* and *Groaning in Faith: African Women in the Household of God*. Articles have been taken from other edited collections and from a variety of church and mission journals. The EAETC symposia, committed to the promotion of contextual theology since 1987, and funded by Americans (Maryknoll Fathers), Germans (Missio) and the All Africa Conference of Churches (AACC) have been particularly important for East African Circle members. Articles by Circle members have been published in *Concilium, The Way, The International Review of Mission* and a variety of other journals, especially those of the WCC (*The Ecumenical Review*), LWF, EATWOT (*Voices of the Third World*), the Kinshasa Theological Weeks, CIWA (*Journal of Inculturation Theology*), the Catholic Higher Institute of Eastern Africa (CHIEA) (*African Christian Studies*) and the Circle's own occasional in-house journal *AMKA*, which means 'Wake up'.

I have been most fortunate and privileged over the last few years to meet Circle members in a variety of locations and to attend as a guest the second international Circle conference in Nairobi in 1996 where many of the participants were generous with their time and conversation. It has been an enormous joy to be with women who are pioneering a theological voice for their less privileged sisters in research, teaching and church institutions across sub-Saharan Africa. I first met Mercy Amba Oduyoye in Bossey in 1994, along with Musimbi Kanyoro, Nyambura Njoroge and Elizabeth Amoah. I am indebted to them for their warmth and hospitality in meetings, conversations and email exchanges which have occurred over the last 6 years. My time at the Circle conference in 1996 gave me the opportunity to meet less published researchers, pastors, counsellors,

politicians and women's right activists, whose work has not been
published in books but whose reflections and insights have been of
real power in the creation of this account. My heartfelt thanks are
extended to all the women who gave me a generous welcome and
shared their laughter in the midst of adversity.

In my initial research I had hoped that I might be incorporated
by the Circle in their project of awakening myths, narratives and
histories of empowerment for African women, in a manner similar
to that pioneered by Bennetta Jules-Rosette, and developed by Wim
van Binsbergen in their methodology of participant observation (Jules-
Rosette 1975; van Binsbergen 1991). Unfortunately, and maybe
inevitably, it soon became apparent that in terms of Circle mem-
bership, 'African women cook alone in their kitchens', and such a
method would not be possible for a white British academic (Oduyoye
1996d). The emergent discourse on the problematic of whiteness is
not explicitly addressed in this work, although the wise reader will
find numerous moments where the issue at stake is precisely that of
unarticulated whiteness as the alternate otherness, the privileged gaze
so unnerving for the black constituency caught in the spotlight
(Frankenberg 1993; Opie 1992; Moghadam 1993). Even if in the
end African women must necessarily continue to cook alone at this
juncture in history, several leading Circle women granted non-struc-
tured and recorded interviews alongside informal conversations, which
developed themes of common concerns for gender and racial justice
across our divided continents.

Perhaps the best exposition of what I have attempted here is to
be found in Virginia Woolf's description of Boswell's biographical
technique. She remarks:

> The biographer is doing two incompatible things. He (sic) is provid-
> ing us with sterile and fertile. Things that have no bearing upon the
> life. But he has to provide them. He does not know what is relevant.
> Nobody has yet decided. A bastard, an impure art (Lee 1997: 10).

This work is the compilation of an 'unofficial biography' of the Circle
of Concerned African Women Theologians, and one by which the
owners of that history will, it is hoped, be provoked into the creation
of an alternative map. In one sense, no-one is entitled to describe
the life of another and so I await the official biography with real
anticipation. However, I offer an outsider's perspective and hope that
I elucidate in these pages connections with wider movements and

ideas that have had a bearing on the emergence of the Circle's the-
ologies and life. As a woman, a researcher at a leading university
in Europe, a white citizen of a former colonial power, and a member
of 'fortress Europe', I have been made painfully aware during the
course of this study of the numerous complications 'positionality'
raises within both 'giving' and 'obtaining an account' (Friedman 1995:
124; Reay 1996). The enlightenment project of writing an 'objective
account' through empirical research is clearly not sustainable in such
treacherous waters, even if it were ever philosophically possible. I
have also become aware in a very personal way of the dangers of
ethnocentricity in research with regard to the skewed power relations
between researcher and the women whose histories I have researched.

It has been a difficult and sometimes excruciating place to work.
Many were the times I would have cheerfully walked away. My place
of privilege, difference and exclusion was frequently alluded to in
my conversations with central Circle members. After all it was I, a
white non-African, rather than one of their own, who had received
a field-work scholarship, I who had secured the funds for study, I
who had the library resources on hand in Cambridge to pursue the
research when away from the field and day to day contact. I expe-
rienced in a very personal way the loss of innocence that has over-
come recent feminist researchers in their considerations of race and
class. The stark writing and speaking of African-American theorists
and 'women of color' has shattered for us all any facile aspirations
of gender unity, a simple shared experience of women and uncom-
plicated advocacy (Zinn and Dill 1996; Edwards 1990).

My hope however, through all these limitations, has been that,
through a proper attention to the emergence of one particular school
of theological development in a place of difference, Northern theol-
ogy would be further encouraged to attend afresh to non-white, non-
male concerns rooted in their own history of cultural diversity and
difference (Moore 1988: 11; McCarl Nielsen 1990: 22 ff.). It is noth-
ing less than an invitation to change the accepted parameters of the
theologically worthy and 'orthodox', and to open our minds to the-
ological renewal. It is a project based on inter-subjectivity and intense
listening with the intention of delineating a mode of being Church
and doing theology which is post-colonial and informed by the best
insights of feminist theory. To do this, women's agency, dialogic rela-
tionship with those researched, permission for difference and disso-
nance rather than 'sameness', have been assembled as part of the

methodology of research. It remains an attempt flawed in the contingencies of distance and separation in its psychological as well as its geographical form during the research process. Nevertheless, I offer the work, however inadequate, as a start to a richer and deeper engagement as North and South enter into the dangerous terrain of exploring each other's theological desires, socio-religious histories and contemporary worlds.

The book has been developed from the early ecumenical context of the emergence of the Circle and explores the theology of leading Methodist and Circle founder, Mercy Amba Oduyoye. Oduyoye's task has been to recover the strengths of African culture and to account for its corruption by Christianity, in such a way that both the culture and Christianity might be released into a new creative symbiosis. She seeks nothing less than a total renewal of the African mind and society based on African cultural resources, traditional religious practices and the unleashing of the 'Christ-Event'. A theologian who is relentless in her pursuit of the renewal of African society, the well-being of all women, and an almost Ethiopianist dream of a reconstituted black Africa with a culturally gathered but physically mobile diaspora, her theology is imbued with the self-help and class motifs of early Methodism, as well as with the self-confidence and wisdom of Akan culture. In contrast to the independent Protestantism of Oduyoye, the study moves on to explore some of the incongruities within the motif of African self-realisation and representative womanhood of Roman Catholic religious. Although the social reality of African women religious has been noted by scholars in Africa, Europe and America over the last 20 years, little work has been undertaken to describe their theological contribution. I have given particular time to their reflection on the themes of motherhood and fecundity through the use of Marian motifs and also considered the impact on their thinking of Vatican II and their interaction with Papal letters and regional synods over the last thirty years. Their social reality as religious women in community under lines of ecclesial authority which traverse national and African limits presents much food for thought and discloses the looseness of ideological imperative within the Circle's life.

In choosing to look at the Circle through the grid of denomination rather than region, I have necessarily reduced the overview of the work of the Circle in its regional configuration. There are, as I have indicated, Circle networks across Sub-Saharan Africa. I have not had the opportunity to visit or interview members of the

Portuguese-speaking regions nor to expound the rapidly changing political scene of South Africa.

For those who wish to develop their understanding of the contribution of the Circle to the evolving life of the rainbow nation of Southern Africa, I commend the collection edited by Circle members Denise Ackermann and Emma Mashini, *Women Hold up Half the Sky*, published by Pietermaritzburg publishers, Cluster Publications (Ackermann & Mashini 1991). This was the first published work by black and white women theologians in South Africa. It served as something of a response to Bernadette Mosala's call five years earlier for religious women to embroil themselves in the mess of the contemporary political struggle in Southern Africa and Bonita Bennett's criticism of the inert role women were playing within the South African churches (Mosala 1986: 129–34; 169–174). Afrikaner women's contribution was limited in the debate, with a silence imposed both by the apartheid position of their own churches and by the growing discomfiture of black theologians with the perceived subalterns of their politico-religious masters. A bench-mark history of South African women's religiosity as practised by the *Manyanos* had already been published by Mia Brandel-Syrier in 1962 (Brandel-Syrier 1962). She produced a startlingly sympathetic white commentary on the religious experience of black women as male work-related familial displacement, and the grim racial segregations of townships, hardened in the political configuration of the apartheid state. Unfortunately, Brandel-Syrier's treatment lacks any self-critical analysis of her research within the contours of South African politics. The difficulties of securing a liberational method to do research and theology in the conditions of an oppressive state was embedded from early on in the recent literature.

Five years after Ackermann's anthology and eighteen years after that of Brandel-Syrier, another Afrikaner, Christina Landman, also an academic and member of the Dutch Reformed Church, sought to undermine the walls of racial difference with an edited work on South African historiography focused on the life of women, *Digging up our Foremothers* (Landman 1996). Landman assembled writers from all sides of the apartheid religious fission and gender divide to retell their people's stories, convinced that research is becoming 'gender trapped', and that it is important that both sexes tell the 'stories of women with the common goal to retrieve, to voice, to break the silence of research objects trapped in gender' (Landman 1996: 3).

Her project is wider than that of opening feminist writing to the contributions of men or indeed to make the silenced theology of Southern Africa's women present as a resource for contemporary nation building and reconciliation. Landman employs a method which makes colour, like gender, disappear. In this way a white Afrikaner woman can make her contribution to the small but growing literature on white missionary women, African catechists, evangelists and apostles, Afrikaner, Zulu, Xhosa, Shona, San and the numerous people groups which make up the aspiring rainbow nation (Landman 1996). However, her project is contested within the Circle network, as it theoretically removes the significance of gender and colour as essential points of difference at a point when women and non-white people are rediscovering their subjectivity in their distinctiveness from those who have dominated their recent cultural and political history. The problematic of Brandel-Syrier remains.

Denise Ackermann is now working on a spirituality of lament, to articulate the dysfunctionality of South African politics and social life for a contextually authentic Christianity. In the wake of disappointments over the ability of the new democratic dispensation to deliver the almost millennial aspirations of the subjugated black majority, premature Christian speech about forgiveness and reconciliation, and AIDS infecting an estimated one in five adults in South Africa's population of about 41 million, Ackermann believes that the ancient tradition of lament is available for victims and former oppressors as a way of both 'bearing the unbearable', responding with integrity to the realities of contemporary Southern Africa and with a 'wailing of the human soul, a barrage of tears, reproaches, petitions, praise and hope . . . beat against the heart of God' (Ackermann 2001). With AIDS threatening to unravel the economic development and hard won societal gains achieved, with the staggering costs of caring for the sick, the dying and those they leave, this call of Ackermann's particularly to mainline Christianity for a recovery of the language of lament would facilitate the communication of a post-colonial church in spiritual solidarity with the intense human suffering which is sapping life from every sector of African society. It is more than timely.

Professor Isabel Apawo Phiri, a Malawian professional lay woman, situates her academic contribution as one generated from an urban-educated location of privilege not representative of the majority of African women who 'live in rural areas and exist under very difficult economic, social, and spiritual conditions. For the majority of African

women' she reminds us 'it is issues of survival that concern them most rather than discussions about their gender' (Phiri 2000: 329). As co-ordinator of the Women in Church and Society programme at the University of Durban-Westville, Phiri sought to 'encourage both men and women to explore ways of affirming women's faith in the promotion of justice for all people across cultural, racial, economic, political, social and denominational background' (Phiri 2000: 330). Phiri has been concerned to let us hear the silenced voices of women and encourage them to set their own agendas. The Women in Church and Society course represents a natural outcome of the November 1996 conference held for South African theologians entitled *Women in Ministry and Theologians*. Here the needs of women in ministry and theology were assessed as the need to write and have access to a theology of their own; to train one another to write and contribute to such a theology, and to develop skill among themselves to manage transformation in parishes, academic institutions and in South African society as a whole (Phiri 2000). This and the meetings of the KwaZulu Natal chapter of the Circle has been an inspiration for Phiri in the delivery of a range of empowerment workshops. These take place across the divisions of lay and ordained, academic and non-academic, denominations and race. There are Bible Studies which focus on HIV/AIDS, cultural differences in the home, Church and the country and domestic violence and research programmes which explore some of the issues arising from these encounters outside the walls of the University. The praxis-orientated Centre for Constructive Theology has an important contribution to make in raising the awareness of students in the University of Durban-Westville and churches in KwaZulu Natal to the issues of African women and the presence of African women's theology.

Phiri's doctoral study on *Women, Presbyterianism and Patriarchy* established her credentials as an historian who understands the context of women's religious disempowerment through the colonial experience up until the present, and an engaged theologian in the best liberation and feminist tradition (Phiri 1997a; Phiri 1997b). The work of the Centre for Constructive Theology is a practical demonstration of Circle theology best practice in its attention to the needs of African women for improved literacy, access to adult education opportunities, strategies to resist domestic violence, and a range of other empowerment issues. Present at the 1996 pan-African conference of the Circle in Nairobi, Isabel Phiri's contribution along with Afrikaner

and English-speaking women offers the potential of the Circle net-work as a strategic participant in the creation of a new empowered and entitled civil society after the brutalisation of the apartheid era. The challenges of making an informed and cohesive democracy in the post-apartheid South Africa are very great indeed. However, this story remains to be written by another.

The practical outworking of some of the concerns of the Circle is particularly marked in their active involvement and participation in resisting three areas of cultural violence nominated by African Women theologians as areas of critical theological and spiritual con-cern. These are the issue of domestic violence (assorted forms of bat-tery, sexual control and rape), female genital mutilation (a particularly intrusive cultural marking of women's bodies for transition into wom-anhood and marriage), and the welfare of women within polygynous marriages. Of these three areas, the first two have received no sus-tained attention from male theologians in Africa. It is therefore of even greater significance that this problem has generated numerous articles from Circle writers and a specific volume from the Kenyan Circle in 1996 (Wamue 1996).

In conclusion, I engage again with some of the difficulties posed by the current Circle project. Recent feminist scholarship has had to engage with the fragmentation of a once facile commonality of 'sisterhood' asserted by western women's scholarship. The fragmen-tation has made its impact both within gender, and also within ethnicity and race. In the short term, identity politics and identity theology threaten working majorities to drive forward some of the larger political and ecclesial projects of justice-making, promoted by such supra-national organisations as the United Nations and the World Council of Churches, due to representatives' advocacy and perception of difference. So far the Circle's practical pan-African project and much western literature on global solidarities in the fem-inist cause have avoided serious theoretical engagement with this difficulty. However, how gospel, race and gender relate to culture is the stuff of contemporary theological, philosophical and anthropo-logical debate. I hope that in some way this research on the pio-neering activities of concerned African women theologians will help to sharpen some of the practical and important issues which pertain to how that relationship is decided. The relationship is not one of mere casuistical interest but is implicated in the social construction and sustenance of society in gendered and racial diversity which has

gospel values of justice and equality at its heart, whether this be in Africa or any other continent.

The writing of this book has been informed by my own missionary engagement in the Congo, in a contemporary immersion in Africa (1987–1990) as a white privileged outsider, and a social science commitment to the permeability rather than the immutability of boundaries. However, as my own experience as a researcher and church worker have incontrovertibly revealed to me, if to no one else, easy solidarities whether based on religious confession, gender or race are not to be had in this highly charged arena. The binary divisions which have been favoured by some Western and Circle theologians in their encounter do not encourage a sympathetic reading of Africa's recent history, nor a helpful model for future theological discourse across cultures, nations and ethnicities. These simple divisions clustering around colour and land have resulted, as Susan Stanford Friedman has remarked, in scripts of 'accusation', 'denial' and 'confession' (Friedman 1995: 120). Post-colonial feminists have proceeded, through a meta-narrative of race, to reduce some of the historical and contemporary ambiguity in the mediation of power in politics, religion, cultural identity and gender to a single story of colour and racism (Thistlethwaite 1990). This narrative is based on the binary of 'white/other' within a 'victim paradigm of race relations' (Friedman 1995: 121). Such is the pain inflicted on the universal eye in any undertaking of cross-cultural research and the challenge for us all in this 'globalising' world village. However, I trust that in these pages you will find the struggle to understand worth the pain of not knowing, feeling lost, and being separated, and through your attention will discover from women in Africa a gift of liberation and understanding through relatedness in your own journey.

THE ECUMENICAL AND CONTEMPORARY LOCATION OF THE CIRCLE OF CONCERNED AFRICAN WOMEN THEOLOGIANS

The Circle is unique in being the initiative and vision of one woman, which gained the enthusiastic welcome and support of EATWOT women in Africa and subsequently that of many more. It has won the generous support of church women's organisations, ecumenical bodies and mission boards. The Circle is unique in defining theologians on the basis of the concept of theology by the people and for the people; specifically theology by women for the whole community of women and men that constitute Africa's three main faith communities (Oduyoye 1997c).

We believe that African theology must be understood in the context of African life and culture ... The African situation requires a new theological methodology that is different from the approaches of the dominant theologies of the West ... Our task as theologians is to create a theology that arises from and is accountable to African people (Appiah-Kubi and Torres 1979: 193).

Introduction

In this chapter, I explore the ecumenical and ideological history which has shaped the emergence of the Circle of Concerned African Women Theologians. Our history starts with the formation of the WCC in 1949, and notes the work of the TEF and the regionalisation of theological associations in Africa. The creation of the Ecumenical Association of Third World Theologians (EATWOT) is charted as it becomes a force within global theological formation, with its self-conscious post-colonial southern identity and rapid secondary development of the EATWOT Women's Commission (EWC) at Oaxtapec in 1986. Pan-African ideals have been critical in the development of an African theology which works with an understanding of both the black diaspora and a form of African essentialism. This approach has permitted an open field of theological discussion to cross the Atlantic from the United States and interact fruitfully across the ethnic, political and lingual matrix of Africa.

In the new educational diaspora of Africa there has been an exchange of ideas with advocates of the women's movement within theology which has both enhanced and at points embittered relations across the racial and Atlantic divide. We will explore the reasons why religious pluralism has been adopted by the Circle as its modus vivendi within Africa, and how the organisational structure of the Circle has been influenced by ideas found in organisations at one remove from the continent; principally the WCC, the LWF and the YWCA.

Changes in the nature of African Roman Catholicism after Vatican II are noted; in particular the emergence of national religious orders, the targeted training of African women as theologians and superiors, and the impact of the African Synod. The development of African Catholic theology is examined in the light of its direct impact through shaping leading co-ordinators and thinkers in the Circle of Concerned African Women Theologians.

The interaction of key Circle fondateurs with the thought of first-world women, both published and in conference, workshop and seminar settings, is of real interest in the development of ideas and movements; certainly the ideological and physical links which are in place between African-American academics and Circle theologians are not negligible. The wider secular setting of various UN initiatives, in particular the decade for the development of women (1975–85), has had a very real impact on the life of African theology over the last three decades, and the wide-ranging impact of the decade dedicated to women on ecumenical church agencies is worth appreciating. Circle membership is preponderantly drawn from the old missionary churches, with many women already involved in a variety of ecumenical and international sponsored conferences and workshops. The ecumenical range of the Circle is indicated by the presence of AIC women as members since the first pan-African Circle conference in Accra in 1989. Nevertheless, they were in a minority, with most members coming from the old mission denominations: the Methodist, Anglican, Lutheran, Catholic and Presbyterian Churches.

The ancestry of the Circle of Concerned African Women Theologians is complex. It is dependent on numerous unarticulated strata crucial for its successful functioning, both administratively and theologically, which are seldom brought to the surface in the quotidian of its life. The Circle has a symbiotic dependence on the West, which lies undisclosed in its public pronouncements. This interdependence

is part of a more general entanglement of interests, ideas and personnel. Movements do not only flow one way down the colonial and post-colonial hierarchy but are far more molten, with forward and reverse flows breaking up the former cultural and ecclesiological landscape of coloniser and colonised.

This has been demonstrated in the journey towards the 'emancipation' of women, the development of theological instruments to repossess the Christian story for women, the acquisition of educational goods, the creation of new pan-African solidarities and the appropriation of African-American black identity politics. The new political and social realities of the African-American diaspora have forged a confident set of womanist theologies affirming black dignity and black women's strength to sustain community in adversity. Furthermore, pan-Africanist goals minted in the alienation of diaspora, such as Negritude, Ethiopianism, and Garveyism, have been translated into an ideological mechanism which has enhanced a theological vision for African women as they negotiate the divisions of ethnicity, national boundaries and religion by an appeal to motherland, biology and a unitary historical and contemporary location.

Much Circle theological engagement depends on theoretical work already undertaken by African male theologians through the dying years of colonial rule. This effectively incorporates part of the Circle project in a gendered dependency upon the continuing struggle for national authenticity. The Circle is thus to be understood as a theological movement which reflects in its inner contradictions and desires the maelstrom and ambiguity of modern Africa.

The World Council of Churches was created in Amsterdam in 1948. It represented the combination of the Faith and Order and Life and Work movements into one permanent secretariat. The Committee of Thirty Five, which commended this innovation at Westfield College, London in July 1937, saw this 'new child' as the means to 'facilitate the more effective action of the Christian Church in the modern world' (Visser't Hooft 1949: 43). It was the logical step for Protestant churches to develop more mature links with their daughter churches and seek to evangelise for Christ a broken world by an appeal to the unity maintained by the churches. Amsterdam saw representatives from over one hundred and forty-seven churches and forty-four countries. There were twenty-two delegates from the Asian churches but few from Latin America, and, of the thirteen delegates from sub-Saharan Africa, there was only one Reformed

and one Presbyterian delegate, both from South Africa. Anglican and Methodists predominated. There were no representatives from the AICs, and there were no Roman Catholics from any region, even as observers. All the delegates from Africa were men, but this fitted the overall pattern, an overwhelming preponderance of clerical representation which skewed gender dramatically: two hundred and seventy out of the three hundred and fifty-one delegates were clergy (Visser't Hooft 1949: 223–267).

Dr Visser't Hooft, the first President of the WCC, had met, through his work with the World Student Christian Federation, women who had been engaged in the Resistance during the Second World War, and he 'proposed collecting material on the contribution made by women in the churches during the war' (Herzel 1981: 6). The Baarn Report, which emerged from this research, was prepared by a pre-Amsterdam conference of the Study Committee on Women (a mixed committee of both men and women). The report, which was seen as addressing not simply the 'problem of women alone' but 'the whole Church', was presented to the Amsterdam Conference in 1948 (Visser't Hooft 1949: 148). As Herzel comments, 'not since the reformation had systematic attention been directed to gaining a picture of the life and work of women in the Church as a whole, both professional and voluntary, evaluating it and seeing the hopes for its future' (Herzel 1981: 8). In fact, such was the scope of the report, which focused on Europe but included India, West and South Africa, Korea and China in its purview, that it should be considered as a transformational document. It altered the terms on which women's ministry and contribution would in future be discussed by the WCC. The report, *The Life and Work of Women in the Church*, was 'commended to the churches for their serious consideration and appropriate action' (Visser't Hooft 1949: 146).

An Indian academic, Sarah Chakko, presented the findings of the Baarn Report to the Amsterdam conference. In the debate that ensued, the decision was taken to give greater prominence to the role of women in the life of the churches by the creation of a Commission. Dr Chakko was chosen quite deliberately, as a 'Third World woman', to head this Commission on the Life and Work of Women (CLWW) (Herzel 1981: 13). The CLWW was not sidelined into working with what she called the 'shadow churches', the women's organisations particularly favoured in the USA, but which were also burgeoning in the churches of Africa. These she regarded as rendering

women 'second class citizens', and keeping women out of the 'real operational' processes of the churches (Herzel 1981: 13). 'The great cry from Africa' according to the final report was the

> need for the training of women, not only because they are illiterate and totally unused to assuming responsibility in any community, but because the slick and shallow freedom of the Western world is being brought by the film, press and radio, and a narrow embittered nationalism is demanding that Africans shall have all the outward trappings of European and American 'civilisation' . . . The younger women are not able to distinguish the good from the tawdry in all that comes to Africa from the West, and the criteria of a judgement can only be given by *education and training* in the best. There is a feverish haste at present to train leaders for Africa's independence, and no doubt leaders in the political, administrative and academic spheres will be men. But that will not touch the deep springs of the life of the people which flow from mother to child through the endless customs and traditions of the home: only the training of women can do that (Bliss 1952: 181).

Training and education, the enduring imperatives of women's contribution in missionary endeavour, became the priority of CLWW as well. This time it was not to rescue Africa from 'darkness' but to prevent Africa's slide into the mire of European and American 'modernity'. Sponsorship for women to study for theological degrees was to wait until the 1970s. Training was envisaged in an innocent restatement of domestic ideology of the high imperial era. Women were the key influence on children at home and in schools. 'The deep springs of life' needed to be trained, and so numerous study initiatives for women were established. The idea of women elders of local churches was applauded, but the idea of women's ordained leadership in African and Asian churches was not actively promoted. Sarah Chakko and Kathleen Bliss edited a study guide on 'fundamental issues' which looked at the doctrines of creation, fall, redemption, the apostolic age and marriage symbolism for consumption in a variety of study workshops, which used contacts established by the YWCA, and WCC-affiliated church missions.

In 1954, at their Evanston Assembly, the CLWW was accepted as a fully-fledged department of the WCC, with a new name to specify that it was not simply a 'women's department'. The Department on the Co-operation of Men and Women in Church and Society (CMWCS) was soon absorbed into the Division of Ecumenical Action, which included the departments of laity, youth and the influential

Ecumenical Institute at Bossey. The department had all the elements crucial to effective functioning (as recognised by Dr J.H. Oldham at the World Missionary Conference at Edinburgh in 1910), a full-time secretary and a working budget (Visser't Hooft 1982: 9). These were realities essential to CMWCS's effectiveness and the emergence of CATI, EATWOT and the Circle.

In 1965, during the third year of the Second Vatican Council, a significant association between Catholic women and the World Council was forged. It found official expression as the Women's Ecumenical Liaison Group at the Uppsala Assembly in 1968 (WELG). Ecumenical liaison in western Christianity between women was now in place. Women continued to be poorly represented in the WCC despite the recommendations of the CLWWC at Amsterdam in 1948 that a 'greater number of women be chosen to serve on the commissions, the major Committees and the Secretariat of the WCC' (Visser't Hooft 1949: 149). On the Central Committee, the body which guides the WCC between Assemblies, only two out of a potential ninety places were given to women in 1948, rising to four out of one hundred at New Delhi in 1961 and, even at Uppsala, reaching only six out of one hundred and fourteen (Hammar 1988: 529).

> This pressure for the Assemblies to be more inclusive did not come from the founding churches of the first world but from the newcomers. A Filipino woman provoked a visual demonstration by asking 'the women who were (present) representing their churches as fully appointed delegates [to] stand'. Only nine per cent of the conference could do so. Furthermore, only a smattering of Third World voices were heard (Herzel 1981: 50).

The CMWCS was mandated at Uppsala in 1968 to dedicate itself to leadership training among Third World women, just as Brigalia Hlophe Bam was released from apartheid control in South Africa to take up her position as General Secretary of the women's desk. Like many of the women at the heart of the Circle, Bam's forebears had deep roots in the missionary invasion of the mid-nineteenth century. Her great-grandfather was an early Anglican convert.

Before arriving in Geneva, Bam had undertaken a tour of South and North America. In Brazil, she had met Dom Helder Camara and discussed *machismo* and the search for human liberation. In North America, she encountered Dr Martin Luther King weeks before his assassination (he was to have given the opening address at the Uppsala

assembly). Their conversation ranged over issues of race, civil rights and emancipation. On arrival in Switzerland she was given fresh cause for thought:

> the Swiss women, all professionals... wanted to hear about South Africa. Of course, I was telling them, and they said 'we don't vote'. These educated women!... and then I realised, 'Oh, my God, this is really serious' (Bam 1996).

Brigalia Bam had been working with the YWCA in Johannesburg and had attended the All African Youth Assembly in Nairobi in 1962, organised by her predecessor at the Women's Desk, Madeleine Barot. She attended the inauguration of the All Africa Conference of Churches in Kampala in 1963 as a youth delegate. The conference had a profound effect on her life. In 1996 the General Secretary of the South African Council of Churches (SACC) in Johannesburg, she recalled how she

> was part of a youth group that had gone the year before... in 1962, to a youth assembly, [a] very exciting youth assembly. I still remember it, 'Freedom under the Cross', and I was thinking the other day, I would like to use that theme in South Africa... 'Freedom under the Cross'. They brought youth from all over Africa, from all over Africa, and I was part of the delegation. At the end of this youth assembly of hundreds and hundreds of youth, they chose ten young people to represent the youth of Africa in 1963, the following year, at the youth assembly. So I was a privileged one, amongst the ten, to go now to Uganda. So ten of us young people, feeling very proud that we were chosen by hundreds and hundreds of youth, [went], and the World Council met me there, and that's how I discovered that the World Council existed. I didn't know what it was, I didn't know what it was doing, and later on they then invited me (to Geneva). From that time onwards I had contact with them (Bam 1996).

Training programmes on the African continent had concentrated on French-speaking West Africa under Madeleine Barot in the early 1960s. Now, under Bam's influence, these were extended across Central Africa, and down to Southern Africa. The importance of the interpersonal, of the face-to-face contact of women, was of profound significance to Bam, and is an acknowledged feature of the importance of conferencing in the life of the EWC and the Circle:

> Opportunity for education [in the developed countries] hasn't meant liberation nor the solving of problems. These are things which papers can't communicate, but personal encounters, conversations and friend-

ships can. Human experience and personal contact are things people do not forget. And such sharing forms an invisible sense of community, removing the deep fear of isolation (Herzel 1981: 68).

In conversation with the author Bam remarked:

> Delegations come to Geneva and they would be all male. Then we started the debates on ordination of women, and then we did research, how many member churches were ordaining women . . . I was able to globalise the issue. I was able to get the terminology and the instruments. But the American women then in the sixties really hit me. Like Letty Russell later, lots of them . . . the famous woman . . . the Catholic theologian . . . Schüssler Fiorenza, then it was really something else. Those American women!
>
> Pemberton: They were making links for you?
>
> Bam: Strong, strong links. Then they were really on it and Europe was not ready. Europe was not there. And then we would have these consultations in Geneva which I would call theologians from Europe . . . when they did come, they came strongly. (Dorothy Sölle, Elisabeth Moltmann-Wendel, were indicated) . . . Pauline Webb's office, they came through there, then it changed. The debate changed. Then the world started to take it seriously (Bam 1996).

Bam remembers how, when Mercy Oduyoye came to Geneva to work at the WCC women's desk, she urged her to write:

> Mercy said, 'why should always, exactly, everything written, research, the analysis be done for us?' And then Mercy and I would be very angry. Now Mercy writes very well. I don't have very good skills in writing. Mercy says I have skills in writing but I'm lazy and I'm not disciplined! 'And so this is it Brigalia, now we must write!' I said, 'No Mercy, I can't write.' 'No, now stop it.' So we talked about this and we talked. And this is how the Circle idea came. That, let's get the African women to research, to do serious intellectual work. Research and reflection and analysing their situation. But in Africa we can't do it without culture, because culture is very, very strong. We cannot separate religion and theology away from culture. That's how it came about (Bam 1996).

The WCC Berlin consultation in 1974, on *Sexism in the 1970s: Discrimination Against Women*, saw Dr Letty Russell's first dealings with the WCC. Dr Russell, an American Presbyterian, Associate Professor at Yale Divinity School, had been involved with African-American ministry as Director of Education in the East Harlem Protestant Church of New York for nearly twenty years. Black consciousness was in the ascendancy amongst black radicalised youth. So, too, was

the concern for racial justice, cultural identity and gender equality, which have dominated Russell's theological corpus over the last two decades. Feminist hermeneutics, the round table, non-hierarchical theology and cross-cultural diversity have all been well represented in her publications (Russell, Diaz et al. 1988; Russell 1992; Russell 1993; Russell 1994).

The consultation at Berlin was a watershed in the development of women's contributions to the WCC. For the first time the planning group for this conference decided that this WCC consultation should be for women only, a distinct move away from the mixed group consciously adopted by the Life and Work committee of 1947. Brigalia Bam noted a 'new wave of self-awareness among women', and that 'sisterhood will be an expression of solidarity, as we work for an end not only to sex discrimination but to all forms of oppression' (Bam 1975). The West Indian-born General Secretary, Philip Potter, apologised at the consultation for the lack of a female General Secretary to the Assembly, and made early pre-womanist reflections on African-American women's experience. Potter maintained that Caribbean women's strength of character exceeded that of men because of slavery and its aftermath. They possessed a strength which he expressed in the phrase 'my mother who fathered me' (WCC 1975: 27). Potter also warned of future tensions in the emerging sisterhood by noting that 'many (white) women have often been the worst racists' (WCC 1975: 27). This was a theme which was to surface again and again in the years ahead, as dreams of a facile feminist utopia were shipwrecked on the rocks of history, class and race. The representation of the South was poor at this consultation, with three-quarters of the delegates coming from the North. Africa provided eleven out of the thirty Southern delegates.

The Berlin conference saw a combination of new elements of women's sharing of experience, and theological and political aspirations away from male censorship. Warning bells sounded once more over the North-South division of interests and women's different cultural locations. 'Disappointments, misunderstandings, frustrations, hurts and tensions remain unresolved . . . we all bear the imprint of our different traditions, cultures, ideologies and theologies', reported Liselotte Nold of the Evangelical Lutheran Church (Nold 1974: 131). Twenty years later such tensions would emerge again among Third World women at the EATWOT women's conference in Costa Rica (see below).

Berlin was a moment of great importance for women's participa-

tion in world theological dialogue, as a conference, as a widely disseminated publication and in the resolution of its participants to increase women's representation at the forthcoming Nairobi conference of the WCC in 1975. Participants at Berlin recruited and helped finance a whole raft of women delegates for the Assembly, so that Nairobi 1975 saw, for the first time, women as a conspicuous element. Twenty-two per cent of the official delegates were women and women's issues were given a high profile. These included a re-examination of the traditional views of human sexuality, the importance of gender in considering the implications of confessing Christ, and the release of funds to bankroll women's concerns through the WCC Women's Desk. Women overran the allotted time on the plenary session on 'Women in a Changing World'. Kiyoko Takeda Cho, who chaired the session, urged women to speak out 'clearly, fully and radically' (Herzel 1981: 80). They did. Their participation was buoyed by the UN and World Bank's insistence on the importance of integrating women in the task of tackling development in the postcolonial Third World. The challenge to reach economic 'take-off' had already necessitated a second Development Decade (Pietila and Vickers 1994). NGOs and Governments were under considerable pressure to establish women's bureaux during the 1970s as part of programmes for grant aid and development (Gordon 1984).

By 1983 women's representation had risen to thirty per cent at the Sixth Assembly of the World Council of Churches in Vancouver (Best 1990). Significantly, papers presented to Vancouver included Bible studies from Africa, which had involved Dr Elizabeth Amoah, then a young theologian, trained under Professor John Pobee at the University of Ghana in Legon. Dr Amoah had already been involved in the workshops initiated by Marie Assaad, an Egyptian Coptic Orthodox, who was the first deputy General Secretary of the WCC, and the staff moderator of the WCC Unit on Education and Renewal in which the Women in Church and Society project was located.

In a project that was designed to coincide with the UN commemoration of a decade of concern for women, Professor Amoah produced an essay on 'Femaleness: Akan Concepts and Practices' in *Women, Religion and Sexuality*, and a Bible study on 'The Woman who Decided to Break the Rules', a reflection on the woman with the flow of blood recounted in Mark 5: 25–29 (Amoah 1987; Amoah 1990). The Bible study was part of a project jointly led by Professor Pobee, then Director of the WCC sub-unit on Theological Education,

and the wife of the former General Secretary of the WCC, Bärbel von Wartenberg-Potter.

Professor Amoah had participated along with Rose Zoé-Obianga and Mercy Oduyoye in the important Sheffield consultation of 1981, part of the ecumenical study program, the 'Community of Women and Men in the Church' (CWMC), which had been commissioned by the Nairobi Assembly. It was a project designed to change the practice of the ecumenical church in three areas: the study of theology, participation and relationship. It stated as a situation of immediate concern

> the inter-relationship of women and men who frequently exploit one another. This exploitation often takes the form of misuse of power over each other (Parvey 1983: ix).

Participation was seen as the way to effect liberation. This was a process in which former colonial/missionary paradigms of civilising, and vicarious action on behalf of the subjugated, were dismissed in favour of a paradigm which was emerging from the civil rights movement in North America, liberation theology in South America and out of the struggle of newly independent Africa. Namely 'in order to be truly free, all people must participate in working toward their own liberation' (Parvey 1983: ix). Yet again a study-book was produced and distributed worldwide, utilising the contacts of the WCC Women's sub-unit. It had a massive distribution of over 65,000 copies and was taken up in Africa by the AACC through their representative Isabella Johnston (a Sierra Leonean). A regional conference was set up in Ibadan in preparation for Sheffield by a trio of Isabella Johnston, Daisy Obi (the Nigerian Director of the Institute of Church and Society in Ibadan) and Mercy Amba Oduyoye, then a lecturer in the Religious Studies Department at the University of Ibadan.

The resulting pan-African conference was held in 1980 at the University of Ibadan. Dr Oduyoye claims it as the first of its kind in Africa (Oduyoye 1994 f.). However, it was not the first time that the University of Ibadan had heard Dr Oduyoye's views. Inspired by the UN Women's Decade, she had already held a conference in the late 1970s on *Women and Culture* in the Religious Studies Department. She recalls the aggression unleashed in the University's staff room by this initiative:

> Because of the UN Women's Year there were all kinds of conversations and snide remarks . . . you know . . . women don't need any liberation, African women certainly don't need any liberation, the sexist

and misogynist culture is not African. It's all brought in and so on . . . this was everywhere . . . this sense of the uselessness of talking feminism in Africa. So I did a study of Akan/Chi proverbs, to show that in our own language there is sexism and that this sexism shows up in proverbs and in folk tales and so on.

I did this study of the proverbs . . . and I have never had such an audience . . . real, real audience, with the place running over to the outside, and everybody said, 'Thank you for raising this' (Oduyoye 1994 f.).

The idea of the Circle came from many different sources. Part of its genesis lay in the work of the Program for Theological Education (PTE), (now incorporated into the WCC under the direction of Professor John Pobee); part in the Conference of African Theological Institutes (CATI), which located finance for the further training of women theologians (Kalu 1997). There were thirty women participants at the Ibadan conference, some with their first degrees in theology, others in linguistics, most involved in education, translation work, administration or healthcare. Ordination for women in many of the churches was out of the question, even when money and time had been expended on specific seminary training (Nthamburi 1987). Dr Ighodaro, a leading YWCA activist within Nigeria, called on the women delegates no longer to 'feel apologetic about studying theology'. Women, as life bearers, should be in the forefront of the science which relates God to humanity and the universe and yet 'female theologians are fewer than female coal miners' (Oduyoye and Kanyoro 1990: 32).

The Ibadan consultation with its theme *Women Theologians—Partners in the Community of Women and Men in Church and Society* was held the week before the study project of the WCC, thus skilfully minimising travel and travel costs. Dr Sofola, from the Arts department of the University of Ibadan, took the stance that 'woman-power' in African tradition 'put Christianity to shame', and argued that negative opinions on 'the African way of life and thought are indications of a colonial mentality' (Oduyoye and Kanyoro 1990: 31). On reflection, Dr Oduyoye believed Dr Sofola's contribution, and the debate which ensued, signalled that African theologians could not 'ignore the presence of Islam and Africa's Traditional Religions. The Circle we are inaugurating has this in mind. We have to stop creating a hierarchy of religions in Africa' (Oduyoye and Kanyoro 1990: 32).

The history of the WCC clearly demonstrates the way in which its concerns were both initiated and transformed by the participation of African women in theological debate. I have sought to explicate something of the organisational opportunities that were offered

by the ecumenical movement for the incipient Circle secretariat. The
issues of culture, race, the missionary past, nationalism and economic
inequalities became part of the intellectual environment in which
WCC conferences and working parties existed, and which individ-
ual delegates and staff members had to negotiate. At the WCC
Mission and Evangelism Assembly in Bangkok in 1973, the WCC
was firmly reminded that culture was the voice that answered the
voice of Christ. Culture was not a thing to be despised, rejected or
ignored, but to be nurtured and reappropriated as part of the very
mandate of creation and the gospel (WCC 1973). The elevated con-
sideration of culture, and the new attention to 'salvation in this-
worldly terms' which Bangkok marked, soon worked its way through
the various units of the WCC and its sabbatical conferences (Bosch
1991: 396–398). Future Circle members were amongst the African
theologians who gathered at a pre-assembly meeting in Accra in
1973, which brought a new political unity to the emergent African
voice in the world-wide ecumenical arena (Setiloane 1979: 60; Oduyoye
1981b: 72, 77).

The process for the ecumenical movement has not been without
its tensions, on both sides of the racial, North-South divide. The
Circle's genesis has not evaded the tensions of that process, yet many
of its concerns can be seen as paralleling the WCC debates. African
women were incorporated in the CWME conference in Sheffield in
1981. Dr Rose Zoé-Obianga, a Presbyterian from Cameroon, pre-
sented a paper on 'Resources in the Tradition for the Renewal of
Community', and pointed to the alienation of the first Christian élites
from the positive resources of their abandoned traditions owing to
missionary negativity. She maintained that the 'deplorable situation
which exists in my society at the present does not derive from the
tradition' (Zoé-Obianga 1985a). African traditions had within them-
selves the resources to resolve 'two inter-related problems, that of
our identity and that of our participation' (Parvey 1983: 72).

> The speech of women has made possible the awakening of conscience
> to the situation which prevails at the present time . . . We must act
> together, for history teaches us that nothing has ever been achieved
> without courage and obstinacy. It is at the level of action and com-
> mitment that change will be possible. It is for women and men of
> good will to denounce the situation of domination and discrimination
> and distorted relationships. We have need for the solidarity of all men
> and women (Parvey 1983: 72 citing Ela, 1980, 1986: 72).

Thus, true inculturation of the gospel and the liberation of Africa was firmly placed in the 'speech of women' and their active participation in the theological project.

EATWOT: The Rise of the Third World Theologian in Conference

At this stage we must take cognisance of another ecumenical movement of Roman Catholic origins, which was to strengthen the theological hand of the southern churches. This was the Ecumenical Association of Third World Theologians (EATWOT). It gained its ecumenical spirit from Vatican II, while its radical theologising came, in the first instance at least, from the liberation theologies of South America. The 'god-father' of EATWOT was Fr Sergio Torres, a priest from Chile, who had fled his motherland at the end of Allende's government (Pobee 1997). Fr Torres was to edit five of the Conference reports of EATWOT over the first two decades of its existence, and was General Secretary from 1976 to 1981. The future first woman officer of EATWOT was Maryknoll sister Virginia Fabella, who joined the staff eight months before the association's formal establishment at Dar-es-Salaam in August 1976. Originally from the Philippines, but with missionary involvement in Latin America behind her, she was determined to break EATWOT's 'macho' image (Fabella 1993: 2). Fr. Torres himself was deeply committed to the liberationist paradigm of gospel allegiance implying identification with the economic poor. He outlined his vision as that of creating a forum that could eventually encompass

> Christians of the First World and of the Third World, working together to overcome forces of oppression and aiming at a New International Economic Order, a new prophetic commitment, and a new theological reflection (Appiah-Kubi and Torres 1979: 9).

The original idea of EATWOT has been claimed by Oscar Bimwenyi, who maintains it arose from his discussions with his Professor, Francis Houtart, while he was studying at the Catholic University of Louvain in 1974 (Bimwenyi 1980: 19). Latin American theologians were, at that same time, considering how to engage with theologians across the 'Third World' (Torres and Fabella 1978). This development recognised their marginalisation and terms of incorporation within the Northern power-centres of the academy and the Church. The academics'

removal from the pressure of the everyday struggle for survival per-
mitted the necessary exchange of ideas to generate new utopias. This
has been an essential ingredient in the development of recent African
theology and seems an irreducible element in the EATWOT process.
It is at the same time its methodological Achilles' heel.

The WCC conference at Nairobi in 1975 provided the venue to
create the EATWOT steering committee. The first EATWOT con-
ference was held in Dar-es-Salaam a year later and its conference
report was published by Orbis as *The Emergent Gospel* which promoted
the idea of a new, process-based form of theology, from the cradle
of the 'developing world' (Torres and Fabella 1978). The theolo-
gians who gathered at Dar-es-Salaam in 1976, from Latin America,
Asia and Africa, self-identified as members of the Third World, but
the liberation paradigm, honed in the specific socio-political realities
of South America through the grid of Marxist engagement, tended
to dominate the debate.

Four theological motifs that were to be of real significance for the
Circle came from these early EATWOT consultations. First, the nomi-
nation of particular continents as the places from which the story of
the underside, 'liberation theology' could be announced regardless
of the class, gender, race or power relations within the particular
continent. The initial ascendancy of Latin American liberation the-
ology as the mode of theological reflection was soon undermined as
African and Asian theologians made their contexts speak.

Secondly, Englebert Mveng from Cameroon began to develop the
idea of cultural silencing. The universal application of the nomen-
clature of 'Third World' had, in a manner similar to imperialism,
silenced other voices (Mveng 1983: 219). Liberation theology for
Mveng had failed, because of its obsession with the economic para-
meters of Marxist analysis, to take account of the phenomenon he
called 'anthropological poverty' (Mveng 1983: 220). The discussion
reached its apogee in the claim by Aloysius Pieris that 'the phrase
"Third World" was a theological neologism for God's own people'
(Pieris 1983: 113).

Thirdly, the arrival of 'context' as one of the chief determinants
of how to develop continental or regional theology meant that the
contexts of delegates from countries where Christianity was the minor-
ity faith raised a different series of questions from those of, say, the
Latin American liberationists. Aloysius Pieris advanced the proposi-
tion that a new 'Third World theology of religions' should be devel-

oped (Pieris 1983: 122). This was to discover a 'religious instinct', a form of religious essence to be distilled from across the world's practice of religions which desired to create a 'new humanity' (Pieris 1983: 134). Pieris urged fellow delegates to pursue a theopraxis of liberation, executed through a 'Third World hermeneusis' of identifying, across the world religions, the presence of 'God's' saving power erupting from the 'earth's slaving poor' (Pieris 1983: 136). In EATWOT theology the imperial privileging of Christ over and against other religions was ending.

Lastly, the proposal of reintegrating history and culture within the framework of an anthropologically extended 'liberation theology' made space for new paradigms to be absorbed in the struggle for the heart of African theology. Now, there was a way forward for EATWOT theologians to talk the language of cultural recovery as well as that of liberation.

The Emergence of Black and African Theologies

The 1950s had seen significant contributions from the Catholics in French-speaking Africa. These were heralded by Belgian Franciscan, Fr Placide Tempels, in his ground-breaking work of 1945, *La Philosophie Bantoue*. Tempels, for the first time, attempted to take seriously and describe what he saw as the African mental world. Less than 10 years later, the impact of this publication was felt in three important works written by European-trained Catholics in the Belgian Congo and Rwanda. *Life and Unity among the Bashi, Banyarwanda and Barundi*, published in 1955, came from the hand of Vincent Mulago, a Catholic priest from the Belgian Congo who had just graduated from Urban University in Rome (Mulago 1956). *La Philosophie bantou-rwandaise de l'être*, published in the following year, was written by Alexis Kagame, a Rwandan priest, and later in the same year a joint publication, *Des prêtres noirs s'interrogent*, came from a group of African priests (Kagame 1956a; Kagame 1956b).

In 1976 Kagame published *La philosophie bantou comparée*, which developed a generalised Bantu philosophy (Kagame 1976). D.A. Masolo argues in *African Philosophy in Search of Identity* that Kagame accepted and applauded 'Tempels' presentation of African philosophy as a static phenomenon that is impervious to change' (Masolo 1994: 96). This need to respect the Bantu mind as mature and replete

with its own philosophical organisation, able to be engaged by Western
philosophical tools, rather than as a *tabula rasa*, or as 'irrational', was
of great significance for the development of the African theological
project, particularly by Western-trained Catholic theologians, skilled
in systematic theology.

In 1968 the Faculty of Catholic Theology at Kinshasa entered the
fray by dedicating its fourth annual colloquium to the subject of
indigenous theology. This had been the subject of an earlier heated
exchange at the point of Congolese independence, between the future
Catholic Archbishop Tshibangu and the Belgian missionary dean of
the faculty at the Lovanium, Fr Vanneste. In 1958 Vanneste had
declared that in his view the time had not 'yet come to launch an
"African theology"' and insisted that European culture uniquely pos-
sessed the 'high degree of perfection which the entire world' recog-
nises (Vanneste 1958; Molyneux 1993: 101). Tshibangu responded
with a call to clear cultural identification in *Vers une théologie de couleur
africaine*, which argued for integration between the Christian faith
and 'African life, mentality and the way of looking at things' (Tshibangu
1960). Vincent Mulago, who had been anxious to demonstrate the
presence of monotheism in his work on the religion of the Bashi,
Banyarwanda and Barundi, responded with the view that there could
be no universal theology, and that Africans now had to assert their
newly won freedom in theology as well; in 'nôtre mentalité, à nôtre
culture' (Mulago 1965). English-speaking Protestant theologians soon
joined the vociferous body of Catholic theologians struggling for an
inculturated theology, including Fabien Eboussi-Boulaga (Cameroon),
Benezet Bujo (Zaire), Charles Nyamiti (Tanzania), J.-M. Ela (Came-
roon). Amongst the early Protestant voices were John Mbiti (Kenya),
Kwesi Dickson (Ghana), Byang Kato (Nigeria), and John Pobee
(Ghana).

Besides the emergence of a new African theology from Roman
Catholic and Protestant academics, other black voices, more explic-
itly political, were beginning to exercise their influence. The strug-
gle against apartheid in Southern Africa allowed the African-American
liberation theologian James Cone to identify the struggle for civil
rights and dignity of the black minority in the United States in the
1960s and 1970s with that of the South African majority black pop-
ulation. In 1977, the first African regional conference of EATWOT
was held in Accra. Known as the Ecumenical Association of African
Theologians, (EAAT), and later published, again by Orbis, as *African*

Theology en Route, the conference provided the opportunity for James Cone to lock horns with John Mbiti and Edward Fasholé-Luke for their criticism of South African 'black theology ... [as] being too narrowly focused on blackness, liberation and politics' (Cone 1979: 182). Cone went on to suggest that the imperative for African theology was to concentrate on politics and liberation,

> not only out of a Christological necessity. It is also a necessity that arises out of the ecumenical context of contemporary theology. By locating the definition of African theology in the context of the political and economic conditions of Africa, African theologians can easily separate their theological enterprise from the prefabricated theologies of Europe and establish their solidarity with other Third World theologies (Cone 1979: 183).

Black theology claimed to offer a way out of a stagnant, ivory tower attitude which had overwhelmed much of African theology. Canon Burgess Carr, a Liberian church leader, and General Secretary of the AACC 1972–1978, saw this form of black theology as offering the future to 'advance beyond academic phenomenological analyses to a deeper appreciation of the ethical sanctions inherent in our traditional religious experience'. At the Third Assembly of the AACC, Burgess Carr pronounced the 'gospel of Jesus as an ideological framework for [Africa's] struggle for cultural authenticity, human development, justice and reconciliation' (Carr 1974: 78).

African theology thus had a clear fault line running through it. On the one side lay those theologians concerned to discover strength and identity from continuities between dogmatics and biblical revelation and their cultural heritage. On the other hand were those situated in South Africa, and their ideological cousins in the United States of America and Liberia, who located their black religious identity in the firmament of political struggle, race awareness and economic redistribution. James Cone used the oppressive triad of 'racism, sexism and classism' to identify the forces ranged against black theologians as they united with Third World theologians against the imperial forces of the white West.

There developed a theology of confrontation. This theology commanded attention by its unremitting advocacy of the poor, oppressed, marginalised, enslaved, colonised people of the world. The theological enemy was the 'prefabricated theology of the West', the white heirs of a colonial power system which was hostile to the interests of 'Black being', the 'encroachment of white oppression', the white's

'symbolic association' and 'pathological hatred' of the dark brother (Cone 1983: 371). Black theology was a theology of liberation, which Cone recognised in the early 1980s as more militant, aggressive and hostile to white Christianity than its milder sibling guarding its 'good reputation in WCC circles' (Cone 1983: 377). Creating links for African-Americans to the African theological project was strategically crucial. It needed 'African legitimation' coming out of the cauldron of US civil rights engagement. Cone argued this legitimation by attempting to set African theology amidst the wider project of liberation theology in its 'creative appropriation of the language and culture of the people'. He enlisted Desmond Tutu and Manas Buthelezi as fellow travellers espousing African theology's vocation to 'be concerned for the poor and the oppressed about the need for liberation from all sorts of bondage' (Tutu 1975: 33; Cone 1979: 24).

The struggle over African theology was being worked out in the consultations called by the Protestant AACC. The first General Assembly of the AACC (1963), following an initial experimental conference in Ibadan in 1958, received papers in preparation for the Conference from the Southern Africans, Ndabaningi Sithole and Gabriel Setiloane, on 'African Nationalism and Christianity' and 'Freedom and Anarchy in the Church' (Setiloane 1963; Sithole 1963; AACC 1963b). Sithole wrote:

> Christianity, as a religion, has nothing to fear from African nationalism, but it has something to fear if it is a subtle political force of a colonialist type . . . somewhere Christianity has failed to capture the imagination of many people and it this point which needs to be fully explored especially if Christianity is to readjust itself to the new and fast changing situation. African nationalism has come to stay and Christianity must come to terms with it, in the spirit that people were not made for Christianity but Christianity for the people (Sithole 1963: 5, 4).

Kampala reoriented the compass points of African Protestantism as more powerfully attracted to issues of African solidarity and less dependent on their 'home churches'. African Christianity now needed to respond to the challenges of post-colonial Africa, and be critically involved in the development of new African identities. Nationalism, which had been a substantial part of the missionary paradigm of the high imperial era, was being realised.

At the same time women declared their desire for a new deal. The Women's Consultation held at Kampala before the main AACC conference, jointly sponsored by the WCC and AACC, saw 'mothers,

nurses, teachers, theological students, school principals, social work-
ers and professional church workers' gathered to claim their stake
in the post-colonial church. The consultation recommended improved
representation of women on church boards and other committees,
attention to 'training lay women' for church work, and 'financial
support' to enable 'highly trained women' to emerge to meet mod-
ern Africa's changing needs. The consultation urged the AACC to
respond in a positive way to the issue of ordination for women which
was on the table for the imminent meeting of the Faith and Order
commission of the WCC at Montreal later that year (AACC 1963b).
The ecumenical movement's pursuit of ordination empowered those
with 'feminist' concerns in the AACC Women's Consultation to
encourage what represented a revolution in the male-dominated cler-
icalism of their own national churches (Bam 1970).

Cutting the Ties

By 1974 the AACC had come to a position of severing its connec-
tion with the West by calling for a moratorium on Western mis-
sionaries at its Third General Assembly at Lusaka (AACC 1974: 53).
'It was' the Lusaka statement declared

> the only option . . . as a matter of policy, and as the most viable means
> of giving the African Church the power to perform its mission in the
> African context, as well as to lead our governments and peoples in find-
> ing solutions to . . . economic and social dependency (AACC 1974: 53).

A moratorium on personnel and money was essential in order to
realise freedom from Western jurisdiction over Africa's future auton-
omy in politics, economics and, decisively for Gabriel Setiloane,
Professor at the University of Botswana and Swaziland, her theol-
ogy. At the 1977 EAAT conference, Setiloane recalled how, at the
WCC conference on mission and evangelism at Bangkok, the 'idea'
of moratorium permitted African theologians to talk about 'the African
theological view' and how 'Africans at the conference' discovered
their 'unity of . . . presuppositions' across regional and ecclesiastical
difference (Setiloane 1979: 60). Bangkok challenged the white hege-
mony of the World Church and launched African theology as a new
factor in the history of Christianity on the continent. African-ness,
was now proposed as a common denominator for theological reflection,

based on 'first existing in community' (Setiloane 1979: 65). Africa's myths, traditions, psychologies and theologies pointed to a 'dynamically related community of being', with 'a higher understanding of Divinity' than that of Western Christian dogmas, such as the disparaged 'Hellenistically-originated' baggage of Trinity (Setiloane 1979: 65). At the conference *Christianity in Independent Africa* in Jos in 1975, Setiloane argued that

> *Modimo*, the Supreme Deity of the Sotho-Tswane, is in fact a much deeper concept than the Christian translation for God in the Bible or other Christian literature . . . Of course, it was very startling and disconcerting to the superiority-complexed Western Christian theologians. But it is the point at which African theology is today . . . put tauntingly, it says that the Western Christian theologians' 'God' could easily die because he is so small and human. The Sotho-Tswane God . . . could never die (Setiloane 1979: 60).

EAAT theologians were now engaging in the form of 'taunt' theology which had until now been largely characteristic of their 'boisterous counterpart from the urban ghettos of America' (Cone and Wilmore 1993: 377). The deterioration of the terms of trade in the mid-1970s, and poor internal financial support of the AACC made the implementation of moratorium impossible. Africa still needed outside financial backing for its theological adventure in indigenisation and contextualisation, but many theologians resented it.

There were only six women at the EAAT conference in Accra (1977). Rose Zoé-Obianga, who was to become the first co-ordinator of EATWOT's women's programme in Africa in the mid-1980s, had called on church leaders to receive the gift of educated women within ecclesiastical structures and urged women to new feats of self-help. They should

> fight against their own alienation, their timidity, and for their influence within the church . . . We well know that children, husbands, friends and colleagues will almost always be obstacles to the commitment of women . . . to succeed. We must therefore cease to play the role of figureheads and pawns whom men push around at will in the effort to show that we are forever incapable . . . Commitment to Christ requires the liberation of African women. They will no longer be slaves, not of uncomprehending and intransigent husbands and brothers, nor of a retrogressive society. . . . We point up the fact that—because of the deliberate absence of women from decision-making within our churches—true control is in the hands of men only. Let Africans, men and women, not behave in such a way as to show the world a mask that hides Jesus Christ (Zoé-Obianga 1977: 148–149).

It was a seminal meeting. Old patterns of 'white' theologies driven by denominational interest and male African representation were challenged. African theology was becoming increasingly an all-black African affair (Parratt 1995: 23–27). Female participants were few, but, it was argued, this was not a matter of principle but because there was a paucity of trained women theologians (Parratt 1995: 51; Kalu 1997). Zoé-Obianga's challenge would not yet be contested, but the supposed unity that Setiloane had proposed was effectively sundered. Gender counted for something within the hierarchy which 'community' obfuscated. This would be the future task of the Circle theologians to explicate.

Dr Oduyoye, from her new situation as a lecturer at the University of Ibadan, served notice of her commitment to religious pluralism, themes pursued at the AACC Lusaka and Abidjan conferences, and attacked the adequacy of modernity to realise Africa's desire for freedom (Utuk 1997: 126). She exploited the UN Women's Year (1975) as a means of demanding new research on the role of women in African religion, and disrupted the smooth reading of African 'corporate personality' by noting the religious and cultural exclusions consequent on the taboo of women's menstruation and Africa's 'irrational fear of blood' (Oduyoye 1979a: 112). Now that women had the freedom to speak, Oduyoye was to protest against their alienation into 'secondary roles' and 'relegation to the background'. If Dar-es-Salaam represented the 'Bandung of theology', where for 'a moment, (theological) history seemed to have stopped—effectively to have changed direction'—this was EAAT's moment of gender-quake (Torres 1988: 108). No matter that Lusaka principles of African self-discovery and pride were evoked with her evangelical missionary reversal, which called for the 'African spirit' to 'revolutionise Christianity to the benefit of all who adhere to it', the gender question was irrevocably on EAAT's future curriculum of concerns (Oduyoye 1979a: 116).

Oduyoye's petition was in tune with Kofi Appiah-Kubi's demand 'to serve the Lord on our own terms and without being turned into Euro-American or Semitic bastards before we do so' (Appiah-Kubi and Torres 1979: viii). Western theology needed to be resisted, and old missionary entanglements required incisive removal, whether by amnesia or euthanasia. African theology turned to old themes of Negritude, of African 'legitimacy', of cultural pride, to find there was in her much-maligned history 'nothing to be ashamed of . . . but rather dignity, solemnity and even glory' (Fanon 1978b: 51; Utuk 1997: 108). Oduyoye spelt out one of the underlying principles of

pan-Africanism that 'we prosper or perish together as a people'. She cited Nkrumah, 'our task is not done and our own safety is not assured until the last vestige of colonialism has been swept from Africa' (Nkrumah 1959: 240; Oduyoye 1979a: 111). Fresh attention would be paid to 'the religion of our forebears', in an imaginative leap that could transcend the formative missionary engagement of the nineteenth century. Without this, Oduyoye was convinced that African Christianity would be nothing more than 'a fossilised form of nineteenth century Christianity' (Oduyoye 1979a: 110).

The fragile working unity even within EAAT and EATWOT was soon to be exploded, however, by the irruption of women's representation. Male African theologians were about to have turned upon them the full force of the anti-colonialist rhetoric of slavery, cultural negation, non-being and exclusion, from a feminist perspective. In 1978 a cloud no bigger than a man's fist broke on the horizon, with an ecumenical gathering of Latin American women theologians before the Sao Paulo regional conference meeting 'for the first time . . . to reflect systematically on the situation of women in Latin America' (Torres and Eagleson 1981; Chung Hyun Kyung 1991: 16; Fabella 1993: 24). Encouraged by the presence of Sr Virginia Fabella, women delegates at the 1981 EATWOT Conference in New Delhi met to look at their own perspective on the theological programme and to lead worship. This had not previously occurred despite the protestations of EATWOT that liberation from sexism was part of their mission.

At New Delhi, African-American women were amongst the delegates, including Jacquelyn Grant. During the opening prayers at New Delhi she called on a 'Mother/Father God', praising God as 'our Creator, God our Sustainer, God our Liberator' (Fabella and Torres 1983b: 186; Mananzan, Oduyoye et al. 1996: 1). Male participants objected, calling her audacity 'untheological and unbiblical' (Fabella 1993: 31). Grant's illicit use of the maternal in relation to God was followed by Marianne Katoppo, an Indonesian theologian, who appealed for a fresh regard for inclusive language in 'our language about God and before God'. The laughter and jokes which this contribution from the author of *Compassionate and Free* attracted from male delegates, was, according to Oduyoye, the 'irruption within the irruption' of the conference, whose proceedings were published as *Irruption of the Third World: A Challenge to Theology* (Oduyoye 1983c).

The intended irruption had been that of Third World theology

sundering the previous hegemony of the West. In the event some of the seismic changes which had been occurring within Western theology came to fracture the tenuous unity of the Third World theologians. 'One cannot assume that African men and African women', wrote Oduyoye in the months after Delhi, 'will say the same things about African reality' (Oduyoye 1983c: 251). She continued:

> Those who will examine our language, proverbs, myths, and fables cannot exalt our African culture into one that backs up the woman who seeks a fuller participation in her community ... [There is now] a challenge to the maleness of Christian theology world-wide, together with the patriarchal presuppositions that govern all our relationships, as well as the traditional situation in which men reflected upon the whole of life on behalf of the whole community of women and men, young and old' (Oduyoye 1983c: 253 f.).

This was a clear African challenge to EATWOT's chauvinism. Oduyoye attacked the present division of power and representation within African society. She was well aware of the empowerment of women in West African traditional religions and Southern African AICs. However, at this stage she maintained that patriarchy had a universal manifestation, even in the traditions of Africa. Oduyoye went on to recognise the participation of church women in the WCC's desk in CMWC as vital, bringing the WCC to honour their founding father's intentions to honour 'men and women created as responsible persons to glorify God and do his will' (Oduyoye 1983c: 251).

The first international dialogue between EATWOT theologians and first world theologians in Geneva took place in 1983. The proceedings were later published as *Doing Theology in a Divided World*. The publisher, as for all the major EATWOT conferences, was Orbis. In this way the work of EATWOT became more familiar to many academics in the USA than to academics within the Third World. Important links were established at this conference between all the women participants. The European and United States feminist theologians included Dorothee Sölle, Frances Arbour, Rosemary Radford Ruether and Letty Russell. Their analysis was seen to be the most 'fully developed theology of liberation in the first world and created the impact on the gathering' whilst these women challenged the 'Third World male liberation theologians for their sexist language and patriarchal perspective' (Fabella 1993: 34). Rosemary Radford Ruether maintained feminism's *a priori* privilege as

> the cry of protest of another yet more invisible and marginalised
> group—women—within the communities of the oppressed ... sexism
> exists as a universal system of marginalization of women within vari-
> ous cultures and at every class level (Ruether 1985a: 65).

Ruether further argued that Third World women suffered from dou-
ble oppression, a 'doubled kind of *sexist* oppression that comes from
the multi-layered oppression experienced by women of oppressed
groups' (Ruether 1985a: 70). She called on EATWOT to consider
the 'effects of Christianisation and Westernisation on women of the
Third World' (Ruether 1985a: 71). Sr Virginia Fabella recalls Ruether's
analysis as provoking 'a lengthy discussion on sexism, which became
the major theme of the conference' (Fabella 1993: 34).

> The session with the First World Women made the Third World
> Women realize they were not clear about their own priorities; they
> needed to organise themselves if they were to set their own agenda.
> Second, the discussion on women's oppression (at Geneva) called for
> a concrete and immediate response ... Thus on January 14, 1983, the
> commission on Theology from Third World Women's Perspective became
> a reality (Fabella 1993: 36).

Regional co-ordinators were appointed. Africa was divided into
French- (and Portuguese-) and English-speaking sectors with Rose
Zoé-Obianga serving Francophone and Lusophone Africa and Sr
Teresa Okure the English-speaking countries of the continent. A
three year plan of regional conferences was drawn up to culminate
in an intercontinental Third World consultation which took place
before the EATWOT General Assembly at Oaxtapec outside Mexico
City in 1986. Suggested areas of reflection were proposed: women's
oppression in society and the Church, country by country social
analysis, theological reflection on the Bible alongside other sources
from their indigenous religions, God-talk, Christology, Mariology,
pneumatology and new forms of spirituality (Chung Hyun Kyung
1991: 18). In the same year there were two regional consultations,
one at Port Harcourt organised by Sr Teresa Okure and the other
at Yaoundé, Cameroon, with representation from Cameroon, Rwanda,
Madagascar and Zaïre (Balasuriya 1988). The Yaoundé consultation
recommended that because

> Galatians 3: 26 shows that men and women are equal in Christ. We
> ask the churches to give to women their due place, that our churches
> come out of their ivory towers, so that they can play their prophetic
> role in our society and in our countries. That they turn themselves

towards the impoverished and ignored. We say that the struggle for the liberation of women must be managed by women themselves (Mbuy-Beya 1989: 271).

At Oaxtapec in 1986, the African women delegates saw a fresh combination of Protestant and Catholic women determined to change the situation of women on their continent, over and above the divisions of denomination. Nigerian representation was exclusively Roman Catholic: Sr Teresa Okure (SHCJ), who had recently completed her doctorate at Fordham University, and Sr Rosemary Edet (SHCJ). The other women delegates were Sr Bernadette Mbuy-Beya (Ursuline sister, Zaïre), Dr Rose Zoé-Obianga (Presbyterian, Cameroon), Brigalia Bam (Anglican, South Africa), Mercy Amba Oduyoye (Methodist, Ghana), Professor Elizabeth Amoah (Methodist, Ghana) and Dr Musimbi Kanyoro (Lutheran, Kenya). It was here at Oaxtapec that the springboard for the Circle was constructed, and its goals for African women established (Amoah 1996).

Womanism and African Theology

The black community was discovering the impact of disclosing women's experience of living under male hegemony. *In Search of Our Mother's Gardens* was Alice Walker's contribution to restoring black women's matrilineal inheritance, the pride and strength of African-American women which had enabled them to survive years of degradation at the hands of white enslavement (Walker 1984). In her introduction, Alice Walker set out a new African-American woman's charter. The account she was rendering was a 'womanist' way of interpreting the world. 'Womanist' was the opposite of 'girlish', with its synonyms of frivolity, irresponsibility and lack of serious application. There was in this antimony an ironic criticism of the white feminist movement which had moved into an area with which black women in their struggle for 'survival', recognition' and 'getting through' could no longer relate (Walker 1984: xi). The implication was clear. White feminism was adolescent, selfish and 'not serious'. Womanist was appropriated solely as a descriptor for a black feminist. The derivation was from black folk usage to teenage children meaning to be 'outrageous, audacious, courageous' and even to be 'wilful' in behaviour (Walker 1984: xi). Womanism is thus a commitment to black and coloured women's dignity, history—present and future. It is a

movement of resistance with huge creative potential extending its
hospitality to all women of colour.

The alliance between womanist theory and theology was almost
immediate for African-American and African women in diaspora
studying at theological seminaries and divinity schools in America.
Although Alice Walker had rejected her parents' Christianity as 'a
white man's palliative' which they had been 'force fed', she recog-
nised that they had transformed the religion into 'something noble',
which was more radically obedient to the 'teachings of Jesus than
the people who believed that God must have a color and that there
can be such a phenomenon as a "white" church' (Walker 1984: 18).

Jacquelyn Grant, who sparked off the irruption at New Delhi, was
a protégée of James Cone at Union Theological Seminary in New
York. The first black woman to hold a PhD from UTS, her thesis
was later published as *White Women's Christ and Black Women's Jesus:
A Feminist Christology and Womanist Response*. This text quickly became
a standard work in the theological appropriation of womanist the-
ory. Grant asserted that black women had found feminist theology
both 'white and racist', and therefore entirely wanting. White women,
she argued, have correctly privileged experience in their quest for
theological reconstruction, but failed to see that these sources 'refer
almost exclusively to white women's experience' (Grant 1989: 195).
Like all oppressors they have 'defined the rules and then solicit oth-
ers to play the game. It is to presume a commonality with oppressed
women that oppressed women themselves do not share' (Grant 1989:
200). Grant saw the fault line of slavery and racial segregation as
so radical that black and white women live in entirely 'different
realms', so much so that the 'white feminists' common assumption
that all women are in the same situation with respect to sexism' is,
for her, unsustainable (Grant 1989: 196).

Grant asserted that black women have a God-consciousness, which
preceded the revelation of God in the scriptures, but that the scriptures
gave that consciousness content. Womanist theology is necessarily
contextual, liberating and resourced through the Christian scriptures.
Secondly, black enslaved women identified easily with Jesus' suffering,
persecution and death, in their experience of being, in the words of
Katie Cannon, 'outsider(s) in society' (Cannon 1985: 32).

During the early 1980s, Mercy Oduyoye was exposed to wom-
anist theory through her participation at a variety of Religion and
Culture programmes in the United States and Ecumenical confer-

ences. At Princeton in 1987 her contribution to the Women and Culture forum focused on listening to her grandmother's and mother's generations and the women of Africa's future. There are certain affinities with the womanist reading of the priority of black women's experience, the history of colonialism, plantation economies and the over-riding 'invisibility' of women's contribution, alongside women who laboured to create community and ensure their children's survival. Oduyoye spoke of how women in her generation were effectively leaving the Church as 'they have little time for the Church to misuse' with its male leadership and paternalism. Yet, 'every new doctorate is like a breath of fresh air. The role models are finally being created. A new day is about to dawn for the African woman, and for the church to which she belongs' (Oduyoye 1988c: 47).

The Role of Catholic Women

Catholic women work with particular constraints and opportunities when they wrestle with the ideas of identity and inculturation. They belong to a church with a clearer sense of united identity across nationalities than any of their Protestant counterparts. This common faith is secured through a dogmatic structure founded, as Vatican II says, on 'Sacred Tradition and Sacred Scripture', which 'make up a single sacred deposit of the word of God, which is entrusted to the Church' (Vatican II 1965 f.: 755). Adherence to this ensures the unity of priest and people, whilst the orthodoxy of the Church's teachers and theologians is secured by the Vatican-based guardian of orthodoxy, the Sacred Congregation for the Doctrine of the Faith (SCDF). Fr Tissa Balasuriya's excommunication in January 1997 reminded Third World theologians that EATWOT members are not beyond the power of Vatican sanction, and with it the consequent alienation from one's own national church infrastructure and hierarchical approval (Stanton 1997: 187, 201 ff.).

Pope Paul VI, when he visited Africa in 1969 to close the inaugural meeting of the Symposium of the Episcopal Conferences of Africa and Madagascar (SECAM) in Kampala, exhorted the Bishops to 'have an African Christianity' in adapted pastoral, ritual, didactic and spiritual activities. This exhortation in *Africae terrarum* was the signal within the Church to experiment further with liturgy, teaching and pastoral methods. *Africae terrarum* also contained a vindication of

the activity of missionaries. Pope Paul VI maintained that they were 'inspired and guided by the highest motives in their unselfish and heroic labours'. Moreover they had 'for love of Him, left their countries and families, and very many of them (had given) their lives for the welfare of Africa . . . they have your gratitude' (Paul VI 1969: 23).

Vatican II saw independence from their missionary foundations granted to a whole raft of African religious congregations, a movement facilitated by the mood of nationalism and liberation abroad in the early 1960s. Slowly but surely, despite the fact that the Catholic Church continues to have the majority of missionaries amongst the denominations, African women replaced their White Mother Superiors (Gifford 1994: 523). African sisterhoods were established from the early decades of this century, and many are now connected as pontifical congregations to the International Union of Superior Generals (UISG) in Rome, which enables a surprising degree of independence from their diocesan Bishops (Kupalo 1978). The place of the religious in the mission strategy of the male hierarchy is extremely important. Cardinal Malula, who founded the Sisters of St Thérèse of the Child Jesus of Kinshasa, claimed that his whole effort in mission could be summarised as the formation of 'girls who are fully women, authentically African, and authentically religious' (Mbuy-Beya 1993).

There are obvious constraints on the leading Circle Roman Catholics. Bernadette Mbuy-Beya, Teresa Okure and Anne Nasimiyu-Wasike undertake their work within a patrimony of church unity, and under a papal authority that stresses continuities with Christendom in revelation and history. All three of them belong to international orders which train many of their members to the highest echelons of education available in their countries. Part of their theological self-confidence, which we will see in chapter four, may arise at least in part from the numerical dominance of religious sisters in their own church. Across the Episcopal Conference of Africa and Madagascar (SECAM), religious sisters numbered 45,014, brothers 6,001 and Religious and Diocesan Priests 21,754 in 1995 (AMECEA 1995). On the outskirts of Langata alone, there are 'around thirty religious houses, some for considerable numbers, (to) train the new recruits of European religious orders' (Gifford 1994: 523).

The Catholic women's intelligentsia in Africa is principally focused in their religious congregations. They are élite members within society even though they undertake vows of poverty, because they have

resources and opportunities for educational development denied to other African women. It is from these women that the Catholic voice in the Circle is gathered. They are the leading theological resource in Africa, as they constitute the overriding majority of trained women theologians (Gifford 1994: 521). Catholic dominance in this area has important implications for the future development of the Circle, if it is to remain truly ecumenical, spanning a complete range of Christian churches from the AICs to Roman Catholicism.

How can religious institutions that were initially extensions of European Catholic sensibilities of the late nineteenth and early twentieth century become a form of inculturation and not continue the process of Europeanising Africans (Hillman 1991: 317–319)? Postconciliar permission to view their work as prophetic and no longer part of the 'conveyor belt system for the magisterium' has released the Circle religious to explore new connections with African women's spiritual and practical needs, which we shall explore further in chapter four (Hebblethwaite 1975: 103). The process of the African Synod, which finally met in Rome in April 1994, had been preceded by a whole range of pre-synodical papers and preparations co-ordinated through SECAM. The *Lineamenta* encouraged a vital theological engagement between religious, priests, academics, bishops and their constituencies, and raised the profile of African ownership of the Roman Catholic Church in an unprecedented manner. Moreover, the Pope's encyclical *Mulieris Dignitatem* in 1988, referring to women's 'radiance' and previously unattained 'power', was interpreted by some Circle theologians as a vindication of their call to the churches for 'a radical change of mentality . . . to redefine the man-woman relationship in society and in the Church' (John Paul II 1988b; Mbuy-Beya 1996a: 176).

Conclusion

Kagame's 'Bantu soul' of 1960s theology has been ruptured, under the pressure of conflicting desires and power struggles between men and women in the new African dispensation. Feminism has entered into every discourse in which Circle members share, Catholic and Protestant alike. Sr Bernadette Mbuy-Beya, reflecting on the African Synod, wrote:

the Synod has denounced all discrimination against women in society and at all levels of the Church. When I was at convent school I was taught good manners, such that I should occupy a small space when I sat down, and that I should walk on tiptoe to make as little noise as possible. The aim was that women should pass unobserved. But when I went home and behaved in this way my mother protested. 'You are not a slave or a daughter of a slave. This is your house and when you come in we want to hear you' (Mbuy-Beya 1994).

We can see that the migrations undertaken particularly by Mercy Amba Oduyoye, the founding mother of the Circle, into Europe and America brought her into contact with a range of theological perspectives and organisational opportunities which were incorporated into the formation of the new theological network. The work of the WCC had always had a theoretical attention to the situation of women since its earliest stirrings in the Faith and Order Conference of 1927 (Bate 1927). It has seen its task as re-establishing the unity of churches after the fissiparous era of nineteenth-century missions. It restructured the global mandate of the high imperial era, and has sought to create a network of sibling relationships with the daughter churches now come of age. However, these daughters, in the process of reaching their own maturity, have insisted on making Christianity respond to their particular cultural and socio-political histories and needs. John Mbiti, from a WCC revisionist position, argued that 'as Christianity develops in our continent, answering African needs and being firmly rooted in our culture, it will derive great benefit from the work already done by African Religion' (Mbiti 1979: 313).

African theologians and church leaders have a serious challenge in how to square an increasingly contested 'African-ness' with regard to ethnicity and gender, and still work with the categories of an equally contested Christianity. Neo-liberal understandings of Christianity encounter resurgent conservative African philosophies and religious practices on the one hand and ecstatic immediacy and exclusivity of the Christian revelation on the other. Church leaders and theologians need to make their African credentials and vision compelling, whilst developing their own contemporary expressions of the white man's religious import. Meanwhile, post-independence Protestant African women are in the process of reconstructing African Christianity while male theologians ponder the relationship of Christ with Africa's past. In nominating women's experience as their new point of departure, African women have ruptured their assumed incorporation in

the African male theological quest for a theology of selfhood in the newly independent Africa. Global theologies have been established with the Southern nations establishing connections through EAT-WOT over and against the perceived theological power and exclusion of the old colonial centres. Other global networks have been used, through the linkages of feminist solidarity, particularly amongst Protestant women, using contacts established through the WCC. The EATWOT Women's Commission has united Catholic and Protestant women in the search for global justice for women, but at the same time developed its own criticism of white supremacy. It has exploited many of the tools of the enlightenment in its insistence on justice for women, and its freedom to read myths, traditions and sacred scriptures for sources of empowerment, rather than taking any of these systems as dominant cosmologies determinative of understanding. Circle theology is not uniform; like the crucible from which it emerged there are many theologies and emphases. The common denominator might be said to be the assertion of women's identity and resistance of patriarchy. In the next section we shall see how Mercy Oduyoye articulates her search for a theology which asserts African women's autonomy within her community, affirms undermined traditions and resists the embedded patriarchy of Western Christianity.

REMAKING AFRICAN THEOLOGY: MERCY AMBA ODUYOYE'S THEOLOGY OF RESISTANCE AND RE-IMAGINATION[1]

In Ghana there is no way that you can be born, live and die with-out being affected by the Traditional Religion. So what we are doing in the Circle is to see how the supportive elements which we have in the Traditional Religion and the supportive elements which we have in Christianity can support one another to support our life. Because it is not a question of the tradition being totally depraved or Christianity being completely supportive. But there is a lot which the Western inter-pretation of Christianity has done to us which is negative, and which was not in our tradition. Because it had come with a more powerful group, with a people who had hegemony. We had to put aside a tradition which was supportive of women and take up one which was not sup-portive of women but which the Church prescribes (Oduyoye 1994e).

Introduction

Professor Mercy Oduyoye is the chief initiator of the Circle of Con-cerned African Women Theologians and for the first decade of its life its most published advocate. Oduyoye's theological contribution has been moulded by her interaction with EATWOT theology. Her own writings, however, are genuinely creative and challenging, wonderful examples of feminist freedom from denominational restraint. Unfor-tunately for the general reader they are widely scattered, and not yet found in anthology. At present they straddle American, African and Asian publications. Oduyoye works with ideas with a lateral connectivity that acknowledges the African-American womanist heritage as well as developing her Akan matrilineal roots. Herein is offered a re-imagined sign of 'African woman'. Her theology blends themes from classical

[1] Another version of this chapter appears as 'Harmony in Africa: healing the divided continental self. Mercy Amba Oduyoye, feminist and theologian' in *Challenging Women's Orthodoxies in the Context of Faith*. ed. Susan Parsons, CUP, Cambridge, 2001.

Christian theology, her own and other African cultures, and eco-
logical motifs. She seeks to redefine the theological, ecclesiological,
legal and political space that élite African women now inhabit and
that they seek to influence for the communities they 'mother'.

Elected in December 1997 as General Secretary of EATWOT at
its fourth international conference in the Philippines, Mercy Amba
Oduyoye has well fulfilled the promise of the eldest daughter of the
Akan household into which she was born in 1934. Her father, the
Revd Charles Kwaw Yamoah, was President of the Wesley Methodist
Church of Ghana. Like other daughters of the manse, the young
Yamoah was sent away to a Methodist boarding school. At Mmo-
fraturo, in the heart of Asante land, Amba Yamoah regularly read
from the Authorised Version of the Bible for morning prayers. She
particularly valued the Old Testament books of Ecclesiastes and Pro-
verbs, and the Sermon on the Mount (Oduyoye 1996a: 174). She
went for her sixth form studies to Achimota School, a government
school dedicated to retaining Ghanaian cultural pride whilst impart-
ing an English curriculum.

It was at Achimota that Oduyoye learnt songs that were to shape
her future. Her music teacher was a Ghanaian nationalist *Owura*
(Master) Ephraim Amu, who proudly wore the *Ntama* (great-cloth)
in the days before independence (Oduyoye 1986a: 71). Three of
these songs merit noting at this stage: *Yen ara Asase ni*, meaning 'this
land is ours'; *Okofo Kwasi barima*, a song encouraging the subject to
return and pick up weapons which have been neglected and for-
gotten, the weapons of knowledge, peace and wealth; and *Ewarade
no nim na obehwe ara*, based on the words of Jesus on the cross to his
mother and the beloved disciple (John 19: 26–27). The themes of
national pride, neglected reserves of African wisdom and the com-
passion of Christ in the midst of suffering are integral to an under-
standing of the older Oduyoye. So, too, is her sense of commitment
to her matrilineal upbringing, and the inspiration of Asante fore-
mothers and churchwomen who surrounded and enabled her fur-
ther training. As Oduyoye recalls:

> The women of the Christian community symbolised by my grand-
> mother and my mother are not only an inspiration, they are a guide,
> and sometimes they function as monitors of what I write. I feel account-
> able to them as someone expected to carry on a tradition of ensuring
> life-centredness in the community. I have sought to articulate what my
> grandmother acted out in her lyrics... To this I have added my

mother's quiet insistence that a person owes her community nothing
less than her best, but she cannot give of her best if she is not empow-
ered to do so. Luckily for me, my father shared this view of human
development (Oduyoye 1988c: 50).

Amba Yamoah went to Legon University where she took courses under
Professors Kwesi Dickson and John S. Pobee, and thence to Osei-
Tutu Teacher Training College at Akropong in Ashanti. Yamoah
came as a mature student to Newnham College, Cambridge, to read
theology at the University in 1963. In 1965 she returned to Ghana
and taught at Wesley Girls High School for two years before being
recruited for the post of Education Secretary in the Youth Depart-
ment of the World Council of Churches. In 1970 she went to work in
Nairobi as the Secretary for the newly created Youth Department
in the reorganised secretariat of the All Africa Conference of Churches
following the Abidjan Conference of 1969. Participants at Abidjan
had issued a clear call for acculturation, Christian-Islamic dialogue,
ecumenical co-operation, the recognition of the previously shunned
African Initiated Churches (AICs) and had begun the process which
was to lead to the call for a missionary moratorium at Lusaka in
1974 (Utuk 1997: 82, 87, 118).

She married Adedoyia Modupe Oduyoye in 1968, and in 1974
they moved to his homeland, Nigeria. She was the first woman lec-
turer in the Religious Studies Department of the University of Ibadan,
where she taught church history and Christian doctrine. Her con-
cerns were, from the start, inter-disciplinary and she was committed
to communicating to 'church women and men' the 'ideals' of the
Christian faith and the riches of 'the traditional view that the life-
force [that] is in us is that of God' (Oduyoye 1986h: 7). Feeling like
'an Elijah in the midst of all the priests and prophets of the patri-
archal Baal', she was urgent in her desire to release theology from
'the past-time of an obscure and marginal group of eggheads' (Oduyoye
1986h: 6). Besides her lecturing, she involved herself in voluntary
work amongst churchwomen following the pattern of her mother
and grandmother before her (Oduyoye 1988c: 51). 'churchwomen's
groups', Oduyoye reflected at the first pan-African conference in
1989, 'are our natural home' and the base for a 'network of allies'.
'The power of African women is in the solidarity achieved through
the formation of sisterhoods' (Oduyoye 1990f: 48). In 1990 she was
awarded a doctorate by the Academy of Ecumenical Indian Theology
at the Lutheran College at Madras, and the following year she was

appointed to be a Deputy General Secretary at the World Council of Churches in Geneva, where she stayed until her retirement in 1996.

A sometime visiting lecturer and Professor at Princeton Theological Seminary, Harvard Summer School and Women's Studies Programme, and Luce Professor in World Christianity at Union Theological Seminary in New York, Oduyoye actively promotes the cause of Third World women theologians. With Dr Kate Cannon of the University of Calgary, she runs MA and doctoral programmes which have an emphasis on praxiological learning, using centres of 'exposure' across the Southern hemisphere. She is widely regarded by the participants of the Circle as the Queen Mother of the movement, a phrase replete with Akan overtones of traditional authority and respect. She currently co-ordinates research initiatives for the Circle from her home in Legon, Ghana, and is in constant demand for her theological leadership at ecumenical conferences across Africa.

The Literature

Oduyoye is the most prolific writer of the Circle. Her published work numbers several books as well as dozens of articles which feature regularly in the in-house journals of the WCC, EATWOT, AACC, and in the Circle's own *AMKA*. African theological journals and Western mission theology publications such as the *African Theological Journal, The Way* and the *International Review of Mission* have all featured essays by Oduyoye. She perceives her theological writing as her commitment to the 'poor', in a revision of liberation theology's premise that 'commitment is the first act of theology' (Oduyoye 1990e: 103).

In much of Oduyoye's cascade of writing she has openly crusaded for Africa and African women. She has written for Ursula King's *Feminist Theology*, Letty Russell's *Inheriting our Mothers' Gardens*, and Susan Thistlethwaite's *Lift Every Voice*. She has been the African women's 'voice' in numerous EATWOT conference papers, and an essayist for numerous WCC conference reports, particularly on Youth, the Lima process towards Unity, the Community of Women and Men in the Churches and theological education. She has edited both reports on the Circle's biennial conferences.

The Daughters of Anowa, published in 1996, was a clear call to discover an African theology rooted in the religious cultures of Africa which realise the dignity, leadership spirituality and autonomy of

African women. All her books have been published either by Orbis, the WCC, or Daystar Press in Ibadan, where her husband, Modupe Oduyoye, has been senior editor since its formation. Her first publication for the Western market, *Hearing and Knowing* (published in 1986 but since running to a fifth edition), was published by Orbis. Although this publishing house is the charitable wing of the missionary Maryknoll order, its publications present very real pricing difficulties for an African readership. Without an African co-publisher these books have little chance of reaching target audiences in Africa.

It is important not to underestimate the market for African writing accessible to African-Americans, with multi-cultural feminist courses proliferating in the United States. Oduyoye's work is consistently cited by writers working in African-American womanist theology, by other EATWOT colleagues and by members of the International Commission on Violence. Apart from these sources, her work and concerns have been conspicuously neglected by the theological academy in Britain and Northern Europe. Britain's colonial experiment in Ghana has one of its most persistent critics in Oduyoye, which might help to explain the British academy's virtual ignoring of her corpus.

At the 1997 Conference of the AACC in Addis Ababa, Oduyoye, as the newly elected General Secretary of EATWOT, challenged delegates in her keynote speech to consider their situation as citizens of Africa. *Den mmusu na yaabo?* 'What has happened to us?' she asked:

> Why is it that culturally we have become what the Akan proverbs enjoins us not to be, 'a people who takes out its own stomach and fills the void with straw'? We are alienated from our roots, but do not seem to have the means to become fully integrated into the Western world, which we so much yearn to be a part of. We do not lay the ground rules for the games in which we participate . . . We are ready to follow every advice of others whose real interest is to help their own people to sustain and enhance their own standard of living. We know of nations whose people are unemployed even while their gross national income rises and their production lags; they live on the interests we pay them. We are witnessing the sad paradox of an abortive economic development policy which induces an inversion of financial transfers . . . what has happened to us? We are unable to provide quality education for our children. Instead we engage in remedial adult education. *Den mmusu na yaabo?* Have you not heard? Have you not seen? Do you not experience it in your life encounters? That in being poor, we are making others rich (Oduyoye 1997b: 1).

This is the most recent articulation by Oduyoye of two central concerns which have helped inform her theological writings over the last twenty years, the cultural displacement of Africa's identity and the continued economic 'bondage' of her post-independence reality. That economic concerns should inform a part of her theological reflection is consonant with many of the theological currents of which she has been a part. Perhaps more significant was the Wesleyan holiness movement which was so influential in nineteenth-century mission in Ghana. This form of Methodism was committed, from its genesis, to the freeing of slaves, keen resistance to poverty and the liberation into wholeness through the salvific message of Christ in both the United States of America and England before ever it came to the Gold Coast (Hollenweger 1997).

EATWOT has consistently united its disparate theological concerns and approaches through an outrage at the prevailing North/South division of wealth, using categories of dependency of the periphery to the metropole. The WCC also became used to the terms of theological engagement being established first of all on lines of wealth and poverty. Oduyoye, speaking in the AACC submission to the sixth General Assembly of the WCC at Vancouver, called for the removal of 'rags' and 'beggary' and a return to 'wholeness of life', which she perceived not simply in Christianity but in the 'dynamic' of African society (Oduyoye 1983a: 118, 119). The AACC conference in Nairobi in 1981 contained a description by Kenyan President Daniel Arap Moi of Africa as a 'bleeding continent' whose recovery depended on independency and African internal self-examination (Utuk 1997: 139). This descriptive strategy is similar to many of the public manifestations of first generation post-colonial Presidents such as Mobutu, Kaunda, Kenyatta, Senghor and Nkrumah. For Oduyoye, the way forward out of the economic, military and civil disease of Africa was to draw afresh from her own religious and cultural resources (Masamba, Stober et al. 1983: xix, 114). Her theology is a call to life from all that would deal death to Africa and her women (Oduyoye, Kanyoro et al. 1999).

In reply to her question, *Den mmusu na yaabo?* What has become of us?, she develops a theology which is dependent on a number of factors. All of these are familiar to the EATWOT constituency: liberation theology committed to the underside of history, the voice of the poor and the privileging of contextual readings of the Bible. A

variety of 'theologies'—African inculturation theology, feminist the-
ology, womanist theology, minjung theology, black theology from
South Africa and the United States, and EATWOT theologies—are
employed in her corpus. We have already seen the importance of
anthropological poverty and the theopraxis of liberation in the work
of Mveng and Pieris, who raised these ideas as responses to the colo-
nial expurgation of an ethnic identity and the reality of religious plu-
rality in the post-colonial world.

The Sources of Alienation

There are many paradoxes with which Oduyoye struggles in her
theological writings. The most explicit is this: how is it that an 'Africa
which thinks whole (and) preaches wholeness . . . is riddled with divi-
siveness and brokenness?' (Oduyoye 1983a: 114). Oduyoye's early
work at Ibadan University posited the answer that Africa has for-
gotten herself, and African Christians have allowed themselves to be
detached from their roots in the pursuit of enrichment and 'self-
centeredness' under the 'cloak of Westernisation' (Oduyoye 1983a:
122). Thus, Africans have a responsibility to pursue the ancient paths
of communal accountability, with the whole of life viewed as sacred,
and not the degenerate 'Western deviation' of Christianity. Oduyoye
sees this deviation stemming, in a reading that runs counter to much
Western historiography, from the edict of Constantine which, she
maintains, sundered the sacred and secular domains, and has poisoned
Western Christianity up until the present (Oduyoye 1983a: 117).

Oduyoye's first extended response to the difficulties of Western
Christianity and the damage it had inflicted on Africa through the
missionary movement was *Hearing and Knowing*, published by Orbis
in 1986. A better translation of her concerns in this work would be
'Hearing and Accepting'. For in Oduyoye's mind many Africans
have not accepted the package of 'mission Christianity' (indeed, should
not) and therefore live in an ambivalent relationship with their reli-
gious cultures. This is particularly the case, Oduyoye argues, with
women, who have retained pre-Christian perspectives on life and
spirituality, despite the transformation of Africa's public conceptual
landscape. The early conversions of the nineteenth century were, she
contends, based on the African commitment to hospitality and grat-
itude. It was the gratitude of freed slaves to their liberators, who

then offered hospitality to the white religion, as part of the goods of trade and education (Oduyoye 1986a: 34). But gratitude is different from negotiation and evaluation of all the new ways.

Oduyoye roundly criticises the early white missionaries of the Wesleyan mission to the Gold Coast for failing (like their Portuguese predecessors in 1471) to understand, respect or 'do theology' with the people they encountered. Oduyoye, unfortunately, uses a broad brush too similar to that used by nationalist politicians and academics to portray missionary encounter as hierarchical, insensitive, and derogatory towards culture. On the other hand, Oduyoye states a necessary reality which is often overlooked, that the missionaries were foreigners and, what is worse, mostly of 'a different human-type (call it race)', ill equipped 'to protest' against 'incipient racism, exploitation and other injustices' which were a part of Western colonialism (Oduyoye 1986a: 43). Even when she concedes the black presence of the dynamic Sierra Leonean church and its subsequent mission into Nigeria and Ghana, the fact that these missionaries were bearers of 'different cultures, languages and customs' to those of the receiving population is enough for the problematic offence of 'foreignness' to arise (Walls 1970; Oduyoye 1986a: 31).

The necessary nature of foreignness in any transmission across particularities, whether communal or personal, is, unfortunately, not addressed by Oduyoye. Undoubtedly the sense of 'foreignness' was significant for both sides of the missionary exchange (Furedi 1997). This is the nub of the problem of an incarnational religion and its mission; Oduyoye fails to rise to the challenge, preferring to collapse the issue into a single binary opposition (Oduyoye 1986a: 18, 21, 27). She builds her sense of grievance by recalling such missionary practices as renaming African church members and domestic servants with European names because of the difficulty of pronunciation, or because of their 'heathen' quality. She reminds her readers of white exclusiveness in social behaviour, and the wholesale rejection of African religious practices as 'evil' and 'heathen'. All this made the missionary period one of wholesale 'cultural occupation' (Oduyoye 1986a: 33). The language of 'partnership' or 'fellowship' that were to become the professed paradigms of later missionary engagement, as the colonised states moved towards political independence, never, for Oduyoye, realised themselves in practice (Oduyoye 1986a: 33, 34). Thus, in the new post-imperial religious economy, a new way of being Christian and African independent of the enslaving

manacles of the North needs to be realised if Christianity in Africa, and Africa herself, is to survive.

This fresh appropriation of Christianity in Africa, on terms more consonant with her religious roots, is the hope that Oduyoye offers the mission churches of escape from being becalmed in the 'decadence' and 'inertia' which is troubling the entire continent (Oduyoye 1997a: 9). The mission churches imported a 'static theology' with certain non-negotiables of faith which decried life-giving aspects of African traditional cultures as 'heathenism', and tore the creative and life-sustaining heart out of the African world (Oduyoye 1986e: 19; Oduyoye 1995e: 82). Furthermore, with the failure of the moratorium, many of the mission churches still have their headquarters in the West, and African leadership is, therefore, limited in the freedom with which it can rethink its alignment. Western Christian culture is a 'hydra-headed' monster which has focused on class, and raised a brood of political, business and church élites, which are at best insensitive to ancient African concordats of mutuality and accountability. At worst they have raised up new gods for Africans to worship: individualism, the West and 'foreign exchange' (Oduyoye 1995e: 80).

Oduyoye's commitment to rehabilitating African traditional religion from the theoretical 'dustbin', into which she believes three generations of mission church leadership have consigned it, has its African antecedents in the Ibadan conference of 1965 (from which the AACC emerged). An AACC symposium in 1966 considered the relationship of the 'biblical concept of God and the African concept of God, between what God has done and is doing according to Biblical record and teaching, and what God has done and is doing in Africa according to African traditional beliefs' (Dickson and Ellingworth 1969: 16). The conference affirmed

> the radical quality of God's self-revelation in Jesus Christ ... yet ... because of this revelation we can discern what is truly of God in our pre-Christian heritage: this knowledge of God is not totally discontinuous with our people's previous traditional knowledge of Him (Dickson and Ellingworth 1969: 16).

Bolaji Idowu, then Professor of Religious Studies at the University of Ibadan (where Oduyoye herself was teaching), contributed to this process with a paper on God. Previously he had broadcast three seminal talks in 1961, just after Nigerian independence, calling for the 'indigenisation of the Church in Nigeria'. His challenge to Nigerian Christianity was to divest itself of the 'apron strings' of the mis-

sionary churches, expunge the 'accidental accretions which have given the Church her European complexion', study the rise of the African Initiated Churches (AICs) which had emerged and were already proliferating in Nigeria, and look at the traditional beliefs which were being affirmed in a new light (Idowu 1965: 14, 48).

This mixture of resistance to the white infiltration of Africa, the idea of the colonisation of the black mind with its consequence of loss of 'a dynamic perspective on life', and the 'identity crisis' particularly amongst 'the urbanised, the Western educated, and the Christians' is strikingly similar to the analysis offered by Marcus Garvey in the 1920s (Oduyoye 1986a: 54). Garvey argued for the reassertion of 'black pride', 'black history' and black culture, and argued for the re-envisaging of God in black categories, a God to 'be worshipped through the spectacles of Ethiopia' (Garvey 1969: 44; Clarke 1974: 383).

Oduyoye, whose national leader Nkrumah acknowledged his own indebtedness to Garvey's black *risorgimento*, translates the motifs of Ethiopianism into the categories of Akan proverbs and folk wisdom (Clarke 1974: 326 ff.). A new pride in West African culture, based on the riches of the Asante and Fante worlds, informs much of Oduyoye's blistering attack on the wrongs of European and North American white engagement with the continent. The assignation by white missionaries of 'ignorance' to the 'native' population, considering them as 'rude and illiterate', 'perishing' souls, and minors in need of paternalistic care and instruction, is hard for her to forget (Stock 1899: 147–149; Oduyoye 1986a: 41, 52).

This largely negative assessment by the missionaries did mean that there was little engagement with the African mind as a philosophical system. This contrasts with the method of the early Fathers of the Church, whose dialogical method enabled the successful entry of Christianity into the Hellenistic world. This method is now under acute examination by fellow Ghanaian, Professor Kwame Bediako. His work places 'Primal Religions' centre stage. He argues that the recent

> persistent concentration by Africa's theologians on the continent's Primal Religions in the formative period of African Theology may have brought us to a new creative stage in Christianity's encounter with the Primal Religions of the world . . . that in Africa, the opportunity for a serious theological encounter and cross-fertilisation between the Christian religion and the Primal Religions, which was lost in the earlier evangelisation of Europe, can be regained (Bediako 1995b: 57).

Oduyoye contends that the significance of African Primal (or Tradi-
tional) Religions was ignored by the Protestant missionary enterprise
because of a deficient doctrine of creation dominated by a pessimistic
view of human nature as sharing in universal sin (pp. 33, 184). This
condemned ATR out of hand as mere 'superstition' and 'heathenism'
(Oduyoye 1986a: 34). Dialogue and integration in these circumstances
would have been interpreted as apostasy. All these factors, maintains
Oduyoye, have alienated the mission churches from the integrating
potential of ATR. They have left Africa and her peoples vulnerable
to external and internal exploitation and violence, her mission churches
fossilised and Christians generally impotent to help in the political,
social, religious and economic crises which Africa faces (Oduyoye
1979a: 110; Oduyoye 1983a).

African Traditional Religion: The African Old Testament?

Oduyoye takes a fresh look at ATR in relation to the Christian scrip-
tures. She challenges the thought of C.G. Baëta, who advocated the
application of Christian dogmatics to the needs of contemporary
Africa after the fashion of liberation theology. Baëta was content to
release Christianity to speak for and from the perspective of the poor
and oppressed. His reading ignored not only the Jewish cradle of its
formation but also ATR, which taught one how to live the good life
(Oduyoye 1986a: 59). Oduyoye agrees with Baëta that ATR does
teach the good life and should be recovered, but disagrees with him
in not critiquing the Hebrew scriptures nor allowing ATR to be
engaged theologically. Her early work was fairly critical of ATR
because of its exclusion of women from ritual power on the grounds
of menstrual and blood taboos (Oduyoye 1981d: 88). Fifteen years
later, in *Daughters of Anowa*, much of this hostility mellows, with
Oduyoye seeking to give tradition a more creative place for future
dreams of women's empowerment. Oduyoye proposes that traditional
African systems of political, social and religious organisation medi-
ate the desire for 'wholeness', which she perceives at the heart of
the 'Christ-event'.

> If an integrated view of life is an African ideal: if seeing every human
> being even the least of them, is the concern of the African: if wholis-
> tic views and seeing all sides of issues is a virtue: if healthy living is

the wholeness of a spirit-filling body and the health of one is insepa-
rable from the health of all, then in Africa we do well to celebrate
the Christ-event. In all its entirety... In him the African finds the
wholeness that our Africanness rests upon (Oduyoye 1983a: 122).

Oduyoye maintains that 'traditional' life values for the African were
permeated by religion before the advent of Islam or Christianity,
and that these religious elements are carried not only by 'cultic places
and persons but (by) beliefs', which have survived the impact of
Christian mission, modernisation and urbanisation (Oduyoye 1979a:
116). These include the living-dead, the existence of spirits, magic
and witchcraft, which underline the non-materialistic elements of
Africa's religious quest. That quest, she maintained, is a 'yearning
for life after life'. The theological task for African theologians is not
to 'domesticate the African spirit', but rather to 'ensure that the
African spirit revolutionises Christianity to the benefit of all who
adhere to it' (Oduyoye 1979a: 116).

Her method was attacked by some members of the African theo-
logical fraternity as an act of 'syncretism'. It was a condemnatory
epithet for which she had already prepared. Oduyoye maintains both
here and in other papers that syncretism is a 'positive and unavoidable
process' in the inculturation of Christianity into other religious contexts.
ATR, she argues, emphasises the 'common origin of humanity', 'the
religious basis of life' and reinforces the 'Christian doctrine of crea-
tion' by insisting on the 'divine spirit in nature', a posture which
has substantial pay-off in a renewed theology of ecological concern
(Oduyoye 1979a: 110, 115). The role of the ancestors in ATR is also
commended as a constant reminder of 'roots and (a) source of self-
identity'. She insists that 'the ancestral cults (which) have been the
custodians of the African spirit, personality, and vivid sense of com-
munity' need to be incorporated into Christian belief and practice
(Oduyoye 1979a: 110). In North Atlantic feminist theological thought,
particularly in Europe under the influence of the French philosoph-
ical school, the ability to attend to the 'other', to refuse the domi-
nance of the 'one' and to reap the gains of multiplicity and change
is a theme which is championed by many, and opens western fem-
inism to attend to the ambiguous and critical journey which Oduyoye
has undertaken (Schüssler Fiorenza 1994a: 162; Irigaray 1985).

The importance of engaging with the cult of ancestors is a project
shared across the sub-Saharan belt by Protestant, Catholic and many
Independent churches. Charles Nyamiti, Kwame Bediako and Kwesi

Dickson began to explore these previously illicit ways of integrating Christology with African ancestor rituals and beliefs in the late 1970s (Dickson 1984: 61–67; Nyamiti 1984; Nyamiti 1990; Bediako 1995a: 223–229). It has also been a long-term concern of John Mbiti, notable in his anthology of African prayers published in 1976 (Mbiti 1976). Mbiti proposed at the end of the sixties that the African trajectory of existence and self-understanding moves backwards rather than forwards, demanding engagement with a different theological orientation other than a forwardly-moving eschaton. He calls this orientation towards the *zamani* (Swahili for the past) as the place where the resources on which the *sasa* (Swahili for the present) rests.

> People constantly look towards the *zamani*, for *zamani* had foundations on which the *sasa* rests and by which it is explainable or should be understood. *Zamani* is not extinct, but a period full of activities and happenings. It is by looking towards the *zamani* that people give or find an explanation about the creation of the world, the coming of death, the evolution of their language and customs, the emergence of their wisdom, and so on. The 'golden age' lies in the *zamani* and not in the otherwise very short or non-existent future (Mbiti 1969: 24).

Oduyoye's theological project has difficulties with the concept of *zamani*, because that past has been so ambiguous in its realisation of women's freedom. She insists, however, on its incorporation as one of the imaginative resources available to women theologians in their project of building both a better present and future for Africa. Her theological focus is almost exclusively existential. She repeatedly asks, both implicitly and explicitly in her writings, how African churches, African Christians, and more recently Africans of good will, can galvanise the resources of tradition and culture to create the possibility of a just, peaceful, co-operative, wholesome life on the continent. The localisation and the embodied realisation of whatever hopes are available is both deeply African in its materiality and feminist in its refusal of ideation. African feminist theology for Oduyoye is liberational, pan-local and incarnate. All else is evasion.

African Theology and Gender Concerns

Oduyoye is familiar with feminist critical theory in the study of history and culture, and so is alert to the fact that ATR is not neces-

sarily benign in its construction of gender. At this point Oduyoye made a clear break with her male theological contemporaries. At the EAAT meeting in Accra (1977), published later as *African Theology en Route*, Oduyoye first broke silence on gendered exclusion. From these intimations of gender criticism as a component of her analysis of African traditions came a series of articles prompted by her research into Asante proverbs and their treatment of gender (Oduyoye 1977; Oduyoye 1979b; Oduyoye 1981c; Oduyoye 1981d). At the second International EATWOT conference, the *Irruption of the Third World*, Oduyoye clarified the rupture in method and strategy from a feminist perspective in distinction to that of the African male theologian. Feminists, asserted Oduyoye,

> claim that 'the male-dominated patterns of culture and social organisation' oppress women in society and manifest themselves in the life and theology of the Church. This is not simply a challenge to the dominant theology of the capitalist West. It is a challenge to the maleness of Christian theology worldwide. [During the conference] it became clear that we cannot assume that African men and African women will say the same things about African reality (Oduyoye 1983c: 251).

This explicit separation of men's and women's interests and explanations is raised in other work, most extensively in *Daughters of Anowa*, but perhaps most starkly in her article 'The Hearth of the Matter', where she cites an Akan proverb, *Nea oda ne gya na onim senea ehyehye fa* (it is the person sleeping by the fire who knows the intensity of the heat). 'Do not let African men tell you that African women do not need to speak of oppression, nor allow them to define what is the real source of oppression for African women' (Oduyoye 1989d: 442). Notwithstanding her chastisements on the limits of representation, including the warning that 'the voices of women from one stratum of African women's experience do not constitute the African woman's voice', Oduyoye conducts her theological engagement as both a personal and a corporate crusade against all that inhibits, constrains and diminishes life for the daughters of the continent (Oduyoye 1989d: 443).

Oduyoye's most recent book, *The Daughters of Anowa: African Women and Patriarchy*, is her excursus into developing a theological anthropology for African women. Her method is to explicate the myths, folklore and wisdom literature of the Akan and Yoruba peoples. She draws from this mix of matrilineal and patrilineal material images

of former power and authority wielded by women within society before the arrival of Western Christianity and its 'negative effects on the self-image of African women' (Oduyoye 1996a: 9).

Although traditional religions and cultures made more space for women's contributions than the patriarchally driven patterns of Islam and Christianity, Oduyoye maintains that 'by the time a woman has spent her energies struggling to be heard, she has barely the energy to say what she wanted to say' (Oduyoye 1996a: 13). Moreover, Oduyoye claims that the simple application of 'ancient remedies' by African women is insufficient to 'cope with our modern wounds' (Oduyoye 1996a: 11).

Notwithstanding these caveats, Oduyoye launches into an extensive perambulation around the myths and folk-tales of powerful women leaders within Asante and Yoruba culture. Political women leaders such as the Queen Mothers of the Asante, the *Ohemaa* (Queen Mother) who in strict political protocol was senior to the *Ohene* (King); the Yoruba *Iyalode* (variously translated as Mother of the Town, Mother of All Women, She whose Business is Women's Affairs); Mama Urhobo Iyaloja of Dugbe market who controlled the Olulu Masquerade and the syndicate of Ibadan's thieves; and the Aba women of eastern Nigeria who resisted the British government in 1929 are evoked to assert African women's secular and cultic leadership before the advent of Christianity and colonialisation (Oduyoye 1996a: 93–98). Many freeborn women had freedom of movement, a measure of economic independence and avenues of representation within the domestic and public spheres long before European intrusion. Some élite women, by virtue of rank and age, exercised substantial authority. This important perspective has been explored by recent feminist-inspired anthropologies and histories (Wipper 1988; Etienne 1987). However, when Oduyoye explores these two mythologies further, a more ambiguous heritage emerges which she never satisfactorily resolves.

The mythologies of African culture leave little trace of powerful females amongst the cosmologically significant ancestors. Where they exist, men are always the ones who perform their presence in the dances and masques dedicated to their re-entry into the community. Oduyoye recognises the paucity of female ancestors and seeks to address this in *The Daughters of Anowa* by retrieving a female history and mythology from the traces of female presence in Asante and Yoruba folk memory. She uses a method familiar at once to those

working with developments in North Atlantic feminist biblical studies (Stanton 1895; Trible 1984; Newsom and Ringe 1992; Trible 1992; Schüssler Fiorenza 1994b).

Oduyoye builds on literary ideas of two African writers, Ama Ata Aidoo and Ayi Kwei Armah, who use a mythical woman, Anowa, as the liberational symbol for their novels. For Aidoo, Anowa is a priestess never formally apprenticed, and in Armah's epic, a mythical woman who represents Africa. Both authors describe Anowa as a woman who opposes slavery and the slave trade, and portray her as a symbol of all that is life-sustaining and life-protecting. Anowa is also a popular Fante name, and this local provenance helps it carry some key ideas of liberation and identity within Oduyoye's work. Anowa is adopted by Oduyoye as 'Africa's ancestress' (Oduyoye 1996a: 6).

It is significant that Oduyoye does not have a series of cult festivals to assert Anowa's position as an ancestor, nor does she choose other female ancestors located in the folk mythology and cults of other ethnic groups. Anowa serves as Africa's ancestress because she resists slavery and the 'slave trade', by which the reader is presumably to infer Arab and European slavery, as Oduyoye herself never dwells on the ubiquity of autochthonous domestic slavery recorded by European traders, missionaries, anthropologists and freed slaves themselves (Livingstone 1874: 53, 168, 183; Livingstone 1923: 65 ff.; Thornton 1983). She is an ancestor who encourages resistance, nurtures vision, leads a people in an exodus-style migration and inspires unity. Moreover, she embodies an Africa freed of artificial national divisions and political and economic friction. Anowa is an ancestor who is present for Africa before the humiliation of European colonisation. Anowa, in this sense, replaces Ethiopianism by locating an idea of Africa's unity in Akan mythology re-imagined in feminist mode.

Africans, regardless of creed and race, become 'Children of Anowa'. Despite Oduyoye's continual reminders to herself and her readers that African women have varied cultures, histories and social locations, the power of the unitary idea of Anowa frequently overwhelms her attention to difference and diversity (Oduyoye 1996a: 6–11). The call of Anowa to her daughters, all African women, is for self-determination. This is the challenge of the great female ancestor through her prophetic medium. Oduyoye maintains that the sons and daughters of Anowa still 'climb onto "slave ships" and leave their mothers desolate', her sons who run the continent 'use the strength of

their manhood on what does not build a living community'. Moreover, her daughters

> are expected to be custodians of all the ancient healing arts and keepers of the secrets that numb pains inflicted by internal aggressors. They are to pray and sing and carry. They are to tend the wounds from battles in which they are not allowed to fight . . . Raped by the patriarchal manipulation of the North, Africa now stands in danger of further battering by home-grown patriarchies (Oduyoye 1996a: 10).

A fresh imagination, she maintains, is required, releasing new political possibilities where, as in Akan migration histories, women are placed in the centre and lead 'the community to freedom and prosperity'. Oduyoye fears that if 'the direction of our contemporary journey is left solely in men's hands, we may not reach the waters of Eku-Aso, where our religious leader Eku (a mythic priestess) saved us from the fear of death by thirst' (Oduyoye 1996a: 9).

A pillar of fire by night and a cloud by day provided direction and support for the Hebrew slaves as they escaped from bondage in Egypt. Oduyoye argues for the creation of fresh imaginative symbols to escape from what she perceives as the bondage of European Christian dogma. A patriarchal white hegemony rooted in the ideology of Christendom has, she argues in *Hearing and Knowing*, robbed Africa of her creativity and natural ability to solve her contemporary political, economic and social difficulties from her own neglected resources. She proposes several new symbols of women's wisdom in *The Daughters of Anowa*, and develops further the idea of *abusua* in two articles, one written in honour of Gustavo Gutiérrez in 1989 and the other for the WCC's *Ecumenical Review* in 1991 (Oduyoye 1989d; Oduyoye 1991).

The symbols chosen in *Anowa* all derive from Asante culture. *Sankofa* is originally a gold weight used in trade and legal matters, and is used by Oduyoye as a symbol of using one's own neglected resources, particularly the resource of folk wisdom (Oduyoye 1995e: 86; Oduyoye 1996a). Within this wisdom is the rich oral tradition which has been, and is still, transmitted across the generations from grandmother to grand-daughter, mother to child, aunt to niece, in a rich texture of women's communication of knowledge. *Sankofa* therefore reminds the daughters of Anowa to draw on their diverse cultural riches, one of the specified aims of the research of Circle members (Kanyoro 1990b: 4).

In an article redolent of Alice Walker's collection *In Search of Our Mother's Gardens*, Oduyoye recalls how she absorbed from her mother's stories the 'daring' of Asenie women, the 'side of my family that was not as completely sold on Christianity as other branches (of the Akan) seemed to be'. As a young girl she learnt of the priest politician Okomfo Ankoye, who was instrumental in uniting the Asante into a strong nation. 'In my veins' discloses Oduyoye,

> flows the blood of Abena Gyata, the mother of the Asenie. My mothers were leaders, caring and compassionate, self-motivated and strong of will and character. Blood may be myth, genes too scientific, but there is nothing like a story to fix one's self image ... Even though I have not grown up among my mother's mothers, there was enough of them left in her and in the stories she told. Westernisation could not rob her of the stories of her mothers. Neither could Christianity lead her to demean her ancestry ... I have faith in the future of the African woman and her power to transform Africa (Oduyoye 1988c: 37–38).

Women's power, a power able to transform nothing less than a continent, is Oduyoye's religious quest. Re-appropriation of mothers' stories and histories is one method of strengthening women's 'loosened wrists', in the face of the multiple challenges of violence, corruption, poverty and indebtedness and increasing 'patriarchalisation' of marital and ecclesial practice across Africa (Oduyoye 1996a: 10, 107).

A great deal of Oduyoye's intellectual energy is concentrated on redefining African women's identity. She has some real difficulties to overcome in her critical engagement with African traditional thought and culture, because these tend to deliver a view of woman as only definable as a mother. In order to enable women in Africa to facilitate a migration for the whole community into freedom, Oduyoye has to confront the difficulties of women who, if childless as she herself is, can be abused by cultural taboos and religious practices. Moreover, Oduyoye takes as a critical point of departure in reading African traditional wisdom that women have the God-given 'right' to be fully human whether or not they choose to be attached to men. This type of 'freedom' not only with regard to childbirth but also in terms of being free from the 'authority' of men is a revolutionary idea for Africa where, even amongst the matrilineal Akan, a woman, whilst not being a 'chattel ... is a gift with strings attached, and these strings are held by her maternal uncle' (Oduyoye 1996a: 137).

Many of the ideas Oduyoye uses regarding women's 'self-authentication', 'ego' and 'self-determination' are clearly derived from Western

sources. She acknowledges that the two books that most influenced her during her years of schooling were the Bible and John Stuart Mill's *The Subjection of Women*. Mill's enlightenment analysis of the loss of autonomy for women through marriage and childbirth was of foundational importance for Oduyoye, and inspired her to look at ecclesiastical, colonial and (her own) cultural history with a critical perspective. The possibility of taking such a critical view is distinctly a modern phenomenon, and it is modernity which, in so many other respects, she rejects.

This conflict of interest is thrown into sharp relief as we look at the symbol of *abusua*. Oduyoye uses it to examine the strengths of African culture, to generate a means of enriching ecumenical discourse, and, with an eye to an increasingly dislocated and urbanised Africa, as a means of women enhancing one another. The *abusua* also delivers one model of how Oduyoye conceives of the role of the Circle. In her most extensive treatment of *abusua*, an article entitled uncontroversially 'The African Family as a Symbol of Ecumenism', Oduyoye shows that the Asante *abusua* are clans derived from female heads.

The *abusua* is a lineage made up of numerous households which are 'ever-expanding, outward looking communit(ies)', they are multi-generational, and are organised through bifocal systems of authority for men and women ensuring the full participation of all (Oduyoye 1991: 466). Although households within each *abusua* are chronologically diverse, including the living-dead and those yet to be born, as well as 'spatially dispersed', families in 'diaspora' (as African-Americans or in Europe or across the Continent itself), the *abusua* consider themselves to be one blood because they have a common female ancestor. Wherever a member of the *abusua* finds herself, her responsibility is to seek out the head of the local family and make herself known. For, as Oduyoye insists, as an Akan no one is expected to operate 'as an individual isolated from the *abusua*' (Oduyoye 1991: 468).

The *abusua* is an indivisible unity from which one cannot separate oneself. There are no distinctions between siblings and cousins, mothers and aunts, fathers and uncles. In this way a childless woman, such as Oduyoye herself, is enabled to be respected as a mother within the *abusua*, for she is a member of a wider familial unit, a unit in which all members are committed to one another's welfare and carry the responsibilities of each age-set. This experience of being a member of a unit of mutual interdependence has furnished Oduyoye with a model of how the Circle could operate as a theo-

logical group committed to research, publication and mutual support. It also provides her with a powerful illustration of how the Church could develop its vocation of catholicity and ecumenical solidarity. It is not enough, she argues, for the 'Christ clan' to honour the same mother, but to act viciously and irresponsibly with one another. Likewise, the denominations become different households within the same *abusua*, respecting one another as part of the same clan and blood inheritance.

Abusua *and Inter-Faith Relations*

In an interesting extension of this symbol, Oduyoye plays with the idea of 'other *abusua*'. Other *abusua* in this instance would be other religious communities, such as Islam, Hinduism, Buddhism and ATR. The 'Christ family', the Christian *abusua*, demonstrates the hospitality of Africa with an 'open-door' approach to the outside world, with particular rules and regulations which structure the relationships with other *abusua*, households of other faiths. Oduyoye encourages her readers to consider the advantages of adopting a method of being in 'pro-existence', not simply co-existence, with other faiths, recognising that *abusua* with its network of household relationships engineers human goodness (Oduyoye 1991: 471).

Abusuas may be different in language, origin and cultures, but they share a world view which 'rests on a religious interpretation of the universe' (Oduyoye 1991: 467). In this way the Akan experience of clan, household and family is offered by Oduyoye as a way of resolving the aggression of North Atlantic missionary activity. It becomes instead a means of creating harmony and co-operation with the two other major religions of the continent, Islam and ATR, whose presence, in varied percentages of dominance or minority, marks every country across Africa (Barrett 1982; Pobee 1992: 62, 132, 133). The plurality of religious affiliation in the continent is a particular concern of the Circle, whose membership significantly includes (although in minuscule numbers) Islamic teachers and ATR exponents and affiliates.

The concern for inter-faith reconstruction in Africa is high on Mercy Oduyoye's agenda. The Circle's 1996 conference dedicated a full morning to explicating Muslim-Christian dialogue, facilitated by Dr Janice Nassibou, African-American director of the Programme for Christian/Muslim relations in Africa (PROCMURA). One

morning's worship was led by Muslim participants, another by traditionalists from South Africa. In *The Will to Arise*, Dr Rabiatu Ammah explicated the position of women within Islam and concluded, 'in reality, the picture might be bleak for Muslim women, but we must also aim at the ideal. So must women in all religions' (Ammah 1992: 84). Circle women were asked to recognise the disadvantage at which Islamic approaches to education had placed women—and the alienation the early Christian monopoly on education had created.

The East African and South African Circles had already undertaken a three-year study process which resulted in the publication of *Groaning in Faith: Women in the Household of God* (Kanyoro and Njoroge 1996). This publication included contributions from ATR, Hindu and Muslim writers, but the overwhelming majority of contributors were Christian theologians, University lecturers, NGO and para-church workers. The new orientation of the churches towards Islam, driven by the concern voiced by the Oduyoye of *'Den mmusu na yaabo?'*, relies on an appeal to a common humanity, specifically a common African heritage and identity. If this is a desire within the AACC for peace and prosperity, it is also a yearning for the *shalom* of African traditional thought, *ubuntu*; health for community, household and individual, recognising no dualistic interruption between the physical and the spiritual (Bam 1998). This is voiced by Oduyoye in 'Liberative Ritual and African Religion'; African people have a 'desire for salvation' in the midst of international debt, internal political crises and religio-cultural trauma (Oduyoye 1990c: 87).

Oduyoye argues that there is a crisis in Christianity not only in Africa but also across the world. The old metropolitan centres of North America and Europe have no answers for the suffering and dislocation of Third World peoples and churches (Oduyoye 1989a: 198). This is a theology which is recognisably out of the EATWOT stable. At the same time, Oduyoye preserves links with certain Euro-American women when she argues that particular women-in-mission from the Northern churches have unveiled 'the need for the re-evangelisation of the Church and the re-appropriation of what Christ means for the world' (Oduyoye 1989a: 199). She acknowledges in this article their seminal influence on contemporary women theologians in Africa (Oduyoye 1989a: 199). However, Oduyoye argues that African women within the churches already demonstrate a way of being radical theologians, with a form of spirituality 'so deep that *men's* religion has not been able to separate them from Christ' (Oduyoye 1989a: 199).

Oduyoye's theological mode is oratorical. She is first and foremost an advocate, not a researching academic. She has a theo-political struggle to win, and to that end she commandeers the praxis of African women as theological ammunition against the 'constraints' and 'disempowerment' of Northern Christian dogma. Her contention is that the 'missionary' understanding of Christ is too limited and imperialistic to properly engage with other religions found in the world. The phrasing 'religions found in the world' rather than 'world religion' is significant, as it allows African Religions to find their appropriate place in being religions-in-need-of-dialogue rather than as aberrations that can be arrogantly dismissed by the other world religions. Every society, she contends, even that founded by '"illegal" immigrants who came to people the Americas from Europe' are in need of the mission of Christ, which addresses amongst other features the 'smugness and idolatry of material wealth' (Oduyoye 1989a: 199). All peoples need to be addressed afresh by the Gospel of Christ, and most missionary churches need to reassess what the Gospel of Christ is in terms which do not leave participants of different religious systems as 'other' (Oduyoye 1989a: 199).

Christ the Compassionate One

The first book published by the EATWOT Women's Commission was entitled *With Passion and Compassion*. Africa's particular contribution is the contention that Christ for African women is the 'caring, compassionate nurturer of all'. In the Oaxtapec EATWOT women's conference of 1986, Jesus was named as liberator and *compañero* in Nicaragua and as the exorcist and healer of *han* for Korean and Filipino through the power of his passion (Fabella and Oduyoye 1993: 138, 112). The passion of compassion is, I suggest, the dominant motif asserted by Oduyoye in African women's spiritual experience. Oduyoye advances this proposition by citing examples from this single undifferentiated category—African women's experience—and by using the prayers of women within the AICs. One such woman whom Oduyoye is fond of exploiting is Afua Kuma, a 'charismatic leader' amongst the Akan, whose praise names for Jesus 'range from titles of royalty and warriors, to that of friend and mother, the highest praise a woman gives a man' (Oduyoye 1990d: 249). Further, Jesus is the saviour of the poor, who supports them and makes them into persons commanding respect (Oduyoye 1990d: 249).

Oduyoye maintains that the prayers of Afua Kuma reveal an immediacy of relationship between the suppliant and God in Jesus. Jesus is the 'wonder-worker', the 'mother', the 'true-friend'. Women are empowered through this relationship without any need of male or priestly intervention (Oduyoye 1990d: 251). Oduyoye goes to the experience of the 'potent prayer' of women to see how prayer has been used by women in African history. She associates her ideas with those of Malawian, Annie Nachisale. Women have simply exchanged the practice of praying through their grandmothers and great-grandmothers, their female ancestors, and now pray through Jesus (Oduyoye 1990d: 251; Nachisale-Musopole 1992: 196).

This is an attractive thought, but, in the onrush of her alternative historical imagination, Oduyoye glosses over how continuities like this can be asserted over what are very different religious fields. In Malawi, amongst the Chewa, a matriarchal people, the women were priests, mediums and rainmakers. Their experience tunes well with the matriarchal cultural paradigms of much of the Asante. However, we do not have, and it is not clear whether Oduyoye is committed to acquiring, a full range of the historical modes of prayer used by African women. These might show, across the continent, profound discontinuities as well as continuities between traditional religious practices themselves and the explosion of Christianity. Patriarchal societies would offer alternative challenges to historical sources of women's religious empowerment, where women were frequently excluded from the public naming and petitioning of God.

In an essay from 1988, Oduyoye asserts that Christ is above all 'the liberator' for African women. His liberation for women was achieved not on the cross, but by being 'born of Mary', and, in so doing, ridding society of the ostracism of women in communities 'riddled with blood taboos and . . . inauspiciousness arising from women's blood' (Oduyoye 1988b: 123). This is reminiscent of her contribution at Accra in 1977, where she undermined African men's authority to speak for African women whilst they neglected the issue of female exclusion from key cultic roles due to menstruation and childbirth. It is assertions like this that demonstrate quite clearly that Oduyoye is dependent, in her critical reappraisal of African culture and desire for women's well-being, on a Christ similar to the one of the missionary evangel. A Christ who has power to save, who 'washes the disciples feet', who is the 'companion, friend, teacher, truly woman [sic] . . . yet truly divine . . . the truly Compassionate one' (Oduyoye 1988b: 123).

Ironically Oduyoye occasionally lapses into the language of high imperial era mission journals with Christ annulling the condition of women as 'silent "beasts" of societies' burdens, bent double under racism, poverty and lack of appreciation' and invites us to do the same (Oduyoye 1988b: 123; Hawker 1911; Shaw 1932). However, the African woman's Christ, according to Oduyoye, is not 'the only way to God'. She specifically resists particularity in Christian doctrine, as that which has destroyed Africa's religious heritage and confidence, and a contemporary threat to peace from the generation of religious antagonisms.

We have already noted Oduyoye's championing of the role of AICs as bearers of an authentic spirituality. However, she tends to amalgamate them all under the title of Aladura (literally, the praying churches), because of what she perceives to be their commitment to the efficacy of prayer. In 'Wholeness of Life in Africa', Oduyoye identifies AICs as Aladura when they are 'marked by indigenous African initiative and leadership, Pentecostalism and emphasis on prayer'. The 'true spirit' she claims 'of African Christianity is what has found expression in these churches' (Oduyoye 1983a: 113).

Initially a name given to a set of Yoruba Independent churches by themselves, Aladura is specific to Nigeria. It is at points such as these that one is no longer aware whether one is dealing with a representation of ecclesial history or an imaginative reconstruction of a powerful symbol of autochthonous spirituality. For in Nigeria itself there are both Aladura and non-Aladura churches amongst Independent churches and the ascription of 'Aladura' to all AICs either in Nigeria or across Africa is misleading to say the least. Oduyoye seeks, through naming them all Aladura, to prioritise the focus on prayer in these churches, as well as their independency from Western initiatives and interference.

However, of the churches designated 'Aladura' in Nigeria—the Cherubim and Seraphim, the Faith Tabernacle (later the Apostolic Church in Nigeria), the Christ Apostolic Church and the Church of the Lord (Aladura)—at least one has had significant contact with Western Pentecostalism. The Philadelphia Faith Tabernacle based in the United States has early exchanges with the founder of the Diamond Society of the Faith Tabernacle, which later changed its name to the Apostolic Church as its geographical and ecclesial link shifted from America to Wales. Missionaries from the revival movement swiftly forged links from the mining valleys and industrial towns of Wales to their co-believers in Africa (Peel 1968: 67, 105).

The Cherubim and Seraphim was founded consequent upon a series of visions granted to a young woman, Abiodun Akinsowun. She came from an élite family and was, before her extraordinary encounters with angels, a confirmed member of the Anglican community of St Paul's Breadfruit (Peel 1968: 71). The clear break that Oduyoye seeks from the contamination of Western Christianity is simply not so easily won in the ebbs and flows of Christianity's incorporation into African independency.

Moreover, although initial scholarly study of Christian independency in Southern Africa portrayed independency as either a road back to 'heathenism' or as 'home' from the alienation of hostile mission Christianity, more recent work has revealed other dynamics of creative theological alliances (Sundkler 1948: 55; Welbourn and Ogot 1966; Daneel 1972). David Maxwell has applauded Walter Hollenweger's fresh perspective showing the links of personnel, funding and ideas to the Zionist churches of South Africa from the 'American counter-establishment Christianity' of Pentecostalism and, in particular, John Dowie's Zion City Church in Chicago (Hollenweger 1972: chapter 9; Maxwell 1997: 2). A decade later, Oduyoye seems to recognise the need for greater geographical and doctrinal precision in *Daughters of Anowa*, where she uses Aladura in its ecclesial specificity. Aladura churches undoubtedly have given

> women more room to express leadership abilities than do the churches that have grown out of the Euro-American missionary enterprise. This can also be said of the AICs of West Africa. Because the Aladura and the Zionist churches follow closely the practices of African Traditional Religion, many adherents of the religion are office bearers [but] few such churches have women heads. [However], my reading of the women founders and leaders of the AICs leaves me convinced that African women like Captain Abiodun (head of the Cherubim and Seraphim from 1986) reflect the leadership of women in African Traditional Religion . . . Churches in Africa cry for the richness of this empowering and caring ministry (Oduyoye 1996a: 126).

The importance of ATR in the transformation of ecclesial organisation and theological aspirations is undeniable in the practice of Christianity in the AICs. However, the other threads of connectedness with the West and mission churches are systematically denied in a way which does not build bridges for global understanding.

Oduyoye's approval of AICs is not, however, carte blanche. Whilst applauding the Independent churches' realisation of African desires

for health and well-being, Oduyoye searingly attacks the churches which are the fastest growing phenomenon in Nigeria, the Pentecostal 'success theology' churches. She characterises these churches, many of which receive substantial funding, literature, training and personnel from North America and Germany, as simply 'success' orientated, a judgement that fails to do justice to the complex manner in which these churches are inculturating the faith (Oduyoye 1995e: 86).

Oduyoye protests at the pre-modern affirmation of witchcraft, dreams and harmful spirits peddled by this 'Bonnke-type Christianity' [sic], which is one of its strongest suits in the harnessing of passion and commitment by its African adherents and which cuts across all denominations (Gifford 1992: 174; Oduyoye 1995e: 86). The power of healing and of prayer, in continuity with ATR, is what marks out the Aladura for Oduyoye. However, she negates it because of its promotion of 'individualism', a 'mission style' Christianity which is now being chosen by hundreds of thousands of Africans and has seen classic AICs in Ghana and Nigeria suffer serious decline in their membership (Gifford 1994: 526; Oduyoye 1995e: 86).

Moreover, Oduyoye fails to see any benefits for women come out of this recent Pentecostal phenomenon, which has had profound impact on university populations and young professionals in Nigeria. Ruth Marshall has argued that the new-wave Pentecostals, although influenced by the prosperity Bible colleges of the United States, have a profound sense of community, posited though it is over and against society, and have some aspects of their teaching and practice which are beneficial to women. These she names as the relief of negative pressure from in-laws on the wife, with the promotion of love-marriages over arranged unions and freedom for young urban women to move into the job-market and obtain university qualifications which gives them a measure of choice and independence. These churches strengthen their adherents against fornication; this can give young women the confidence to resist pervasive sexual pressure in the academic and professional market place (Marshall 1992).

It is of real significance that Oduyoye fails to engage positively with this movement and its enthusiastic reception by huge numbers of Africans, in much the same way as she resists any positive dialogue with mission-church theology and practice. She fails to see that the religion of most AICs has elements of success theology, prioritising as it does the securing of health and the overcoming of witchcraft by a greater power. She has abrogated to herself the measure

by which African women can find spiritual integrity to match their
innate authority and nurturance, and no church seems at present
adequately equipped to deliver. In this sense, I would suggest that
the Circle of Concerned African Women Theologians is a form of
women-church, similar to that which Rosemary Radford Ruether
advocated as 'a particular historical movement' with its own organ-
isation and credal formulae. As Ruether explains:

> Women-church represents the first time that women collectively have
> claimed to be church and have claimed the tradition of the exodus
> community as a community of liberation from patriarchy. Patriarchy
> is named as the historically contrived social system by which the 'fathers'
> (ruling class males) have used power to establish themselves in a posi-
> tion of domination over women and also over dependent classes in
> the family and society (Ruether 1985a: 57–58).

The form of church that Oduyoye envisages is, I would contend,
not a fully eucharistic one, but a Wesleyan-style cell or prayer fel-
lowship, where mutual support, teaching and instruction occur within
the context of prayer and worship. At the Nairobi biennial confer-
ence in 1996, the day's proceedings were preceded by prayer or an
invocation of ancestral spirits, a reading from the Bible or the Qur'an
and a praise song or hymn.

The central aspirations that Oduyoye has for African women in
the churches of Africa are those of leadership and spiritual freedom.
However, the solution that Oduyoye preaches has Western enlight-
enment woven into its African cloth. The answer to Oduyoye's
initial question to the AACC, *Den mmusu na yaabo?*, is cast in terms
of analytical and critical enquiry based on paradigms of human
equality and feminist analysis. It is never clear on what heuristic
principle Oduyoye proceeds, in what is a substantially post-modern
deconstruction of tradition and the Christian scriptures. Her final
authority seems to rest on her perception of what would secure
African women's identity as nurturers, mothers, leaders and libera-
tors. Her favoured technique in the *Daughters of Anowa* is the re-imag-
ining of stories, myths and fables, which she claims as women's
domain in the constitution and reconstitution of the clan's identity.
Her earliest venture into this terrain was her work on Asante proverbs
in the mid-seventies, and her presentation to the pan-African women's
theological consultation in Ibadan in 1980. There she freely admit-
ted that because of the analysis by 'feminist studies' of the 'age-old
issue of the "proper" relationship between men and women', it was

necessary to 'prescribe' new 'just and proper relations' between the sexes, by developing and executing new myths, so that the old ones, which kept women in a situation of 'subordination', could be destroyed (Oduyoye 1981d: 82).

The very churches she claims bear the hall-marks of African identity, and nurture African women's spirituality would have real difficulties with accepting her method of evaluation. Her assessment is based on an idea of women's autonomy and freedom from biological impurities, ritual defilement and the authority of the Christian scriptures or even a programme of allegiance created by a founding father or mother. None of this would be acceptable to any existing AIC.

In this context, Oduyoye emerges as a founding mother of a new religious movement, with low ecstatic mediation, a high threshold of literacy and a well-developed theology of *koinonia*. Her new myths, dreams and visions have been developed through intellectual contemplation rather than ecstatic revelation, but her authority is located in the radical nature of her vision and its attempt at a decisive break with the missionary past of her African world. She wishes to retain continuity with the religion of her cultural past, where it suits the imperatives of women's freedom of choice and personal integrity, and her charismatic leadership and patron-client relations have established the Circle as a theological resource for women across the continent.

Mothering Africa

Oduyoye redescribes the way in which African women can think and be thought about. The libation prayer of the Asante people, 'let the women bear children and do not let our men become impotent', has to undergo transformations to realise a form of religious and social vision which releases men and women from their purely procreative function (Oduyoye 1981d). Oduyoye confronts the dominant motif of women as mothers, and moves it away from the biology of mothering to the social mothering practised amongst the Akan in mothering the nation. Furthermore, she challenges what she sees as the idea of 'female sacrifice' indulged in by the Christian community, where women are sacrificed in brutal marriages, or in unrecognised and selfless giving (Oduyoye 1988b). She wants to affirm women's power as 'mother' power, the fulcrum point of the community, and yet is alienated from its implication in the African psyche of

'the general acceptance of the sacrificial role of women' (Oduyoye 1986d: 73). Oduyoye maintains that 'woman is the glue that holds society together'. This is put even more strongly in the Akan proverb, *nsamanpow mu soduro, wo ni wu a w'abusua asa*, the death of the mother augurs the death of the family unit (Oduyoye 1986d: 72).

She seems genuinely unable to free herself from tradition or church practice which sacrifices women's time, talents and resources for the sake of the community. Her own work in the Circle, with her expenditure of time, energy and monetary resources, all reflect the dominance that this pattern has for her. The coalescence of domestic theology in nineteenth-century mission, and the place of the mother in the Akan, has been entirely successful in giving Oduyoye a belief in the prophetic, salvific potency of women for their societies. Women are free to give themselves to the community to realise justice or salvation, but the giving must be free and never demanded, like the sacrifice of Christ (Oduyoye 1988b). Oduyoye's inculturation of Christianity is thus undertaken with the imperative of autonomy informing her affirmations of nurturing and mothering as clear African goods, with an eye to what sustains life and nurtures well-being within tradition, and what has impeded it in Christianity.

Oduyoye has signalled her distance from her African colleagues over precisely this subject. Contributing to a Festschrift for John Mbiti, Oduyoye spoke as a woman to his text, *Love and Marriage*:

> What you read here is from one who is, in many ways, 'other' than Mbiti. It is an African woman's reading of Mbiti by one who is a lay Christian, born into a doubly matrilineal and monogamous home, a spouse but not a mother ... This essay arises out of concern that Christian theologians might study to aid the Church to play a more dynamic and salvific role in the upheavals taking place in African family life today. Clustered in the Academy, African Christian theologians may disown all accountability to the Ecclesia (Mbiti 1973; Oduyoye 1993f: 345).

For Oduyoye, family, marriage and beliefs surrounding procreation are some of the essential moments where inequalities between 'male-female relations' are reproduced (Oduyoye 1981d: 83). Oduyoye insists that the socialisation of women into auxiliary roles is maintained within traditional and Christian understandings of the marriage relationship. We shall explore some of the implications of this in chapter six, where sites of violence against women are principally domestic. Suffice it to say that Oduyoye is extremely critical of the denial of freedom and choice assigned to girls before marriage. In Akan folklore, the image of woman in marriage is generally 'uncom-

plimentary', one of someone who is 'self-seeking' (Oduyoye 1981d: 86). Oduyoye rehearses themes that are redolent of nineteenth-century missionary women's criticisms of African marriages; the denial of liberty, the difficulty of the barren woman, the assignation of witchcraft to women who seek to liberate themselves from subordination.

Oduyoye could be the campaigning Mary Wollstonecraft across the distance of time, place and race (Wollstonecraft 1792). She claims that it is the 'non use of [women's] intellect in problem-solving situations' caused by male hierarchy within marriage, religion and society, which turns them into developing the 'cunning of slaves, the malice of witches or else vegetate' (Oduyoye 1981d: 87). Oduyoye sees the 'widespread accusation of witchcraft against women' as society's recognition of the 'potency' of women's spirituality and a 'demotivation' for women's public contribution (Oduyoye 1990d: 257). This power, if subverted, is used to harm the community or for women's own individual advancement. Thus, successful career women are frequently accused of success through witchcraft. Marriage is a critical location for public dis-ablement, and Oduyoye wants to develop a new vision of empowerment within marriage.

She fails to see in her tradition or Christian teaching unmixed resources. Christianity with its inherited Hebrew creation myths of fall and separation from God necessitates, for her, female purification 'through child-birth [and] submission to the male' (Oduyoye 1994e: 94). In Oduyoye's engagement with Mbiti, whose work has rehearsed the spiritual significance of procreation in African society, she argues that such belief systems have fundamentally served the interests of men and effectively oppressed women.

Secondly, she aligns herself with the African-American womanist movement, with an affirmation of homosexuality as a choice open for men and women, of significance for Oduyoye because it underlines that woman's sexuality should not be defined through procreation, and gives to women freedom to choose, in this most personal but traditionally socially defined area (Walker 1984: 287–289; Oduyoye 1993f: 348). This is not, it must be said, a major strand of Oduyoye's theology, and does not undermine her consistent affirmation of women's 'mother power' a power which 'gives our race the guarantee of survival' (Oduyoye 1989c: 30). The challenge for contemporary Africa is to enhance the wisdom of the traditional 'mother-centred Asante' and see 'human relations and . . . community life' which honour the woman, mother and child as the criterion by which the economy, technology and political decision-making is judged (Oduyoye 1989c: 26).

Conclusion

Mercy Amba Oduyoye has developed a theological strategy which, whilst dependent on many contemporary Western-minted theological approaches, is a creative synthetic theology which prioritises African women's contribution to international, national, ecclesiastical and theological development. She remonstrates with the mission churches for their ecclesial misogyny and their failure to escape the North Atlantic captivity in which they were both established and sustained. Like many AACC theologians, Oduyoye hails the AICs as the true carriers of African spirituality and theological indigenisation. However, Oduyoye's theology is itself informed by post-colonial and feminist discourse.

It is tied to nationalist aspirations of independence from the religious, political and economic control of former colonial 'masters' (themes echoed in the discussions of the AACC since Kampala in 1963). The dialogue with AICs on their own terms has hardly yet begun. At present they are incorporated into her project of cultural reformation within the African church, to liberate Africa and Africans into a spirituality which affirms African identity and history, whilst redefining women's place within society and religion.

It is particularly difficult to understand why, when Oduyoye sustains a clear assault on the colonial infestation of Christianity, and its supposed inferiority to traditional religious mores, she chooses to retain allegiance to its religious inspiration. Oduyoye is committed to a pluralistic vision for Africa, and teeters on the verge of describing its three main religious contributors, Islam, ATR and Christianity, as secondary commitments to the ultimate vocation of securing peace for the land and its peoples in their ethnic and religious plurality. The theological outworking of Christology, and the claims to Christian uniqueness, are explored in this environment, with the commitment to peaceful resolution and resistance to domination as key themes in the explication of the idea of the Kingdom of God. Hers is a bold rendition of a political theology which seeks to reinvest African women and men, and all those who claim African racial descent, with confidence to confront the 'de-humanising' effects of missionary colonialism and post-colonial disorder with their own historical and cultural resources.

The challenge she sets for the African church is already being advanced within the activities and writings of the Circle of Concerned

African Women Theologians. The preparedness of the African churches to hear her crusading words to adopt a 'two-winged theology' is not so certain. Her proposal seeks to rehabilitate African culture alongside a vigorous theology centred on the Jesus-event, and forge a fresh alliance between men and women as equals within the domestic and the public realms (Oduyoye 1990f: 38). Her theology of resistance and renewal is one of the most creative and urgent voices in the current literature, and a provocation to the African churches to seek wisdom; a wisdom that promises a future and hope to both Church and people in the multiple fissions of contemporary Africa.

Oduyoye is the leading theologian of the Circle of Concerned African Women theologians not only in terms of her output, but also as a unique thinker in her persistent refiguring of African theological thought. She has pursued a determined and critical course to insist that the African woman is fully human. It was, in many ways, the project of missionary women in the high imperial era, but now that mission has been embodied within Africa and her peoples. Her task has included remembering African women's history and contribution in the formation of churches and the protection and sustenance of the nation. It is not surprising that in this she has dealt severely with Western intrusion into Africa, and has neglected some of the complexities of the religious and cultural exchanges of the past.

Her tendency to generalisation is plainly open to objection and her dependency on the particular merits of matrilineal Asante culture creates difficulties when she proposes women's empowerment across Africa based on primarily Asante models. Her strategy has been to give African women a public voice, and in this task she has been an indefatigable and resourceful crusader. The partisan nature of her theological and historical creation is part and parcel of the role of advocacy to which a 'committed theology', one of the EATWOT call signs, is inevitably dedicated.

SISTERS AND MOTHERS:
CATHOLIC SISTERS IN THE CIRCLE

Mary stored all these things in her heart and pondered on them
(Luke 2: 19)

Introduction

The survey work of religious academics (such as Sr Weinrich and Sr Ancilla Kupalo) in African communities has been an important source for scholars seeking to understand both the explosion in numbers of African women in European-founded and indigenous religious orders and the tensions experienced by them (Weinrich 1975; Kupalo 1978; Weinrich 1978). The more recent contribution of Sister Joan Burke, with her careful exploration of the life of the Sisters of Notre Dame de Namur in lower Congo, is rich with insight into the unique place religious sisters inhabit in the imaginative economy of African motherhood (Burke 1993, 2001). Recent works on African mission history and theology by Caucasian Roman Catholic scholars Adrian Hastings, John Baur and Aylward Shorter have recognised the presence, growth and contribution in education, evangelisation and health provision by African sisters and their European forebears (Baur 1994: 107, 135, 268, 316, 415; Hastings 1994: 601, 604; 1989: 36–51; Shorter 1988: 69, 267).

Sr Teresa Okure, Sr Rosemary Edet, Sr Bernadette Mbuy-Beya and Sr Anne Nasimiyu-Wasike are the four leading Catholic members of the Circle whose work will be explored in this chapter. All have been published in edited work in the West, and are from the modern African educated élite. All occupy or have occupied senior ground-breaking positions in their religious communities, and have received PhDs from Western universities. All have a common commitment to the identification of women's concerns in their work, and are convinced of the importance of making the Catholic religion

relate to the hearts, minds, cultures and societies of modern Africa. They all use the pronouncements of Rome, particularly the documents of the Second Vatican Council and the papers generated by the African Synod of 1994, to assist in their transformation of Catholicism into a radical vehicle of 'human promotion' and 'inculturation' across the continent (Africa Faith and Justice Network 1996).

The work of these four religious is spread across journals and edited collections within Africa. Only Okure has a monograph published by a Western publishing house, although all four have edited collections from conferences and Nasimiyu-Wasike has edited collections for CEAT. Okure has co-edited the proceedings of the theology weeks held at CIWA since 1990. Other articles are to be found in EATWOT's *Voices from the Third World*, and the in-house journal of the Circle, *AMKA*. Their work appears in African journals such as CIWA's *Journal of Inculturation*, the Gaba Institute's *Spearhead* and *AFER*, and occasionally in European and American journals committed to the publication of missionary material, for example *International Review of Mission*.

Once again this corpus has been largely overlooked by Western publishers even in areas where there is a congruence of subject matter with theological concerns of the Western churches as, for instance, that of Marian research. This may be due to one of the great strengths of the Catholic contribution to the Circle. All four are grounded in religious communities, working in health or education at executive level within Africa. Their orthopraxis has, perhaps, removed them from the orbit of theological publication and the promotion of their thought in the Northern world of academic publication, although Teresa Okure has been published in Schüssler Fiorenza's collection on feminist interpretations of the Christian scriptures (Schüssler Fiorenza 1993). Their writings, apart from their doctoral dissertations, have mainly arisen from conference participation. They are literary markers of a conviction that African Catholicism can build on diffuse traditions of women's leadership and initiative to promote a communal vision of wholeness, which incorporates healing and dignity for men and women. This vision unites the individual to the present, the future and the past as part of a continuum in a particularly African perspective, and is claimed as the proper business of Christ's ministry. All insist that the present condition of women and children across the continent in Church and society is

a scandal to the gospel of Christ, should outrage the professed morality of Western society and is an open challenge to the professed integrity of the local and universal Church.

The African Synod in 1994 generated a great deal of fresh writing and reflection on the nature of African women's theological contribution. This writing exudes a new confidence in Catholic identity, and uses the Holy scriptures in the light of post-Vatican II teachings as a tool to create the terms of liberation within Africa and harmonious relationships across the world. It is a manifestation of both the *aggiornamento* of Roman Catholicism begun by Pope John XXIII in 1959 and the modernisation of the Church and its relationship to the changing world. These authors also follow the pioneering incarnational theology proposed by the Bishops of Africa and Madagascar at the Synod in Rome in 1974, with, now, a contemporary account of the female experience of Africa rather than the all-pervasive male one (John XXIII 1959; AFER 1975; Mveng 1992). Their voices are not therefore, 'exotic' scratchings on the periphery, but voices of contemporary *magnificat* for Africa and Catholicism. Yet, though they specifically address Africa from their local perspectives, they provoke a secular, ecclesial and religious discussion, which has a thoroughly international frame of reference. We shall hear their voices over a range of contemporary challenges: wholeness and agency drive Anne Nasimiyu-Wasike and Bernadette Mbuy-Beya to look at AICs and charismatic renewal; the struggle for identity and empowerment brings Rosemary Edet and Mbuy-Beya into dialogue with ATR; the meanings of motherhood and the breakdown of traditional households occupy Mbuy-Beya's attention in particular; Marian spirituality as a way of mediating empowerment for women is an approach particularly developed by Okure and recently appropriated by Nasimiyu-Wasike, whilst Christology, the challenge of an African feminist hermeneutic and their reflection on their own vocation as religious are ongoing interpretative frameworks for all.

The sense of orthopraxis, orthodoxy and the primacy of prayer, a form of African mystical theology, is always present, and will be discussed in our examination of Mbuy-Beya's thought and work. All four sisters are praxiological theologians, fulfilling the EATWOT and EAAT injunctions of Third World 'engaged' theology. All four have their criticisms to make of the Church, particularly in terms of the 'masculine' distribution of power and teaching authority. These are most clearly articulated by Anne Nasimiyu-Wasike, head of the Little

Sisters of St Francis at Makerere, Uganda: 'Although we should be co-workers in the Church, we are subjugated, we are servants. We are maids' (Mbugguss 1991: 44).

Religious Sisters and Theoretical Perspectives on Women and Motherhood

In their account of what an inculturated or incarnational theology might mean, the all-male hierarchies of post-Vatican II Catholicism and early EATWOT had failed to take account of the presence of gender in the cultural transformations envisaged. As the acknowledged cultural imperative for both men and women in Africa is to reproduce life within the continuum of their community, it is the notion of women as life-givers, the ones who bear children for the clan, that needs careful exploration. For women are the wealth generators, the traditional means through which the clan extended its friendship with other communities and exchanged wealth. This was and continues to be so, despite modernity and urbanisation, and is expressed at marriage by bridewealth (most often from the groom's family to the bride's family). The dialectical relationship between African converts and Western missions and the creative transformations of inculturation is very clearly shown in the ritual of novice-making in Karema, by Lake Tanganyika. The first three sisters of the White Sisters who made their perpetual vows in 1910 fell under the patrimony of the missionary founding Father Ludman, a White Father, whose role was understood clearly within Fipa culture to be that of a father and elder. When Fipa women took their lifetime vows in the 1990s they expressed their commitment through the receipt of a wedding ring, along with traditional Fipa wedding rituals. The Mother Superior also offers the symbolic equivalent of *lobola* for the young woman as she enters the threshold of the Mother House for the first time (Smythe 1997: 13). Fipa nuns understand their religious vocation in terms both of marriage to Jesus, and the patrimony of the White Fathers, thus retaining the idea of marriage as alliance, which involved wealth-exchange. The theological reflection of the Circle religious reveals radical discontinuities as well as continuities with the lot of other women. This mainly inheres in the social separation between religious women and the women's worlds they address, particularly in their female autonomy. They seek to

overcome this separation through the ideas of consecrated advocacy, representation and education.

Although there were over eight hundred and eighty-five thousand women religious and over thirty-three thousand members of women's secular institutes in the African Roman Catholic Church (as the Synod of Bishops noted in their *Instrumentum laboris* in preparation for the African Synod in Rome in 1994), this figure is a minuscule percentage of the women involved in reproducing Africa (Synod of Bishops 1992: 27–29). These unnumbered millions bear children in a multitude of different formal and informal arrangements, in polygynous or monogamous marriages, as '*deuxièmes bureaux*', or in female-headed households raising children without the support of biological fathers. Fertility is a fundamental tenet of the African social and religious imagination, and, although social order has gone through seismic change since the intrusion of the West, this commitment to reproduction has remained substantially unscathed (Dinan 1985: 345). African theologians are continually at pains to remind us that 'African anthropology, unlike the Greek one, views the human person as a unity' and human community as an inter-generational project (Okure 1992d: 86). J.S. Mbiti informed an intrigued Western audience that 'anyone who dies without leaving behind a child or a close relative to remember him or pour out libations for him, is a very unfortunate person' (Mbiti 1975: 29).

There are strikingly different perceptions of fecundity in Africa and the congested urban centres of Western Europe and North America, a fact demonstrated consistently by Africans' contributions at successive World Population Conferences from Bucharest 1974 to Cairo 1994. The Dakar Declaration of 1992 formally saw the acceptance of contraception by most African governments. However, Africa remains at a popular level determinedly pro-natalistic. Her societies have been dedicated for millennia to maximising population within 'land-rich cultural tradition[s]', even when land has been sometimes scarce (Iliffe 1995: 5). Circle women, and most Africans, live with a sense of space that needs filling, a sense encouraged by the ancestors, who require remembrance to live in the future generations of their children.

At first sight, for priests and women religious, celibacy clearly runs counter to the dominant pro-fertility culture. In a monograph about African priests and celibacy sub-titled 'where a man without children is a waste', Emmanuel Obuna reflects on the new relationships developing between seminarians and novices, postulants and lay

women. Traditional customs pertaining to eventual marriage are cur-
rently pursued by future priests, with the exchange of gifts and joint
attendance at weddings, family feasts and funerals. 'Young sisters'
spend up to a fortnight at their 'boy-friend's' family; cooking, wash-
ing and generally 'taking care of his personal guests and friends.' In
recognising this as a 'Nigerian Solution' to inculturating celibacy,
Obuna, from the confines of the Gregorian University at Rome, is
left wondering how far 'the celibate can go with women and still
remain celibate?' (Obuna 1986: 74). The question highlights the
difficulty of celibacy and personal identity in Africa, where religious
tradition, taboos and social meaning still consolidate around fertility
and parenthood (Ilogu 1974: 74; Bleek 1978; Goody 1978; Obiego
1984; Hackett 1989).

Motherhood was, until the impact of modernity and the entrance
of women into the industrial labour market, an uncontested good
across Africa. Work undertaken by Carmel Dinan in Accra in the
early 1980s revealed a startling new category of women in West
Africa—modern, independent, unmarried, with or without children—
who, although forming a 'minute percentage' of the region's total
female population, are a salient reference group for modern urban
lifestyles (Dinan 1983). Many of these women headed households
with multiple dependants, but preferred the freedom of singleness to
the dependency of marriage. The majority had had abortions, were
in their early twenties, belonged to Christian churches and were
immigrants into Accra. Such a reference group needs to be borne
in mind as a site of abrasion in any smooth reading of motherhood
developed from a paradigm of African nurturing. Modern forma-
tions of identity in the cities of sub-Saharan Africa challenge the
easy readings of difference between black and white, communal ver-
sus individual, intra-generational versus class (for instance), as the
pressures which encouraged the West's own feminist enlightenment
in the writings of such women as Kate Millett and Germaine Greer
take effect (Millett 1970; Greer 1971).

The first novices of the early Catholic missions claimed that they
came to 'pray'. They also came to escape unwanted options within
a male-dominated society. The writing of Bernadette Mbuy-Beya
helps us to understand the continued attraction of the religious life
today, in terms not so very different from theirs. She includes a
vision for society transformed within the celibate and religious voca-
tion. For any African woman developing a sense of her own power

the ubiquitous symbol is motherhood, motherhood for power and
the well-being of the community, as we shall see throughout this
chapter. Note here that women religious have a different account of
celibacy from male priests, a reading that leaves them as advocates
of celibacy as a site of female power within Africa. Mbuy-Beya sees
the religious woman as transferring her biological fecundity into spir-
itual reproductiveness. She says of women who work as catechists,
teachers and healers that they are to be understood as mothers, for

> out of the child that she carries in her womb . . . whom she brings
> into the world, she tries to make the beginnings of a man or a woman.
> She initiates the child to [its] mother tongue, to life in society and to
> spiritual and cultural values . . . Protectress of life, she also plays the
> role of mediatrix in her family and her circle. She joins other women
> to try to ward off death that comes through war or family conflicts.
> She helps preserve social order by respecting the traditions which favour
> life . . . she bears children for the Church by teaching them catechism
> or preparing them for baptism. She is at the *centre of inculturation in
> Africa* [author's emphasis] (Mbuy-Beya 1994: 74).

There is here a clear correspondence with the proposal by Sr Joan
Burke that, 'a different understanding of celibacy [than one] resting
on continence alone' has been absorbed by the new generation of
Kongo religious. This has enabled members of celibate communities
to understand themselves in a trope of maternity, as those who are
'mothers for all the people' (Burke 1993: 257). Burke shows this shift
in metaphor amongst sisters and their village communities through
a conversation between a mother and her son walking behind a
group of nuns. In the following conversation *Ba Mama BaMaseri* is
to be literally translated as 'Mother-Sister'.

> The young boy asked his mother, *Mama*, who are those women there?'
> she replied, 'They are *BaMama BaMaseri*'. He looked at her with a
> puzzled expression, she continued, 'They are *Mamas*, but not in the
> same way as I am your *mama* (sic). *BaMama BaMaseri* are women who
> are Mamas for us all' (Burke 1993: 257).

Teresa Okure's work also transposes being single without children
into spiritual fecundity through her theological reflection on the per-
son of Mary. Mary, the mother of the Lord, represents the power
of non-breached virginity in the bearing of the divine. Lavinia Byrne
reminds us that medieval theologies of Mary saw her as

> a Virgin, not sterile but fertile; married to a man, but made fruitful
> by God; bearing a son, but not knowing a man; forever inviolate, yet

not deprived of progeny; a virgin pregnant but incorrupt, and intact even in childbirth; a virgin before marriage and in marriage, a pregnant virgin, a virgin giving suck, a perpetual virgin; a virgin without concupiscence conceiving the saviour (Byrne 1990: 142).

Through the figure of motherhood, then, Mbuy-Beya and Okure are transforming celibacy, as their foremothers have before them, so that African sisters become women with status, authority and power in their own lands.

Sister Bernadette Mbuy-Beya and the Cry of Life

The writings of Bernadette Mbuy-Beya have been limited to her essays in *The Will to Arise; The Spirituality of the Third World; The African Synod Documents, Reflections and Perspectives; Théologie Africaine: Bilan et Perspectives* and *Voices from the Third World.* She is important amongst the Catholic and Francophone members of the Circle, having been active in preparations for the African Synod. She was from 1996 the Circle's co-ordinator for Francophone Africa. She is an Ursuline sister, Mother Superior of a small community of five in Lubumbashi, DRCongo, and works as the Director of the Institut Supérieur des Sciences Réligieuses. Mbuy-Beya undertook her tertiary training at Lumen Vitae, the Institut des Sciences Réligieuses in Brussels.

Mbuy-Beya brings classic concerns of European missionary sisters to her work in Lubumbashi. Her theological contribution majors on issues of education, health, prayer, and resistance to violence against women and children. She is comfortable with the post-conciliar concerns of her church, which has opened its face towards the community and seeks to give Africa her voice as part of the 'Church of Christ' (Vatican II 1964a: 1, 8). The Church is at a point of renewal, and the language of charismatic opportunity and change permeates her writing. As an urban community health co-ordinator, she is actively engaged herself in the struggle for life on the continent. She believes that women have a unique contribution to make within Church and society, and nominates the supreme work of woman as that 'of mother, giving and bearing life' (Mbuy-Beya 1996a: 186).

Mbuy-Beya's theology, as befits an active EATWOT theologian, is praxiological and experiential. She insists that the first step of any theological engagement with African women is to take proper account of their incessant struggle for the necessities of daily life, for food, shelter, work and health. They are the ones who nurture the life of

the community in the shadow of men, in the constant presence of violence (Mbuy-Beya 1989; Mbuy-Beya 1996a: 186). She calls her theological contribution 'prophetic', and it is clearly evangelistic, concerned with the active promotion of 'la bonne nouvelle aux pauvres' (Luke 4: 18–29) (Mbuy-Beya 1989: 264). She insists that the continent of Africa cannot receive the hope of Jesus Christ without the complete liberation of women, in society and the Church. In this she regrets that her church has failed to give women a voice. She takes African theology to task, for despite 'des efforts considérables dans le domaine de l'inculturation . . . elle [la théologie] ne pourra pas sortir de la prison des discours abstraits si elle n'apprend pas à compter avec la femme et à reçevoir Dieu par elle' (Mbuy-Beya 1989: 258). Mbuy-Beya sees herself as part of a growing band of women who are 'coming out of the margins' to speak out women's spirituality and perceptions of the divine (Mbuy-Beya 1989: 257). Women, she maintains, have the responsibility to fight for their liberation in society and their proper recognition within the structures of the Church for themselves (Mbuy-Beya 1996a: 185). Their theology will be one of 'passion', 'fondée sur le savoir mais aussi sur le sentiment, sur la science mais aussi sur la sagesse, une théologie qui se fait non seulement dans la tête mais aussi dans le coeur, le corps, le ventre' (Mbuy-Beya 1989: 261).

Within this struggle for women to be heard, Mbuy-Beya retains a deep appreciation of the religious vocation. This is not something to be decried as a European import, or the last vestiges of colonialism. The struggle for women's freedom, as Mother Kevina asserted, is won in spiritual discipline and prayer (O'Hara 1979: 18). Mbuy-Beya re-articulates this. The 'fight' for the liberation of women must be based, she says, 'in a great inner freedom acquired through prayer and a spirit of sacrifice, in a deep and intimate relationship with Jesus Christ' (Mbuy-Beya 1996a: 185). The goal of this engagement is to liberate the Church and to realise human dignity for men and women. Mbuy-Beya freely refers to the teachings of the Church affirming human dignity, and sustains throughout her writings an active dialogue with the scriptures and post-conciliar encyclicals. Thus she finds encouragement from *Mulieris dignitatem* as she seeks to recall the Church to the divine will of mutual dignity between men and women (John Paul II 1988b). The Church, she maintains, frequently lags behind society in its acknowledgement of women's gifts and contributions.

She considers the liturgical and catechetical work of women as strategically important in the growth of the Church, the sustenance of Christian education and the renewal of society. She, therefore, called on women in the Church after the African Synod to build on the founding activities of twentieth-century mission, despite its ambivalent relationship with colonisation (Mbuy-Beya 1991: 66; Mbuy-Beya 1996a: 186). The education and advancement, which women had received at the hands of mother Church, now need to come alive. The insidious cultural difficulty of silenced women, and the silence surrounding the brutality of their lives, must be overcome by women themselves, and as a religious sister and theologian this is precisely what Mbuy-Beya seeks to do (Mbuy-Beya 1996a: 186). Thus a feminist commitment in the West, in the words of the Eurythmics song that 'sisters are doing it for themselves', is also one of the first steps of renewal within the Roman Catholic Church in the Congo.

In her essay on African spirituality, 'A Cry for Life', Mbuy-Beya echoes two contemporary African theological contributions: Jean-Marc Ela's influential *African Cry* and the AACC contribution to the WCC Sixth Assembly of 1983, *An African Call for Life* (Masamba, Stober et al. 1983; Ela 1986; Mbuy-Beya 1994). Her contribution to EATWOT's Nairobi Conference in 1992 on the *Spirituality of the Third World* reflects her commitment to 'gut' theology (Mbuy-Beya 1994a: 184). The cry is for the 'liberation of the oppressed and the transformation of the world', and it is 'answered in the Gospel if at the same time we give our life to Christ and follow in his footsteps' (Mbuy-Beya 1994a: 66, 67).

This is the foundation of Mbuy-Beya's engagement with society. It is done out of a profound conviction of the reality of Jesus as 'the Way, the Truth and the Life' (Mbuy-Beya 1994b). Her early experience of vocation and subsequent Catholic education was classically orthodox, whilst her location in a church which has been a part of the political process of democratisation and source of political criticism of despotic leaders, when civil government has failed its people, gives her a confidence in the relevant and immediate linkages between Church and society (Mbuy-Beya 1994a: 67; Ununwa 1995: 21–24).

Modern Africans lack points of reference, and at root the problem is a spiritual malaise of homelessness. Their quandary is similar to that of the 'great crane', reflects Mbuy-Beya, '[which] when removed from its natural habitat will not reproduce in captivity'

(Mbuy-Beya 1994a: 65). Mbuy-Beya's Catholicism restrains her from an unrestrained appropriation of African myths and traditions. Certainly, she affirms many of the traditional mores of African society, but she recognises that now over 'forty six per cent of Africa's 569 million people live their spirituality' through Christianity (Mbuy-Beya 1994a: 66). What is required is a spiritual renewal of Africa's people, and the African Church. In particular she challenges Africa's religious to renewed attentiveness to the inner life, to a fresh focus on God, which realises itself in a reinvigorated commitment to life.

Sr Weinrich has commented on the desire for members of the African congregation of the Sisters of the Child Jesus in Gweru diocese, Zimbabwe, for a deeper experience of contemplative prayer. She noted that 'many young women who joined missionary orders and congregations (were) unhappy in the active religious life and . . . accused European and American missionaries of having brought their people schools and hospitals, but not having offered them a deep spirituality' (Weinrich 1975: 220). This attention to spirituality is an important part of Mbuy-Beya's theological reflection and personal commitment. Religious sisters have a call 'first of all "to be with the Lord" (Mark 3: 14), the African woman religious says "Yes" to the Lord so that life may spring forth in Africa' (Mbuy-Beya 1996a: 184). This is not an academic exercise but part of understanding and creating practical solidarity with other women, inside and 'outside of the convent' and the Church, united in their joint 'fidelity to God' to work for peace, to bring health, and to fight poverty (Mbuy-Beya 1996a: 184).

In 'A Cry for Life', Mbuy-Beya looks at the work of three 'shepherdesses' of local prayer groups in Lubumbashi. This has evident roots in Tempels's *Jamaa* and the later work of the Belgian Benedictine, Father Philippe Verhaegen (Janssen 1967). Verhaegen transformed the ancient practice of prayer-houses during the charismatic renewal movement of the 1970s. These houses have multiplied in the Katanga district over the last twenty years (Mbuy-Beya 1994a: 68). Prayer houses also became an 'integral part of Anglicanism in Nyanza and throughout much of East Africa' in the 1920s (Hoehler-Fatton 1996: 71). Mbuy-Beya sees their recent emergence in Catholic renewal as a vital expression of engaged spirituality. A form of the Latin American inspired Basic Ecclesial Community, the transposition of this idea in Congo becomes liberation and healing through prayer rather than political action (Torres and Eagleson 1981; Marins, Trevisan et al. n.d.). The reality of spiritual oppression as the cause of material dys-

functions is a core component of African traditional cosmologies. In much ATR, those seeking the help of 'medicine men' would often move into the medicine man or woman's home, and contribute their labour towards the costs of their stay, which could include exorcisms and miraculous healings (Ilogu 1974). These elements, prayer for exorcism, healing of the sick, praise and worship and even claimed instances of 'the raising of the dead' are exercised in over twenty-two prayer houses in Lubumbashi alone, officially under Catholic jurisdiction (Mbuy-Beya 1994a: 68, 71).

Of course there are numerous others operating outside the hierarchy's control, many, according to Mbuy-Beya, marginalised because of their 'fetishistic practices, characterised by punishments and public denunciations of witches' (Mbuy-Beya 1994a: 70). Even those within the hierarchy's jurisdiction exercise what could be deemed shamanistic power. Mbuy-Beya tells of one shepherdess, Mama Régine, who raised a daughter of a family which 'had made a pact with the devil' (Mbuy-Beya 1994a: 71). Mama Régine's testimonies of her spiritual journey inculturate the imagery of Mary, and build on other elements of ATR. In her account of her first communion at the age of seven, Mama Régine tells Mbuy-Beya that she physically 'felt the presence of the Lord in me . . . I carried God', she said, through the physical ingestion of the 'body and blood of Jesus Christ' (Mbuy-Beya 1994a: 69).

The three-hour afternoon meetings on Wednesdays, attended by women of every social class, are not seen as primarily interesting locations of inculturation by Mbuy-Beya (Mbuy-Beya 1994a: 71). Her interest is that of someone who wants to nourish and encourage as many forms of women's spiritual agency and empowerment as possible in the desperate struggle for life within her country. She is concerned that the commitment and pastoral concern of the shepherdesses continue to be incorporated into the mainstream life of the Church. They represent an implicit criticism of a church which has neglected these forms of ministry and liberation. She recognises in them those who have found a 'new way of being of service to life—physical, moral and spiritual', and finds a solidarity with those who are 'marginalised by contemporary society, prostitutes, street youths, singles in search of spouses, infertile women, practitioners of witchcraft', men and women in equal numbers (Mbuy-Beya 1994a: 73).

Some of these women are involved in the local meetings of the Circle. Mama Véronique Kyabu Kabila is a married woman, the mother of seven children, and a member of *Bilenga ya Mwinda* (Children

of Light), as well as a committed member of the national Circle.
Mama Véronique makes the Virgin Mary the inspiration for her
desire to be a 'handmaid of the Lord', but sees the clergy as ignor-
ing and indeed hampering the contribution of the laity and women
in evangelisation and pastoral care (Mbuy-Beya 1996a: 180). In sup-
porting these women catechists, pastoral workers, co-foundresses of
religious orders and shepherdesses, Mbuy-Beya prosecutes a case
against the masculinisation of the Church. She finds in the ministry
of Mama Anto (a shepherdess taught 'to pray without ceasing by
the Lubumbashi Carmelite nuns who possess the gift of healing') and
other women involved in the charismatic renewal, those who are
available as spiritual and 'consecrated' women for the wider renewal
of Church and society. As Sr Générose, a Daughter of St Paul in
Congo, tells her 'the liberation of the African woman is an urgent
concern . . . Action must be quick if Africa is to be saved' (Mbuy-
Beya 1996a: 181).

The importance of women trained to handle theological ideas,
and the centrality of a contextual and communicable theology is an
indispensable part of Mbuy-Beya's vision for life for the continent.
'Theology', she says,

> must reflect the reality of the life of our people. We must create a
> theology in which all the sons of our continent will recognise them-
> selves. That is to say that our theology is contextual theology. Women
> [theologians] are rare among the Catholics . . . women who can truly
> be called 'theologians', in inverted commas, because after all, just
> because you have a theology degree it doesn't really make you a the-
> ologian . . . you have to do theology, the kind of theology that is also
> theology for the non-graduate. This kind of theology must be very
> clear, so that each side truly understands the other (Mbuy-Beya 1996b).

The missionary sisters' paradigm, which developed during the period
1880–1930, of education for service and continued mission through
an African sisterhood, is exemplified both in Mbuy-Beya's commitment
to education and her own life testimony. Mbuy-Beya considers it
incumbent upon both the Church and religious congregations to pro-
vide adequate theological training for girls and their own sisters, to
insist that fathers educate their daughters as well as their sons and
to work against the practice of men marrying illiterate women to
facilitate their domination (Mbuy-Beya 1989: 259; Mbuy-Beya 1996a:
185). Literacy work should, maintains Mbuy-Beya, be a high prior-
ity for the Church in realising the dignity of women as advocated
in *Mulieris dignitatem* (John Paul II 1988b; Mbuy-Beya 1996a: 186).

Mbuy-Beya's own story of conversion has all the hallmarks of Catholic missionary paradigms within it. The Simba rebellion in 1961 saw the murder of many white religious, spiritual emblems of the colonial power. Mbuy-Beya was a girl of fourteen at a convent school run by the Sisters of Charity in Lubumbashi, when a white Belgian sister told the story of the massacres. She told the girls, 'they killed the missionaries. Now we need other missionaries to take their place' (Mbuy-Beya 1996b). Whether the discourse was one of continuity of white missionary activity in a chaotic Congo or a new attention to black agency is not clear, but the young Bernadette disrupted the surviving narratives of North to South, white to black enlightenment, and her cultural destiny of marriage and biological motherhood as she lay in her bed and considered.

> I went to bed. Then I said, 'Well then, they need other missionaries to replace them. What is it to be a missionary? It is to proclaim the gospel.'
> So I went to see this sister, and I said,
> 'I will replace one of these missionaries that have been killed, because I too want to proclaim the gospel.'
> I was sent to another school because, when I had decided to be a missionary they said to me that to be a missionary I had to be a religious. So this was the only possibility offered me—to be a missionary I had to be a religious. So I went to another place where I saw the Ursuline Sisters. I told them my story, and they said,
> 'Very well, come and we will see if you really want to be a missionary'.
> And I find that when people talk about destiny I don't quite know what they are trying to say. But these days, when I give this testimony of the road I have followed to become a religious, I always say it has not happened by accident (Mbuy-Beya 1996b).

What is clear is that for Mbuy-Beya the call to mission in Africa should not be tied to the order of celibacy and the 'consecrated life'. She is urgent and persistent in her call for the male distribution of power within the Church to be re-examined in the light of Scripture, the 'irruption of Jesus Christ' and the paradigm of equality which she sees in the actual work done by women in education, catechesis, worship leading (Mbuy-Beya 1989: 263, 269). Moreover, the implication of her study on the Shepherdesses of Lubumbashi leads to a pneumatological base for equality, in that the gifting of the Holy Spirit of both men and women in spiritual power and ministry does not privilege gender, which therefore should not be privileged within the life of the Church.

Mbuy-Beya affirms the position of most Circle authors in stating that African women do not wish to align themselves unambiguously

with Western feminism. She understands that form of feminism to imply a rejection of the essential biological and social differences that prepare women for motherhood, a role to which all African women are called in some way. Christian women, she says, wish to 'reread our history as African women and women of the Third World in the light of the Jesus Christ event, and uncover [that which] oppresses women and contributes to the dehumanisation of our people and our societies' (Mbuy-Beya 1989: 264). African woman, with her 'splendid lissom body [which] functions as a powerful element of erotic attraction for men . . . her posture, her gait, her proficiency in . . . traditional dances', is the

> generator of life. She is the mother of the children, the mother of everyone. By her motherhood, she establishes her status in society and ensures the demographic growth of the group. And she is mightily proud of it (Mbuy-Beya 1992a: 158).

All four of the Catholic writers under review regard social motherhood as the key metaphor for the wise and good woman of Africa. The impact of modernity in Africa, particularly through urbanisation, has still not dislodged the power of the symbol of mother amongst most of Africa's people, and certainly not in the Catholic imagination. Van Wing's classic observation of 1920s still holds good:

> The woman is most necessary to the clan for her productivity. It is she who gives (to the clan) the best of goods, human beings: *mbongo bantu*, 'riches in humans'. And, by her labour, it is she who ensures their well-being. She herself is the first of all 'riches' for the Kongo (van Wing 1921).

Despite her protestations that women should not be 'defined in terms of her reproductive function', and her claim that 'consecrated celibacy' can help women to realise their 'authentic calling as equal partner with man in all things . . . by proclaiming the values of the Reign to come', Mbuy-Beya considers the effect of modernity has been to destroy 'femininity', and undervalues 'the mediatrix', the 'wife and mother' (Mbuy-Beya 1992a: 168). Consequently, when Mbuy-Beya looks at what could be simply seen as an issue of individual morality, in her essay on prostitution in *The Will to Arise*, the degradation of women as prostitutes in Lubumbashi is a powerful symbol of a society in crisis (Mbuy-Beya 1992a).

Her study of over twenty women is done with a clear sense of the promotion and recovery of human dignity, lost in this form of

wage-labour. Prostitution is not viewed by Mbuy-Beya as a personal sin, but as a social malaise which 'contaminates the soul of the population and compromises the future of Africa' (Mbuy-Beya 1992a: 171). Her informants revealed that they had taken up prostitution because of parental unemployment, following abuse by husbands, as a result of polygyny, widowhood, and the scandalous 'opération minerva' (a means of paying school fees and passing examinations within a degraded school system by giving sexual favours to education providers). Mbuy-Beya thus confronts popular vilification of the woman prostitute as the 'bad woman', and refers the problem back to social organisation. These women are not taboo, she asserts, but their situation, and the birth of children into such a compromised situation, is. For whereas 'the African woman is a wife and a mother [who] by bringing children into the world . . . wins respect, [in] prostitution, motherhood is a misfortune' (Mbuy-Beya 1994a: 169). Prostitutes are deprived by the violation of society of the respect which, as mothers, should be theirs. Mbuy-Beya is constantly at work to affirm human dignity. She speaks with approval of post-conciliar Catholic values of sexuality and marriage, and the interconnectedness of society's injustice and women's degradation (SCDF 1979; Malula 1986: 5).

Mbuy-Beya's classic concerns for health and education are the perpetual underlay of all this theological work. Whether she addresses the misconceived population control of UN initiatives, the threat posited by HIV, sexually transmitted diseases or sickle cell anaemia, her voice in the Circle is one whose model of ministry is in clear continuity with those of the European sisters who founded the mission. Her own life and that of her community is based on a deep 'intimacy with Jesus'. It is an African Magnificat, rooted in the reality of contemporary Congo (Mbuy-Beya 1992a).

Sister Teresa Okure

The cry of the prostitute could so easily be paralleled with the cry of Mary, the single woman found pregnant by the Holy Spirit, needing the support of her husband and her friend Elizabeth to see her through the difficult road set before her (Okure 1997). This is the theological connection made by Sr Teresa Okure, who is Academic Dean at the Catholic Institute of West Africa (CIWA), Port Harcourt, Nigeria. A sister of the Society of the Holy Child Jesus, she served

her noviciate in Britain and later received her PhD from Fordham
University, New York, for her study of the missionary method of St
John's Gospel. The daughter of an Igbo chief, Okure has been a
vice-president of EATWOT. She trains male priests, and has been
involved as a regular speaker and editor of the CIWA theology weeks
at Port Harcourt. She is the most published Roman Catholic author
in the Circle, and the most travelled, with academic associations in
the United States, Rome and Jerusalem. She has taken up the EWC's
challenge to reread the scriptures and profile women's contributions,
with a vengeance. Her contribution in *The Will to Arise* addressed
the scriptural theme of the conference title, an encouragement to
African women to take the imperative for change upon themselves,
which is a contemporary pontifical position as well as having excel-
lent feminist credentials (John Paul II 1995b: 4, 6). Several of her
essays, as well as her doctoral thesis on *The Johannine Approach to
Mission*, explore the theme of women's initiative in mission and the
creation of salvific community (Okure 1985; Okure 1988; Okure
1992a; Okure 1992c; Okure 1993c; Okure 1995c).

Mary is currently being given a great deal of attention as an
emblem of human integration in both feminist and ecumenical worlds
(*The Way* 1975; Stacpoole 1982; Küng and Moltmann 1983; Bingemer
1989; Schüssler Fiorenza 1994a; *The Month* 1996). Okure has used
the figure of Mary to reconstruct an inculturated Mary from an
African perspective of powerful, initiative-taking womanhood. She is
concerned to de-construct the 'anti-feminist seminary traditions', based
substantially on 'Thomistic-Aristotelian theology', which have divided
the integrity of the divine with the material, and sustained negative
cultural perspectives on women (Okure 1993a: 79). Okure is com-
mitted to recovering a divinely endorsed view of woman as woman
in all her biological connectedness with nature and reproductiveness.
As she says of the Virgin Mary, she was 'co-redemptrix with Christ',
and she was chosen, 'not because she was full of grace' but because
'she was a woman' (Okure 1995c: 198).

Again, the African perspective, which views women's sexual fecun-
dity not as site of sin but as site of community renewal, informs
much of the inculturated theology which Okure seeks to construct
through her use of Mary. She deploys Catholicism's traditional
alliances between Mary and Eve, in the *proto-evangelium* both 'moth-
ers of all the living', one in creation and the other in the Church
(Okure 1985: 23; Okure 1995c: 199). She claims that 'the woman's

special charism from God' is 'to be covenanted with life. The woman, as mother, provides the womb and the body from which, for nine months, every human being draws life' (Okure 1989: 324). Because this is the case, Okure can call Mary literally a co-worker with God in the divine plan of bringing to birth the great 'mystery of Christ', God's 'definitive' word for salvation (Okure 1990a: 56; Okure 1995c: 209). The attention which Okure gives Jesus' one hundred per cent physical connection and dependency on the 'flesh and blood' of Mary in conception, growth, birth and breast feeding, are themes which are the stuff of feminist theology, with its attention to embodiment and affirming the goodness of women's gynaecological and obstetric processes (Daly 1978; Okure 1995c: 200).

However, the African inculturation which Okure is anxious to develop in all her work as part of the missionary vocation of the Church (a theme she develops in 'Inculturation: Biblical/Theological Bases'), is to provide African men and women with an understanding that 'women stand at the centre, not the periphery of this divine activity' (Okure 1990a; Okure 1995c: 201). Moreover, as the incarnation took place through the body and active mothering of Mary, so, by implication, the inculturation of Christianity within African cultures today can only be done through the active co-operation and participation of African women as co-workers (Okure 1990a: 57; Okure 1995c: 209). The elision of incarnation with inculturation established by the SECAM bishops in 1974 facilitates for Okure a creative interplay of ideas, which leaves the origins of the Church directly attributed to woman and not man. Mary, the mother of God, is the human initiator of the divine mission to humanity (SECAM 1978).

Okure has a particular project in hand. She is convinced that the Church, colonisation and some aspects of African culture have undervalued and denigrated women's effective participation in society and the mission of the Church (Okure 1990a: 73; Okure 1992c: 225, 227, 230; Okure 1992d: 91). As a systematic theologian, she has undertaken a venture to reinterpret the Christian scriptures to release 'liberative . . . elements in the Bible', to reconstruct the history of early Christian origins to include the women's contributions and to develop 'new hermeneutical principles for reading the Bible', after the style of Schüssler Fiorenza (Schüssler Fiorenza 1983; Okure 1993b; Okure 1993c: 149). This strategy is to deliver women with a 'solid divine basis' for women's 'necessary and unique participation in the mission of Jesus' (Okure 1995c: 197). Scriptural bases will help silence

within the churches critics of women's teaching and leadership of men, as well as giving women the strength to explore their own vocation as 'co-workers' with God in the renewal of their societies. The end of this participation is not to exalt women's place in redeemed humanity, but to establish genuine co-operation and mutual respect between men and women, which, Okure claims, is a particular approach of African women's theology (Okure 1993a: 77). Recent Catholic concentration on human promotion and the recovery of dignity expressed in *Gaudium et spes* and in John Paul II's encyclical letter *Redemptor hominis* is seen by Okure as fundamental to under-standing the contemporary mission of Jesus in the world (Vatican II 1965a; John Paul II 1979a; Okure 1994: 128). Pre-Vatican II ideas of Mary as aloof and estranged from the human domain are, there-fore, to be transformed, through a rereading of the birth narratives and the annunciation, into texts which mediate human promotion, in particular a sense of African woman's power which colonialism and modernity have diminished.

This account of Mary as one who took initiative and leadership was developed by Okure in her lecture series at the Cambridge Theological Federation in 1997, where the rhetorical hermeneutic of *The Johannine Method* was translated into a dynamic teaching form. Redolent of oral cultural transmission, collaboration was sought between speaker and listener in the realisation of a narrative account of Mary as the 'mother of mission' (Okure 1997). Mary not only birthed the saviour, but continued to influence him as a mother until he had been initiated into the public form of his ministry at Cana (Okure 1995c: 202). It was a powerful confident reading of moth-erhood and kenotic divinity. Jesus recognises Mary's authority and concern that wine is wanting in the community celebration. As Okure argues, Mary 'acted as midwife who assisted Jesus to bring to birth the mission that lay hidden in his heart' (Okure 1995c: 205).

In Legio Maria, the Kenyan AIC which came out of the Roman Catholic Church and which is particularly inspired by Marian devotion, the Virgin is symbolically connected to a variety of myths relating to old women. They are frequently women who come to people seeking the traditional conventions of hospitality and are rejected. This Mary genuinely inhabits the African world, an old woman full of mystical post-menopausal power. As one of Nancy Schwartz's informants stated:

> The Virgin Mary, when Legio began, came earlier [in the 1940s]. You drove her from your homes. You called her Min Omolo Kanyunja, the woman who ate children. There was no child she ate. She said, 'I am looking for my son' (Schwartz 1985: 4).

Okure does not develop Legio ideas, which are a fascinating blend of Luo mythology and Legion of Mary piety. Fellow Circle member Teresia Hinga did her PhD on women's power and liberative scripts within Legio, but this work has not yet been absorbed into the thinking of these religious (Hinga 1990; Hinga 1992a). Okure's Mary has many points of continuity with Legio Maria's powerful women, and gives to contemporary African Catholicism the means to interact creatively with ancient myths and current translations of Christianity in the dynamic setting of religious independence.

Whereas women's protest in Africa has historically found its power in protecting women's rights as mothers and providers, American and European feminists have been working with ideas which have insisted on women's freedom from motherhood, with legal battles hinged around women's freedom to procure legal and safe abortions. Motherhood is the dominant motif within the rhetoric of Circle Catholicism. Just as Jesus is driven out into the wilderness by the Holy Spirit after his baptism by John, so his Mother drives him into his mission through the events at the wedding feast. Jesus recognises in Mary the authority of the new Eve and his birth mother:

> Jesus does recognise that his mother does have something to do with his mission. Left to himself he would not begin at that point. But I think this where God upholds the rights of a mother over that of the son (Okure 1997).

Motherhood is redefined for the European mind by Okure according to her Igbo experience. Motherhood gives status, entails power, implies authority. In a polygynous society, which was the case in Igboland until the arrival of European missions, the psychological relationship between mother and offspring was emotionally more important than that between spouses, and the mother wielded tremendous authority over her children (Okonjo 1983; Ware 1983: 17; Obiego 1984).

This reading of Jesus, as a son who might prefer not to have engaged in mission at the opportunity presented at Cana, opens up interesting theological space around ideas of Jesus' humanity and his real dependence on human relationship and interaction to be the

catalysts for God's moments of disclosure to himself, his disciples and the wider audience. Jesus is no omnipotent, independent actor, manipulating, along with God the Father, the world of first-century Israel. Rather, in this instance in Cana with his mother, he responds as one involved in inter-subjective dialogue, genuinely open to the possibilities presented by the female other; and even more significantly, for Okure, an other who is mother. So Jesus awaits the response of women in the Church and society, and still the male disciples remain at a loss until they participate. Okure has this as the focal point for her work. African women must respond to the Divine calling which like Mary they know within themselves, 'for Africa will not arise unless its womenfolk, the mothers and bearers of life, arise' (Okure 1992c: 230).

In *Africae terrarum*, Pope Paul VI stated that 'the African woman is today expected to become ever more vividly aware of her dignity as a woman, of her mission as a mother, of her rights to participate in the social life and the progress of the new Africa' (Paul VI 1969). Along with the 'wake up call' of the Circle, Okure uses the authority of Jesus' ministry to call into question the dependency of women on men as husbands or fathers. In *The Will to Arise*, Okure likens African women to Jairus' daughter; they need to 'obey Jesus' command, to awaken from sleep, be empowered for action, and prepare their own theological articulation of 'praise to . . . God' (Okure 1992c: 225).

> African women . . . are traditionally expected in most of our cultures to be dependent . . . like Jairus' daughter. [We] have largely depended on others to speak for us and present our plight and needs before the world. We have depended either on expatriates . . . or on African men to speak for us theologically and otherwise. Has the time not come for us to learn to speak for ourselves? Having arisen from the sleep of silence, will we now let others determine how we should speak and do theology? (Okure 1992c: 226).

This independence, which we have noticed in Larrson's analysis of religious sisterhood, is a quality that underscores the contribution of African sisters and is the raison d'être of the Circle.

This extraordinary independence is tempered by a real concern for interdependence and equality to be realised in the wider community, which features in Okure's work, in particular in her reflection on the apostolic commission to Mary Magdalene (Okure 1992a). Okure describes a courageous and committed Mary who becomes

through her singular devotion the first person to be commissioned by Jesus after his resurrection. Her womanly 'love drove her to visit the tomb in the dark hours of the morning at great risk to her own life' whilst the men stayed away from the challenge out of 'fear' (Okure 1992a: 179). Mary becomes the 'first fruit' of Jesus' mission and the first apostle of the resurrection. What is of supreme importance for Okure in Mary's commission is the 'Easter message concerning the new status of believers', which she receives personally from Christ. Believers are from now on the 'children of God, and brothers and sisters of one another' (Okure 1992a: 185).

To develop the idea Okure suggests two blood codes, the mixing of blood to create 'lasting bonds of friendship', and blood inherited through common ancestors. The cosmology of ancestors has already been explored by Charles Nyamiti and Kwesi Dickson as an important source for an inculturated African Christianity. The ancestors are 'always alive and exercise a protective and watchful role in the community which unites peoples ... of the same ethnic group' (Okure 1992a: 186). This is paralleled by 'the blood of Christ shed on the cross' whereby believers become quite literally, and not simply metaphorically, 'blood brothers and sisters' (Okure 1992a: 186). This form of post-conciliar transubstantiation realised in the bodies of believers entails numerous mutual responsibilities and accountabilities. Amongst these, Okure argues, is the centrality of a common identity in Christ nourished through a Eucharistic spirituality, which should take priority over potentially divisive alliances with Islam (Okure 1992a: 186). This is a point of potential disagreement with some of the Circle's Protestants whose empathy with Islam is more marked. In global relationships there is a blood imperative for the North to respond to the Christian family culture of 'sharing' and mutual respect in all relationships with Africa. Such sharing should involve technological skills as well as wealth (Okure 1992a: 187). These are clear missionary principles of the earlier twentieth-century missionary sisters, and consonant with recent papal declarations on continental interdependence, but they sit less easily with the moratorium articulated by the AACC at Lusaka in 1974 (Paul VI 1969: §26; John Paul II 1995a: §38, 77, 137).

From the situation where the rationale 'for doing theology is the survival of the peoples of the continent', Okure reaffirms the words of the African Synod that the 'West [should] evangelise its own people for justice towards Africans in terms of cancelling one-sided debts,

eliminating current exploitative measures and [averting] . . . the future exploitation of the continent' (Okure 1994: 140). For Okure, the mission of Jesus is one which 'promotes the full dignity and rights of all God's children' (Okure 1994: 141). It has no colour, is to be established in the cultures of all peoples, honours women in its founding narratives, and upholds the dignity of all. This is a post-Conciliar vision, with an EWC heart for the renewal of the religious narrative to realise mandatory women's empowerment. Although Okure sees Christianity as a 'commitment to a personal God, through Jesus of Nazareth', it is in her hands a community not an individual piety, and a mandate for social identity and renewal based on African paradigms of religion, motherhood and society (Okure 1990a: 71).

Sister Rosemary Edet

At the opening of the second Pan-African convocation of the Circle in 1996 there was a minute's silence and prayer. This marked the death of Sr Rosemary Edet. The fact that she had died in 1993, and this fact was only now being announced to many Circle members gives us an indication of the challenges in communication that face Africa and the Circle. Rosemary Edet's work is of immense importance in understanding the development of the life of the Circle. She was, with Mercy Oduyoye, a founder and enabled the first Nigerian Conference of the Circle to explore issues of women and culture in 1990. She was also a founder member of EATWOT and a member of the Catholic Association of Nigerian Theologians. She was Vicar General of the congregation of the Handmaids of the Holy Child Jesus and holder of a PhD in Religion and Culture from the Catholic University of America, Washington, DC.

Edet was clear in her writings that African feminists had to maintain an ambivalence towards their traditional religious and cultural practices because:

> in a society where gods, human ancestors and spirits dwell together and interact either positively or negatively, life is affected by fears, hopes, faith and love . . . in our situation exist both life-affirming and life-denying forces that women have to grapple with. The fear of witches, evil spirits, hunger and infant mortality increases women's anxiety in their weakness while at the same time it generates dependence on God and being in his favour. Twin mothers and their babies are in dan-

ger of death because their very presence is regarded as an evil omen by some sections of society. The Osu caste system makes some women unmarriageable for no fault of theirs [sic]. All these and many more create a state of helplessness for women. [Jesus] was born of a woman ... Jesus the Christ is Good News for Nigerian women (Edet 1991: 179).

There is, with inculturation, the realisation of positive strands within African culture, the constant challenge of how to acknowledge those elements that caused the nineteenth-century missionaries such difficulty. But the criticism that Sister Edet metes out to aspects of traditional religion is also turned on Church and modern society. Like Mbuy-Beya and Okure she is a woman's champion, a mother speaking out for her sisters and daughters. 'Culturally', protested Edet,

> the ideal image of Nigerian woman is that of weakness and receptivity, handmaid of man, and mother of his children. All these attributes are functional and say nothing about her characteristics of womanhood which make her a human person. She only receives orders (and) is expected to carry them out cheerfully. She is to be seen occasionally and not heard. If she has no children she is disregarded and marginalised in society even by other women for failure to fulfil her role (Edet 1991a: 178).

The Church was not much better, according to Rosemary Edet's joint paper with the Kenyan, Bette Ekeya, at Oaxtapec in 1986,

> because the one consistent and persistent scandal that obscures the full symbolic presence of the Church as the sacrament of communion between God and humanity is male predominance ... Ironically, the Church is customarily referred to as female while the whole structure and hierarchy are ... male. No wonder the symbolism of birthing and the female womb-essence means very little in the Church ... The Church in Africa must reflect the feminine face of God as traditional religion tries to do through the institution of the priesthood as a function for both women and men ... as the AICs are attempting to do (Edet and Ekeya 1993: 8).

Sister Anne Nasimiyu-Wasike

Sr Anne Nasimiyu-Wasike, the Mother Superior of the Congregation of the Little Sisters of St Francis (LSSF) in Kampala at the time of writing, was until her move to Uganda the convenor of the Kenyan national circle. Her order was the 'crown' of Mother Kevina's work in Uganda, a remarkable Irishwoman who founded the Ugandan

order in 1923, one of the earliest African congregations (O'Hara 1979: 9). In 1952 the congregation gained Vatican permission to become a Papal congregation, independent from its initial white moorings. The LSSF is now a missionary congregation in its own right working in Tanzania. Before this, Nasimiyu-Wasike was the East African Circle's co-ordinator whilst senior lecturer in the Department of Religious Studies at Kenyatta University. She gained her doctorate from Duquesne University, Pittsburgh, in 1987. Her doctoral thesis tackled the problems raised in the process of inculturation and the impact of Vatican II (Nasimiyu-Wasike 1986).

Nasimiyu-Wasike's range of theological concerns covers Christology, AICs, the prophetic vocation of African women and the churches, polygyny, domestic violence and a contextual study on the spirituality engendered by devotion to Mary. For the Circle, Nasimiyu-Wasike contributed a study on polygyny discussed in chapter five. She has recently completed a study for CEAT on Mary's role in the spirituality of African women and men, Protestants and Catholics. CEAT is a significant consultative forum which arose from the concern of Dr J.N.K. Mugambi and Fr Carroll Houle to 'stimulate scholarly theological discourse amongst leading African Christian theologians' in an ecumenical setting (Mugambi 1989b). In this latter work Nasimiyu-Wasike asserts that Mary is 'the link between Israelite piety and Christian piety' (Nasimiyu-Wasike 1997: 168). Building on Rosemary Radford Ruether's insights, Nasimiyu-Wasike postulates Mary as a 'theological agent in her own right' and 'the embodiment of the people of God, Israel and key figure in salvation history and in God's work' (Ruether 1979: 27; Nasimiyu-Wasike 1997: 169).

Given this critical inter-cultural symbiotic role which Mary is seen to play, it is obvious that Mary is of vital theological importance for Nasimiyu-Wasike's own project of finding theological resources to empower African women to address the multiple difficulties they face. Nasimiyu-Wasike seeks resources from Marian spirituality to generate 'models of human justice', so that African women can experience the 'totality of feminine dignity' and enter into their 'ontological and historical vocation to become more fully human', as agents of change (Nasimiyu-Wasike 1990c: 68; Nasimiyu-Wasike 1993a: 170; Nasimiyu-Wasike 1997: 177).

Nasimiyu-Wasike refers to this theological project as *Wakina Mama* theology, literally, the 'way of the mother' (Nasimiyu-Wasike 1990c: 57). However, as can be seen from her work on domestic violence,

her essays on the 'Prophetic Mission of the Church', 'Polygamy' and 'African Rituals of Birth and Naming', she is not content to let the current culture of African women and their location in society and Church determine her paradigm of 'Christian motherhood in Africa'. However, she is sympathetic to the power of incorporative community rituals in which mothers are enlisted in numerous African rituals of initiation (Nasimiyu-Wasike 1990c: 57; Nasimiyu-Wasike 1992a: 114–116; Nasimiyu-Wasike 1992b: 45; Nasimiyu-Wasike 1993a: 169–171; Nasimiyu-Wasike 1997: 177).

Nasimiyu-Wasike argues that African cultures are universal in the way that they present woman 'as one who has to fulfil her destiny by being a Mother' (Nasimiyu-Wasike 1997: 176). However, in becoming a mother, the woman 'renounces her personal identity' (Nasimiyu-Wasike 1997: 176). This is a difficulty for Nasimiyu-Wasike. For, although a woman often attains an honorific title with the first born and enters into the 'ranks of all the respectable women of the clan, becoming worthy of consideration as an adult', she loses her own 'personal identity', being known as the mother of her son or daughter. Moreover, those women without children are not accorded equal respect (Nasimiyu-Wasike 1992b: 42).

Nasimiyu-Wasike wants to develop a way for women to speak and think about themselves which refuses the definitions of 'child-bearer or sex object', and the humiliations that come from living in a society where their place is determined by men, who enjoy 'all the privileges and prestige' (Nasimiyu-Wasike 1993a: 169, 172). Nasimiyu-Wasike sees examples in African history; prophetic women emerge as liberators for their people or refuse cultural definition by men. One of the examples she cites is a young Bukusu woman from Western Kenya. Kezia Nabalayo is reported by Nasimiyu-Wasike to have been the first Bukusu girl to receive formal Western education. Kezia resisted bridewealth and its implications of being owned by other people, and 'sought a man that would accept to relate mutually and be a partner for life' (Nasimiyu-Wasike 1993a: 169). She died unmarried before independence.

In the light of these considerations, Nasimiyu-Wasike expounds with relish patristic writing of the second century. Mary as the 'New Eve' reverses the 'evil work of Eve', by her *fiat voluntas tua* bringing forth Jesus. Virginity has counter-cultural potential as a mode of holy living, inculturation is identified with the late fourth-century integration of Marian feasts into the agricultural cycle, and even teaching

on Mary's bodily assumption as 'a symbol of hope of the human race for the final salvation' has a potential dynamic for social change and inspiration for women's agency (Nasimiyu-Wasike 1997: 171). However, Nasimiyu-Wasike considers that the Mary of the late medieval Church became a cipher for 'virtue and piety' which, when transferred to the African context, has failed to challenge the suffering and injustice borne by African women (Nasimiyu-Wasike 1997: 174).

Nasimiyu-Wasike is altogether happier to work with ideas from liberation theology from India and Latin America. Her principal influences are George Kaitholi and Ignacio Lerranaga (Lerranaga 1991; Kaitholi 1993). These two authors draw out of the gospel of Luke the picture of the 'liberated woman, active and daring . . . free from fear inhibitions and taboos' (Nasimiyu-Wasike 1997: 176). This is the Mary towards whom the natural devotion of African Christians should be channelled; a radical empowered Mary, as yet inadequately appropriated.

Mary is established for Catholic and Protestant respondents alike not only as the 'Mother of the Saviour' but also the Mother protector of most of her devotees (Nasimiyu-Wasike 1997: 174–175). Nasimiyu-Wasike does not completely renounce the ideas of birthing and self-giving in the imagery of Mary, but she does seek to invest her with energy and power, as does Okure. The imagery of annunciation, where a woman's active co-operation and initiative, alongside her reproductive ability, became the means of 'God's liberating intervention', is exploited by Nasimiyu-Wasike. She challenges the 'traditional position' of African women, where sacrifice and 'playing it safe' has meant that women 'suffer in silence and weep in secret' (Nasimiyu-Wasike 1997: 176). She calls attention in language similar to Ruth Fisher's to the

> sacrifice of mothers for their children . . . millions of African women . . . struggling in body, wasting away and working hard tilling the land, baby sitting, home keeping, cooking, washing clothes, fetching water, looking for firewood and petty trading in fruit and vegetables, leading the singing and prayers at liturgical and para-liturgical celebrations, so that the lives of others may flourish (Nasimiyu-Wasike 1990c: 67).

This traditional struggle of women needs to be addressed along with the naming of 'Third World' hardship brought about by 'economic exploitation, wars, droughts, famines and political oppression' (Nasimiyu-Wasike 1990c: 57).

For Nasimiyu-Wasike the symbolic leverage for transformation is that given through the Eucharist. The woman offers the 'sacrifice'

traditionally assigned to Christ, women give themselves 'in a bodily way' to the struggles for liberation, and again, 'woman's body is eucharistically given'. For Nasimiyu-Wasike, women like Mary and Kezia, or Me Katilili who led the Giriama on the coast of Kenya against the British in 1811, act as an inspiration for women to fight for 'their rights to fully participate in the struggles for the restoration of humanity, its integrity, peace and justice'. She sets their example quite explicitly against the 'gender-discrimination, ethnocentrism, racism, economic exploitation under the guise of cost-sharing and structural adjustment programs, and political strategies that manipulate women to keep unjust regimes in power' (Nasimiyu-Wasike 1993a: 168, 169). At no point in her published work does Nasimiyu-Wasike utilise any of the first missionary sisters. There are many remarkable women who transcended in measure the colonial arrogance to which Circle women rightly object; women such as Mother Kevina could bear the weight of engagement to explore women's enabling power and vision across race (Oliver 1982). The memory of the colonial experience that divested the black religious and social economy of its sense of dignity and cultural identity is, as yet, too close for such a potentially healing procedure. Recovery of African agency and pride is the strategic priority, and this process needs to be supported in the construction of confident communities able to take forward political democratisation and accountability in post-colonial Africa.

Sisters and Priests

All four women share a common commitment to issues of women's empowerment and have resisted the pre-conciliar injunction to keep 'quiet and [give] in to authority', which Nasimiyu-Wasike claims was an important part of their training (Mbugguss 1991: 44). Through double reference to instances of women-affirming motifs in African tradition and the gospel accounts of Jesus' relationship with women, they seek to establish new paradigms for the Catholic mission in Africa. It is an indication of the stress under which the continent groans, and the dynamism of modern African Catholicism, that these women, trained in hierarchical obedience, are speaking out against the exclusion of women from decision-making at every level of national life.

Both major missionary religions are seen as culpable by Edet. Islam and Christianity, despite their 'concern with human life, have

only reinforced male domination in every aspect of African life'. The experience of African church life for women within Catholicism is, she asserts, 'a variation on the theme of missionary paternalism and the struggle for the birth of an authentic Christianity' (Edet 1990a: 114, 118). Her theme is clear. If the Catholic Church is serious in its intention to promote the inculturation of the gospel, as the post-Conciliar statements have variously suggested, then how is it taking any cognisance of the initiatory role of women in traditional African societies, where women exercised authority as healers, priestesses and community leaders as well as mothers?

The answer, as any scanning of the current literature from the male African hierarchy and the Roman Curia shows, is that women are not accorded ecclesial leadership. This is the case even though *Mulieris dignitatem* and *Christifideles laici* acknowledged 'women's issues as prophetic', and despite the fact that women are dynamic sources of religious service and have been cantors, catechists and choir leaders and pastoral workers from the earliest days of Catholicism on the continent (John Paul II 1988a; John Paul II 1988b: 47). Religious orders are one thing, but any notion of freeing the priesthood from male hierarchical control seems currently out of the question (Edet 1991: 189).

At Oaxtapec in 1986, Edet used some of the ideas of Maria Clara Bingemer to make her case that Nigerian women should be recognised as an integral and important part of the 'mission of liberation'. She agreed with Bingemer that because women were shown as the most oppressed category in Jesus' world, they became the privileged recipients of the announcement and freeing praxis of Jesus (Edet 1986). This was an idea further elaborated by Sr Teresa Okure in her work on the apostolic commission to Mary Magdalene in John's account of the resurrection (Bingemer 1989: 194–203; Okure 1992a). In a paper presented in the first National Conference of the Circle in Nigeria, Sr Edet went as far as to articulate the 'scandal' of women priests in saying that

> Within the African context, inclusion of women in church ministry is not simply a question of women's rights nor a capitulation to clericalism, but rather a step towards a psychological revolution in the way we relate to God, to leadership, to each other, to nature and to the relation of the church to the world. Woman's inclusion in the ministerial roles of the church would greatly enhance the ministerial nature of the local church ... Including women into the ordained ministry could enhance the representational power of priestly service (Edet 1990a: 119, 116).

The widely held West African Christian concern over how to live with Islam, which the Synod of Bishops called an 'important and often difficult partner' in the *Lineamenta* (working documents of the African Synod), stirs these writers to renew their attention to inculturation and women's empowerment (Synod of Bishops 1990: 61 ff.; Edet and Ekeya 1993: 12). Edet views the rise of Independency and Islam as threats to Catholicism and urges women, teachers and catechists to be engaged in dialogue, finding common ground for 'dismantling sexism' and renewing the Church's 'mission, ministry, and theology as a sphere of women's service' (Edet and Ekeya 1993: 12). Similarly, Okure commends a return to the practice of consultation practised by Nigeria's traditional rulers, her Obas, Obongs, Owelles and Emirs, in the life of the Church (Okure 1990a: 76). The tendency to 'colonial pomposity' of the Catholic Church's hierarchy, redolent of 'medieval feudalism and Roman imperialism', needs to be transformed by 'effective inculturation', rooted in a priesthood and religious cadre with 'deep personal commitment to Jesus Christ'. They have a responsibility to help in the 'solid evangelization and theological formation of catechists, teachers' and laity into a more accountable form of communal life (Okure 1990a: 76, 80). This alone can inhibit the 'increasing exodus' of the laity into 'the emergent syncretistic Independent Churches' (Okure 1990a: 75). The dominant themes of life, well-being, people not structures, mission and evangelisation and gender equality were clearly articulated by Edet also as she faced the challenge for Catholicism in the next millennium:

> evangelization by the year 2,000 will remain a slogan not a reality in Africa. The church should be less concerned with structures and institutions for dialogue, but more concerned with persons, with life . . . I expected the [*Lineamenta*] . . . to face squarely the injustice within its rank and file especially in Africa. For example, what has the church done in its imitation of its Lord to renew or normalise men/women relationships? Sex discrimination as practised in the Church is as bad as apartheid for it hinders human development and degrades humanity (Edet 1993: 168, 171).

Internal dialogue with women and the laity, rather than external dialogue with other faiths, needs to be the first priority. Okure and Edet urge that theological institutions be open to women, the laity be trained to 'defend the faith', and inculturation pursued to make Catholicism properly at home in Africa. As Okure observes, at present 'Christianity is almost synonymous with attending "Mass", "saying" the rosary,

"going" to confession and fulfilling the Easter duty of receiving Holy Communion' (Okure 1990a: 71). Inculturation is required to bring 'Christ to the very centre of African life', and enable 'Jesus to live and be at home to [sic] our people' (John Paul II 1980: 198; Okure 1990a: 72). Inculturation in the language of the Catholic sisters is the language of effective and enduring Christian mission.

<center>Conclusion</center>

These Catholic Circle sisters are in the process of developing a theological language which, whilst being absolutely orthodox, gives women new authority and autonomy as mothers, and argues for a fresh dispensation of power within the ecclesia. They seize the opportunities of scriptural texts, using the liberating praxis of Christ and the apostolic authority of Mary, and papal announcements, to argue for women's proper dignity and authority within their own religious, modern African world. Their focus however is not purely that of women's liberation or cultural recovery but of a Catholicism that can mediate justice, political freedom and women's empowerment through the fresh conception of 'Church, as communion, family and people of God' and a fresh appropriation of the 'mind of Christ' (Okure 1990a: 74). The ideas that Okure and Nasimiyu-Wasike have elaborated concerning the authority of Mary have been used by Western feminist theologians, but their particular context has resulted in fresh theological and ideological vistas in the exchange between scripture, African tradition and the struggle for a modern African theology. Feminism then, as well as Christianity, has to be inculturated. A discourse which seeks the model of motherhood as a source of power, rather than as subordination, works with ideological commitments to the goodness of procreation and the regeneration of life, rather than Western enlightenment models of the ultimate good of autonomy.

In his letter *Mulieris dignitatem,* John Paul II spoke of the time when 'woman's vocation is realized . . . when woman takes on in the world an influence, a radiance, a power until now unattained' (John Paul II 1988b). Bernadette Mbuy-Beya reports how the Archbishop of Lubumbashi gave a charge to women religious in 1976, calling on them not simply to pray or to lament, but be actively committed to helping people improve their lot (Kabanga 1976). These messages

from the hierarchy regarding the importance of women religious as agents of change form part of the legitimacy for these Circle sisters' call for women to 'wake up', to 'arise'. The religious call to action, to just living, to renewed dignity and self worth, to 'magnificat' principles is, perhaps, a Christian reconfiguration of the traditional motif of women's prophetic role in ecstatic prayer (Boddy 1989; Blakely and Blakely 1994; Hoehler-Fatton 1996). Unless the women arise and participate in the religious rituals of the community, it cannot be healed.

Celibacy has been introduced into African tradition as a model for women's religious agency and power which, perhaps unexpectedly, inculturates astoundingly well. The consecrated life promoted by early Catholic women religious has been zealously adopted in contemporary Africa, women's vocations far outstripping those of the men. Thus, female agency in the Roman Catholic Church is seen by these writers as a means for social transformation. The consecrated life means that women's fecundity and life-giving powers are transferred to the service of the Catholic Church, with the potential for reinvigorating the continent.

All four sisters display a deep family commitment to the wider community of Roman Catholicism, within which they criticise its hierarchical practice and gender discrimination. Both Mbuy-Beya and Edet disliked the way in which the opportunity for ecclesial inculturation was lost in the Roman location of the African Synod. For each, Vatican II has been a means of successfully transforming Catholic faith into a form of religion which can be used by Africans on African terms. Recent teachings on the dignity of women from John Paul II, the Vatican and the African Synod have been positively welcomed as points of solidarity and empowerment. Their relationship with ATR, on the other hand, is more cautious than Oduyoye's. They do not see ATR as redrawing the paradigms of the creeds, although they are flexible in seeing how some traditional practices could be used. The frequently active and mediatorial role of women within traditional religion is a potent source of contemporary empowerment for women. This is also part of the reason for Nasimiyu-Wasike's attention to the growth of AICs.

Christology is deployed in an incarnated and liberation mode, with Jesus seen as an enlightened male and respectful son, who recognises women's full humanity and maternal authority, even in relation to the divine mission. This is particularly the case in terms of women's religious authority within the Church, and Sr Teresa Okure's

work should be read at least partly in the light of the struggle of
African women religious to oblige the Catholic Church's hierarchi-
cal and male-dominated structures to include women's participation.
However, whilst undertaking a theological strategy which forces the
issue within the exclusively male church hierarchy of women's appro-
priate inclusion in the corridors of teaching authority and ecclesial
representation, congregations of religious sisters across Africa are still
in a profoundly anomalous situation in relation to the position of
most of their African sisters. The majority of these are biological
mothers, frequently located in familial and clan relationships which
give neither the access to higher education from which many reli-
gious sisters benefit, nor their freedom of action and thought.

The sisters' access, then, to the goods of health care, education,
time for reflection, and personal freedom is rare indeed for women
on African soil. It suggests that further reflection needs to be under-
taken to see how their potentially strategic analysis and prophetic
calls for action can be owned by and of use to the wider women's
constituency. Their freedom to be a part of the struggle for dignity
for Africa's women and children is facilitated by their very difference
from the condition of those for whom they speak. The difference of
celibacy and their common life together in a women's community
echoes some of the strengths of polygamous marriage and women's
society attested to by contemporary researchers (Mason 1988: 620).
Religious sisters occupy an extraordinary proleptic space of woman-
church in their everyday lives, although incorporated within a frame-
work of male hierarchy, gate-keeping the distribution of liturgical
goods and Vatican privileges. Theirs is a theology of passion and
compassion based in a commitment to inculturating the Christian
gospel and women's development.

Within these constraints, Circle religious write, teach, pray and
engage in a theological cry for dignity and life, in contemporary
Africa. Resentment towards colonialism is present but is not dwelt
on. The sense of hope in God's future and the eschatological real-
isation of a new Jerusalem is particularly present in the work of Sr
Mbuy-Beya, but all four of these writers have as their focus the
bringing of dignity here and now. Their intellectual frame of refer-
ence is Catholic, but they do not deny other initiatives within soci-
ety their Christian authenticity: their orientation is ecumenical and
bridge-building with other faith traditions and denominations. However,
biblical teaching, the presence of the Holy Spirit, the significance of

prayer, and the constitutions, declarations and exhortations of the Holy See are clearly central to their self-understanding. They have incorporated the call of Pope Paul VI to put down roots in African soil, and their orientation is to the active evangelisation of Africa. The power of Christ and the Christian life of prayer and consecration is, they believe, a means of transforming Africa's traumatised society into one of health through the revival of women's spiritual engagement and a new alliance with men.

VIOLENCE AGAINST WOMEN: CIRCLE WOMEN RESPOND

I completely want it abolished, but I usually look for ways not to trash those women who have done it, but rather to explore with them ways to abandon it for something better, their health and their lives. Because I have worked at grassroots with such women, I am sometimes disturbed by how cruel activists treat their feelings when they are already facing many health hazards.

We don't have FMG (sic) and I am aware that I do not have a personal or first hand experience. So I have restrained condemnation in my writing, in order to be effective at the local level when I speak with communities and women in particular. But believe me, I think it is one of the most dehumanising praxis that I know of (Circle Activist 2000).

Introduction

At San José, forty-two women theologians from twenty-four countries, including Circle members Mercy Oduyoye, Musimbi Kanyoro, Elizabeth Amoah and Mary Getui, began a 'struggle against violence'. Violence was not just one topic of feminist liberation theology but

a core topic of feminist liberation theologies, because women on the margin and all women in a patriarchal society suffer violence of many kinds that is legitimised both by religions and by the societies of which we are a part (Russell 1996: 21).

The resurgence of attention to domestic violence is rightly ascribed to the resurgence of feminism in America during the 1970s. This reiterated, in a new key, the feminist responses to 'Crimes against Women' that were a part of the activities of American women's organisations, and indeed western missionary women's observations in Africa, in the last half of the nineteenth century (Pleck 1983: 452). This 'core topic' of feminist liberation, however, places Circle women at the cusp of two solidarities. Oduyoye's project of a two-winged theology with men will be tested in the turbulence of resisting male violence in family and society, and any alliance sought by North Atlantic women on the grounds of a universal ethic of women's rights

and freedoms will be faced with African cultural particularity and the discourse of economic violation and post-colonial racism. Our first act will be to follow Musimbi Kanyoro's and international feminism's *cri de coeur* to break the silence on women's violation (Tadesse 1988; Kanyoro 1989; Gnanadason 1993).

Any commentator approaching this highly charged area is mindful of Mercy Oduyoye's claim that to isolate 'violence against women' in Africa 'is like complaining that one had stepped on hot embers when one's house is on fire' (Oduyoye 1996b: 162). Oduyoye insisted at San José that 'total reconstruction' in the face of all forms of cultural, economic and political violence was demanded by true 'global sisterhood' and that African women should be allowed to say 'our own word' without undue interference from western commentators (Oduyoye 1996b: 170). Nevertheless, I have been so bold as to cast a Western gaze on the area of violence specifically endured by women, precisely because it does disclose a fertile area of theological response to the challenge of inculturation, which dramatically distinguishes Circle writers' work from that of their male colleagues. The 'marginalization of women's pain' has been described by Mercy Oduyoye as the 'patriarchal construct of reality which African women need to resist . . . vigorously' (Oduyoye 1996b: 163). It is important to note how Christian theology, practice and mission has colluded with 'patriarchy', and what tools for resistance Circle theologians are using.

The discussion that follows will take us through highly charged and contested sites of identity forged in the furnace of Africa's pre-colonial history and post-colonial struggle. Simone de Beauvoir asserted that 'one is not born, but becomes a woman. No biological, psychological, or economic fate determines the figure that the human female presents in society; it is civilization as a whole that produces this creature' (de Beauvoir 1949: 295). African women have been sites of a swathe of competing interests over the last two centuries, determined to create and replicate their identity through the construct of 'the woman'. These have ranged from nationalist, Christian, Islamic, local and feminist projects. Whether in the alienation and violence of enslavement, adoption into the missionary project, incorporation in the nationalist struggle or 'discovery' as victims in North Atlantic feminist rhetoric of liberation, African women have been imaginatively constructed and manipulated by others.

Age-setting, contests for gendered power, missionary engagements and diverse cultural arrangements for reproduction within Africa herself present difficulties for any liberative theology which does not

assert some universal rather than local ideal. In working with this issue of violence, I have drawn attention to continuities of contemporary Circle concerns with their missionary foresisters, and through this attempted to demonstrate how intercultural issues marred some of the interventions against women's violation undertaken by Western missionaries and colonial legislators. We find ourselves faced repeatedly with the dominance of strategic considerations which have and continue to operate both in the silences and in the protests of women. The 'two-winged' theology of the Circle affects the way in which the colonial past and the contemporary North-South struggle for resources is understood, and women's struggles for equality are articulated. Violence against women offers us a clear testing ground for some of the theological postulations of the Circle to take root and make a difference.

Breaking Alliances

The issue of violence against women disturbs the univocality of Circle theologians and their male counterparts in the inculturation project. Because they focus on women's experience, and seek to assert their subjectivity and co-humanity, it leads to a more complex reading of African culture, and questions precisely which parts of the tradition can be recovered in the quest for authentic African society and being Church. Thus,

> the task of African women is not only to correct past records but also to provide fresh data on the variety of women's experiences and the nature of their struggles against oppression. The objective is not merely to write women back into history, but also to record gender struggles as defined by history, culture, race and class structures in Africa. Some aspects being encountered share the analysis done by women from other parts of our global community, but in the area of culture we see that our experiences offer a certain uniqueness that is specific to Africa (Kanyoro 1995: 27).

At the Bossey seminar in 1994, Musimbi Kanyoro proposed a way of reading African society which left the authority to change what outsiders perceived as violence in the hands of those immediately affected. She called her modulated feminism 'cultural hermeneutics' (Kanyoro 1995: 21). This gives priority to the 'victim' to decide their nomenclature and to develop their own strategies for change with

the support of those from outside. As an active campaigner for the
rights of women, involved with both the Vienna World Conference
on Human Rights in 1993, and the Beijing Conference in 1994,
Kanyoro is well aware of the importance of universal rights to
empower women, and encourage civil legislation to secure women's
well-being (UN 1989; Kanyoro 1995: 18; UN 1995c).

Kanyoro is well aware of the tendency of Western commentators
to regard cultures which structure gender relations in ways different
to the western norm as 'barbaric', or indeed in need of *carte blanche*
feminist liberation. She proposes instead a 'cultural hermeneutic',
which sees gender relations in any context as the location of peo-
ple's social resolutions, with 'empowering' and 'disempowering' aspects
for women's lives. Kanyoro advocates allowing all women to be writ-
ten back into history as agents, so that women themselves are seen
to undertake cultural change for systems in which they have not
only been co-opted but have also co-operated. In this way Kanyoro
reads female genital mutilation (FGM) as a means by which 'mil-
lions of women [affirm] their cultural heritage and . . . their dignity',
despite the fact that it is 'harmful to the health of the woman'
(Kanyoro 1995: 25). The key, she claims, is to engage in feminist
analyses which 'speak to the experiences not only of women who
are against traditional practices, but also to those who find personal
empowerment in [them]' (Kanyoro 1995: 26). The Circle's com-
mitment to read African women's theology from their cultural loca-
tions and the mandatory nature of 'mature cultural dialogues' is well
asserted by Kanyoro. However, the problem remains throughout of
how one maintains a commitment to universal human rights whilst
respecting cultural particularity. The two, particularly in the case of
female genital mutilation, are in apparent conflict, particularly in the
overwhelming number of incidents when legal minors are the recip-
ients of adult incisions. Kanyoro dangerously erodes common west-
ern feminist understandings of violence and violation in order to
retain cultural entitlement to difference and women's autonomous
empowerment. Western understandings are grounded in modern
democracy's commitment to the right of the individual to the welfare
of her own body, rather than the right or entitlement of others over
her body. The difficulty within Africa is that the communitarian idea
of what makes one a person who is acknowledged and supported
by one's society is marked by other indicators than, for example,
the right to vote, marry or leave school. The 'right' of a minor to

bodily integrity in some African contexts has to compete with the right to be incorporated into a community whose practice is circumcision, whether male or female, and thus to inherit full entitlements as a sexually mature adult when older. From the different matrix of cultural entitlement fabricated by modernity, entitlement is located in political maturity and citizenship, and cultural marking which cuts into the body will always be seen as an intrusion, a totally unacceptable violation of personal space and bodily integrity.

The struggle for African identity, and cultural pride is clear in their resistance to the imperial designs of North Atlantic feminism. Susan Brooks Thistlethwaite, also at Costa Rica, wrote in an earlier work, on the nature of cross racial and cross cultural theological analysis that,

> sin for white women, may in fact, consist in asserting connection, sisterhood, bonding, whereas what is needed is respect for cultural difference . . . all too frequently white feminists stop with interpersonal self-examination and fail to move on to political and economic analyses. If hegemony of God the Father is a particular cultural legacy of Western Christianity, a white feminist analysis of that fact should include a systemic analysis of its social and political origins . . . Hannah Arendt has written: 'the extreme form of power is All against One, the extreme form of violence is One against All' (Thistlethwaite 1990: 120, 121).

This realisation by Thistlethwaite of the power of difference in race and culture, and the contested missionary paradigms of unity in practice and ethics, cuts both ways in the cultural inscription of sexuality. Further, as Musimbi Kanyoro observed, the idea of patriarchy is complicated by the fact that 'women are not only victims but also, more often than not, perpetrators' of violence in widowhood rituals, FGM, divorce and polygyny. She explained to the international forum at Bossey:

> These are the areas of women's violence against women. We have to break the vicious circle of women violating other women in the name of culture. We cannot continue to bemoan the socialization we have had when there are lives at stake . . . [our] lack of collective solidarity is not a matter of a generation gap, or different levels of education . . . but of cultural loyalty (Kanyoro 1995: 23).

The issue of FGM raises in the most acute form the Circle's anxiety with North Atlantic feminism and their own solidarity with young women and children who undergo what Oduyoye chooses to call 'female genital modification' (Oduyoye 1996b: 169). So great is

Oduyoye's mistrust of the EWC's interest in this matter that she argued any presentation by the Africans present at the consultation would only reinforce 'the already endemic image of African women as the most oppressed of all women' (Oduyoye 1995a: 169). FGM then is an issue to be resolved by African women themselves, without the contributions of moral crusades executed by such as Mary Daly. Her analysis in *Gyn/Ecology: The Metaethics of Radical Feminism* ascribed FGM to the realm of 'Sado-Ritual Syndrome', with unspeakable atrocities played out on women in the name of a 'phallocratic higher order' (Daly 1978: 154–167). Kanyoro, too, is unhappy with this form of Western intrusion. As she pointed out in her seminal paper at Bossey, some aspects of culture offer 'a certain uniqueness that is specific to Africa', and should not be submitted further to 'second-hand' or 'distorted' research and reportage, as had been the case of 'merchants, missionaries, colonialists, anthropologists and, later, African men' (Kanyoro 1995: 27). Mercy Oduyoye is more explicit. 'We do not', she continued at the Costa Rican conference,

> agree on what constitutes women's issues and especially on the method of seeking reconstruction. Above all, it is very exasperating to have impatient liberators on one's back... African women are learning together about their religio-cultural context and are seeking to discover how to make it empowering for women. The solidarity we seek from the global sisterhood is that we get our rightful space to say our own word (Oduyoye 1996b: 169).

Here the debate on cultural matters of great delicacy meets the debates in the Letter to the Galatians. Do the rules of the Jerusalem church obtain, or is the Gentile church permitted to proceed in its own way? Galatians 5: 6 was a verse particularly favoured by the Church of Scotland mission in Kenya in the 1930s to justify their interventions against female circumcision (CSMC 1931; Ward 1976; Lonsdale 2002). Although Oduyoye asserts that attention by Westerners to female genital mutilation is 'sensationalism', the remit of the debate has always had parameters wider than the purely local. The local, undisturbed by outside 'voices', continued a way of defining women and men which was not open to critical reflection. This was to change for ever in the wake of the 'contest' of the missionary, racial, national, colonial and local definitions of women's bodies and cultural identities which arrived with empire. It is the locus of contemporary analysis, and reflection upon it is undertaken by the Circle, using the revived categories of enlightenment ethical imperatives

gleaned from J.S. Mill, Mary Wollstonecraft and Immanuel Kant, and the biblical themes of equality and the dignity accorded women taken from Genesis and the ministry of Jesus.

If ethics is located in community, as African ethical method would suggest, then what happens when the women's community amongst a particular people declares for excision or infibulation, rather than against? For many Western feminists these women are suffering from false consciousness, and the child 'victims' of FGM must be liberated at all costs, no matter what violation the surrounding community suffers as a consequence. Mission Christianity introduced a new religious discourse of personal identity and subjectivity which triggered points of individual disruption rather than smooth community transition. This occurred again and again in the gendered transcripts of marriage, motherhood and women's rights and freedoms. Christianity was a conspiracy of new desires deeply implicated with modernity and the colonial project. Crucially, in its promotion of a non-local yet personal divinity, Christianity operated as a social virus that encouraged a new freedom for the individual in both geographical place and social status.

Mission history, however, simply does not support Kanyoro's assertion that 'Christian missionaries tended to see African cultures as totally barbaric' (Kanyoro 1995: 27). Across denominations, regions and personalities there was considerable difference displayed as to which traditional practices were deemed appropriate to leave and which to resist, an ambivalence expressed in the conflict between Gikuyu Christians themselves in the 1930s (CSMC 1931; Murray 1974: 7, 316 ff.; Ward 1976: 123 ff.). The morass of contingency, when ethics floated free from a religious universal, is plain to see in the circumcision controversy. Its complex history reveals some of the operations of identity politics in post-colonial modernity: the educated moderns over the illiterate, new ways over old, national over ethnic and autonomy over communal control.

The contest has now widened to include the new international rights of women and girl children promoted by the UN and the WHO (UN 1995a: 762). I am concerned to see this area addressed by Northern as well as African theologians, because the mutilation of an estimated one hundred and nine million women's bodies on the continent of Africa, with a current circumcision rate of six thousand girls per day, is currently understood by UN legislation as an international scandal, and queries most acutely the limits of cultural

discretion (Dorkenoo 1994: 89, 162; UN 1995a; UN 1995c). Are there irreducible rights which will transcend the relativities suggested by any 'cultural hermeneutic' which does not explicate central identifiers on what constitutes humanity or divinity? (Kanyoro 1995) And how then does Kanyoro's quest for this hermeneutic sit with recent Kenyan church history and the Gikuyu circumcision crisis of the 1920s? (Murray 1974).

Circle authors use the ideas of 'liberation', 'empowerment', 'representation' and 'freedom from suffering' as non-negotiable goods by which African cultures and religious practices are opened up to critique. Unfortunately, we have no theological map to guide unwary travellers through the perplexing diversity and gendered asymmetry of African cultures. Circle members can make their African sisters hostages to abuse when they fail to secure a philosophical or religious meta-narrative from which to challenge culture or religious practice. The favoured method of gleaning women's stories does not necessarily provide that which is required for the political and social struggle for the transformation of power across gender (Oduyoye 1988c; Kanyoro 1992b; Kanyoro and Robins 1992; Njoroge 1995). The parochial structure of African cultures and cosmologies with their unique configuration of gendered controls and asymmetrical sexed power, and the construction of women as men's source of reproduction, needs both stories of liberation and strategic analysis to inform intelligent transformative action. What is required is a new social contract of equality and entitlements in conversation with African traditional discourse to harness minds and hearts for the societal overhaul it portends, but which is still distant in its articulation.

This may in part be because their strategy is based on the decision to build 'a future in which men are friends. Building that future means not [beginning] by attacking men but by finding methods of bringing change together with them' (Kanyoro 1995: 23). It is also certainly affected by the praxis-orientated approach of much of the Circle's work, which would seek to work in partnership with affected women to discover together organic strategies for transformation and liberation inside their communities, rather than speak any language of enforcement which threatens as a consequence of putting entitlement language in forensic mode. Working within the contours of a post-colonial 'patriarchal Africa', with a frequently inhospitable state and legislature, can mean that the going is slow and painful (Kenyan Government Marriage Commission 1979: 109–114). Moreover the

terms of traditional women's empowerment, and its re-articulation by many Circle theologians as mother-power, places the terms of the struggle within the contested domain of the family and clan, where violence has been borne silently by African women for generations.

Domestic Violence: The Silence is Broken

Sr Anne Nasimiyu-Wasike, in one of the two articles dedicated to the consideration of violence specifically against women in the African Christianity Series *Pastoral Care in African Christianity*, confirms the sense that 'traditionally, violence in the family has been silenced, overlooked and . . . even accepted as a way of keeping women disciplined and under men's control' (Nasimiyu-Wasike 1994: 105). It is a silence shared by the mainstream churches, which have failed to name violence against women in the home or indeed in the public domain as an issue in need of ethical or theological redress. The limits of discipline and the limits of sexual access within marriage have been squarely moved out of the public domain, where women's councils had traditionally upheld the markers of their society's specific moralities on behalf of their women members. Hazel Ayanga comments, in her contribution to *Violence against Women*, that following an intervention by the Attorney General of Kenya in a historic ruling on rape within marriage in 1994, he

> was accused by a cross section of the society of inciting wives against their husbands. This was because he issued a warning that men who sexually assault their wives would face the law . . . Church leaders, notably the Archbishop of the Church of the Province of Kenya (at that time The Most Rev Manasses Kuria) voiced similar accusations against the Attorney General. The general feeling seemed to be that rape can never happen within marriage, and that if it does, it is acceptable. A woman who says 'no' to her husband's sexual demands is guilty of a breach of her vows both to him and to God (Ayanga 1996a: 13).

The problem is simple. Within the marriage relationship, neither sexual invasion nor physical 'disciplining' of the wife is a matter for State or Church because the wife is still seen as the husband's property. Nasimiyu-Wasike cites a Cameroonian: 'men won the women for they have bought them, just like shoes, cars or other property. They feel they can beat them as much as they like—after all, it is their money' (Nasimiyu-Wasike 1994: 106). According to many of

the anthropological accounts of marital relationships in Africa, particularly in cultures of virilocality, the woman is supposed to offer obedience and respect towards her husband (Brinkman 1996: 69). After all he is the one (within patrilineal economies), as Nasimiyu-Wasike indicated, whose family have paid *lobola* or a bride price in the transference of her productive and reproductive capacities from her kin to her husband's kinship group. The wife bears sons and daughters to work the land, sons to inherit the land and daughters to be 'bags of money', as say the Nnobi, where a traditional song stresses the importance of women in terms of exchange:

One has given birth to a bag of money.
Thanks be to God.
This cloth I wear is money.
This meat I eat is money.
This fish I eat is money.
This child (daughter) I have is money
(Amadiume 1987: 78).

According to Elizabeth Schmidt, colonial intrusion meant that women stayed in extremely abusive and life-threatening situations, where previously it had been a feasible option to return to their father's compound (Schmidt 1992: 114). Mission compounds, which sprang up like fungi across Africa in the nineteenth century, offered an alternative destination. Runaway wives constituted some of the first Bible-study congregations and students at the new mission schools, which developed in the missionary enclaves (Hodgson 1997; Schmidt 1992; Walls 1996). Although inequalities in gendered power existed well before the arrival of Western missionaries and colonial authorities, there was frequently, particularly in matrilineal societies, the balance of reciprocity and accountability which saved some of the worst excesses of male violence against their spouses or daughters. It is an undoubted fact that colonial authorities and mission churches colluded with male interests to secure female subservience and obedience, in accordance with perceived biblical order and 'civilized' marriage. Mission agencies were particularly antipathetic to women's sexual freedom in matrilineal societies. The Catholic mission amongst the Kwaya, a Bantu-speaking people in northern Tanzania, urged, from the 1940s onward, the ending of *bumama*, the custom by which children do not inherit their fathers' goods, and *kukyuka*, whereby children at the age of puberty are declared the children of their maternal uncles (Kirwen 1979: 89). Quite what was the impact of

these interventions on the power alignments in the sexual economy is not yet historically clear; they may well have exacerbated male domestic violence against women, with the removal of protector males from women's kinship groups.

The churches, without doubt, did exacerbate difficulties for women. Excommunication, designed to discipline polygynous men, frequently placed the African wife and mother outside the effective evangelisation and care of the churches. The White Fathers declared Christian marriage was impossible without the payment of bridewealth. Those married without 'a dowry . . . [were] forbidden the sacraments' (Kirwen 1979: 89). A study of the Anglican Church in Buganda in the mid-1950s by John V. Taylor concluded that 87% of married men and 80% of married women were permanently excommunicated, adding:

> A Church in which the majority of adult members are permanently excommunicated is a monstrosity which demands the most serious reappraisal of basic assumptions (Taylor 1958: 244).

Women were afforded a measure of liberation through education, and Christian teaching did break, for some, inhibiting taboos and the fear of the evil eye. However, colonial legislation was exceedingly disruptive. Hut taxes, introduced by the British, Belgian and French colonial authorities to incorporate the barter system of Africa into the monetary economy of empire, disturbed older forms of gendered separation and solidarity. In many instances, women had slept and lived in separate huts from their husbands, which created women's space. Hut tax forced women and men into the same living area, and thus impelled men and women into previously un-negotiated spheres of power distribution and conflict resolution (Brinkman 1996: 60).

The practice of woman-beating by husbands as a requisite discipline amongst some people groups in Africa was no European invention to exonerate colonial presence. In *Women against Violence*, Hazel Ayanga cites Gikuyu proverbs which urge men to control their 'untrustworthy wives' and argues that Luo, Kipsigi and Gikuyu proverbs reveal a thought world where women are property, of either the clan, the father or the husband (Ayanga 1996a: 16). A woman, therefore, has no rights subjectively, only those vested in her by the wider community of men. There is a similar negative reading of traditional gender relations in Oduyoye's 'Asante Women: Socialisation through Proverbs' and 'Naming the Woman' (Oduyoye 1979b; Oduyoye 1981d; Oduyoye 1994e). Ghanaian folk tales tell of the reckless yet

powerful Ananse (the spider-man/god) whose control over his wife and children is pervasively violent and devious (Oduyoye 1981d: 87; Oduyoye 1996a: 47). Women's traditional lot is rehearsed as one to be avoided in this context, since they 'have no past to return to, only a future to build' (Oduyoye 1981d: 94).

Nasimiyu-Wasike comments how in other traditions a man was given a whip on his wedding day (Nasimiyu-Wasike 1994: 106). Beating women is maintained as a traditional means of settling family disputes by Zimbabwean Dr Mawema, and 'women's movements' are blamed for inciting wives to leave their husbands after an assault (Nasimiyu-Wasike 1994: 105). It is a pattern of abuse that has formed an enduring part of many African domestic economies, as it has been present in other cultures across the world (Ofei-Aboagye 1994: 933). The study of proverbs reaches back into the asymmetrical relationship of women with men's disciplinary power in pre-colonial times. Mary Slessor, the daughter of a violent alcoholic father, intervened explicitly as missionary and magistrate against male violence in her work in Calabar, and educationalist Ruth Fisher working in Buganda at the turn of the twentieth century noted her concern about wife and child abuse (Livingstone 1923: 130; Fisher 1911: 41).

Nowadays, the agenda of American feminism brings rape crisis and legal advice centres to Nairobi, Kampala and Accra, and seeks extra-familial resolution through the new 'palavers' of women's solidarity groups in non-affine urban locations (Nasimiyu-Wasike 1994: 105). Educated churchwomen are part of women's groups who protest on the streets about the violence that accompanies women in home and in the public domain. After Kenyan Ednah Sang, the ruling Kanu party candidate in the 2000 political contest for the Rift Valley, was stripped naked in public and beaten by opposition supporters to shame her out of the race, churchwomen stood alongside the Kenyan Women's Political Caucus and the Federation of International Women Lawyers as Sang continued her candidature only to lose the election (Wanja N. Gihinji, *Time*, June 5, 2000). This contemporary co-operation with women lawyers and political lobbyists to effect legislative protection and support for women is a re-invention of women's traditional unions. Among the Igbo, social and political unions of married and unmarried daughters were naturally formed and known as the *Umuada Azuanuka* or *Mgboto*. The daughters who were married away from the village and the wives of men of the village formed other unions called the *Umuokpa alu alu* and the *Umu ndomi Ndom*.

Both of these 'groups maintain order, promote life and bring con-
solidation, joy and solidarity among themselves and to the village
community' (Anyanwu 1993: 130).

Christian women have their own solidarity groups, but first they
have to overcome what Esther Mombo has identified as *vumilia*
(suffering) theology. This teaching is based on the paradigm of a
silently suffering crucified saviour, and women, in like manner, endure
and sacrifice themselves for the survival of Christian marriage and
Church reputation (Mombo 1998). An additional difficulty for Christian
women is the source of their teaching, controlled, as it is, by a male
clerical discourse, which fails to release liberative theological ideas
into this domestic domain. Bishops' and Moderators' wives are fre-
quently the presidents of these solidarity groups, which retain a con-
servative line on issues of women's freedoms and rights within marriage.

Teresia Hinga reflects on an incident where a woman was 'beaten
for not less than four hours, in the streets of Eastleigh in Nairobi'
by her 'boy-friend' in 1979, with no-one coming forward to inter-
vene. Instead, the bystanders shouted approval. '"She deserves it!"
they shouted, "It teaches her not to misappropriate men's money"'
(Hinga 1994: 118). This woman was not protected by her kinship
group, or even by the traditional disincentive to undue violence in
patrilineal households, the return of bridewealth. Marriage, monog-
amous and polygynous, with its formal ties of reciprocity, is in retreat
to serial non-formalised sexual relations in much of modern urbanised
Africa (Dinan 1977; Dinan 1983). Such support as the woman could
have expected from her age-set, co-wives or her extended family,
now needs to be sought in the legislative processes of the state. At
the turn of the millennium, she is not in a strong position, with few
states prepared to interfere in the domain of men's traditional property.

Women outside formal kinship-secured relationships are thus at
the mercy of 'bad behaviour'. However, many women choose a pat-
tern of sexual autonomy and female-headed household arrangements
precisely to avoid male violence in the domestic domain. The point
is well made by Ofei-Aboagye that, for the fifty women interviewed
at the Legal Aid Clinic of the International Federation of Female
Lawyers (FIDA) in 1991, all understood domestic violence to be the
'beating of a wife by her husband'. While only ten per cent responded
that it was accepted in their culture for a wife to be beaten by her
husband, subsequent questions intimated that a distinction was drawn
between disciplinary action and 'beating'. Aboagye notes:

Their responses to a subsequent question (imply) that there was a level at which beating 'transcends the norm', when for instance, 'he injures her', 'she is hurt or experiences any pain'; he beats her to 'leave a scar or deformity'; 'he leaves her with a fracture'; 'he beats her publicly'; the beating is 'more than three slaps or he beats her three or four times'; a slap or two to discipline a wife is 'acceptable.' Only two women emphatically stated that 'any beating at all' transcends the norm (Ofei-Aboagye 1994: 929).

Freedom and Violence

The second pan-African meeting of the Circle in Nairobi opened with a play which portrayed the life of a rural Kenyan woman, a virtual slave to her growing school-age children, small baby and brutish husband, who beat her with his belt when the food was not ready. 'Am I the woman, the woman to be?' asked the pensive young teenage girl narrator, to a hall who murmured their recognition and disgust. 'This is how it is, this is the life of the poor women in our country', Judy Mbugua, of the Pentecostal-inspired Ladies Home Care Fellowship told me (Mbugua 1996). This public portrayal of violence, of back-breaking work, of the triple burden of reproduction, production and male violence, is a script around which the Circle have identified a node of resistance. Their outrage and compassion is a source of potential unity across race and nationality, and their analysis of how to bring about change through legislation is similar to that of Circle members.

Hannah Kinoti argues that there were traditional practices and strategies that enhanced female power within the Gikuyu world. The new wife would adapt 'so well to her new home that her husband was rendered "unable to command her"' (Kinoti 1983: 142). Brinkman notes that older women occasionally blame younger women for provoking men in patrilineal Kenya by their eagerness for power to such an extent that

> now the woman has become a man! The man tells his wife: 'warm water so that I may wash myself!' And she doesn't warm the water! . . . She just picks up the wallet and leaves! (Brinkman 1996: 68)

They are irritated too by women's failure to manage men, whilst confirming that violence within the domestic domain has been a long-standing difficulty.

> In the past men liked very much to beat women. A woman could be
> beaten to death by her husband. But women knew this very well and
> they knew how to appease their husbands with nice food, so as to
> make him happy (Brinkman 1996: 70).

Men, however, have stressed the harmony of married households
including the polygynous, reinforcing ideas of mutual respect. The
idea of violent domination within marriage is singularly absent in
the works of male theologians regarding the present challenges fac-
ing Christianity in contemporary Africa.

Musimbi Kanyoro, the Secretary for Women in Church and Society
at the LWF, organized in 1993 as part of the EDCSW initiative a
conference on non-violence sponsored by the WCC and the Life
and Peace Institute of Uppsala, Sweden. A case study from Kenya
told how, after mass rape and murder at St Kizito Secondary School
in Meru in 1991, where nineteen girls died and seventy-one girls
were raped, a spontaneous grouping of women emerged, called
Mothers in Action. They undertook 'to lobby, raise awareness . . .
and . . . ensure that no such tragedy would ever again happen'
(Umbima 1996: 97). However, they soon found that women's issues
in the political domain were only regarded important insofar as their
contribution affected the economic 'development of the country'
(Umbima 1996: 97). Issues associated with the power arrangements
between men and women, focused in women's bodies, were rejected
by a state based on an 'ideological patriarchal dominance' (Umbima
1996: 97). Mothers in Action have now organized into 'Kenyan
Women in the Democratisation Process', seeking entitlement through
representation in the new multi-party state legislature and the courts.
A similar process of non-representation occurs within the churches,
according to Kanyoro. As one of her interviewees told her,

> My husband started coming home late and finding fault with me for
> everything . . . he would call me lazy and punch me. His whole fam-
> ily insulted me in many ways. I talked to my pastor, but he simply
> told me to persevere and not to do anything to annoy my husband.
> He also asked me to repent of my past sins and remember the man
> is the head of the home (Kanyoro 1996b: 5).

Kanyoro argues that although the women's liberation movement in
Africa can be seen as a point of contention in a marriage relation-
ship and a source of embarrassment for activists' husbands,

to seek justice for women's well-being is a command from the Scriptures. Both men and women are in the same category and Christ died for all. All have sinned. All have fallen short of the glory. Christ died for all. This means all people, men and women alike have received the grace through Christ's death (Kanyoro 1996b: 8).

This Christocentric attention is paradigmatic for Kanyoro, with the household codes of Peter, Ephesians and Corinthians seen as singularly unhelpful. It is the Jesus of history and his taboo-breaking, woman-affirming relationships which provide the wellspring for theological energy. Jesus brings justice at Nazareth when he preaches good news to the poor (Luke 4: 16–18). He sees poverty, religious and economic oppression, unemployment, the physically ill, and he is moved to compassion and action (Matthew 9: 35–38) (Kanyoro 1996b: 8). For Kanyoro, the extreme embarrassment occasioned by talking about sexuality or domestic violence impedes the kingdom of God. It also brings sickness to the nation, with the increase of HIV/AIDS amongst the young. Kanyoro resists an African patriarchal and post-colonial categorisation of feminist theology as Western and not for 'their' women. For 'African women to be "African"', she argues, does not mean 'to be silent and submissive in the face of injustice and oppression'. African women must speak for themselves, and establish their identity and needs in a 'new literature', which is being created 'in which the truth about women is told' (Kanyoro 1996b: 10; Kanyoro and Kanyoro 1996c). This truth includes the perceived violence against women in African oral literature, barrenness, polygynous marriages, widowhood, rape, economic violence and female subordination.

Speaking from Outside

In their dialogical approach to theological method none of the Circle theologians has so far published accounts of her own experience of violence. They are advocates for others, similar to many earlier missionary women, with their assertion of African women's full humanity (Holding 1942). Their representation is from a degree of separation. Daughters of ministers, evangelists, Sunday School and Church School teachers, many have been to boarding school, seminary and university, which further separates them from many of the marginalised women whose corner they defend. Nyambura Njoroge observes:

> Although my church pioneered the ordination of women in this coun-
> try, it is still far from addressing women's concerns in a concrete way.
> As one who has spent the last 15 years in the full-time ministry of the
> Church (both as student and minister), I have encountered in my min-
> istry many women in great pain and suffering. Most of the time I felt
> powerless and ill prepared to deal with or even to identify with their
> suffering. Neither was I prepared to minister to poor people in situa-
> tions of extreme poverty, such as in the slums of Nairobi . . . My train-
> ing did not prepare me to minister to prostitutes and the victims of
> domestic violence and sexual harassment in the workplace. Women . . .
> began to confide their inner secrets: betrayed relationships and bro-
> ken marriages, bruised ribs and blackened eyes, bloodied faces, attempted
> suicides. Childless women shared the pain of coping with insults from
> in-laws and second wives, and the agony of divorce. Widowed women . . .
> others whose husband I had buried came for counsel . . . How does
> one minister in such a congregation? The elder, his wife, his mistresses
> and their children in the same church! (Njoroge 1996: 7)

What Njoroge set herself as a young pastor 'to understand my soci-
ety and its institutions' has been realised across a gulf created by
education, class and creed. Her response as a young woman pastor
to the suffering of parishioners was within the missionary education
paradigm. The theological expression of Njoroge's experience was in
Christological terms. How could she reconcile the tension of the
'lived experience of a tortured Christ, and the risen Christ full of
joy and new life', with the 'pain and anger experienced by women
in the Church' (Njoroge 1996: 9)? The Church, the body of the res-
urrected Christ, kept silence in the face of violence against women.
This disappointment with the Church, as failing to provide a safe
space for women, or to act as an advocate for women, has provoked
Njoroge to become a campaigner for women's entitlement and full
corporeal inclusion in the churches as a sign of Christ's radical inclu-
sive ministry. Njoroge calls for the Church to 'enter into the jour-
ney of Golgotha with Christian women who ache in pain and anger
as they fight against exclusion and violence in Church and society'
(Njoroge 1996: 11).

The Regulation of Sex

One of the key things which Mercy Oduyoye remembers from her
mission schooling at Mmofraturo Methodist Girls High School,
Kumasi, was the demarcation by her Methodist teachers of marriage
as 'good' and 'bad' in terms of monogamy and polygyny:

> British single women, our teachers, organised us to debate the pros
> and cons of polygamy (as we were taught to say) . . . monogamy-good,
> polygamy-bad . . . in the midst of a mother-centred culture we were
> being directed to the conclusion that 'avuncular inheritance' was unac-
> ceptable, by women who had come from patriarchal culture (Oduyoye
> 1993d: 341).

The distance of these white British single women, is, in part, replayed
in the voices of the African Christian women who criticise polygyny
as a violation of women's 'well-being' (Nasimiyu-Wasike 1992: 107).
This paradigm of well-being, which is health enjoyed in the biolog-
ical, social, domestic and political sense, is adopted by several authors
in the Circle's *Groaning in Faith* (Okemwa 1996: 177 ff.; Kanyoro and
Njoroge 1996: 272; Gomes 1996: 223; Mwaura 1996: 268). Women's
well-being becomes a way of asserting some universal ethic without
recourse to divisive religious dogma. It critiques and resists patriar-
chal domination through the assertion of the good of women's total
well-being which entails liberation from male hierarchies and constraints,
a terrain which is successfully shared by Circle women whether
Muslim, Christian or ATR (Shaikh: 94, Madiba 1996: 272, 276).

 The earlier pan-African *Will to Arise* had over half its contribu-
tions dedicated to the issues directly relating to women in marriage.
Three specifically addressed polygyny, and, of these, two were seri-
ously hostile to its continuance. Judith Bahemuka called it 'oppres-
sive', a 'thing of the past . . . designed to dominate women' (Bahemuka
1992: 129). Musimbi Kanyoro was agnostic, whilst Nasimiyu-Wasike
compiled a list of seven reasons why polygyny manifested a distorted
relationship between men and women, and should be seen as enhanc-
ing 'men's power and domination over women' (Nasimiyu-Wasike
1992a: 107). She said:

> Much of what has been written on the subject of polygamy has come
> from the male perspective and has emphasised the socio-economic
> dimensions of the institution . . . while neglecting its religious dimen-
> sion (Nasimiyu-Wasike 1992a: 107).

Nasimiyu-Wasike is at one with her Catholic sisters on this. All of
them follow the teachings of the Vatican which uphold monogamy,
despite the pressure for a change of stance by some leading male
and female theologians *vis à vis* church discipline and the practice
of polygamy (Hastings 1973; Hillman 1975; John Paul II 1981;
Shorter 1994). Teresa Okure indicated in her 'Critical Overview' of
the *Lineamenta* that the neglect of church marriage disciplines in the
preparations for the African Synod was pitiful, and there was a

desperate need for open discussion on marital arrangements as they affected women (Okure 1993d: 184). Mbuy-Beya spoke after the Synod of 1994 of the range of violence both psychological and physical which African women experience, and to which her church fails to respond. Amongst the psychological abuses nominated were 'insults, infidelity (accepted by tradition), incest and repudiation of the wife', all sustained within the marital relationship. Like Nasimiyu-Wasike she favours monogamy, 'the conjugal bond is . . . in the image of Christ's love', but she upholds some of the economic and social welfare aspects of traditional polygyny (Mbuy-Beya 1992a: 177). The silence on this area by the Roman church means that the actual disposition of male sexual power within African societies is not explored, the inculturation project is barred from critical encounter with the present organisation of sex and gendered privilege, and the voice from women's experience is silenced.

Polygyny, Marriage and Male Control

The social benefits of polygyny are well rehearsed in recent research. Polygyny can offer social aid during childbirth and the years of nurture, in working women's 'gardens' (where both domestic food-stuffs and cash-crops are grown), and, in the event of death, security for children (Davison 1989: 57 ff.; Kilbride and Kilbride 1990: 206; Brinkman 1996: 71). Kathryn Mason noted that in Burkina Faso amongst the Moose co-wife relations were frequently a source of solidarity, with *mabiiri* (literally friendship, based on a sibling metaphor) meaning the wives share the same work, possessions, food, celebrations of birth, support each other in bereavement and natal village festivals.

> Like kin, co-wives check on each other and nurse each other . . . when ill. After a woman gives birth, a co-wife prepares her food and washes her clothes until the mother is allowed to leave her house three or four days later. The new wife's co-wife-mother will care for the first child of the new wife for some time (Mason 1988: 620).

However, acrimonious relationships also exist among the Moose in the Nakomse neighbourhood, whose *pogtaare* (antithesis to *mabiiri*) relationship is argumentative, prone to mutual avoidance, violent and gossiping (Mason 1988: 621). Ingrid Brinkman's account of polygyny amongst the Gikuyu in East Africa reveals the potential for an

age, as well as a gender bias in polygyny. Frequently, younger educated women see polygyny as a curse, whilst older women see younger women having lost the facility of 'manipulating men', a facility which was eased by the potential co-operation of co-wives in the withholding of food and sexual favours (Brinkman 1996: 71). The picture is further complicated by the child's perspective. Being the recipient of multiple care, affection and provision is a positive good, but being the child of a battered mother at the hands of a jealous co-wife can offset any romantic picture of this arrangement (Kilbride and Kilbride 1990: 206–210).

The most frequent difficulties relate to co-wife jealousy, with its concomitant religio-magical complications, 'the evil-eye' and witchcraft accusations. Other problems include strained financial resources, loss of mutuality and various psychosexual disturbances. The decision to marry another wife is frequently the husband's alone (Kilbride and Kilbride 1990: 213; Wright 1993: 87). The change in Anglican practice over withholding baptism from polygynous households at Lambeth in 1988, a century after its decision in 1888 against baptising polygynists, is seen by Nasimiyu-Wasike as a pastoral rather than a 'doctrinal' one (Hillman 1975: 32; ACC 1988: R26). For Nasimiyu-Wasike the 'truth about polygamous (sic) families', is that they are 'a world of uncertainties, jealousies and rivalries ... problems [which] are passed on from women to their children' (Nasimiyu-Wasike 1990a: 113). This negative reading of polygyny is in perfect accord with nineteenth-century women's missionary teaching and surveyed opinion of educated women in Nigeria and Kenya (Ware 1979; Kilbride and Kilbride 1990: 205).

Men in East Africa are more in favour of polygyny than are women, particularly educated women (Kilbride and Kilbride 1990). This is reflected in the re-readings of the missionary/national church struggle for identity amongst contemporary male theologians. Douglas Waruta and John Mbiti are spiritual heirs of Jomo Kenyatta in affirming polygyny as an integral part of the 'African world' (Kenyatta 1938: 174–80). For Waruta, senior lecturer in the Department of Religious Studies, Nairobi University, Western missionaries introduced 'a largely puritanical and hypocritical attitude towards human sexuality', with an insistence on monogamy and demolition of community forms of sexual organisation, which has proved 'neither practical nor humane for African Christians' (Mbiti 1969: 225–228; Waruta 1994: 93). Polygyny continues in clandestine modern forms,

mistresses and 'secret homes' 'thrive', whilst Christianity fails to pro-
vide for young widows, the divorced, or the children of failed mar-
riages (Waruta 1994: 93).

Throughout history, the shape of the African family has been con-
structed by the varying constraints of responding to an often inclement
environment and hazardous relations with invaders from the North,
East and West (Iliffe 1995: 1–4). Nasimiyu-Wasike returns to ancient
African creation myths to shed further light on the issue, but priv-
ileges the Jewish creation accounts as revealing 'monogamy . . . as
the ideal form of marriage for humanity and the only one sanc-
tioned by God. Monogamy . . . is not a cultural product, but a foun-
dational relational aspect . . . meant to promote mutual dependence . . .
between woman and man' (Nasimiyu-Wasike 1992a: 111). The Genesis
creation story is only 're-echoed' in the African 'myths' of the ori-
gin of human life. This foundational equality and interdependence
is what she claims to hear in African women's testimonies against
polygyny. She rebukes 'African men and their Western European
and African male sympathisers', and insists that African women's
views 'differ from men's apologia' (Nasimiyu-Wasike 1992a: 111).

If polygyny fails to deliver equality and partnership between the
sexes, then it is no different from the criticism unleashed against
many other practices: the patriarchy of the mission churches, the
constraints on women's sexuality, the ubiquity of blood taboos, the
treatment of widows, the naming of girl-children, witchcraft accusa-
tions and women's limited access to the opportunities of politics, edu-
cation and the market place (Oduyoye 1979a; Oduyoye 1983b;
Amoah 1987; Amoah 1990; Nwachuku 1992).

Njoroge's contribution to the debate is nuanced by a glance at the
childless wife. Taking Hannah's experience of childlessness and the
ridicule to which she was subjected by Peninnah (1 Samuel 1: 6–10),
Njoroge comments that the centrality of placing 'childbearing as the
central function of the woman and fertility of the woman as the foun-
dation of marriage' creates continued pressure for polygyny in con-
temporary Kenya (Njoroge 1996: 25). Far from easing the difficulties
for the barren woman, as Waruta claims, polygyny can lead a child-
less woman to be 'tormented' by her co-wife, and by her husband's
kin. Njoroge maintains that the Church has failed to 'loose the bonds
of injustice' for childless women suffering pressure towards polygyny
from their husbands (Njoroge 1996: 25). Women in this situation
are almost always seen as the 'guilty party'; if they are childless it

is because they, not the man, are infertile. These women experience culturally approved violence, as in the practice of permitting the husband's brother or circumcision kin, *riika*, to deal with the husband's infertility by having clandestine conjugal relations with the wife to ensure the next generation (Amadiume 1987: 71, 46, 125; Nasimiyu-Wasike 1992a: 103). However this is better than being sent away in disgrace as many women have experienced, without a secure diagnosis of their own rather than their spouse's infertility.

The Quest for Immortality

The nub of the problem for both Mercy Oduyoye and Nasimiyu-Wasike is the religious world-view, which places immortality in the production of children for the man and his wider dead lineage. Citing John Mbiti's work, *African Religions and Philosophy*, Nasimiyu-Wasike notes that,

> The man with many descendants had the strongest possible manifestation of immortality, as his personal immortality was kept in the physical world by his numerous descendants long after he was dead ... (thus) ... Many wives and many children meant stronger 'immortality' for that family (Nasimiyu-Wasike 1992a: 102).

Meanwhile, Oduyoye remarks in the *Festschrift* for Mbiti that,

> the quest for immortality, which seems to be the fountainhead of marriage and procreation, is a theological issue ... Most of the issues of contemporary feminism are located in the sexualisation of women that arises directly from the biological factor of procreation: women's lives are being discussed within the hedge of their sexuality. Discussions on family life are carried out as if 'family' is co-terminus with 'women' or children ... Christian immortality, as identity with and in Christ, and African immortality, as part of the Living-Dead, does not need individual reproduction to become a viable concept (sic) (Oduyoye 1993d: 344, 347).

Both Oduyoye and Nasimiyu-Wasike move the discussion of polygyny on from the pros and cons of socio-economic and cultural realisation, to criticise the cosmology that drives men to seek multiple wives and maximise their reproductiveness. Oduyoye draws attention to the importance of the 'connectedness of humanity across the dimensions of time', working with her key ideas of identity sustained in community (Oduyoye 1993d: 348). She recognises that integral to

that connection is the act of remembrance. It is through the genealogical production of sons and daughters who remember one's name, and undertake certain religious observations when one is no longer physically membered, that one lives on when one dies. As long as you have children to remember you, you are not really dead. You are part of the 'Living-Dead, keeping close spiritual involvement in the living family' (Oduyoye 1993d: 346). Thus, in order to free immortality from biological reproduction she exploits the idea of the extended household, the *abusua*. Again, 'identity with and in Christ' would release the pressure on reproductiveness as women's sole self-actualisation, and remove the theological driving force behind polygyny in the male-constructed African cultural imagination (Oduyoye 1993d: 347). Furthermore, for Oduyoye this idea serves as a contribution from African theology into the wider global debate surrounding the viability of immortality as a socially useful idea in the contemporary world. Its 'link between this future orientated meaning of life and the connectedness of the human race which we seek here and now' establishes a way forward for transforming the eschatological and soul-saving language of the African missionary evangel into a theological tool to effect justice and right relations today (Oduyoye 1993d: 348).

We have discussed in chapter four the possibility of particular women fulfilling a symbolic function of virginity. These women offer pregnant alternative possibilities for survival in the community of the Church, beyond kinship and procreation. The challenge now rests for male theologians to face theological inculturation on the 'ownership', production and meaning of women's wombs (Oduyoye 1993d: 358). To surrender her ownership of the means and outcomes of production to men eradicates woman's identity. Judith Bahemuka claims that the teaching of Christ that, 'I am eternal life, whoever comes to me shall have eternal life', has new resources for the construction of female equality and autonomy in Africa (Bahemuka 1992: 131).

A barren woman could only be pronounced 'a worthless human being', because she could not secure for the man or the clan the requisite tools for the future (Oduyoye 1993d: 359). These were children for farming and their spiritual future; for, in the rehearsal of their memory, the practice of certain rituals, and potential reincarnation of their spirits in future progeny, a person's 'immortality' would be secured. The nineteenth-century mission attacked polygyny from the hegemony of Genesis-driven monogamy. This strategy

concentrated on the limitation of sexual partners and the control of 'savage licentiousness'. It singularly failed to engage the religious underlay of male desire to burst the limits of the corporeal, which has in part ensured polygyny's widespread continuance today. If you are a 'big man' in politics or business, you will want to marry more than one woman to show your wealth, to bear children and to multiply your immortality (Tshelane 1996). In the urban economy the rural underpinning of women and children as agents of production is not so important. At base the craving for immortality and status drives its contemporary popularity.

Attention to the psycho-social importance of immortality is virtually absent in Western feminist writings, but it is of immense import for Africa. Only by attention to the affirmation that an individual's identity is established not through ownership of the product of another's reproductive and nurturing capacities, but through one's alignment with the person and intentions of the Christ of God, can true liberation for persons both female and male begin. Unless there is a new ethic of relationship, sustained by a theology liberating immortality from biological connectedness, then barren women, the abused co-wives, divorced women and the wave of teenage pregnancies will continue. Woman, protests Oduyoye, requires the socio-psychological space to fulfil herself as a being in the image of the creative God apart from reproduction (Oduyoye 1986c: 122–128; Oduyoye 1989c: 23–27; Oduyoye 1993d: 359–363). It is within such a reconstituted view of humanity, women and men as co-equal creators of the kingdom of God, that women and children's dignity will be restored in the African household economy outside 'of the hedge of sexuality' and 'the objectification of women in marriage' (Oduyoye 1993d: 344, 356).

Circumcision: Reproducing Women

The construction of womanhood in the rite of circumcision is one of the most multi-layered and problematic dimensions of African culture with which the Circle has to engage. The majority of those undergoing the operation are young girls between 8–12 years of age (Amadiume 1987: 77). It is manifest in the first and mildest cut to a woman's site of focused sexual pleasure (Masters and Johnson 1966: 45; Hite 1976). This cut, habitually enacted through a female

circumciser's poorly sterilised razor or knife inherited from her own mother, can be as moderate as the removal of the prepuce or hood of the clitoris, a procedure similar in impact to the removal of the foreskin in most male circumcision (Walker and Parmar 1993: 178, 317). This is called *Sunna* circumcision, and was supposedly advocated by the prophet Mohammed, but it constitutes the smallest percentage of contemporary circumcisions practised in the Sudan at only 2.5% (Saadawi 1980: 39; Dareer 1982: 3). However, *Sunna* circumcision can also refer to partial or total clitoridectomy and scarification of the labia (a problem for researchers seeking to understand the extent of the practice). The circumciser's cut goes deeper and the inner strength of the woman-in-the-making is interrogated by her mother, aunts and peers, when the clitoris is partially or totally excised with part of the labia minora. This excision is the most widespread form for women. This passes far beyond the equivalent cut in men. Eighty per cent of women now undergoing genital reconstruction in Africa experience this operation (Dorkenoo 1994: 5). This is the beginning of what is termed by those working for its abolition as female genital mutilation.

Deeper into the texture of resignification is infibulation. Here the anterior of the labia majora—often its entire medial section—is cut away, 'scraped' and checked through by fingers of circumciser and often female relatives, and the vaginal opening is re-constituted by silk, catgut or thorns. The vaginal opening is maintained by a piece of wood or reed through which menstrual blood or urine may pass (Dareer 1982; Koso-Thomas 1987: 16; Dorkenoo 1994: 7, 8). This is Pharaonic circumcision, still practised in the majority of cases in the Sudan. Health concerns remain high amongst medical workers. Dr Rosemary Mburu, a Kenyan gynaecologist, has estimated that fifteen per cent of all circumcised females die of bleedings or infection. Many of the survivors endure in social silence psycho-sexual problems, chronic urinary and obstetric difficulties and complications in child-birth (Saadawi 1980: 36 ff.; Dorkenoo 1994: 15). Awa Thiam, one of the first African researchers to speak out against the practice in the academy sees circumcision as the 'most eloquent expression of oppression of women by men'; one which demonstrates male control of women's sexuality as his 'possession or property' (Thiam 1983; Walker and Parmar 1993: 288, 289).

The metaphors exploited by the Sudanese in describing the impact of such physical intrusion are, smooth, enclosed, clean, a pure oasis,

in stark contrast to the Western medical and literal experience of rough scarred tissue, frequent fistula irruptions, compromised cleanliness, and blocked orifices for the extrusion of the menses (Boddy 1989: 69–75). This range of 'mutilations' affects at least twenty-six African nations. In the Northern Sudan, an estimated eighty-nine per cent of women are operated on. Projections from small-scale studies in Ethiopia, Mali, Gambia, Burkina Faso and Eritrea deliver statistics of over seventy per cent of the female population undergoing some form of circumcision (Dorkenoo 1994: 88).

Close attention to the politics of circumcision reveals a sub-text of women's solidarity affecting *mariika*, significant age setting and a hierarchical control of women by women through gerontocracy. This solidarity, induced through a common initiation ceremony, has given women in a variety of African peoples remarkable resilience in their gendered distribution of power. Among the Kamba and Gikuyu there is a significant weight of authority of older women over younger age sets. The empowerment of older women carries with it access to women's councils. The cultural enforcement of respect for elders and particular mutual support between sponsor and sponsored, marriage gifts for the mother and trade income for the (usually) female circumciser, all depend on the circumcision of the daughter (Robertson 1996: 624–625; Thomas 1996: 340).

In Kenya, these councils had significant power over food crops, rainfall, land use, the discipline and regulation of girls and women's social lives. They also controlled violence against women. Men who were perceived to have 'maltreated' women had to pay a fine in gourds, cooking pots or beer, and endured the withdrawal of food and sexual favours from the abused woman's co-wives. If the offence was deemed outrageous, the man would experience *guturamira ng'a-nia*, a form of genital exposure similar to the *Anlu* of the Kom of Cameroon (Lambert 1956: 95–100; Ardener 1975: 37).

For the girl herself, circumcision ensures her graded acceptance into the adult community. Before circumcision, girls are treated as minors; after they are welcomed into the company of women who shall become mothers. This is clearly seen in the songs of circumcision. In the words of Wangeci, an old widow from Mutira:

> After *Irua* [the initiation-circumcision ceremony], was over, I felt that now I was a mature girl. Then I started waiting for my first menstruation. Others treated me differently. Because I was growing big breasts and was circumcised, they started to respect me and treat me

like a grown person. *Irua* taught me how to move from childhood to womanhood, It helped me to leave my childish ways and start acting like a grown up. Today one is born, but she does not pierce her ears like we did (one of the concluding stages of the circumcision cere- mony) and she does not go for *Irua*. Where does she shed her child- hood acts and behaviours? She grows with them, matures with them, and even marries with them. Her acts are childish. She is not clever, nor is she mature in her mind (Davison 1989: 121).

Breasts and Perspiration

The missionary attack on circumcision rituals in the 1920s in Kenya saw the loss of such practices as *nguiko*, a fact lamented by Hannah Kinoti in *Violence Against Women*. *Nguiko* was a post-circumcision sex- ual skills initiation, with young women able to go into the young men's hut (*thingira*) or, occasionally, that of the young women (*kiriri*). Time was spent one to one, but sometimes *à trois* or even more, the girls having first pulled their soft leather apron (*mwengo*) between their legs and secured the ends at the waist, to resist penetration. This practice encouraged polymorphous arousal, known in popular idiom as *nyondo na njoya*—'breasts and perspiration' (Kenyatta 1938: 157–159; Leakey 1977: 740, 419; Kinoti 1996a: 81). The public domain of this premarital sexual activity functioned as a brake to full sexual inter- course. Where the boundaries were transgressed by a couple, the young man and woman were excluded from their age-set, in a cus- tom of shame, until rectification had been made. Any over-enthusi- astic youth caught untying a girl's *mwengo* was made *kohingwo* ('sent to Coventry') by the girl's age set, and refused future privileges of *nguiko* (Kenyatta 1938: 160).

Nguiko was interpreted by the Church Missionary Society, the African Inland Mission and the Church of Scotland Mission as a license for fornication and adultery. In Church of Scotland Mission areas, young mission-educated boys and catechists broke up youth gatherings of *nguiko*, whilst Perlo, an early pioneer missionary with the Consolata Catholic Mission, wondered how 'morals [could] be found among this people who in their age-long abandonment have become so corrupt as to raise practices openly immoral to be a social institution?' (Cagnolo 1933: 257).

The difference between African cultures' organisation of sexuality and that of the missionaries led to numerous misreadings of the

moral location of sex and the cultural construction of chastity from South Africa to the Sudan. Kenyatta was appalled by this 'European puritanism', and provocatively contrasted the 'Gikuyu man's . . . technique of self control in the matter of sex', and that of the white man, who 'would not be able to restrain himself under similar circumstances' (Kenyatta 1938: 159). The misunderstanding is analogous to Mary Daly's outraged attack on female circumcision, which she sees as principally the removal of women's right to sexual pleasure and '100% enslavement to men', without regard to its other social functions (Daly 1978: 159). To collapse female solidarity groups mediated through *irua* without attention to other forms of solidarity and women's ability to discipline men was a failure in inculturation.

Hannah Kinoti argues that the Mission churches' hostility to *nguiko* amongst the Gikuyu has resulted in women being less able to discern a future husband's temperament. It has further meant the loss, for both men and women, of sexual control and temperance in the conduct of sexual intercourse, and the deterioration of men's manners and respect towards women. In *nguiko* there was a desire to 'grace one's name among age-mates and the community'; all this has now disappeared (Kinoti 1996a: 82). The view that women are 'sex objects', the increase in rape, teenage pregnancies outside marriage and violence in marriage is, Kinoti argues, a phenomenon of modernity. It is, for her, an indication of the breakdown of cultural values. The traditional location of the Gikuyu woman, she reminds us,

> has valued womanhood and motherhood, even regarding them as sacred. Women bring forth life and God has feminine attributes as well as masculine. The Gikuyu . . . regarded the sun as a manifestation of God . . . every evening it died and resurrected every morning. In this connection they have a saying, 'when the mother of men resurrects, why does a man cry?' Women are traditionally appreciated as mothers of their communities (Kinoti 1996a: 84).

When alternative moral paradigms came to Africa, and were imposed through church discipline, separation from the exercise of kinship authority through boarding school education, without clear understanding of the implications of 'sexual training' (it is clear that many missionaries misunderstood that normally *nguiko* was non-penetrative), the complex of gender regulation and the control of women and men's sexual conduct by traditional mechanisms began to unravel (Erlank 1997: 7). To pay close attention to these practices, however strange they may at first glance seem, is to attempt to locate the

deep symbolic and moral structure of a culture. But such a proce-
dure requires respect of the other, and the absence of larger hostil-
ities impossible in the period of empire and the reconstruction of
ethnic identities, which were mapped out across the continent on
the body of the female.

The discussions which informed the attacks on circumcision in
Kenya in 1956 are informative. The initial ban, proposed by the
Methodist and Presbyterian churches in 1926, asserted that female
circumcision was contrary to scripture, compromised the health of
the girl, and produced multiple complications at childbirth (CSMC
1931). Women's groups were in the forefront of the struggle. Educated
younger women, involved in Western medicine and mission educa-
tion, now located their identity outside the old order into a new *riika*
set, constructed around the mission paradigm of help to the needy,
Bible study and prayer (Njoroge 1992: 25).

The Presbyterian women's movement, the Council of the Shield,
Kiama Kia Ngo, formed by such younger Kenyan women in 1922,
was a movement specifically dedicated to resisting female circumci-
sion. One member was a relative of Nyambura Njoroge, who took
this example of women's agency around the circumcision crisis as
her doctoral study. The death of Elizabeth Ndobi during childbirth
at Tumutumu hospital, where there were early pioneer Gikuyu
Christian women working as medical assistants, started the new *riika*.
Tabitha Wairumu Muriuke remembers the incident that sparked the
process. This eventually led to schism in the Presbyterian Church in
Kenya in 1929 between the *Kirore* (those who vowed, often by their
fingerprint, *kirore*, not to have their children circumcised) and the
Karinga (patriotic Gikuyu who continued female circumcision). Elizabeth,
recalls Tabitha, had developed difficulties in delivering because

> her private parts were removed up to the bone. This partially blocked
> the urinary and vaginal passages. After delivery the passage blocked
> again and the blood could not be released. The doctor (Dr Philio) did
> his best to help her, but she developed an infection in the uterus and
> after three days she died.
>
> After Elizabeth died, Mariamu, Esther Murigu and Naomi Wakunyu
> stopped working (at the hospital). We locked ourselves in a room and
> cried our hearts out. We asked ourselves: 'What should we do for our
> Christian girls?' (Njoroge 1992: 39)

Their decision to create a women's organisation to resist the prac-
tice was partly precipitated by women's non-representation in the
Kirk session, the ecclesiastical mechanism for deciding church busi-

ness. The women lobbied two male church elders to report that they had vowed not to have their daughters circumcised, with the same report going first to the chief, and then, via Tabitha and Mariamu themselves, to the District Commissioner. The furore which then broke out led to women arming themselves to resist men and other women taking their children to be circumcised. Carrying pangas and machetes, they fought circumcision to the point of removing their daughters at the very moment of excision from the crowd of naked girls and their adult supporters (Njoroge 1992: 45–46).

By the 1950s it was clear that the Women of the Shield, by their assertion of the mission health paradigm and appropriation of God's power to support their endeavour, had precipitated a struggle of competing gendered, national and ethnic identities, intersected and fuelled by new religious explanations. Male chiefs supported the ban on clitoridectomy in 1956 during the years of *Mau Mau*, against younger males and older women. The *Ngaitana* (I will circumcise myself) movement encouraged young women to be circumcised despite the government ban (Thomas 1996: 343). Although colonial officers ascribed this movement to men, it has been effectively argued that it was a movement of young women's mothers and grand-mothers, anxious to protect their own social and political power. The girls themselves would not be deemed suitable for marriage without circumcision. They could, so it was believed, be left, with-out the removal of the clitoris, infertile, taboo as regards intercourse, and running the risk of death for any babies they birthed (Shaw 1995: 69, 81). Thus the ignominy of remaining unmarried and the social disgrace of being barren was all that remained for them out-side this ritual of entitlement. Furthermore, the ritual was seen as a place for adolescent girls to demonstrate their sense of cultural iden-tity and protest by enduring a personal ordeal as a direct con-frontation of the colonial state (Njoroge 1992; Thomas 1996: 351). *Mau Mau* fighters regarded female circumcision as obligatory in the resistance to British colonial power in the 1950s. Some girls were forcibly excised without anaesthetic after abduction, others saw cir-cumcision as a way of identifying with the old moral order and cir-cumcised themselves without the aid of their peers or mothers (Thomas 1996: 351, 349). The female body was, variously, a site of abuse, resistance and community identity and aspiration. Meanwhile, like feminist theologians today, the denominations were divided as to how they responded to female circumcision.

Jocelyn Murray's research suggests that the way in which the mission churches addressed the issue dramatically affected the continuity or discontinuity of the practice amongst Gikuyu girls. The Catholic Church never declared against circumcision, the Bishops of Meru and Nyeri maintaining that circumcision was not against the law of God and therefore not open to condemnation by the Church (Murray 1974: 339). Significantly, both Okure and Mbuy-Beya indicate female circumcision as an area of violence against women that they want to see changed (Okure 1990a: 72; Mbuy-Beya 1996a: 176). The most explicit voice of protest is in the anonymous *Leave Well Alone*, which Oduyoye used in her *AMKA* report on Beijing, and in an epilogue at the Nairobi Conference (1996) (Oduyoye 1995a: 29). 'Body mutilation', declares Hinga, is the unwitting collaboration of women in 'their own oppression, for they do the atrocities on themselves . . . [it] dehumanises and brutalises them' (Hinga 1994: 121).

The tendency to public ambivalence with which the Circle approaches this 'very touchy topic' arise not only from its profoundly taboo nature, but because, yet again, African women's most secret location of identity, pleasure, authority, and difference has become the site of new competitions for loyalty and incorporation (Fanusie 1992: 138). Kanyoro's appeal for a cultural hermeneutic to limit the hegemony of Western feminist declamations of 'unspeakable atrocities' should be seen in this light (Daly 1978: 153; Pedersen 1991). A liberation theology for this unkindest cut of all has not yet been satisfactorily negotiated by Circle theologians, at least not for public consumption.

Concluding Reflections

What the Circle women theologians have brought to the moral ambiguity of contemporary Africa is a power of naming. Naming is given theological attention by Mary Getui and Anne Nasimiyu-Wasike in *Violence against Women* and *The Will to Arise* (Nasimiyu-Wasike 1992b; Getui 1996). In the churches with their male leaders at every level, Circle theologians are naming the violence which occurs in Church and society against their sex. Oduyoye states that 'spirituality' should be seen as

externalising the anger and the hurt so that one might look them in the face, say 'NO' to them, and thereby be filled with power to struggle for transformation. It is what enables one to break the silence that makes continued dehumanisation possible (Oduyoye 1996b: 164).

She declares that African Christian women were given by mission and tradition 'a double dose of an energy-sapping consciousness' (Oduyoye 1996b: 164). Now, Circle theologians are intent on recovering a prophetic and energising voice to women's protest.

This 'prophetic' announcement is ambiguous at two levels. African women are not icons of silence who have started to speak. Within Africa's various and rich histories there are numerous examples of revolution and resistance instigated by women's outrage at men's violence or lack of respect (Allen 1972; Ardener 1975: 37; Anyanwu 1993: 118). There has been collusion between biblical injunctions to women to keep silence (1 Corinthians 14: 34) and pre-colonial gendered construction of women as those who bear children for their husband's or uncle's kin, and live under an over-arching economy of male authority. Speaking out has been clear in the refusal of violence against women's bodies in marriage, and beyond it in rape and prostitution. The Circle is less clear on polygyny. The motif of securing immortality and displaying wealth for men reveals the inequality and undesirability of this organisation of sex and gender. Cultural manifestations which are seen as African, traditional and the means of women's social entitlement are more difficult for the Circle to negotiate without seeming to rely on terms of analysis which derive from the West.

In this new discourse, the language of sexual pleasure, bodily integrity and children's autonomy replaces the nineteenth-century imperative of civilisation, but still Africa is left as potentially barbarous and other. Protestant theologians, in particular, are anxious to assert African identity and women's rights of ethnicity against a new Western moral economy. However, as Alice Walker indicates, this could represent a 'serious abdication from and misuse of radical black herstorical tradition', not forgetting the egalitarian tradition entailed in Genesis 1: 27 and Galatians 3: 28 and appropriated by many African churchwomen (Walker 1984: 379). The collapse of public forums for separate political negotiation and representation for both sexes has left women particularly vulnerable in Africa: state and Church are dominated by men's voices. Moreover, the links that

Oduyoye and Walker have made between the cutting of women's bodies in the West in search of socially defined beauty and power, liposuction and breast implants, and the cutting of genitalia in Africa, reveals the global arena for this discussion on identity and men's power over women's bodies (Oduyoye 1995a: 170).

A multitude of difficulties and discouragements face these women theologians. As Isabel Phiri can testify, her commitment to looking at issues of violence at the University of Malawi cost her the renewal of her contract after she pursued research on the sexual intimidation of women students on campus. Phiri argues that violence 'is a very sensitive subject that touches at the heart of the male ego' (Phiri 1997a: 53). To examine and expose acts of male violence in a post-colonial world where Africa feels herself to be in global terms 'a refugee camp . . . exploited, dehumanised and abused' is to run the risk of retribution, ridicule, and a loss of prescriptive nerve (Okure 1995a: 54).

The Circle are committed to continuing their exposition based on the paradigm of Jesus' announcement of the Kingdom at Nazareth (Luke 4: 16–19), and his treatment of women as healer, friend and confidante (Hinga 1992b: 190). They invoke at the same time the urgent noise of Kasai, Kom and Igbo women, spatulas in hand, whose curses and beating of cooking pots resists destructive forces and engages all their sexual and womanly resources (Mbuy-Beya 1992b: 193). This is what Circle theology does best: speaking out resistance and disclosing events that have been hidden. They announce the 'risk of living in the eschaton', the need for women's redefinition of themselves in the light of God's freedom and justice, apart from the violence of the 'men with whom we seek to build a caring community' (Oduyoye 1995a: 176; Oduyoye 1996b: 166). However, as all communities discover, there are some areas which are problematic in bringing to voice, but naming is liberative—a declaration of freedom—such is the challenge of naming FGM. Western women and the international community await a clear lead from Africa's women on how to name this unkindest cut of all.

MULTIPLE IDENTITIES IN-DEPENDENCY: THE CHALLENGE AND CONTEXT OF THE CIRCLE OF CONCERNED AFRICAN WOMEN THEOLOGIANS

Something of the nature of ... political love, can be deciphered from the ways in which languages describe its object: either in the vocabulary of kinship (motherland, *vaterland, patria*) or that of home. Both idioms denote something to which one is naturally tied. ... everything 'natural' there is always something unchosen. In this way nation-ness is assimilated to skin-colour, gender, parentage and birth-era—all those things one cannot help. And in these 'natural ties' one senses what one might call 'the beauty of *gemeinschaft*'. To put it another way because such ties are not chosen, they have about them a halo of disinterestedness (Anderson 1992: 143).

Introduction

The Circle of Concerned African Women Theologians is, as we have seen, engaged in a task which has emerged out of, and indeed is sustained by, a multiplicity of frequently undisclosed dependencies, in a pan-African assertion of independence and autochthony. The role of third sector agencies like the WCC, EATWOT, AACC, LWF and the UN has been influential in creating the terms of its engagement with male-stream African theology and Western feminist theology. Black theology has been particularly significant, not only because of South Africa's engagement with black resistance theology from the civil rights movement of the southern USA, but also because of Circle members' direct exposure to this discourse in American universities.

The Circle 'do theology' in the mode of resistance, in a 'wake up call' for women to arise out of lethargy and describe their space in post-independence Africa. They argue that, in the new Africa, women's passivity has failed to realise the religious, economic and legislative fruits of political independence (Oduyoye 1985b; Hinga 1996a). The Circle's active constituency of teachers, academics, businesswomen and pastors is by its nature a representative forum. It is also a theological forum organised around a degree of advocacy. This is effected

principally through research and publication. However, the Circle is not a mass movement. It is a movement of an educated and committed élite, who voluntarily commit themselves to study, co-operate and publish. The writings of the Circle constitute nothing less than a brave 'will to write', and announce a reconstruction of African theology on women's terms. In this reconstruction there are numerous tensions which surface both in text and encounter, and which have not been addressed in a sustained critical manner by the Circle.

The point of departure from Western feminist discourse for Circle writers was the rejection of the hegemony of white bourgeois culture of which those feminists were a part. African worlds of meaning and life were to be affirmed. In particular, Mercy Oduyoye insisted upon the indispensability of religion in the life of African women. The formation of the biennial institute at Accra in 1989 was the marker that religion and culture belonged together. The 'religious burdens laid upon African people cannot be imagined by the West', Oduyoye declared in her inaugural address. 'Religion is inseparable from culture in the daily lives of women' (Oduyoye 1990f: 45). The same movement, which broke with the dominance of Western feminism, challenged the theological project of cultural recovery of African theologians like Mbiti, Dickson and Bolaji Idowu. Black theology from South Africa had already posed questions about the effectiveness of inculturation theology for liberation. Now, Circle theologians rejected the neutrality of the inculturation process.

They claimed that men could not speak for women, that a cultural theology constructed by men would leave women as non-beings, ciphers of men's history, with their religious identity and bodily integrity in the domain of un-story (Bons-Storm 1996). Furthermore, culture was problematised for these women as a potential site of gender violation and alienation. What Emmanuel Martey calls the 'inherent oppressive elements in African culture', Oduyoye names with precision (Martey 1993: 83). 'The burden of disease and ostracism of a society ridden with blood taboos of inauspiciousness arising out of women's blood' had to be confronted. In the name of Christ, who 'liberated women by being born of Mary', cultural and social patterns were rejected which kept women 'bent double' under poverty, and a 'lack of appreciation of what the fullness of womanhood should be' (Amoah and Oduyoye 1993: 43). The Circle women courageously seized their moment. Inculturation came of feminist age.

Many Circle writers, Mercy Oduyoye included, claim that mis-

sionary failure to take account of the entanglement of religion and culture, and a 'wholesale' refusal to value African cultures, actively caused the denigration of Africa and collapse of women's place within the social order (Oduyoye 1990b: 78; Oduyoye 1990c; Oduyoye 1995c: 161). The debate continues in this area, as the difficulty of disentangling violence and identity in chapter five clearly demonstrates. Ethnicity and missionary memory divides Circle authors on the glories and disasters of a former golden age, when culture preserved the powers of women against the ruthless onslaught of modern Africa. They are united in believing that rescue for Africa cannot be undertaken by a divided people. A creative device asserts relationship with African men through the metaphor of 'two-winged' theology. As Mercy Oduyoye explained at the inauguration of the Circle's biennial institute:

> No bird flies with only one wing, therefore African men theologians cannot alone make African theology fly. Men in theology must realise that it is only as women are empowered to provide the second wing that theology will fly (Nachisale-Musopole 1990: 11).

There is a highlighting of 'generalisable interests': the sake of the whole community, the 'replenishing of the human race', the welfare of Africa itself, and all need the necessary co-operation of men and women in this venture (Oduyoye and Kanyoro 1990: 46). This is the second point of departure. The Circle, on this reading, is therefore not an extension, a dependent bolt-on of Western feminism. Indeed, any such equivalence would have terminated the project. African male theology had ignored the fact that women's experience might not be coterminous with that of men, but once women theologians had created the means to establish and publish their voice, many seemed eager to establish a community of men and women addressing the issues raised. This is reminiscent of the WCC's CMWC strategy, but nowhere is this acknowledged in the literature. Circle apologists prefer to underline African specificity over and against Western procedures. As Oduyoye clearly states:

> [as] the team of mid-wives assisting at the rebirth of African women and the resurrection of the human in Africa we have to operate from the standpoint that Westernising Africa is not our road to liberation . . . For African women theologians feminism is a movement of women *and* men for supporting life and fighting death (Oduyoye and Kanyoro 1990: 47).

Such statements of independence and autochthony permeate both the written and spoken production of the Circle, signs that the trauma of infantilisation within the colonial era and the paradigms of developmentalism are still deep within the psyche of Africa's elite. They serve as powerful warnings to 'outsiders' to keep their distance in the process of Africa's new theological leaders finding their own voice. The issues of whether this voice is necessarily fair to our common history, or indeed grounded within practical theological engagement, is not a question of much relevance in the project. For this call to 'rebirth' and to 'mid-wife' is the task of the priestesses of the homestead, to re-engage the divine for the well-being of the people and the land and not for an outsider, however empathetic, to assess (Hinfelaar 1994: 54).

The Circle's exponents place their theology as a prophetic call to the Church to include women in the project of nation and church building in the post-Independence era. At the Accra conference Oduyoye claimed that

> the canned theology from Europe was bravely swallowed [by Africans], but not applied, for to do so was to deny one's Africanness ... What Third World theology says to Western theology is that other voices must be heard because experiences vary. It is this same word that African women say to African men theologians. We live on the same continent and belong to the one church, but the reality is that there are many Africas—the Africa of the rich and the Africa of the poor, the Africa of men who command and that of women who obey is experienced differently. To all, we wish to say that a new factor has arrived on the theological scene in Africa—women who *write* theology and who have covenanted to articulate the concerns of women. All who call themselves prophetic theologians in Africa will have to reckon with this (Oduyoye and Kanyoro 1990: 41).

With this rallying call to prophetic representation, Oduyoye presents the Circle with the difficulty of the relationship of their theological process with the women they 'represent' and for whom they speak. This is always a difficulty of representation outside of voted delegations and is precisely one of the complications raised by Musimbi Kanyoro in her advancing of the 'cultural hermeneutic' (Kanyoro 1995). Kanyoro claims a new theological paradigm that recognises the 'cultural loyalties' felt by women and men, and refuses, in the first instance, to criticise cultural practices from any unitary standpoint of cultural superiority (Kanyoro 1995: 21). Cultural hermeneutics can only be exercised in an environment of 'mutual trust and

mutual vulnerability', and are designed to give hermeneutical prior-
ity to the actors within a cultural system rather than the audience
outside. However, 'where lives are at stake', there is a priority to
'break the vicious circle of women violating other women in the
name of culture' (Kanyoro 1995: 23). Aporia open up over the issues
of life, death and violence, at which point, however open to mutu-
ally enriching dialogue the cultural hermeneutic purports to be, un-
acknowledged commitments to universal goods of life, health and
women's control over their own bodies are brought into play. In this
sense the newness claimed for African women's theology looks some-
what less convincing and dependence on more recent western tra-
jectories based on a discourse of human rights and legal feminism
is surreptitiously in play (Kanyoro 1995: 21).

The difficulty for the Circle's theological project along the lines they
have set is both a certain naivety and the trauma of colonial deskilling.
Literacy, urbanisation, and access to the goods of world economies
(which includes the academy) sets them in a relationship of cultural
distance from the women for whom they claim to speak. A complete
survey of Circle membership and their academic qualifications has
not yet been researched and published. However all Circle members
must be literate in order to write papers and criticise them corporately
in a 'mutually empowering participatory model' of research (Oduyoye
1996c: 46). The injunction to 'research, write and publish on African
women in religion and culture in order to break the silence sur-
rounding women's lives' is pursued in regional Circles, with certain
writers achieving prodigious productivity (Oduyoye 1996c: 46).

In writing African women into theological existence, explicating
their social location, cultural constraints and religious proclivities, the
Circle is engaged in valuations, crusades and re-presentations in a
form which has been imbibed from the Western education they have
all received. This education was gained from mission schools, whose
influence they now wish to eliminate from the blood stream of mother
Africa. But such elimination cannot expunge the disease which has
now entered Africa's system. The 'neutral' voice of African critical
enlightenment is potentially as corrosive of African women's subjectivity
as was that of the 'white outsider', whether in the guise of Malinowski's
anthropological attentions or of the ubiquitous, and indeed histori-
cally indispensable, missionary recorder (Malinowski 1929).

The arguments of Vicky Spelman and Linda Hogan are instructive
at this point. These writers have queried the assertion of any type

of 'essential woman' or 'essential women's experience' from which
either to assert global solidarity or, as in Hogan's case, a universally
stable feminist theology (Spelman 1988; Hogan 1995). Hogan argues
that feminist theology is right to appeal to women's experience and
praxis but that it must be aware of its methodological implications,
namely, that these epistemological resources of experience are nec-
essarily fractured, limited and 'perspectival' (Davaney 1987a).

The relativism, to which the logical drive of naming the history,
diversity and particularity of women's experience inevitably moves
the project, is reclaimed from the jaws of political and transforma-
tional inutility only by an appeal to 'pragmatic, ethical foundations'
grounded in the 'experiences of communities rather than individu-
als' (Hogan 1995: 170). The difficulty is that these 'communities' are
as much constructions which silence and marginalise the multiple
relations of age, ethnicity, class and political power beyond the fem-
inist 'standpoint'. But, in order to be agents of change, some form
of 'metanarrative' and essential political or ethno-gendered interests
must be organised. As Hinga observes, 'the primary concern of
African women's theology is to voice their protest against sexism and
its roots in religion and culture . . . [it] is initially two-pronged, since
it is directed at both African religion and culture and [Western]
Christianity' (Hinga 1996a: 31).

Consequently, homogeneity of African women's experience is
asserted, rather than empirically tested, for strategic reasons of advo-
cacy and change. Circle theologians are caught in the eye of the
storm raging within feminist theory in the West. The nature of the
impasse is outlined by Nancy Fraser, Linda Nicholson and Susan
Bordo, who argue for effective social criticism from feminist theory,
which recognises the post-modern collapse of both metanarrative and
the knowing subject, without abandoning the resources of grounded
narratives to research for social change. Some form of larger nar-
rative is required, they argue, to explain interrelations and interde-
pendencies that mediate and deny power within political and social
systems, and to organise change politically. The utopia which is being
struggled for is based on liberal enlightenment ideals of freedom and
equality, but insists that the identity of human as white, male and
rational be broken open to permit the plurality and heterogeneity
of 'real-time' humanity (Bordo 1990; Fraser and Nicholson 1990;
Nicholson 1990).

Truth from Below

The method of the Circle theologians, however, is not merely to draw new boundaries around who is entitled to speak for Africa, and who is moved into the no-woman's land of mute outsider. EAT-WOT women's theology implicitly claims a privilege for the perspective of the non-white, non-Northern subject which, as communities of women within a 'patriarchal' economy, have 'a more complete vision than their oppressors' (Hogan 1995: 171; Davaney 1987a; Davaney 1987b). The 'truth' from the underside has fuelled both the launch and impact of the Third World theological enterprise. It is a pragmatic exercise that masquerades as virtually ontological. It presents modern feminist theology with an important challenge to its 'imperialist project', as it has been conceived in the last years of the second millennium, but at the same time tends towards a reductionist approach in the multi-layered entanglement of white women's missionary engagement in the late nineteenth and early twentieth centuries. Thus a new round of antinomies threatens to stalk Christian dialogue across peoples and nations.

Recent contributions from Hinga, Njoroge, Oduyoye and Kanyoro demonstrate an awareness of the epistemological difficulties entailed in nominating the 'African woman' and her 'experiences'. One can trace over time the increased carefulness with which people, place and time are located in their writings. However, attention to class, education and opportunity is not built into their analysis, and in an attempt to generate some sort of pan-African response to what is perceived as the continent-wide alienation of women from well-being and empowerment, the methodological carefulness required is often missed. What then comes into play is a hierarchy of communities, which perceive themselves in descending order of oppression. This is the location of the EATWOT women's theological network, where Third World is the oppressed world, and the interaction of internal gradations of power and oppression can be ignored in the light of the external monetary and military aggressor. This neatly arranges the closure of African women's theological discourse and resistance. It becomes its defining moment. The Circle's unity, its ability to generate a 'theology' amongst many competing experiences, is in its location as part of an oppressed continent, and, as women, an oppressed community within this world. Musa Dube's recent publication, *Other Ways of Reading*, whilst exploring alternative hermeneutical

devices such as divination, using African folk tales, therapeutic read-
ings and degendering the colonial God, still maintains this funda-
mental alignment of the exploited continent of Africa against that of
the colonising West (Dube 2001).

The 'Voiced' Elite and the Mute Majority

It is now evident that the primary part of the Circle's theological
task is that of political advocacy for Africa and for women in Africa.
In consequence, they are engaged in a fresh negotiation of the reli-
gious, social, political and ecclesial landscape in a continent emerg-
ing from a century of active colonisation. However, the neglect of
class and social hierarchies within African societies is a substantial
flaw. Lourdes Beneria and Roldan alert us to the privilege available
to some created by capitalism in Africa, and the gendered skewing
of power (Beneria and Roldan 1987: 7). A similar observation could
be made in relation to the African Christian world, where asym-
metrical lines of access and the enjoyment of economic, political and
religious privilege go relatively unchallenged. There is no doubt that
the business of being educated theologians puts Circle members into
an élite. The potential of 'exploitation' in this regard is common
across races, and the altered resources of undisclosed power forge,
perhaps, unwanted alliances resulting in women's effective manipu-
lation of other women's lives (Cock 1980; Ndegwa 1987). As Yuval-
Davis reminds us, arbitrary closures favoured in the creation of
identity politics

> have helped to obscure . . . class differences. These do not relate simply
> to the fact that Western feminists have usually been represented by highly-
> educated white middle-class women, representing a very specific view
> of women's interests, even of women from their own societies. Third
> World women are often represented by women who come from *even
> more* exclusive circles in their societies: in post-colonial societies they
> often come from the families of the ruling elites (Yuval-Davis 1997: 119).

In an early post-colonial study on the emergence of the educated élites
of Africa in 1966, Dr P.C. Lloyd commented that, although many of
its members came from rural homes and were born to non-literate
parents, those born to literate parents were sons and daughters of
the first colonial provincial élite: primary school headmasters, govern-
ment clerks, village catechists and church ministers. Limited access to

education has been the means of creating the élite, who enjoy the fruits of university education (Lloyd 1966: 20–22). This is a story which many Circle members share. The 'upper caste' within the Circle received sponsored education at their national or provincial universities or, as in the case of Hinga, Oduyoye, Mbuy-Beya, Nasimiyu-Wasike, Okure, Edet, Njoroge and Kanyoro, in Western universities.

Moreover, the fruit of such education, access to work within universities or in European headquarters for international Church organisations, is not simply fiscally rewarding. The debates of the West into which such privileged daughters are drawn are of a very different hue to the exigencies of life lived by the 'mass' of semi-literate women at home. Nevertheless, as Lloyd indicates, these élite citizens understand themselves to be acting on behalf of their kin and wider affine relations (Lloyd 1966: 31–33). In their turn, the ethnically differentiated 'mass' looks to the élite for 'leadership' in how to interpret the intellectual and social goods of the Western industrial world. This process of mediation and leadership is one way of interpreting the contribution of the Circle.

They are not, in the Western understanding of the word, 'representative' persons. The Circle's claim to be able to speak of African women's realities is based on historical methods of ethnic and kinship representation. It has an appealing simplicity but is flawed. At the most naïve level, not every people group in Africa is represented. From its inception there has been a preponderance of members from Ghana, Nigeria and Kenya. This is a reforming movement of a pan-African intellectual élite. It traverses state and church control through its conscious ecumenism. Its life is enticingly free and open. Here are African women responding to enlightenment paradigms: freedom, equality and, instead of a Cartesian sentient I, a proposed communal African consciousness which is written into existence.

How this way of 'doing theology' can be developed is a great challenge. Critical enlightenment theology will have the greatest difficulty in engaging sympathetically with a movement which seeks to unravel the hierarchy of reason through its assertion of radical equality in theological contribution no matter its provenance or form. Of course, the challenge is not simply restricted to whether this is a theological rhetoric with a strategic end of gaining a voice, or a serious reconstruction of the acceptable forms of theological voice. To deconstruct educational differences and evolve a form of educational enterprise which engages the whole nation in its quest for

development would threaten the current élite-making mechanisms of Africa derived through the economically selective school and university. Deconstruction of this kind is not presently in serious evidence at a pan-African level. However, there is an incipient call in Circle writing for such a move (Nwachuku 1990: 42–44; Tetteh 1990: 157; Oduyoye and Fa'atauva'a 1994: 171–172).

Pluralism, Christ and Culture

The terms of the engagement with Islam and ATR vary across the Circle. It is important to recognise the heterogeneity of Circle members in terms of denomination, culture and vision. There is no common creed attached to Circle membership: nothing apart from a commitment to 'write African women back into history', and bring hope for women within the contemporary African world (Kanyoro 1994a; Kanyoro 1995: 27). The critical point of departure is the 'two-winged theology', women working in co-operation with men of good will for the reconstruction of a cultural and religious praxis of sexual equality. This flight-worthy theology has the credentials to criticise culture and religion from the perspective of 'Christ as the norm for the fullness of the human being' (Oduyoye and Kanyoro 1990: 27; Oduyoye 1995c: 168). The contemporary western debate on the gender of the human Jesus is not an issue in which the Circle chooses to invest much time. Rather Oduyoye, as we have seen in chapter three, exploits the person, actions, teachings and resurrection of Christ as a powerful means of criticising women's oppression within contemporary Africa. She boldly invites assessment of their theological project by the template of Christ, his values and his praxis of justice-making (Oduyoye 1995c).

Richard Niebuhr undertook a similar gender-free critique on the person of Christ in his work on the inter-relation of Christ and culture immediately after the Second World War. Niebuhr understood the relationship of Christ to culture in five categories: ranging from the category of Christ affirming culture to Christ absolutely over and against culture (Niebuhr 1952: 26–58). Of the five main alignments of Christ to culture indicated by Niebuhr, I suggest that there are responses amongst Circle members in their writing which would happily rest in three of them. These are Christ against culture, Christ seen as the 'converter of man in his culture and society', and Christ

in agreement with culture. In this last, his teachings and life are 'regarded as the greatest human achievement' and it is the foundation for identification of both the oppressive relationship between Christianity and Western civilisation and the over-determined relationship between democracy, Jesus' teachings and the 'spirit of Marxian society' (Niebuhr 1952: 54–55).

The difficulty is that the categories by which Oduyoye criticises the religious praxis of the mission churches today are unclear. At one point she is clearly in the same theological stream as her male African theological mentors and peers who assert cultural paradigms as part of the liberational theology for contemporary Africa. Yet Oduyoye is forced to critique many of these cultural norms as those which impede women's well-being and developmental aspirations. Her assertion that 'Christ is the norm for the fullness of the human being' is threatened with cultural usurpation when certain African cultures (particularly those of matrilineal societies, such as her own ethnic group, the Fante, and the Brong) are privileged. These groups seem to be a litmus test for the critique of other cultures, because of their affirmation of women and their robust community ethic. Her work is disturbingly unclear as to the hierarchy of paradigms of her critique. When is Christ above culture, and when is Christ beneath culture? For instance, Oduyoye finds certain uncomfortable teachings about the priorities of allegiances in Luke 12: 49–52 offensive to the higher good of African cultural imperatives of family and clan (Oduyoye 1986a: 110, 116, 117; Oduyoye 1991: 468, 475).

This ambiguity is resolved by Oduyoye in arguing for the incorporation of Africans both into 'the Church and into Christ without giving up their incorporation into their human family' and its traditions. She renames the idols and idolaters beloved of the early missionaries. They become the 'idol called state security and the devil's own symbol, material wealth', emanating from the source of so many distortions, the West (Oduyoye 1986a: 118).

We see in Oduyoye's work an attempted resolution of the Christ and culture debate in terms first proposed by John Pobee in *Skenosis: Christian Faith in an African Context* (Pobee 1992). Through *skenosis*, Christ and Christianity domicile in African cultures and criticise one another. The terms of the engagement are, unfortunately, never adequately defined by Oduyoye. This may be because Oduyoye is impatient with the intricacy of the intellectual project whilst 'other African Christians are in the process daily of shaping a Christianity that will

be at home in Africa and in which Africans will be at home' (Oduyoye 1995e: 75).

The nearest working definition to the project in hand is the imperative of 'the Religion of Jesus Christ' (sic) or the 'Christ-event', which describes the essentials of the Christian mission, to be shaped in 'African moulds' whilst the 'gospel' be liberated to 'speak in and to Africa' (Oduyoye 1995e: 77). Christ is radically differentiated from the Church and his disciples across history. This view has similarities to that of the Reformation, in which the true kernel of biblical teaching was that which delivered Christ and salvation from the perceived constraints and corruption of the Church.

Oduyoye is the Priest-Politician, mirroring the achievements of her maternal ancestor Okomfo Anokye, who participated in the unification of Asanteland. She is the bringer of a second Reformation in African theology, which radically separates Christian allegiance from the ancient 'mother' churches, and frees Christian living for incorporation into the task of nation-building and cultural affirmation (Oduyoye 1986g: 2, 3; Oduyoye 1988c: 36). Gospel is closely aligned with the best in African culture for Oduyoye. She claims this analysis for the Circle: the gospel is that which promotes 'justice, compassion, community' (Oduyoye 1996c: 46). Circle women, Oduyoye affirms:

> go beyond juxtaposing gospel and cultures. We propose a move towards 'gospel culture': a way of life creatively crafted from the humanising elements of African culture and church culture. If the Christian gospel is good news, then there is much in our cultures that it should challenge and much in African culture that it could absorb to augment and enhance its transforming powers. 'Gospel culture' will evolve when we are rid of all that negates fullness of life and blasphemes against the image of God in humanity (Oduyoye 1996c: 47).

The Imperative of Christ

The plurality of the Circle, its lack of strict homogeneity and yet its unity in some of the central signs is no more clearly demonstrated than in attention to the imperative of Christ in their writing. Apart from those from other faith traditions, most writers ground their work at some point in the power of Christ. In an ecclesial economy where women trained in theology have been struggling for ordination over the last two decades this makes a great deal of sense.

The authority of Christ is set over and against the voice of ecclesial tradition and the interpretative framework of male hierarchies of knowledge (Bam 1970; Umeagudosu 1990; Owanikin 1992: 215–217; James 1996). Moreover, John Mbiti reminded his readers during the heyday of inculturation theology in 1970 that the 'final test for the validity and usefulness of any theological contribution is Jesus Christ. Since his Incarnation, Christian theology ought properly to be Christology' (Mbiti 1970: 190). As we saw in chapter two, most of the inculturation and black theology debate was worked out in relation to the 'gospel of Christ' and the significance and utility of Christology for African liberation in church dogmatics, praxis and cultural memory. As Burgess Carr has said, 'the gospel of Jesus is an ideological framework for [Africa's] struggle for cultural authenticity, human development, justice and reconciliation' (Carr 1974: 78).

In the writings of the Circle there are elements of a Christology based in women's experience that may announce a new point of departure in African theological reflection. Oduyoye, Amoah, Thérèse Souga, Edet and Kanyoro have written specifically on the implications of Christ for the lives and empowerment of women, and the development of an African feminist Christology. For Western feminist thought it is interesting to hear Musimbi Kanyoro claim that the 'message of the Bible is one of the most powerful means of [women's] empowerment' (Kanyoro 1996b: 158). This, for her, is due to the biblical image of the radical equality of men and women's creation in the image of God (Genesis 1: 27–28) and the 'Jesus hope'. It is the 'model of Jesus' treatment of women ... where he listened to women and women contributed to his understanding and shaping of his own ministry' which Kanyoro takes as giving fresh authority and urgency to the question 'why do many women throughout the world live in poverty?' (Kanyoro 1996b: 159).

On the other hand, Mercy Oduyoye dissociates herself from the 'androcentric Bible and Church', whilst affirming the 'Christology of African women ... centred on Jesus, friend and liberator, who upholds the dignity of the humanity of women' (Oduyoye 1997a: 202). This is to echo the observations of Teresia Hinga in *The Will to Arise*, where she observes that 'Jesus as a personal friend has been one of the most popular among women precisely because they need such a personal friend most ... The image of Christ who helps [women] bear their griefs, loneliness and suffering is a welcome one indeed' (Hinga 1992b: 191).

Jesus, then, is a source of support in the contemporary difficulties that women suffer in modern Africa, and one of the sources for the hope of liberation, through the power given through his words, actions and the Spirit of God. We have seen in chapter three how Mercy Oduyoye's justification of theology is to see 'what God is doing in the margins of society and from within the suffering of people in history' (Oduyoye 1990b: 81). Jesus is seen as empowering Galilean peasants' struggle for a better life. Similarly, the mission of the Church and Circle theologians should be to empower women in their struggle within home and society (Oduyoye 1990b: 79).

Within Catholicism, Rosemary Edet spoke of a Christ who exemplified the androgynous nature of God imaged in the creation of bi-sexual humanity (Edet 1985: 18). This leads to her development of a theology of endearment and tenderness, understood as specifically feminine virtues for her theology of God, who cares as a mother for the suffering and continued oppression of Africa (Edet 1990a; Edet 1991).

The Circle writers believe that African women have a new contribution to Christology. This is because 'God in Christ suffers with the women of Africa'. In their joint article for the first EWC, Elizabeth Amoah and Mercy Oduyoye declared that: 'An African woman perceives and accepts Christ as a woman and as an African'. They saw Christ as the one who offered liberation from the 'patriarchal' assumptions of many African cultures and offered his own 'mothering' of them through their alienations. This was to include the 'sanctifying of the single life as well as the married life, parenthood as well as the absence of progeny' and a command to resist 'human suffering and especially the acceptance of limiting conditions' (Amoah and Oduyoye 1993: 38).

The Dignity of Women

Circle writers continually remind us that they are women who can stand straight with pride. This is done by the use of histories and mythologies of the past, most notably by Mercy Oduyoye in *Daughters of Anowa*. The recapturing of strong myths and legends to affirm women was encouraged by the EWC at the end of Oaxtapec in 1986. Nyambura Njoroge's research into the formation of the Women's Shield in resistance to circumcision can also be seen as part of this recovery of dignity and agency.

Theologically, Christ is frequently alluded to as a source of dignity, as women discover the source of their social alienation removed by his touch, their maternal authority affirmed, or their racial inferiority removed. One of the most interesting theological studies to address the damage of colonialism and 'patriarchy' within African women's Christianity has been Sr Teresa Okure's paper on the apostolic commission to Mary Magdalene. A woman is the first apostle of the resurrection, the first to receive the declaration of the status of 'daughter of God' and a 'sister of Christ' and the one who, as a woman, was commissioned to bear the foundational message of the resurrection to the community (Okure 1992a: 182–185). The insight of Okure is that, through the Eucharist, the blood shed by Christ on the cross unites all humanity into a new family of brothers and sisters called to a communitarian life ethic. This might yet serve as a means of delivering not only dignity to African woman but co-operation and trust across the divisions of history, economics and race.

In the final document of the Oaxtapec consultation of the EWC, the delegates announced a new way in which women from the Third World were undertaking theology. They claimed that,

> The passionate and compassionate way in which women do theology is a rich contribution to theological science. The key to this theological process is the word LIFE. We perceive that in the three continents women are deeply covenanted with life, giving life and protecting life (Fabella and Oduyoye 1993: 188).

This belief that a new way of doing theology, which is passionate and compassionate, has been 'birthed' by Third World women, is one to which Circle members themselves subscribe. The theology of the West is seen as 'rigid, cold and purely rationalistic', lacking connection with the heart of the Hebrew story where we find 'a God of compassion who suffers with the world to keep it from falling apart' (Oduyoye 1986a: 67; Fabella and Oduyoye 1993: 188). Feminist insights of 'relationality' are added into the mix of asserted African world-views of persons-in-community and compassion (Oduyoye 1986a: 43).

The emerging theology of the Circle, particularly that of the Protestants, is, therefore, intimately associated with theologians from the Third World who have developed a paradigm for theology which is ultimately separable from Christian theological moorings. It is a theology of passion and compassion: that passion is not exclusively or necessarily linked to the passion of Christ. Rather, it shares fundamentals with the passionate desire for 'liberation', for 'justice' or for

'women's empowerment'. Moreover, note well the cluster of morally superior qualities it amasses; it is passionate, engaged with the emotions and the 'love of life'. It shares no part of the cerebral, 'dogmatic', calculating and ultimately death-dealing practices of the West.

We see here the subtle dualism which is set in motion by this ascription of the emotional commitment to life to Third World women and the apportioning of cynicism, ill will and abuse to the West. In order to develop a theology of passion and compassion there is, therefore, an inevitable separation from Western theological models and white Western academics. In some instances this separation is almost complete. The 'tense truces' recognised by Letty Russell and Ursula King at the Costa Rica conference of 1994 are a consequence of this way of setting up the relationship of Third World theology with that of the West (King, 1996: 151; Russell 1996: 20).

The gospel account chosen as the symbolic base for this theology is the 'action' of the woman in John 12: 1–8 and Mark 14: 3–9. This is a significant portion of the Western feminist theological canon, having been exploited by Schüssler Fiorenza in her ground-breaking study *In Memory of Her* (Schüssler Fiorenza 1983). EATWOT women reinterpreted this passage to announce their passionate love for Jesus, compassionate 'attention to the poor' and to 'exhort [the community's] solidarity with them' (Fabella and Oduyoye 1993: 190).

Catholic women amongst the Circle are committed to this 'passionate' love for Christ. They have worked extensively on the commitment to life, particularly a reinterpretation of motherhood as a life-giving motif for all women after the pattern of Mary, mother of Jesus, and the new Eve (Okure 1993c). The virginal status of Mary as a mother gives theologians like Okure a vantage point from which to critique the 'universal phenomenon of the plight of woman in marriage', whilst retaining woman's 'maternal role'. Women are life-givers, bringers and sustainers, like Eve and Mary. It is their vocation to be God's 'privileged instrument for conceiving and bringing forth life'. 'No sane woman, and certainly no African woman, would see anything belittling or derogatory in motherhood per se', argues Okure (Okure 1993c: 55). In this attention to the maternal dimension of women's lives and giftings, there is room for seeing one of the central paradigms for African feminist theology emerging from the Circle, certainly a dominant motif amongst the Catholic theologians who have reinterpreted biological barrenness as one of spiritual fecundity.

There is a general resistance to seeing women's reception of bodily violation as in any way salvific for the community. This has been

the case in African traditional religious teaching and in pastoral practice in some churches in relation to violence within marriage (Oduyoye 1988c; Mombo 1998). However, when linked to the language of struggle (a key metaphor for the Circle and EATWOT—specifically struggle for the reign of God) and the commitment to 'bring about life' from 'an intelligent and consciously chosen path of self-sacrifice', then this is 'rooted in the Paschal Mystery' and evocative of the 'rhythm of pregnancy, delivery and birth' (Oduyoye 1990f: 47; Fabella and Oduyoye 1993: 188).

Birth indicates woman's wholeness, as does her pregnancy; the 'wholeness of both the woman and the man', and this birthing in itself is part of the wider struggle of the passion of Christ giving life to the world (Oduyoye 1986c: 42; Oduyoye 1992e: 22). This language of birth, passion, crucifixion and resurrection merges to create a rich matrix of meaning for Circle theology, where talk about Jesus and his death and resurrection is translated into a fresh valuation on women as those who suffer, struggle and are part of the agency of creating a new way of life. This life is based on women's partnership with men, participating in non-hierarchical relationships, released from the constraints of ritual taboos, and enjoying economically and politically autonomous relationships within economically liberated societies. Jesus, claims Oduyoye, leaves the disciples to bring them a 'religion of total dependence on God' (Oduyoye 1986c: 43).

Denominational Differences in the Multiple Identities of the Circle Project

The most noteworthy difference between Circle members is the difference in approach between Protestant and Catholic writers, notwithstanding the presence in the Circle of a handful of Muslim, Hindu and ATR members. The *Weltanschauung* of the Catholic religious sisters has been described in chapter four. The invisible hand of the Vatican is omnipresent. Rome has not been coy in denouncing or controlling the voice of dissidents within its ranks, as in the 1997 excommunication of Fr Tissa Balasuriya (Stanton 1997: 233).

This is not to say that any of the Catholic theologians involved in the Circle modulate their contributions on the side of received orthodoxy, but it does recognise the very different constraints which are involved in their theological exploration and pronouncements from those of their Protestant sisters. To a lesser degree this holds

for ordained members of the mission churches. It must be remembered that this contextual theology is implicated not only in the reconstruction of the imaginative possibilities of continent-specific churches, theologies and liturgical practices, but also the political and legislative arrangement of society. This then is an 'engaged' theology, which enters the public domain as a criticism of the political, ecclesiastical, economic and social power relations situated in gender, race and the post-colonial metropoles.

The Catholic Circle members affirmed the active enablement of lay participation in the process of the *Lineamenta* and joined the call for the African Synod of 1992 to be held in Africa and not the old centre of Rome. Their inspiration for women's empowerment is located in the person of Mary, yet without disrupting Marian dogmas, the dominical commands and actions of Jesus, the power of the Spirit of Pentecost, and their own experience of inter-racial sisterhood and support. They have all enthusiastically embraced an evangelistic relationship to culture and inter-faith relations as described in *The Church in Africa and her Evangelising Mission towards the Year 2000* (Synod of Bishops 1990; Okure 1992b: 4). In this they follow the lead of *Evangelii nuntiandi*, where Pope Paul VI declared the Church to be *tota orbe diffusa* with individual churches putting down 'roots in a variety of cultural, social and human terrains, (where) she takes on different external expressions and appearances in each part of the world' (Paul VI 1975: 30).

So then, even when Anne Nasimiyu-Wasike pronounces against patriarchy within the Catholic church she does so from the basis of 'Christ's call to newness of being or becoming ... new images in the Bible ... based on partnership relationships and on mutual responsibility ... [in response] to contemporary needs and visions of the Church's ministry' (Nasimiyu-Wasike 1990c: 38). All their work is informed by papal letters and initiatives, and their tone of response is typified by a statement following a citation of Pope John Paul II's apostolic letter, *On the Dignity and Calling of Woman*. Sr Mbuy-Beya comments on the Pontiff's assertion that 'the dignity of woman is measured in the order of love, which is essentially an order of justice and charity':

> In the light of the foregoing, we feel a profound gratitude to the dioceses and societies that have dared to assert themselves and help women acquire an awareness of their dignity. In the Church as in the world,

men and women are called to fulfil themselves not in opposition, not in rivalry, but together, with and facing each other, in marriage as in friendship or work (Mbuy-Beya 1992a: 175).

Although Nasimiyu-Wasike is critical of the impact of Western Christianity and the domination of men within the ecclesiastical system, attacking 'clericalism', 'patriarchy' and 'paternalism', there is a marked lack of the language of 'racism', 'colonialism' and 'sexism' favoured by Protestant Circle members (Nasimiyu-Wasike 1990c: 68; Hinga 1996a: 31). Whether this difference in tone can be ascribed to the geographical and cultural intercommunion within the Church which the Catholic sisters experience, or their personal histories of life in communities with white religious, is a subject for further research. Certainly, it is important to understand the new respect afforded to Catholic religious as women who are 'mothers of the spirit [*mama moyo*]', are 'married to Jesus' and who 'bear children for the Church' (Burke 1993: 257; Mbuy-Beya 1994; Smythe 1997: 13). Catholic women, accordingly, are at the heart of inculturation as they spiritually bring to birth the next generation for the Church in the blood and skin of Africa. These women have a clear identity and understanding of their mission. Their principal identity is as those who have 'married' into the Church of Christ and have a commission to bring justice, heal and teach the doctrines of the faith in a way that liberates the people they serve.

It is the Catholics who have worked particularly with the fifth element of EATWOT's women's programme with its encouragement to reconsider the empowering potential for women and theology of Marian devotion. Mary is the source of their reflection and imagination rather than the myths and heroines of their people's past. Devotion to Mary and her Son dominates their imaginative reconstruction, and has kept the difficulties of cultural dialogue with the ancestors, leaders, deities and leaders of ATR somewhat muted.

Maternal Thinking

I have been challenged again and again in the process of researching this book by the variety of ways in which women across racial, religious and cultural divisions have negotiated the category of motherhood. 'Social motherhood' was exploited by single white women

in the nineteenth century as a way of handling the expectations of
their own Western Christian culture for female maturity, and eased
their reception into other cultures where 'motherhood' was the sign
of 'womanhood'. Early North Atlantic women such as 'Ma' Slessor,
Mabel Shaw, Mother Kevina and Maria Fearing disrupted and
affirmed the importance of extended family relationships and the
possibility of women's personhood and agency apart from marriage
and reproduction (Livingstone 1923; Buchan 1980; Shaw 1921;
O'Hara 1975; Oliver 1982; Jacobs 1982). However, inasmuch as
Africans were placed within a hierarchy dependent on both a 'mother'
church in the West, and Western mothers as the domestic purvey-
ors of a new 'civilised' mode of social organisation, this form of
engagement with the missionaries was antithetical to Christian ideals
of equality. This has left Circle women ambivalent about the impact
of Christianity on their own lives and their world. As Teresia Hinga
observes, 'Christianity functioned to legitimise colonialism, racism
and sexism', and yet 'many African women have appropriated for
themselves the gospel of liberty implicit in Christianity as a strong
motivating force in their struggle for liberation' (Hinga 1996a: 31).

The lens of motherhood is one which casts new light on the ide-
ological exchange involved in Africa's encounter with Christianity
over the last century. The struggle in the 1920s in Kenya over female
circumcision was, as we have seen, sited around national identity
and health. Both missionary and indigenous resistance to circumci-
sion was substantially on the grounds of securing health for the
birthing mother, with Galatians 3: 28 as the text which undermined
the requirement for separate national identifiers cut into women's
and men's bodies. On the other side, the insistence on female cir-
cumcision from voices such as Jomo Kenyatta's was concerned with
the survival of the Gikuyu 'nation'. The circumcision ritual was for
him 'one in which the children have been born again, not as chil-
dren of an individual but of the whole tribe' (Kenyatta 1938: 157).
Both the physical pain exacted on the young girl, and the subse-
quent risk to childbearing was subservient to the larger project of
nationhood and the identity of a people, in whose life the welfare
of the woman was symbiotically linked (Kenyatta 1938: 162).

This submission of women to a social construction of motherhood,
which entails exponentially more than a simple one-on-one biologi-
cal reproductiveness, and incorporates women into a wider project

to 'mother' a people, has occupied feminist scholars studying nationalist movements and the construction of womanhood since the 1970s (Ngwenya 1983; Jayawardena 1986). Women have been embroiled in what Nira Yuval-Davis has called the 'multi-dimensionality of Nationalist projects', by turns subverting, reconstructing and being absorbed into them (Allen 1976; Kanogo 1987; Yuval-Davis 1997: 20).

Mercy Oduyoye exploits Asante genesis myths, which explain the division of the Asante into different but connected *abusua*, to provide women with identities as mothers apart from biological reproduction. Age-sets, rather than individuals, carry the responsibility of raising the next generation for the Asante. Oduyoye privileges African commitment to 'motherhood' within the social and religious imagination by effectively prioritising social over biological motherhood (Nyamiti 1985). She sees 'mothering as a religious duty ... what a good socio-political and economic system should be about, if the human beings entrusted to the state are to be fully human'. This, then, is used to propose an 'empowered' women's contribution to the theology and politics of Africa as essential to re-establishing 'life-loving' rather than death-dealing alliances, and lead the recovery of Africa (Oduyoye 1989c: 23, 30; Oduyoye 1990f: 43; Oduyoye 1996b).

As personal interviews and Circle writing shows, the issues of childlessness and singleness remain contemporary struggles for African women. Oduyoye's perspective of social incorporation is limited by the cultural diversity of the continent and remains more of a vision than a statement of reality. The area of childlessness and singleness has been most creatively dealt with in the refiguring of motherhood as a social rather than a biological matter by the Catholic members, although the model is probably only effective for those who become part of religious communities. As seen in chapter four, young girls, runaway wives and widows became part of Catholic religious sisterhoods as small missionary communities established themselves in their areas. We agree with Larrson that religious sisterhoods offered a way of 'marriage protest', educational improvement and freedom from 'orbits that revolve around men' (Larrson 1991: 207).

The transference of marriage rituals and customary exchanges of male authority to that of the Church, recounted by Smythe in *Mother or Mother House*, could be seen as the transfer from one sphere of gendered bondage within a patriarchal organisation to another. Even today, Mbuy-Beya protests against the use of religious as 'personal

housekeepers of the bishop and the local clergy' (Mbuy-Beya 1996a: 184). But there were, and still are, cracks within the process of exchange which allow for genuine agency.

One of the most fascinating transfers of meaning is the transformation of the Virgin Mary in the hands of Okure and Nasimiyu-Wasike, from a frequently somewhat estranged parent in the religious imagination of the West to an icon of a powerful, initiating mother. Mary is the type for the perfected fertility of African religious. African nuns are not barren women. Instead, along with the Mary of Catholic dogmatic teaching, they partake in the plenitude of fertility, so that they are in effect 'mothers of the people' and sources of well-being and protection for the whole community. Looked at another way, however, the transference of women's fecundity, work and productivity into the Catholic church, signified as in the case of the payment of bride price and the reception of a ring, of Fipa nuns previously discussed, is an extraordinary religious inculturation of local and colonial marital exchange rituals. Both are held in the symbolics of virilocal marriage. Heterosexual power relations are sustained through the authority structures of Catholicism, maintained through the control of the Eucharist and the definitive statements of Bishops and Vatican councils being at present firmly in the hands of men. The rupture of the male-stream is therefore only partial in this religious imagining of contemporary Africa.

The Church Universal and Local

One of the key challenges facing Circle theology is how it can both engage in its own context and continue to speak to the Universal Church. Circle theologians broadly work with the considerations of locality and culture as primary categories for theological reflection. In this, they are in continuity with their male counterparts in many of the theoretical tasks of establishing African theological identity. The development of 'Third World theologies', privileging context, motifs of liberation and ethnographic considerations, has been one of the great movements in theological endeavour in the twentieth century. How the 'new' churches and 'contextualised', 'inculturated' and 'indigenised' theologies relate to older identities, formed around ancient ecumenical creeds and Greco-Roman polity, has, however, yet to be adequately theorised.

The last twenty years of the second millennium witnessed something of a stand-off between North Atlantic theologians and their 'Third World' colleagues. It left the ecumenical hopes of the early Faith and Order Commission in some disarray. Their vision of the 'necessity of Christian unity' founded on Christian truth to be 'announced with sincerity' by all churches, 'on the basis of their common faith in their Lord and Saviour, proclaiming their certitude that the kingdom of God alone can save the world' was effaced by a multitude of voices and contexts (Balanos 1927: 505). In the heady days of 1927, the idea of a unifying truth which could be translated across cultures seemed a genuine possibility, limited only by the practical difficulties of wilful adherence to institutionalism, spiritualism and a pervasive refusal to love one's neighbour (Schmidt 1927; Söderblom 1927: 322–24). The intellectual climate of the post-colonial world is very different. Unity has become synonymous with imperial ambition, sustainable only by the suppression of the voice of the 'other'. The works of post-modern critics Jean-François Lyotard, Michel Foucault and Jacques Derrida, and the post-colonial criticism of Edward Said and Samir Amin, have had an impact on the viability of Western claims of objective unity, truth and freedom.

Protestant Circle theologians have trained in North American academies which work with a politics of situation. Positionality and national multiculturalism have fused this with a modern insistence on the homogeneity of the African female subject in the face of international economic disorder. The dominant theological motif is that of international oppression rather than intranational oppression. Intranational oppression exists and is addressed by Circle writers, but the big enemy, the new 'other', the ultimate cause of the oppression, is perceived as deriving from international unities masquerading as friends. Most effective among these unities, in their mind, in infiltrating African cultures, has been that of the Western missionary enterprise of the nineteenth century, and its modern equivalent, denominational missionaries and international institutions such as the LWF, the Lambeth Conference and the WCC. Henry Louis Gates and Cornel West have words of warning within the American Academy about the terms of inclusion of women and 'people of color' within scholarship, alerting the American Studies Convention to 'the invocation of oppression', which was seen as 'a game of academic one-upmanship', whilst the streets outside saw 'half of the black children in this country below the poverty line' (Gates 1990).

In 1927, Nathan Söderblom offered the churches a model for
international communion in his idea of incarnationalism, a term vig-
orously reiterated by the Catholic Bishops of Africa at the Roman
Synod in 1974. Incarnationalism allows for the differences of cul-
ture, nation and histories to be uniquely captured with the apostolic
announcement of the divine word, and offers a way forward in think-
ing out plurality and unity. This is because the unity of identity is
located in the one confession of Christ, but plurality obtains in the
worship of the churches and the witness of Christians in their var-
ious cultural understandings and outworking of their encounter with
the resurrected logos of God (Söderblom 1927: 325). There will be,
because of the diversity of our cultural, gendered and socio-economic
situations, a plurality of 'incarnations' of Christianity in energetic
response to the *kerygma*, the reception of the Spirit of Christ amongst
believers, and their hopes of the coming Kingdom of God specific
to their socio-temporal location.

Söderblom's delicate balancing of culture and confession is expo-
nentially more difficult to achieve in a post-modern world than hereto-
fore. The privileging of context over against the unity of creed has
meant that difference speaks first and loudest: material inequalities,
historical silencing, the embittered place of exile and the erasure of
colonisation. This has now become a dominant mode of encounter
in the EATWOT and Circle frame of reference. The hope that
Christian *philadelphia*, love of siblings, generated by consanguinity as
sons and daughters of the living God, might be the means by which
the disunity and anguish of the world could be overcome by the
unam sanctam, the one holy people of God, seemed palpably close for
some of the delegates in 1927. Now it seems to have been lost in
a discourse which casts international church relations in the gram-
mar of difference, disunity and distrust.

This fracture of first and Third World dialogue has been experi-
enced in other spheres of academic, political and economic exchange
apart from the ecclesial and theological. Yuval-Davis comments on
the 'non-dialogue' in international conferences amongst women from
the late 1970s onward (Yuval-Davis 1997: 117). Non-dialogue, she
claims, is, in part, due to Third World women feeling their cultures
'frozen' into categories of barbarity, with themselves as specimen
counter-examples emerging from gendered subjugation. They were
the mirror, the negation of free white liberal democracy, immobilised

by the totalising vision of the schoolmarms of second-wave Western feminism (Yuval-Davis 1997: 118).

It may well be in a vigorous debate on the constructed and uncertain foundations of identity that movement forward for church unity can yet be made. If all identities are ultimately constructed rather than essential, then the chosen hierarchy of identity is of ultimate significance. Ancient Christian confession to the Lordship of Christ, over above the political identity given by Caesar or the cultural identity ascribed by the Jewish law, points to a foundational new identity adopted at baptism of being 'in Christ'. The reaffirmation of this hierarchy might well pave the way for a fresh apprehension of a unified Church in a common quest of discipleship.

Oduyoye, Hinga and Zoé-Obianga set their discourse on these terms of difference and a history of alienation. Struggle for an alternative account of Christ freed from the *unam sanctam*, from the 'dogmatics' of the imperial, 'patriarchal' Church and Western theologians, locates their project as a form of identity theology. They have privileged their search for autonomy and cultural recovery over the Pauline injunction for *philadelphia*, the end of hostility and a new identity in Christ (Galatians 3: 28).

Generalisable Interests:
The Well-being of the African Woman and the Well-being of the World

The fundamental creed of the theology of the Circle is to secure the 'well-being' of African women, and through her the well-being of the whole community. Peace for the continent and peace for her women from violence and the disruption of war and economic dislocation is the desire of these vision makers. These themes are apparent in the Circle writers we have surveyed across the denominations. Woman's well-being is secured in her immediate domestic and religious situation as well as through the political, economic and health provisions of governments. The implication of this is that a substantial part of African women's well-being has a dependency on the global domain. As Adrian Hastings points out, AIDS, international indebtedness, the removal of Russia's interest in Africa and the consequent cooling of the West's strategic concern in Africa, academic flight to the global North, book and harvest famine and Structural Adjustment

Programmes (SAPs) have resulted in the fact that 'no part of the world has been worse affected than Africa by [the] developments, both mondial and local, of the last two decades' (Hastings 1997: 187).

There is a political, moral and theological challenge in this situation. Oduyoye's strategy, which has been a consistent theme of her work since *Hearing and Knowing*, is for Africa to find its strength, resources and well-being from within the continent. Recent developments at EATWOT have encouraged this approach, not only in the realms of theological separation based on the dualism of the oppressed and oppressor, but now in a new economic analysis of rupturing economic dependency through the fostering of strong internal markets. Oduyoye, with much justification, has looked at the result of four decades of co-operating with World Bank initiatives and over a century of desire for the white man's goods and has concluded that the *kairos* demands a thoroughgoing independence and separation, a decolonialisation of hearts, minds and bodies to ensure Africa's health (Oduyoye 1997a).

Circle theology is rightly characterised as the activity of 'concerned' theologians. It is an engaged vigorous movement which is breathing new energy and life into the African theological project, whilst at the same time making clear some of the 'theological pitfalls' in its wake (Kato 1975). The 'essentially contested' nature of Christianity, to which Stephen Sykes has drawn attention, is held together by 'the conviction that the contest has a single origin in a single, albeit internally complex performance' (Sykes 1984: 254). Perhaps we need to add that Christians, and not simply the story, are held together by being owned by that story. They are held by having their core identity affirmed in the complex narrative of Christ and his life, death, resurrection and the commissioning of the disciples by the Spirit. This is the universal that has the potential of enormous diversity but also inner connectedness, across time, geography, race, gender, class and ethnicity.

The story of Christ is present in the writings of all the Christian participants of the Circle. However, the 'pitfalls' of where core identities are to be asserted is not so clear. The Barmen Declaration of May 1934 asserted the centrality of Christ and the repudiation of 'human self-esteem, [which] can put the work of the Lord in the service of some wishes, purposes and plans or other, chosen according to desire' (German Evangelical Church 1934: 522). Here the struggle was with the powerful national rhetoric of the Third Reich and

the collusion of the German Church. The struggle of particularity, whether of land, race, gender or social status, against the universal paradigm of the Church has been problematic throughout history. There is necessarily within African theology a tendency to privilege particularity, on which Oduyoye's work as a neo-liberal Methodist flourishes. The high imperial era presented an overwhelming meta-narrative of white supremacy and civilisation against barbarity, out of which African theology and Circle theologians have been struggling to create counter-narratives which retain their own sense of history and identity. Within the Circle there are a variety of theologies being developed which are largely dependent on denominational differences. Circle theology is unlikely, therefore, to become an extended incul-turation of Asante feminist cosmology for Africa. Christian theology is a constant intra-national, international and trans-historical engage-ment with the 'complex performance' of the person of Jesus Christ embedded in Jewish exile, colonisation and Roman imperial history. It possesses also enormous resources to move Christians towards a theological engagement which insists on contemporaneity, not least in the shifting allegiances and socio-political alliances entailed in the struggle for justice, and the love imperative with its inner dynamic of inter-subjectivity and gravitation towards a common vision.

As we enter the first decade of the third millennium with all its challenges of globalisation, genocide and gender pressing in from the last century into our present, the future direction and long-term con-tribution of Circle theology is not clear. Profound changes across the continent: unprecedented political and economic instability, traumatic civil wars, concomitant child soldiery, millions of displaced people, above all women and children, the ravages of endemic HIV/AIDS, all these have drained GNPs and undermined even the aspirations of Southern Africa's hope-filled journey out of apartheid. Africa's states, churches, mosques and people are experiencing extraordinary, unrelenting stress. Can the daughters of Africa arise through the prophetic call of the Circle and rework ancient powers as peace-makers in their sanctuaries and political corrals? Will their brothers, as part of the broken winged bird, participate in the healing action of the Circle's words and run together to bring Africa to robust flight? Such reconciliation calls forth the intellectual and moral ener-gies of all who are concerned with the welfare of our interdepen-dent world. It is a struggle which involves more than one continent alone. The last word should be given to the Queen Mother of the

Circle movement: 'The real problem,' Oduyoye reminds us, 'lies in the eradication of [those] forces that work against the solidarity of the human race. It is a challenge to build a reconciled human community in Africa' (Oduyoye 1982b: 179). It is in the quest for such solidarity that this work has been undertaken, and in a continued struggle for its realisation that we are challenged to continue, once these pages have been read and the covers closed.

BIBLIOGRAPHIES

Literature by and about the Circle

Abbas, W. (1996). Conversation with Dr Wedad Abbas. The Second Pan-African Conference of the Circle of Concerned African Women Theologians. Pemberton, C. Nairobi, Methodist Guest House.

Acolatse, E. (1996). Conversation with Esther Acolatse. The Second Pan-African Conference of the Circle of Concerned African Women Theologians. Pemberton, C. Nairobi, Methodist Guest House.

Ada, M.J. (1996). Interview with Sister Mary Juliana Ada (HHEJ). The Second Pan-African Conference of the Circle of Concerned African Women Theologians. Pemberton, C. Nairobi, Methodist Guest House.

Ackermann, D. (1996). 'Participation and Inclusiveness among Women.' *Groaning in Faith: Women in the Household of Faith*. Kanyoro, M., and N. Njoroge, eds. Nairobi, Acton Publishers.

—— Draper, et al., eds. (1991). *Women Hold Up Half the Sky: Women in the Church in Southern Africa*. Pietermaritzburg, Cluster Publications.

—— (2001) 'The Language of Lament: Mission in the Midst of Suffering.' Unpublished Paper given at Currents in World Christianity Seminar, University of Cambridge, May 2001.

Ammah, R. (1992). 'Paradise Lies at the Feet of Muslim Women.' *The Will to Arise: Women, Tradition and the Church in Africa*. Kanyoro, M., and M.A. Oduyoye, eds. Maryknoll, NY, Orbis Books.

—— (1996). Conversation with Dr Rabiatu Ammah. The Second Pan-African Conference of the Circle of Concerned African Women Theologians. Pemberton, C. Nairobi, Methodist Guest House.

Amoah, E. (1986). 'Women and the Emerging Spiritualities in Africa.' *Towards Compassion*. Fabella, V., and D. Martinez, eds. Port Harcourt, EATWOT.

—— (1987). 'The Woman who Decided to Break the Rules.' *New Eyes for Reading: Biblical and Theological Reflections by Women from the Third World*. Pobee, J.S., and B. von Wartenberg-Potter, eds. Philippines, Claretian Publishers.

—— (1990). 'Femaleness: Concepts and Practices in Akan Religion.' *Women, Religion and Sexuality*. Becher, J., ed. Geneva, WCC.

—— (1994). Interview with Dr Elizabeth Amoah. WCC Mid-Decade Colloquium: Churches in Solidarity with Women. Pemberton, C. Geneva, Château de Bossey.

—— (1995). 'Theology from the Perspective of African Women.' *Women's Visions: Theological Reflection, Celebration, Action*. Ortega, O., ed. Geneva, WCC.

—— (1996a). 'Violence and Women's Bodies in African Perspective.' *Women Resisting Violence: Spirituality for Life*. Mananzan, M.J., M.A. Oduyoye et al., eds. Maryknoll, NY, Orbis Books.

—— (1996b). Interview with Dr Elizabeth Amoah. South African Academy of Religion Conference. Pemberton, C. Johannesburg, University of Witwatersrand.

Amoah, E., and M. Oduyoye (1993). 'The Christ for African Women.' *With Passion and Compassion: Third World Women Doing Theology*. Fabella, V., and M.A. Oduyoye, eds. Maryknoll, NY, Orbis Books.

Anon (1996a). *Le Credo des Femmes*. Biennial Institute of the Circle of Concerned African Women Theologians, Nairobi.

—— (1996b). 'Empowerment of Women for the Democratisation Process.' *Obaa Soma (Ideal Woman)* 22 (4) (editorial).

—— (1996c). *Regional Networking Residential Programme.* African Women's Leadership Institute, Kampala.

—— (1996d). 'It's Up To You.' *AMKA* 3.

—— (1996e). 'Leave Well Alone.' *AMKA* 3.

—— (1996f). 'Female Genital Mutilation is a Crime.' Accra, *The Ghanaian Times.*

Ayanga, H.O. (1996a). 'Violence Against Women in African Oral Literature as Portrayed in Proverbs.' *Violence against Women.* Wamue, G., and M. Getui, eds. Nairobi, Acton Publishers.

—— (1996b). 'Religion and Women's Health.' *Groaning in Faith: African Women in the Household of God.* Kanyoro, M.R.A., and N.J. Njoroge, eds. Nairobi, Acton Publishers.

Bahemuka, J.M. (1989). 'The Hidden Christ in African Traditional Religion.' *Jesus in African Christianity: Experimentation and Diversity in African Christology.* Mugambi, J.N.K., and L. Magesa, eds. Nairobi, Initiative Publishers.

—— (1992). 'Social Changes and Women's Attitudes toward Marriage in East Africa.' *The Will To Arise: Women, Tradition and the Church in Africa.* Kanyoro, M.R.A., and M.A. Oduyoye, eds. Maryknoll, NY, Orbis Books.

Bam, B. (1970). *What is Ordination Coming To?* Geneva, WCC.

—— (1975). Preface. *Sexism in the 1970s: Discrimination Against Women: A Report of a World Council of Churches Consultation 1974.* WCC, ed. West Berlin, WCC.

—— (1991). 'Seizing the Moment: Women and the New South Africa.' *Women Hold Up Half the Sky: Women in the Church in Southern Africa.* Ackermann, D., J.A. Draper et al., eds. Pietermaritzburg, Cluster Publications.

—— (1998). 'All About Eve.' *Anglicanism: A Global Communion.* Wingate, A., K. Ward et al., eds. London, Cassell.

Devarakshanam, B.G. (1996). 'In Search of Our Own Wells.' *Groaning in Faith: Women in the Household of God.* Kanyoro, M., and N. Njoroge, eds. Nairobi, Acton Publishers.

Dipe, T.M. (1996). Conversation with Dr Titilayo Mary Dipe. The Second Pan-African Conference of the Circle of Concerned African Women Theologians. Pemberton, C. Nairobi, Methodist Guest House.

Edet, R. (1985). 'Men and Women Building the Church in Africa.' *Voices from the Third World* VIII (3).

—— (1986). 'New Roles, New Challenges for African Women.' *Towards Compassion.* Fabella, V., and D. Martinez, eds. Port Harcourt, Nigeria, EATWOT.

—— (1990a). 'Language of Endearment: An Asset for Women and Theology.' *Women and Culture: Theological Reflections.* Edet, R.N., and G.A. Umeagudosu, eds. Lagos, African Heritage Research and Publications.

—— (1990b). 'The Context of African Women Theology.' *Women and Culture: Theological Reflections.* Edet, R., and G.A. Umeagudosu, eds. Lagos, African Heritage Research and Publications.

—— (1991). 'Christ and the Nigerian Womanhood.' *Life, Women and Culture: Theological Reflections: Proceedings of the National Conference of a Circle for African Women Theologians Calabar 1990.* Edet, R., and M.A. Umeagudosu, eds. Lagos, African Heritage Research and Publications.

—— (1992a). 'Women and Evangelisation: A New Testament Perspective.' *Evangelization in Africa in the Third Millennium: Challenges and Prospects.* Ukpong, J., and T. Okure, eds. Port Harcourt, Nigeria, CIWA Publications.

—— (1992b). 'Christianity and African Women's Rituals.' *The Will to Arise: Women, Tradition, and the Church in Africa.* Oduyoye, M.A., and M.R.A. Kanyoro, eds. Maryknoll, NY, Orbis Books.

—— (1993). 'Critical Review of the *Lineamenta* on Dialogue, Justice, Peace and Social Communications.' *The Church in Africa and the Special African Synod.* Ukpong, J.S., T. Okure et al., eds. Port Harcourt, CIWA Publications.

Edet, R., and B. Ekeya (1993). 'Church Women of Africa: A Theological Community.'

With Passion and Compassion: Third World Women Doing Theology. Fabella, V., and M.A. Oduyoye, eds. Maryknoll, NY, Orbis Books.

Edet, R., and G.A. Umeagudosu, eds. (1991). *Life, Women and Culture: Proceedings of the National Conference of a Circle of African Women Theologians.* Lagos, African Heritage Research and Publications.

Eko, E. (1990). *Bridges of Gold.* Yaba, Nigeria, Cross Continent Press.

Ekué, A. (1995). 'How Can I Sing the Lord's Song in a Strange Land? The Religious Experience of Women of the African Diaspora in Europe with Special Reference to Germany.' Religious Communities in Diaspora Conference, Leiden, Unpublished.

Ekuyandayo, E. (1996). Conversation with Eunice A Ekuyundayo. The Second Pan-African Conference of the Circle of Concerned African Women Theologians. Pemberton, C. Nairobi, Methodist Guest House.

Fanusie, L. (1997a). 'African Christianity in Relation to Taboo and Gender.' Joint Seminar of the Henry Martyn Library & Women's Voices in Religion, Graduate Seminar Series in the Department of Divinity, Cambridge University, Unpublished.

—— (1997b). Conversation with Lloyda Fanusie. Henry Martyn Lecture. Pemberton, C. Cambridge, Westminster College.

Fassinou, M. (1995). 'Challenges for Feminist Theology in Francophone Africa.' *Women's Visions: Theological Reflection, Celebration, Action.* Ortega, O., ed. Geneva, WCC.

Gecega, M. (1996). 'Rape as a Tool of Violence against Women.' *Violence Against Women.* Wamue, G., and M. Getui, eds. Acton Publishers, Nairobi.

Getui, M.N. (1990). 'The Family, the Church and the Development of Youth.' *The Church in African Christianity: Innovative Essays in Ecclesiology.* Mugambi, J.N.K., and L. Magesa, eds. Nairobi, Initiative Publishers.

—— (1994). 'The Plight of Street Children.' *Pastoral Care in African Christianity: Challenging Essays in Pastoral Theology.* Waruta, D., and H. Kinoti, eds. Nairobi, Acton Publishers.

—— (1996). 'The Status of Women in African Naming Systems.' *Violence Against Women.* Wamue, G., and M. Getui, eds. Nairobi, Acton Publishers.

—— (1997). 'The Bible as a Tool for Ecumenism.' *The Bible in African Christianity: Essays on Biblical Theology.* Kinoti, H., and J.M. Waliggo, eds. Nairobi, Acton Publishers.

Gomes, E.d. D.B.P. (1996). 'Sexuality and the Well-being of Women.' *Groaning in Faith: African Women in the Household of God.* Kanyoro, M.R.A., and N.J. Njoroge, eds. Nairobi, Acton.

Hinga, T.M. (1990a). 'Women, Power and Liberation in an African Church: A Theological Case Study of the Legio Maria Church of Kenya.' Unpublished Ph.D. thesis, Department of Religious Studies, University of Lancaster.

—— (1990b). 'Women Liberation in and through the Bible: The Debate and the Quest for a New Feminist Hermeneutics.' *African Christian Studies* 6 (4).

—— (1992a). 'An African Confession of Christ: The Christology of Legio Maria Church in Kenya.' *Exploring Afro-Christology.* Pobee, J.S., ed. Bern, Peter Lang.

—— (1992b). 'Jesus Christ and the Liberation of Women in Africa.' *The Will to Arise: Women, Tradition and the Church in Africa.* Kanyoro, M., and M.A. Oduyoye, eds. Maryknoll, NY, Orbis Books.

—— (1994). 'Violence Against Women: A Challenge to the Church.' *Pastoral Care in African Christianity: Challenging Essays on Pastoral Theology.* Mugambi, J.N.K., and F.C. Houle, eds. Nairobi, Acton Publishers.

—— (1996a). 'Between Colonialism and Inculturation: Feminist Theologies in Africa.' *Feminist Theology in Different Contexts.* Schüssler Fiorenza, E., and M.S. Copeland, eds. London, SCM Press.

—— (1996b). 'The Gikuyu Theology of Land and Environmental Justice.' *Women Healing Earth.* Ruether, R.R., ed. Maryknoll, NY, Orbis Books.

James, R.M. (1996). 'The Church in Africa and Violence Against Women.' *Violence Against Women.* Wamue, G., and M. Getui, eds. Nairobi, Acton Publishers.

Kabeyena, M.C. (1996). Conversation with Martha Claudine Kabeyena. The Second Pan-African Conference of the Circle of Concerned African Women Theologians. Pemberton, C. Nairobi, Methodist Guest House.

Kabonde, M.P. (1996). 'Widowhood in Zambia: The Effects of Ritual.' *Groaning in Faith: Women in the Household of Faith.* Kanyoro, M., and N. Njoroge, eds. Nairobi, Acton Publishers.

Kalu, O. (1997). Interview with Professor Ogbu Kalu. Pew Research Colloquium. Pemberton, C. Nashville, Tennessee.

Kanyoro, M.R.A. (1989). 'Silenced By Culture, Sustained By Faith.' *Claiming The Promise: African Churches Speak.* Larom, M.S., ed. New York, Friendship Press.

—— (1990a). 'Daughter Arise: Luke 8: 40–56.' *Talitha, Qumi!.* Kanyoro, M.R.A., and M.A. Oduyoye, eds. Ibadan, Daystar Press.

—— (1990b). 'Editorial.' *AMKA* 1 (1).

——, ed. (1991). *Our Advent: African Women's Experiences in the Lutheran Tradition.* The African Lutheran Women Theologians Meeting. Addis Ababa, LWF.

—— (1992a). 'Interpreting Old Testament Polygamy through African Eyes.' *The Will To Arise: Women, Tradition and the Church in Africa.* Oduyoye, M.A., and M.R.A. Kanyoro, eds. Maryknoll, NY, Orbis Books.

—— (1992b). 'The Power to Name.' *The Power to Name.* Kanyoro, M.R.A., and W.S. Robins, eds. Geneva, WCC.

—— (1994a). 'When Women Arise the Earth Trembles.' *Claiming the Promise: African Churches Speak.* Larom, M.S., ed. New York, Friendship Press.

—— (1994b). 'When the Wretched of the Earth Speak!' *Claiming the Promise.* Larom, M.S., ed. New York, Friendship Press.

—— (1994c). 'Silenced By Culture, Sustained by Faith.' *Claiming the Promise: African Churches Speak.* Larom, M.S., ed. New York, Friendship Press.

—— (1994d). Interview with Dr Musimbi Kanyoro. WCC Mid-Decade Colloquium: Churches in Solidarity with Women. Pemberton, C. Geneva, Château de Bossey.

—— (1995). 'Cultural Hermeneutics: An African Contribution.' *Women's Visions: Theological Reflection, Celebration, Action.* Ortega, O., ed. Geneva, WCC.

—— (1996a). 'God's Call to Ministry: An Inclusive Hospitality.' *Groaning in Faith: African Women in the Household of God.* Kanyoro, M.R.A., and N.J. Njoroge, eds. Nairobi, Acton Publishers.

—— (1996b). 'Feminist Theology and African Culture.' *Violence Against Women.* Getui, M., and G. Wamue, eds. Nairobi, Acton Publishers.

—— (1997). e-mail communication to Carrie Pemberton.

Kanyoro, M.R.A., and A. Gnanadason, eds. (1996). *Women, Violence and Non-Violent Change.* Geneva, WCC.

Kanyoro, M.R.A., and D. Marple, eds. (1996). *We Are Witnesses: Platform for Action from the LWF International Consultation on Women.* Geneva, LWF.

Kanyoro, M.R.A., and N. Njoroge, eds. (1996). *Groaning in Faith: African Women in the Household of God.* Nairobi, Acton Publishers.

Kanyoro, M.R.A., and M.A. Oduyoye, eds. (1992). *The Will to Arise: Women, Tradition and the Church in Africa.* Maryknoll, NY, Orbis Books.

Kanyoro, M.R.A., and W.S. Robins, eds. (1992). *The Power We Celebrate: Women's Stories of Faith and Power.* Geneva, WCC.

Kinoti, H.W. (1983). 'Aspects of Gikuyu Traditional Morality.' Unpublished Ph.D. thesis, University of Nairobi.

—— (1989). 'Christology in the East African Revival Movement.' *Jesus in African Christianity: Experimentation and Diversity in African Christology.* Mugambi, J.N.K., and L. Magesa, eds. Nairobi, Initiative Publishers.

—— (1994). 'Growing Old in Africa: New Challenges for the Church in Africa.' *Pastoral Care in African Christianity: Challenging Essays on Pastoral Theology.* Waruta, D., and H. Kinoti, eds. Nairobi, Acton Publishers.

—— (1996a). 'Nguiko: A Tempering of Sexual Assault Against Women.' *Violence Against Women.* Wamue, G., and M. Getui, eds. Nairobi, Acton Publishers.

—— (1996b). Foreword. *Groaning in Faith: African Women in the Household of God.* Kanyoro, M.R.A., and N.J. Njoroge, eds. Nairobi, Acton Publishers.

—— (1997). 'Well-being in African Society and in the Bible.' *The Bible in African Christianity: Essays on Biblical Theology.* Kinoti, H.W., and J.M. Waliggo, eds. Nairobi, Acton Publishers.

Kinoti, H.W., and J.M. Waliggo, eds. (1997). *The Bible in African Christianity.* Nairobi, Acton Publishers.

Kinoti, H.W., and D. Waruta, eds. (1994). *Pastoral Care in African Christianity: Critical Essays in Missiology.* Nairobi, Uzima Press.

Kmathiu, G. K. (1996). Conversation with Rev. Grace Kinya Kmathiu. The Second Pan-African Conference of the Circle of Concerned African Women Theologians. Pemberton, C. Nairobi, Methodist Guest House.

Landman, C., ed. (1996a). *Digging up our Foremothers.* Pretoria, UNISA.

—— (1996b). 'African Women's Theologies: A Challenge to the Mind/Body Duality'. South African Academy of Religion, University of Witwatersrand, Johannesburg, Unpublished.

—— (1996c). 'A Land Flowing with Milk and Honey.' *Groaning in Faith: African Women in the Household of God.* Kanyoro, M.R.A., and N.J. Njoroge, eds. Nairobi, Acton Publishers.

—— (1996d). Conversation with Dr Christina Landman. South African Academy of Religion. Pemberton, C. Johannesburg, University of Witwatersrand.

Lugazia, F. (1996). Conversation with Faith Lugazia. The Second Pan-African Conference of the Circle of Concerned African Women Theologians. Pemberton, C. Nairobi, Methodist Guest House.

Machema, A.M. (1990). 'Jumping Culture's Fences.' *Talitha, Qumi!.* Oduyoye, M.A., and M.R.A. Kanyoro, eds. Ibadan, Daystar.

Madiba, D.M.M. (1996). 'Women in African Traditional Religions.' *Groaning in Faith.* Kanyoro, M.R.A., and N.J. Njoroge, eds. Nairobi, Acton Publishers.

Manona, N. (1996). Interview with Ncumisa Manona. The Second Pan-African Conference of the Circle of Concerned African Women Theologians. Pemberton, C. Nairobi, Methodist Guest House.

Mbenoun, J. (1996). 'Pouvoir de transformation: Femmes dans la maison de dieu'. The Second Pan-African Conference of the Circle of Concerned African Women Theologians, Nairobi, Unpublished.

Mbugguss, M. (1991). 'Theological Journeys: A Nun's Views on Veils and Feminine Theologies.' *AMKA* 1 (1).

Mbugua, J. (1996). Interview with Mrs Judy Mbugua, Co-ordinator of the Pan-African Christian Women's Association. Pemberton, C. Nairobi, CPK Guest House.

Mbuy-Beya, B. (1986). 'Expérience féminine de Dieu dans la renouveau charismatique à Lubumbashi.' West African Regional Meeting of EWC: *Faire la théologie dans la perspective des femmes Africaines*, Yaoundé, Cameroon, Unpublished.

—— (1989). 'Faire la théologie dans la perspective des femmes africaines'. *Théologie Africaine Bilan Et Perspectives: Actes de la Dix-septième Semaine Théologique de Kinshasa 2–8 Avril 1989.* Faculté Catholique de Kinshasa, ed. Kinshasa, Faculté Catholique de Kinshasa.

—— (1991). 'African Spirituality—A Cry for Life.' *Voices From the Third World* XIV (2).

—— (1992a). 'Human Sexuality, Marriage and Prostitution.' *The Will to Arise: Women, Tradition and the Church in Africa.* Oduyoye, M.A., and M.R.A. Kanyoro, eds. Maryknoll, NY, Orbis Books.

—— (1992b). 'EATWOT Women's Commission From Mexico City to Nairobi: 1986–92. "Woman's Word on Woman's Work".' *Voices from the Third World* XV (1).

—— (1993). 'Mes ton plus jolie pagne'. Global Forum on Religious Life, Manila, Unpublished.

—— (1994a). 'African Spirituality: A Cry for Life.' *Spirituality of the Third World.* Abraham, K.C., and B. Mbuy-Beya, eds. Maryknoll, NY, Orbis Books.

—— (1994b). Interviewed in the article 'The Church in the World: African Synod hailed as "historic event".' London, *The Tablet.*

—— (1996a). 'Women in the Churches in Africa: Possibilities for Presence and Promises.' *The African Synod: Documents, Reflections, Perspectives.* Africa Faith and Justice Network, ed. Maryknoll, NY, Orbis Books.

—— (1996b). Interview with Sr. Bernadette Mbuy-Beya. The Second Pan-African Conference of the Circle of Concerned African Women Theologians. Pemberton, C. Nairobi, Methodist Guest House.

Mbuy-Beya, B., and J.K. Mbwiti (1986). 'The Reality of Oppression and the Struggle of Women in French Speaking Africa.' *Towards Compassion.* Fabella, V., and D. Martinez, eds. Port Harcourt, Nigeria, EATWOT.

Mndende, N. (1996a). 'Ancestors and Healing in African Traditional Religion.' *Groaning in Faith: Women in the Household of God.* Kanyoro, M.R.A., and N.J. Njoroge, eds. Nairobi, Acton Publishers.

—— (1996b). Interview with Ms Nokuzola Mndende. The Second Pan-African Conference of the Circle of Concerned African Women Theologians. Pemberton, C. Nairobi, Methodist Guest House.

Mombo, E. (1998). 'Resisting Vumilia Theology.' *Anglicanism: A Worldwide Communion.* Wingate, A., K. Ward et al., eds. London, Cassell.

Moyo, F.L. (1996). Conversation with Dr Fulata Lusungu Moyo. The Second Pan-African Conference of the Circle of Concerned African Women Theologians. Pemberton, C. Nairobi, Methodist Guest House.

Mukangara, M. (1996a). 'The Participation of Women in the Church in Zimbabwe.' The Second Pan-African Conference of the Circle of Concerned African Women Theologians, Nairobi, Unpublished.

—— (1996b). Conversation with Rev Martha Mukangara. The Second Pan-African Conference of the Circle of Concerned African Women Theologians. Pemberton, C. Nairobi, Methodist Guest House.

Mwaura, P.N. (1994). 'Healing, A Pastoral Concern.' *Pastoral Care in African Christianity: Challenging Essays on Pastoral Theology.* Waruta, D., and H. Kinoti, eds. Nairobi, Acton Publishers.

—— (1996a). 'Women's Healing Roles in Traditional Gikuyu Society.' *Groaning in Faith: African Women in the Household of God.* Kanyoro, M., and N. Njoroge, eds. Nairobi, Acton Publishers.

—— (1996b). Interview with Ms Philomena Mwaura. The Second Pan-African Conference of the Circle of Concerned African Women Theologians. Pemberton, C. Nairobi, Methodist Guest House.

Nachisale-Musopole, A. (1990). 'Daughters of Africa, Arise! African Women Doing Theology.' *AMKA* 1(1).

—— (1992). 'Sexuality and Religion in a Matriarchal Society.' *The Will to Arise: Women, Tradition and the Church in Africa.* Oduyoye, M.A., and M. Kanyoro, eds. Maryknoll, NY, Orbis Books.

Nasimiyu-Wasike, A. (1986). 'Vatican II: The Problem of Inculturation.' Unpublished Ph.D. thesis. Pittsburgh, Duquesne University.

—— (1990a). 'Religious Ferment in East Africa.' *Voices from the Third World* (XIII).

—— (1990b). 'Christianity and African Rituals.' *Talitha, Qumi!.* Oduyoye, M.A., and M.R.A. Kanyoro, eds. Ibadan, Daystar Press.

—— (1990c). 'African Women's Legitimate Role in Church Ministry.' *The Church in African Christianity: Innovative Essays in Ecclesiology.* Mugambi, J.N.K., and L. Magesa, eds. Nairobi, Initiative Publishers.

—— (1990d). 'Liberation in African Religious Tradition: Response to Rev. Dr. Aylward Shorter's Paper.' *Towards African Christian Liberation.* L. Namwera et al., eds. Nairobi, St Paul Publications.

—— (1991). 'Christology and an African Woman's Experience.' *Faces of Jesus in Africa*. Schreiter, R.J., ed. Maryknoll, NY, Orbis Books.

—— (1992a). 'Polygamy: A Feminist Critique.' *The Will To Arise: Women, Tradition and the Church in Africa*. Oduyoye, M.A., and M. Kanyoro, eds. Maryknoll, NY, Orbis Books.

—— (1992b). 'Christianity and African Rituals of Birth and Naming.' *The Will to Arise: Women, Tradition and the Church in Africa*. Oduyoye, M.A., and M.R.A. Kanyoro, eds. Maryknoll, NY, Orbis Books.

—— (1993a). 'Prophetic Mission of the Church: The Voices of African Women.' *Mission in African Christianity: Critical Issues in Missiology*. Nasimiyu-Wasike, A., and D. Waruta, eds. Nairobi, Uzima Press.

—— (1993b). 'Feminism and African Theology.' *African Christian Studies* 9 (2).

—— (1994). 'Domestic Violence Against Women: A Cry for Life in Wholeness.' *Pastoral Care in African Christianity*. Waruta, D.W., and H.W. Kinoti, eds. Nairobi, Acton Publishers.

—— (1995). 'The Church: Enabling and Empowering of Women in Africa.' *African Christian Studies* 11 (4).

—— (1997). 'Mary, the Pilgrim of Faith for African Women.' *The Bible in African Christianity: Essays on Biblical Theology*. Kinoti, H., and J.M. Waliggo, eds. Nairobi, Acton Publishers.

Nasimiyu-Wasike, A., and D.W. Waruta, eds. (1993). *Mission in African Christianity: Critical Essays in Missiology*. Nairobi, Uzima Press.

Nassaka, O. (1996). 'Women and Taboo.' *Groaning in Faith: Women in the Household of God*. Kanyoro, M., and N. Njoroge, eds. Nairobi, Acton Publishers.

Ndyabahika, G.N. (1996). Conversation with Rev Grace N. Ndyabahika. The Second Pan-African Conference of the Circle of Concerned African Women Theologians. Pemberton, C. Nairobi, Methodist Guest House.

Njoroge, N.J. (1992). 'The Woman's Guild: The Institutional Locus for an African Women's Christian Social Ethic.' Unpublished Ph.D. thesis. Princeton Theological Seminary. Princeton, NJ.

—— (1994). Conversation with Dr Nyambura Njoroge. WCC Mid-Decade Colloquium: Churches in Solidarity with Women. Pemberton, C. Geneva, Château de Bossey.

Nwachuku, D.N. (1990). 'The Context of African Women's Life.' *Talitha, Qumi!*. Oduyoye, M.A., and M.R. Kanyoro, eds. Ibadan, Daystar Press.

—— (1992). 'The Christian Widow in African Culture.' *The Will to Arise: Women, Tradition and the Church in Africa*. Oduyoye, M.A., and M.R.A. Kanyoro, eds. Maryknoll, NY, Orbis Books.

—— (1994). *Contemporary Issues in Nigerian Education and Development*. Enugu, Nigeria, Sam and Star Group Company.

—— (1995). Interview with Dr Daisy N. Nwachuku. Study Week on Development Issues and Population Studies. Pemberton, C. Oxford, Oxford Centre for Mission Studies.

Oduyoye, M. A. (1974). 'Unity and Freedom in Africa.' *Ecumenical Review* 26.

—— (1977). *And Women, Where Do They Come In?* Lagos, Methodist Publications.

—— (1979a). 'The Value of African Religious Beliefs and Practices for Christian Theology.' *African Theology en Route*. Kubi, K.A., ed. Maryknoll, NY, Orbis Books.

—— (1979b). 'The Asante Women: Socialisation through Proverbs.' *Bulletin of the Institute of African Studies* viii (1).

—— (1979c). *Christian Youth Work*. Ibadan, Daystar Press.

—— (1981a). 'Standing on Both Feet.' *Ecumenical Review* 30 (1).

—— (1981b). 'A Decade and a Half of Ecumenism in Africa: Problems, Programmes, Hopes.' *Voices of Unity: Essays in Honour of Willem Adolf Visser't Hooft on the Occasion of his 80th Birthday*. Bent, A.J., ed. Geneva, WCC.

—— (1981c). 'When the Woman is Human.' *South African Outlook* 111 (Dec.).

—— (1981d). 'Naming the Woman: The Words of the Akan and the Words of the Bible.' *Bulletin de Théologie Africaine* 3 (5).

—— (1982a). 'In the Image of God: A Theological Reflection from an African Perspective.' *Bulletin de Théologie Africaine* 4 (7).

—— (1982b). *The Unity of the Church and the Renewal of Human Community: A Perspective from Africa*. Towards Visible Unity. Commission on Faith and Order Lima 1982, Geneva, WCC.

—— (1982c). 'Feminisme: A Precondition for a Christian Anthropology.' *Africa Theological Journal* 11 (3).

—— (1983a). 'Wholeness of Life in Africa.' *An African Call For Life*. Masamba, M., R. Stober et al., eds. Ibadan, Daystar Press.

—— (1983b). Preface at Dresden to the Sheffield Recommendations. *The Community of Women and Men in the Church*. Geneva, WCC.

—— (1983c). 'Reflections from a Third World Woman's Experience and Liberation Theologies.' *The Irruption of the Third World: Challenge to Theology: Papers from the Fifth International Conference of the Ecumenical Association of Third World Theologians, August 17–29, 1981, New Delhi, India*. Fabella, V., and S. Torres, eds. Maryknoll, NY, Orbis Books.

—— (1983d). 'The Eucharist as Witness.' *International Review of Missions* (72).

—— (1984a). 'Church-Woman and the Church's Mission in Contemporary Times: A Study of Sacrifice in Mission.' *Bulletin of African Theology* 6 (12).

—— (1984b). 'Language, Symbolism and Action.' *Cultures in Dialogue: Documents from a Symposium in Honour of Philip A Potter*. Geneva, WCC.

—— (1985a). 'Women Theologians and the Early Church.' *Voices from the Third World* VIII (3).

—— (1985b). 'Who Does Theology? Reflections on the Subject of Theology.' *Doing Theology in a Divided World: Papers from the Sixth International Conference of the Ecumenical Association of Third World Theologians*. Fabella, V., and S. Torres, eds. Maryknoll, NY, Orbis Books.

—— (1986a). *Hearing and Knowing: Theological Reflections on Christianity in Africa*. Maryknoll, NY, Orbis Books.

—— (1986b). *Women's Critique of EATWOT: The African Continent Final Communiqué*. The Second General Assembly of EATWOT, Oaxtapec, Mexico, EATWOT.

—— (1986c). 'Birth.' *New Eyes for Reading: Biblical and Theological Reflections by Women from the Third World*. Pobee, J. S., and B. von Wartenberg-Potter, eds. Geneva, WCC.

—— (1986d). 'Churchwomen and the Church's Mission.' *New Eyes for Reading: Biblical and Theological Reflections by Women from the Third World*. Pobee, J., and B. von Wartenberg-Potter, eds. Geneva, WCC.

—— (1986e). 'Theology from a Cultural Outlook.' *Voices from the Third World* IX (4).

—— (1986f). 'The Roots of African Christian Feminism.' *Variations in Christian Theology in Africa*. J.S. Pobee and C.F. Hallencreutz, eds. Nairobi, Uzima Press.

——, ed. (1986g). *The State of Christian Theology in Nigeria 1980–81*. Ibadan, Daystar Press.

—— (1986h). 'Doing Theology in Nigeria.' *The State of Christian Theology in Nigeria 1980–81*. Oduyoye, M.A., ed. Ibadan, Daystar Press.

—— (1987a). 'Unity and Mission: The Emerging Ecumenical Vision: A Reading of "Baptism, Eucharist and Ministry" and "Mission and Evangelism: An Ecumenical Affirmation".' *Ecumenical Review* 39 (3).

—— (1987b). 'Biblical Elements of a Christian Community.' *The Search for a New Community*. Best, T.F., ed. Geneva, WCC.

—— (1988a). 'Women and the Churches: Discussion on Authority.' *The Truth Shall Make You Free: The Lambeth Conference 1988: The Reports, Resolutions and Pastoral Letters from the Bishops*. Anglican Consultative Council, ed. London, ACC.

—— (1988b). 'An African Woman's Christ.' *Voices From the Third World* 11 (2).

—— (1988c). 'Be a Woman and Africa will be Strong.' *Inheriting Our Mother's Gardens: Feminist Theology in Third World Perspective*. Russell, L., ed. Philadelphia, Westminster Press.

—— (1989a). 'Alive to What God is Doing.' *The Ecumenical Review* 41 (2).

——— (1989b). 'Theology From A Cultural Outlook.' *Voices From the Third World* IX (4).

——— (1989c). 'Poverty and Motherhood.' *Motherhood: Experience, Institution, Theology.* Carr, A.E., ed. Edinburgh, T & T Clark. Concilium 206.

——— (1989d). 'Christian Feminism and African Culture: The Hearth of the Matter.' *The Future of Liberation Theology.* Ellis, M., and O. Maduro, eds. Maryknoll, NY, Orbis Books.

——— (1990a). *Who Will Roll The Stone Away? The Ecumenical Decade of Churches in Solidarity with Women.* Geneva, WCC.

——— (1990b). 'Teaching Authoritatively Amidst Christian Pluralism in Africa.' *What Should Methodists Teach? Wesleyan Tradition and Modern Diversity.* Meeks, D.M., ed. Nashville, Kingswood Books.

——— (1990c). 'Liberative Ritual and African Religion.' *Popular Religion, Liberation and Contextual Theology: Papers from a Congress, January 3–7.* van Nieuwenhove, J., ed. Kampen, Kok.

——— (1990d). 'The Empowering Spirit of Religion.' *Lift Every Voice: Constructing Christian Theology from the Underside.* Thistlethwaite, S.B., ed. San Francisco, Harper.

——— (1990e). 'Commonalities: An African Perspective.' *Third World Theologies: Commonalities and Divergences.* K.C. Abraham, ed. Maryknoll, NY, Orbis Books.

——— (1990f). 'The Search for a Two-Winged Theology: Women's Participation in the Development of Theology in Africa.' *Talitha, Qumi!.* Oduyoye, M.A., and M.R.A. Kanyoro, eds. Ibadan, Daystar Press.

——— (1991). 'The African Family as a Symbol of Ecumenism.' *Ecumenical Review* 43 (4).

——— (1992a). 'The Pact of Love Across All Borders.' *International Review of Mission* 81 (322).

——— (1992b). 'The Beauty of Women's Revolt.' *The Power to Name.* Kanyoro, M., and W.S. Robins, eds. Geneva, WCC.

——— (1992c). 'Feminism and Religion: The African Woman's Dilemma.' *AMKA* 2.

——— (1992d). 'Youth in God's World: A Response after Twenty Four Years.' *Ecumenical Review* 44 (2 April).

——— (1992e). 'Women and Ritual in Africa.' *The Will to Arise. Women, Tradition and Church in Africa.* Oduyoye, M.A., and M.R.A. Kanyoro, eds. Maryknoll, NY, Orbis Books.

——— (1992f). *The Wesleyan Presence in Nigeria.* Ibadan, Sefer.

——— (1992g). *Leadership Development in the Methodist Church Nigeria 1842–1962.* Ibadan, Sefer.

——— (1993a). 'The Christ for African Women.' *With Passion and Compassion: Third World Women doing Theology.* Fabella, V., and M.A. Oduyoye, eds. Maryknoll, NY, Orbis Books.

——— (1993b). 'Contextualization as a Dynamic in Theological Education.' *Association of Theological Studies Bulletin* (Globalization: Tracing the Journey, Charting the Course).

——— (1993c). Liberation and the Development of Theology in Africa. *The Ecumenical Movement Tomorrow: Suggestions for Approaches and Alternatives.* Reuver, M., F. Solms et al., eds. Kampen, Kok.

——— (1993d). 'A Critique of Mbiti's View on Love and Marriage in Africa.' *Religious Plurality in Africa: Essays in Honour of John S. Mbiti.* Olupona, J.K., and S.S. Nyang, eds. Berlin, Mouton De Gruyter.

——— (1994a). 'Reflections from a Third World Woman's Perspective: Women's Experience and Liberation Theologies.' *Feminist Theology from the Third World: A Reader.* King, U., ed. London, SPCK.

——— (1994b). 'Feminist Theology in an African Perspective.' *Paths of African Theology.* Gibellini, R., ed. Maryknoll, NY, Orbis Books.

——— (1994c). 'Violence Against Women: A Challenge to Christian Theology.' *Journal of Inculturation Theology* 1 (1).

—— (1994d). 'Women, Religion and Ritual in African Religion.' *Culture, Women and Theology*. Pobee, J.S., ed. Delhi, ISPCK.

—— (1994e). Interview with Dr Mercy Amba Oduyoye. WCC Mid-Decade Colloquium: Churches in Solidarity with Women. Pemberton, C. Geneva, Château de Bossey.

—— (1995a). 'Violence Against Women: Window on Africa.' *Voices from the Third World* XVIII (1 June).

—— (1995b). 'Look at the World through Women's Eyes: (through the eyes of one out of 35,000).' *AMKA* 3.

—— (1995c). 'Doing Theology from Beyond the Sahara.' *Confronting Life: Theology out of the Context*. Joseph, M.P., ed. Delhi, ISPCK.

—— (1995d). 'Calling the Church to Account.' *Ecumenical Review* 47 (4).

—— (1995e). 'Christianity and African Culture.' *International Review of Mission* 84 (332/333).

—— (1996a). *Daughters of Anowa: African Women and Patriarchy*. Maryknoll, NY, Orbis Books.

—— (1996b). 'Spirituality of Resistance and Reconstruction.' *Women Resisting Violence: Spirituality for Life*. Mananzan, M.J., M.A. Oduyoye et al., eds. Maryknoll, NY, Orbis Books.

—— (1996c). 'Gospel and Cultures in Africa: Through Women's Eyes.' *Women's Perspectives: Articulating the Liberating Power of the Gospel: Seven Essays*. WCC, ed. Geneva, WCC.

—— (1996d). Letter to Carrie Pemberton re the Circle in Nairobi, Unpublished.

—— (1996e). 'Conference Proceedings.' The Second Pan-African Conference of the Circle of Concerned African Women Theologians, Nairobi, Unpublished.

—— (1996f). Conversation over Correspondence with Professor Mercy Amba Oduyoye. The Second Pan-African Conference of the Circle of Concerned African Women Theologians. Pemberton, C. Nairobi, Methodist Guest House.

—— (1997a). 'God Through The Eyes of an Akan Woman.' *The Way* (July).

—— (1997b). 'Troubled but not Destroyed'. The Seventh Assembly of the All Africa Conference of Churches, Addis Ababa, Unpublished.

——, ed. (1997c). Introduction, *Transforming Power: Proceedings of the Pan-African Conference of the Circle of Concerned African Women Theologians. Nairobi. August 25–30 1966*. Accra, Sam Woode Ltd.

—— (2001). *Introducing African Women's Theology*. Sheffield, Sheffield University Press.

Oduyoye, M.A., and R. Fa'atauva'a (1994). 'The Struggle about Women's Theological Education'. *Feminist Theology from the Third World: A Reader*. King, U., ed. London, SPCK.

Oduyoye, M.A., and M.R.A. Kanyoro (1990). *Talitha, Qumi!: Proceedings of the Convocation of African Women Theologians 1989*. The Convocation of African Women Theologians, Trinity College, Legon, Accra. September 24–October 2 1989, Ibadan, Daystar Press.

Oduyoye, M.A., M. Kanyoro, et al. (1999). *Biennial Institute of African Women in Religion and Culture: Transforming Power: Women in the Household of God*. Accra, Sam Woode Ltd.

Okemwa, P. F. (1996). 'Cliterodectomy Rituals and the Social Well-being of Women.' *Groaning in Faith: African Women in the Household of God*. Kanyoro, M., and N. Njoroge, eds. Nairobi, Acton Publishers.

Okure, T. (1985). 'Biblical Perspectives on Women: Eve, the Mother of All the Living (Genesis 3: 20).' *Voices From the Third World* VIII (2).

—— (1986). 'Women in the Bible: African Women's Perspective.' *Towards Compassion*. Fabella, V., and D. Martinez, eds. Port Harcourt, Nigeria, EATWOT.

—— (1988). *The Johannine Approach to Mission*. Tübingen, J.C.B. Mohr.

—— (1989). 'A Theological View of Women's Role in Promoting Cultural/Human Development.' *AFER* 31.

—— (1990a). 'Inculturation: Biblical/Theological Bases.' *32 Articles Evaluating Inculturation of Christianity in Africa*. Okure, T., P. van Thiel et al., eds. Spearhead Numbers 112–114. AMECEA, Gaba Publications.

—— (1990b). 'Leadership in the New Testament.' *Nigerian Journal of Theology* 1 (5).

—— (1992a). 'The Significance Today of Jesus' Commission of Mary Magdalene.' *International Review of Mission* 80 (322).

—— (1992b). 'Inculturation and the Mission of the Church.' *Inculturation and the Mission of the Church in Nigeria: The Third CIWA Theology Week 4th–8th May 1992*. Brookman-Amissah, J., J.E. Anyanwu et al., eds. Port Harcourt, CIWA Publications.

—— (1992c). 'The Will To Arise: Reflections on Luke 8: 40–56.' *The Will to Arise: Women, Tradition and the Church in Africa*. Kanyoro, M.R.A., and M.A. Oduyoye, eds. Maryknoll, NY, Orbis Books.

—— (1992d). 'A New Testament Perspective on Evangelisation and Human Promotion'. *Evangelisation in Africa in the Third Millennium: Challenges and Prospects*. Ukpong, J., T. Okure et al., eds. Port Harcourt, Nigeria, CIWA Publications.

—— (1993a). 'Feminist Interpretations in Africa'. *Searching the Scriptures*. Fiorenza, E.S., ed. London, SCM Press.

—— (1993b). 'The Challenge of the Anointing of Jesus in Bethany for the Contemporary Church.' *Universalisme et Mission dans la Bible*. Pan-African Association of Catholic Exegetes, ed. Nairobi, Katholische Jungschar Oesterreichs and BICAM.

—— (1993c). 'Women in the Bible.' *With Passion and Compassion*. Fabella, V., and M.A. Oduyoye, eds. Maryknoll, NY, Orbis Books.

—— (1993d). 'A Critical Overview of the Synod Process and the *Lineamenta*.' *The Church in Africa and the Special African Synod*. Ukpong, J.S., T. Okure et al., eds. Port Harcourt, Nigeria, CIWA Publications.

—— (1993f). 'Jesus, der Mann, der in der Art der Frauen Wirkte.' *Missionshilfe Verlag (Jahrbuch Mission 1993)*.

—— (1994). 'A New Testament Perspective on Evangelisation and Human Promotion.' *Journal of Inculturation Theology* 1 (2).

—— (1995a). 'An African Regional Perspective on EATWOT Intercontinental Theological Dialogue-Problems and Prospects.' *Voices from the Third World: First EATWOT Inter-continental Dialogue & EATWOT Women Theologians on Violence Against Women* XVIII (1 June).

—— (1995b). 'Going Forth: A Biblical and African Perspective.' Whitney Day, Maynooth, St Patrick's Missionaries.

—— (1995c). 'The Mother of Jesus in the New Testament: Implications for Women in Mission.' *Journal of Inculturation Theology* 2 (2).

—— (1997). 'The Mother of Mission.' Cambridge Theological Federation, Cambridge, Unpublished.

Okure, T., and P. van Thiel, eds. (1990). *32 Articles Evaluating Inculturation in Africa*. Spearhead Numbers 112–114. Port Harcourt, Gaba.

Okure, T., J. Ukpong, et al., eds. (1993). *The Church in Africa and the Special African Synod: Proceedings of the Second Theology Week of the Catholic Institute of West Africa, Port Harcourt, Nigeria. March 4–8, 1991*. Port Harcourt, Nigeria, CIWA Publications.

——, et al., eds. (1992). *Evangelization in Africa in the Third Millennium: Challenges and Prospects; Proceedings of the First Theology Week of the Catholic Institute of West Africa May 6–11, 1990*. Port Harcourt, Nigeria., CIWA.

Owanikin, R.M. (1992). 'The Priesthood of Churchwomen in the Nigerian Context.' *The Will To Arise: Women, Tradition and the Church in Africa*. Oduyoye, M.A., and M.R.A. Kanyoro, eds. Maryknoll, NY, Orbis Books.

Pemberton, C. (1996). Notes on Nairobi Circle Convention, Unpublished.

Phiri, I.A. (1997a). 'Doing Theology as African Women.' *A Reader in African Christian Theology*. Parratt, J., ed. London, SPCK.

—— (1997b). *Women, Presbyterianism and Patriarchy*. Blantyre, Kachere Press.

—— (2000) 'Empowerment of Women through the Centre for Constructive Theology' *International Review of Mission*, 89 (354).

Pobee, J. (1997). Interview with Dr John Pobee. Pew Research Colloquium. Pemberton, C. Nashville, Tennessee.

Ramoelinina, I. (1996). Conversation with Irette Ramoelinina. The Second Pan-African Conference of the Circle of Concerned African Women Theologians. Pemberton, C. Nairobi, Methodist Guest House.

Shisanya, C.R.A. (1996). 'A Theological Reflection on Economic Violence Against Women.' *Violence Against Women*. Wamue, G., and M. Getui, eds. Nairobi, Acton Publishers.

Shiundu, L.A. (1992). 'Violence of Women to Women: Who is to Blame in the Case of Relationship between Daughter in Law and her Mother in Law and Sister in Law.' *AMKA (2)*.

Tappa, L. (1990a). 'Leave us Alone: A Poem.' *AMKA* (1).

—— (1990b). 'Women Doing Theology.' *Ministerial Formation* 48 (30).

Tetteh, R. E. (1990). 'Women in the Church.' *Talitha, Qumi!*. Oduyoye, M.A., and M.R.A. Kanyoro, eds. Ibadan, Daystar Press.

Tshelane, R.S.S. (1996). Interview with Rev. Sipho Tshelane. Pemberton, C. Johannesburg, Institute for Contextual Theology.

Uka, E.M. (1993). *A Theological Reflection of the Death of a 'Religious.' A Tribute to the Late Rev. Sr. Rosemary Nkoyo Edet (Ph.D.)*.

Vuadi, V. (1994). Interview with Ms Vibila Vuadi. WCC Mid-Decade Colloquium: Churches in Solidarity with Women. Pemberton, C. Geneva, Château de Bossey.

Wamue, G. (1996a). 'Women and Taboo among the Kikuyu People.' *Groaning in Faith: Women in the Household of God*. Kanyoro, M., and N. Njoroge, eds. Nairobi, Acton Publishers.

—— (1996b). 'Gender Violence and Exploitation: The Widow's Dilemma.' *Violence Against Women*. Wamue, G., and M. Getui, eds. Nairobi, Acton Publishers.

Wamue, G., and M. Getui (1996). *Violence against Women*. Nairobi, Acton Publishers.

Zoé-Obianga, R. (1977). 'The Role of Women in Present Day Africa.' *African Theology En Route*. Appiah-Kubi, K., and S. Torres, eds. Maryknoll, NY, Orbis Books.

—— (1984). 'Les Femmes africaines et la libération de l'Afrique.' *Bulletin de Théologie Africaine* 6 (12).

—— (1985a). 'Resources in the Tradition for the Renewal of Community.' *Voices from the Third World* 8 (3).

—— (1985b). 'Questions des femmes africaines à l'Église d'Afrique.' *Bulletin de Théologie Africaine* 13–14 (7).

—— (1992). 'When Will the Church in Africa become African?' *Concilium* 1992/1.

—— (1995). 'The Encounter of Gospel and Culture in the Experience of an African Woman.' *International Review of Mission* 84.

Secondary Literature

AACC (1963). *The Women's Consultation*. All Africa Conference of Churches' Women's Consultation: sponsored by the AACC and the WCC, Kampala. Leech Collection, Henry Martyn Library, Westminster College, Cambridge.

—— (1974). *The Struggle Continues: Official Report: Third Assembly of the All Africa Conference of Churches. Living No Longer for Ourselves but for Christ*. Lusaka, AACC.

——, ed. (1993). *Problems and Promises of Africa: Towards and Beyond the Year 2000*. Summary of the Proceedings of the Symposium Convened by the All Africa Conference of Churches in Mombasa, November 1991. Nairobi, AACC.

Abraham, K.C., ed. (1990). *Third World Theologies: Commonalities and Divergences.* Maryknoll, NY, Orbis Books.

Abraham, K.C., and B. Mbuy-Beya, eds. (1994). *Spirituality of the Third World.* Proceedings of the 11th Conference of the Ecumenical Association of Third World Theologians. Maryknoll, NY, Orbis Books.

ACC (1988). *The Truth Shall Make You Free: The Lambeth Conference 1988: The Reports, Resolutions and Pastoral Letters from the Bishops,* London, Anglican Consultative Council.

Adepoju, A., and C. Oppong, eds. (1994). *Gender, Work and Population in Sub-Saharan Africa.* London, Heinemann.

Africa Faith and Justice Network, ed. (1996). *The African Synod: Documents, Reflections, Perspectives.* Maryknoll, NY, Orbis Books.

Albert, O. (1996). *Women and Urban Violence in Kano, Nigeria.* Ibadan, Spectrum Books.

Amadiume, I. (1987). *Male Daughters, Female Husbands: Gender and Sex in an African Society.* London, Zed Books.

AMECEA (1974). *Statement from the Bishops of Africa at Rome Synod.* Nairobi, AMECEA.

—— (1995). *AMECEA in Brief.* Nairobi, AMECEA.

Anderson, B. (1991). *Imagined Communities.* London, Verso.

Anyanwu, U.D. (1993). 'The Gender Question in Igbo Politics.' *The Igbo and the Tradition of Politics.* Anyanwu, U.D., and J.C.U. Aguwa, eds. Uturu, Nigeria, Fourth Dimension Publishing.

Appiah-Kubi, K., and S. Torres, eds. (1979). *African Theology En Route.* Maryknoll, NY, Orbis Books.

Ardener, S. (1975). 'Sexual Insult and Female Militancy.' *Perceiving Women.* Ardener, S., ed. London, Malaby Press.

Ayitevie, A.O. (1996). 'Female Circumcision: Traumatic and Life Threatening.' *Public Agenda.* Accra: April 29–May 5 1996.

Baëta, C. G., ed. (1968). *Christianity in Tropical Africa.* (Studies presented and discussed at the Seventh International African Seminar, University of Ghana, April 1965). Oxford, OUP.

Balanos, P.D.D. (1927). *The Necessity of Christian Unity for the Presentation of the Christian Truth.* Faith and Order: Proceedings of the World Conference, Lausanne, SCM.

Balasuriya, T. (1988). 'From Dar es Salaam to Mexico: Third World Theologians in Dialogue.' *Voices From the Third World* XI (1).

Barnes, V.L., and J. Boddy, eds. (1994). *Aman: The Story of a Somali Girl by Aman.* London, Bloomsbury.

Barrett, D.B., ed. (1982). *World Christian Encyclopedia: A Comparative Study of Churches and Religions in the Modern World AD 1900–2000.* Nairobi, OUP.

Barth, K. (1934). Letters in Correspondence with Henrietta Visser't Hooft. Basel, Unpublished.

Bate, H.N., ed. (1927). *Faith and Order: Proceedings of the World Conference: Lausanne, August 3–21, 1927.* London, SCM.

Baur, J. (1994). *2000 Years of Christianity in Africa: An African History 62–1992.* Nairobi, Paulines Publications.

Bayart, J.-F. (1993). *The State in Africa: The Politics of the Belly.* London, Longmans.

Beaver, R.P. (1966). *Christianity and African Education.* Grand Rapids, Eerdmans.

Bediako, K. (1992). *Theology and Identity: The Impact of Culture upon Christian Thought in the Second Century and Modern Africa.* Oxford, Regnum Press.

—— (1995a). *Christianity in Africa: The Renewal of a Non-Western Religion.* Edinburgh, Edinburgh University Press.

—— (1995b). 'The Significance of Modern African Christianity—A Manifesto.' *Studies in World Christianity* 1 (1).

Beneria, L., and M. Roldan (1987). *The Crossroads of Class and Gender.* Chicago, University of Chicago Press.

Berger, I. (1992). *Threads of Solidarity: Women in South African Industry, 1900–1980.* London, James Currey.

Best, T.F., ed. (1990). *Vancouver to Canberra 1983–1990: Report of the Central Committee to the Seventh Assembly of the World Council of Churches.* Geneva, WCC.

Bimwenyi, O.K. (1981). 'The Origins of EATWOT.' *Voices of the Third World* 4 (2).

Bingemer, I.G., and M.C. Bingemer (1989). *Mary, Mother of God, Mother of the Poor.* Tunbridge Wells, Burns and Oates.

Bingemer, M.C. (1989). 'Jesus Christ and the Salvation of Women.' *The Oaxtapec Encounter: Third World Women Doing Theology.* Fabella, V., and D. Martinez, eds. EATWOT, Port Harcourt, Nigeria.

Bishops of Eastern Africa (1975). 'Statement against Moratorium.' *Telema* 2 (July 1975).

Blakely, P.A.R., and T.D. Blakely (1994). 'Ancestors, "Witchcraft" & Foregrounding the Poetic: Men's Oratory and Women's Song-Dance in Hemba Funerary Practice.' *Religion in Africa.* Blakely, T.D., W.E.A. van Beek et al., eds. London, James Currey.

Bleek, W. (1978). 'The Value of Children to Parents in Kwahu, Ghana.' *Marriage, Fertility and Parenthood in West Africa.* Oppong, C., ed. Canberra, National University of Australia.

Bliss, K. (1952). *The Service and Status of Women in the Churches.* London, SCM Press.

Boddy, J. (1989). *Wombs and Alien Spirits: Women, Men and the Zar Cult in Northern Sudan.* Madison, University of Wisconsin Press.

Boesak, A. (1978). *Black Theology, Black Power.* London, Heinemann.

Boff, L., and V. Elizondo (1988). 'Theologies of the Third World: Convergences and Differences'. *Concilium* 199. Edinburgh, T & T Clark.

Bons-Storm, R., (1996) *The Incredible Woman, Listening to Women's Silences in Pastoral Care and Counselling.* Abingdon Press, Oxford.

Bordo, S. (1990). 'Feminism, Postmodernism and Gender Scepticism.' *Feminism/Postmodernism.* Nicholson, L.J., ed. New York, London, Routledge.

Bosch, D. (1991). *Transforming Mission: Paradigm Shifts in Theology of Mission.* Maryknoll, NY, Orbis Books.

Boss, S. (1997). 'Holy Birth? Sin and Parturition in the Cult of Mary.' Women's Voices in Religion Seminar, Cambridge University Divinity School, Unpublished.

Boulaga, F.E. (1984). *Christianity without Fetishes: An African Critique and Recapture of Christianity.* Maryknoll, NY, Orbis Books.

Bowie, F., D. Kirkwood, et al., eds. (1993). *Women and Missions, Past and Present. Anthropological and Historical Perceptions.* Oxford, Berg.

Brandel-Syrier, M. (1962). *Black Woman in Search of God.* London, Lutterworth Press.

Brenner, L., ed. (1993). *Muslim Identity and Social Change in Sub-Saharan Africa.* London, Hurst & Co.

Brinkman, I. (1996). *Kikuyu Gender Norms and Narratives.* Leiden, CNWS.

Buchan, J. (1980). *The Expendable Mary Slessor.* Edinburgh, Saint Andrew Press.

Bujo, B. (1995). *God Becomes Man in Black Africa.* Nairobi, Paulines Publications.

Burke, J. (1993). '"These Catholic Sisters are all Mamas!" Celibacy and the Metaphor of Maternity.' *Women and Missions: Past and Present: Anthropological and Historical Perceptions.* Bowie, F., D. Kirkwood et al., eds. Oxford, Berg.

—— (2001). *These Catholic Sisters are All Mamas!: Towards the Inculturation of the Sisterhood in Africa, An Ethnographic Study.* Studies in Religion in Africa 22. Leiden, Brill.

Byrne, L. (1990). 'Apart from or a part of: The place of celibacy.' *Through the Devil's Gateway.* Joseph, A., ed. London, SPCK.

Cagnolo, C. (1933). *The Akikuyu: Their Customs, Traditions and Folklore.* Nyeri, The Mission Printing School.

Cannon, K. (1985). 'Black Feminist Consciousness.' *Feminist Interpretation of the Bible.* Russell, L.M., ed. Philadelphia, Westminster Press.

Caplan, P., and J.M. Bujra, eds. (1978). *Women United, Women Divided: Cross Cultural Perspectives on Female Solidarity.* London, Tavistock.

Carr, B. (1974). 'The Engagement of Lusaka: The Struggle Continues. The Official Report of the Third Assembly of the All Africa Conference of Churches.' *Journal of Religious Thought* 31/May.

Chappell, J. (1923). *Three Brave Women.* London, S. W. Partridge.

Chung Hyun Kyung (1988). '"Han-pu-ri": Doing Theology from Korean Women's Perspective.' *The Ecumenical Review* 40 (1).

Chung Hyun Kyung (1991). *Struggle to be the Sun Again.* London, SCM.

Clarke, J.H., ed. (1974). *Marcus Garvey and the Vision of Africa.* New York, Vintage.

Cohen, A. (1981). *The Politics of Elite Culture.* Los Angeles, University of California Press.

Cohen, R. (1997). *Global Diasporas: An Introduction.* London, UCL Press.

Comaroff, J., and J. Comaroff (1991). *Of Revelation and Revolution: Christianity, Colonialism and Consciousness in South Africa.* Chicago, University of Chicago Press.

Cone, J.H. (1979). 'A Black American Perspective on the Future of African Theology.' *African Theology En Route.* Appiah-Kubi, K., and S. Torres, eds. Maryknoll, NY, Orbis Books.

—— (1983). 'Reflections from the Perspective of U.S. Blacks: Theology and Third World Theology.' *Irruption of the Third World: Challenge to Theology.* Fabella, V., and S. Torres, eds. Maryknoll, NY, Orbis Books.

Cone, J.H., and G.S. Wilmore (1993). 'Black Theology and African Theology: Considerations for Dialogue, Critique, and Integration.' *Black Theology: A Documentary History 1966–79*, Volume 1. Cone, J.H., and G.S. Wilmore, eds. Maryknoll, NY, Orbis Books.

Crawford, J. (1995). 'Rocking the Boat: Women's Participation in the World Council of Churches 1948–1991'. Victoria University of Wellington.

CSMC (1931). *Memorandum Prepared by The Kikuyu Mission Council on Female Circumcision.* Kikuyu Kenya Colony. Unpublished.

CWME (1980). *Your Kingdom Come: Mission Perspectives*, Melbourne, Australia, WCC.

Daly, M. (1978). *Gyn/Ecology.* Boston, Beacon.

Daneel, M.L. (1971). *Old and New in Southern Shona Independent Churches, Background and Rise of the Major Movements.* The Hague, Mouton.

Dareer, A.E. (1982). *Woman, Why Do You Weep? Circumcision and its Consequences.* London, Zed Books.

Davaney, S.G. (1987a). 'The Limits of the Appeal to Women's Experience.' *Shaping New Vision: Gender and Values in American Culture.* Atkinson, C., C. Buchanan et al., eds. Ann Arbor, University of Michigan Research Press.

—— (1987b). 'Problems with Feminist Theory; Historicity and the Search for Sure Foundations.' *Embodied Love: Sensuality and Relationship as Feminist Values.* Cooey, P., S. Farmer et al., eds. San Francisco, Harper and Row.

Davison, J., ed. (1989). *Voices from Mutira: Lives of Rural Gikuyu Women.* London, Lynne Rienner Publishers.

de Beauvoir, S. (1949). *Le Deuxième Sexe.* London, Penguin Books.

Dickson, K. (1974). 'Towards a Theologia Africana.' *New Testament Christianity for Africa and the World.* Fasholé-Luke, E., and M. Glasswell, eds. London. SPCK.

—— (1984). *Theology in Africa.* London, Darton, Longman and Todd.

Dickson, K., and P. Ellingworth (1969). *Biblical Revelation and African Beliefs.* London, Lutterworth Press.

Dinan, C. (1977). 'Pragmatists or Feminists? The Professional Single Woman in Accra, Ghana.' *Cahiers d'études africaines* 65 (17).

—— (1983). 'Sugar Daddies and Gold Diggers: The White Collar Single Women in Accra.' *Female and Male in West Africa.* Oppong, C., ed. London, George Allen and Unwin.

Dolphyne, F.A. (1991). *The Emancipation of Women: An African Perspective.* Accra, Ghana Universities Press.

Dorkenoo, E. (1994). *Cutting the Rose: Female Genital Mutilation, The Practice and its Prevention.* London, Minority Rights Publications.

Douglas, M. (1966). *Purity and Danger: An Analysis of Concepts of Pollution and Taboo.* London, Routledge & Kegan Paul.

Dube, Musa W. ed. (2001). *Other Ways of Reading: African Women and the Bible.* Geneva, WCC Publications.

Du Bois, W.E.B. (1980). 'The Work of Negro Women in Society.' *W.E.B. Du Bois:*

Writings in Periodicals Edited by Others. Aptheker, H., ed. Millwood, NY, Kraus-Thomson Organization.

EATWOT Women's Commission (1994). 'Final Statement of the "Women Against Violence" Dialogue.' *Voices From the Third World* XVIII (1).

Ecumenical Review (1975). 'Special on Women.' *Ecumenical Review* 27 (4).

Edwards, R. (1990). 'Connecting Method and Epistemology: A White Woman Interviewing Black Women.' *Women's Studies International Forum* 13 (5).

Ela, J.-M. (1980). *Le Cri de l'Homme Africain: Questions aux Chrétiens et aux Églises d'Afrique*. Paris, L'Harmattan.

—— (1986). *African Cry*. Maryknoll, NY, Orbis Books.

Erlank, N. (1997). 'The Case of J. Beck Balfour: Sexual Impropriety on a Scottish Mission Station in the Eastern Cape, South Africa, 1845.' *Africans Meeting Missionaries: Rethinking Colonial Encounters*, University of Minnesota May 2–3, 1997, Unpublished.

Fabella, V. (1990). 'A Theological Framework for the Woman Question.' Annual Convention of Association of Major Religious Superiors of Women in the Philippines, Tagaytay City, Philippines, Unpublished.

—— (1993). *Beyond Bonding: A Third World Women's Theological Journey*. Manila, EAT-WOT & Institute of Women's Studies.

Fabella, V., and D. Martinez, eds. (1987). *The Oaxtapec Encounter*. Port Harcourt, Nigeria, EATWOT.

Fabella, V., and M.A. Oduyoye, eds. (1993). *With Passion and Compassion: Third World Women Doing Theology*. Maryknoll, NY, Orbis Books.

Fabella, V., and S. Torres, eds. (1983). *Irruption of the Third World: Challenge to Theology*. Maryknoll, NY, Orbis Books.

Fabella, V., and S. Torres, eds. (1985). *Doing Theology in a Divided World*. Sixth International Conference of EATWOT, First Dialogue between First and Third World Theologians, Geneva 1983. Maryknoll, NY, Orbis Books.

Fanon, F. (1978a). *Black Skin, White Masks*. New York, Grove Press.

—— (1978b). *The Wretched of the Earth*. London, Penguin.

Fasholé-Luke, E. (1975). 'The Quest for African Christian Theology.' *Journal of Religious Thought* 32 (2).

Fisher, R. (1911). *Twilight Tales of the Black Baganda*. London, Frank Cass and Co.

Flannery, A., ed. (1982). *Vatican Council II: More Post Conciliar Documents*. Volume 2. Vatican Collection. Northport, NY, Costello Publishing Company.

——, ed. (1988). *Vatican Council II: The Conciliar and Post Conciliar Documents*. Volume 1. Vatican Collection. Northport, NY, Costello Publishing Company.

Foucault, M. (1978). *The History of Sexuality*, Volume 1. London, Random House.

Frankenberg, R. (1993). *White Women, Race Matters: The Social Construction of Whiteness*. London, Routledge.

Fraser, N., and L.J. Nicholson (1990). 'Social Criticism without Philosophy.' *Feminism/Postmodernism*. Nicholson, L.J., ed. London, Routledge.

Friedman, S.S. (1995). 'Beyond White and Other: Relationality and Narratives of Race in Feminist Discourse.' *The Second Signs Reader*. Joeres, R.-E.B., and B. Laslett, eds. Chicago, University of Chicago Press.

Furedi, F. (1997) 'Ambivalent Westernisers—The Missionary Encounter with Traditional Societies.' Paper given at the Imperial History Research Seminar, London. NAMP paper 24. Cambridge, Henry Martyn Library.

Gaitskell, D. (1996). 'Women and Education in South Africa: How Helpful are the Archives?' *Missionary Encounters: Sources and Issues*. Bickers, R.A., and R. Seton, eds. Exeter, Curzon Press.

Garvey, A.J., ed. (1969). *Marcus Garvey: The Philosophy and Opinions of Marcus Garvey*. New York, Atheneum.

Gates, H.L. (1990). 'The American Studies Convention.' *New York Times*.

Gibellini, R., ed. (1994). *Paths of African Theology*. Maryknoll, NY, Orbis Books.
Gifford, P. (1992). 'Reinhard Bonnke's Mission to Africa and his 1991 Nairobi Crusade.' *New Dimensions in African Christianity*. Gifford, P., ed. Nairobi, AACC.
—— (1994). 'Some Recent Developments in African Christianity.' *African Affairs* 93.
Gnanadason, A. (1993). *No Longer a Secret: The Church and Violence against Women*. Geneva, Risk Publications.
Goody, E. (1978). 'Some Theoretical and Empirical Aspects of Parenthood in West Africa.' *Marriage, Fertility and Parenthood in West Africa*. Oppong, C., ed. Canberra, Australian National University.
Gordon, S., ed. (1984). *Ladies in Limbo: The Fate of Women's Bureaux, Case Studies from the Caribbean*. London, Commonwealth Secretariat.
Grant, J. (1989). *White Women's Christ and Black Women's Jesus: Feminist Christology and Womanist Response*. Atlanta, Georgia, Scholars Press.
Greer, G. (1971). *The Female Eunuch*. London, Paladin.
Hackett, R. (1989). *Religion in Calabar: The Religious Life and History of a Nigerian Town*. Berlin, Mouton De Gruyter.
Hafkin, N.J., and E.G. Bay, eds. (1976). *Women in Africa: Studies in Social and Economic Change*. Stanford, Stanford University Press.
Hammar, A. K. (1988). 'After Forty Years—Churches in Solidarity with Women?' *The Ecumenical Review* 40 (3–4 Special Edition commemorating Amsterdam 1948).
Hastings, A. (1973). *Christian Marriage in Africa: Being a Report Commissioned by the Archbishops of Cape Town, Central Africa, Kenya, Tanzania, and Uganda*. London, SPCK.
—— (1979). *A History of African Christianity 1950–1975*. Cambridge, CUP.
—— (1994). *The Church in Africa 1450–1950*. Oxford, Clarendon Press.
—— (1997). 'Setting the Scene.' *The Way* (July 1997).
Hay, M., and S. Stichter, eds. (1984). *African Women South of the Sahara*. London, Longmans.
Hebblethwaite, P. (1975). *The Runaway Church*. London, Collins.
Herzel, S. (1981). *A Voice For Women: The Women's Department of the World Council of Churches*. Geneva, WCC.
Hillman, E. (1975). *Polygamy Reconsidered*. Maryknoll, NY, Orbis Books.
—— (1991). 'Religious Ethnocentrism.' *America* (23).
Hinderer, D. (1872). *Seventeen Years in Yoruba Country: Memorials of Anna Hinderer*. London, Seeley, Jackson and Halliday.
Hite, S. (1976). *The Hite Report*. New York, Dell Publishing.
Hodgson, J. (1997). 'Runaway Wives.' *Africans Meeting Missionaries: Rethinking Colonial Encounters*. University of Minnesota May 2–3, 1997, Unpublished.
Hoehler-Fatton, C. (1996). *Women of Fire and Spirit: History, Faith and Gender in Roho Religion in Western Kenya*. Oxford, OUP.
Hofmeyr, I. (1993). *We Spend our Years as a Tale that is Told: Oral Historical Narrative in a South African Kingdom*. London, James Currey.
Hogan, L. (1995). *From Women's Experience to Feminist Theology*. Sheffield, Sheffield Academic Press.
Holding, E.M. (1942). 'Women's Institutions and the African Church.' *International Review of Missions* 31.
Hollenweger, W. (1972). *The Pentecostals*. London, SCM Press.
—— (1997). 'The Black Oral and the Critical Root.' Henry Martyn Lectures: Pentecostalism: Promise and Problem, Westminster College, Cambridge, Unpublished.
Hooks, B. (1981). *Ain't I a Woman: Black Women and Feminism*. Boston, South End Press.
—— (1984). *Feminist Theory: From Margin to Centre*. Boston, South End Press.
Idowu, E.B. (1965). *Towards an Indigenous Church*. Oxford, OUP.
Iliffe, J. (1995). *Africans: The History of a Continent*. Cambridge, CUP.
Ilogu, E. (1974). *Christianity and Ibo Culture*. Leiden, Brill.
Irigaray, L. (1985). *This Sex Which Is Not One*. Ithaca: Cornell University Press.

—— (1991). 'Women-amongst-themselves: Creating a Woman-Woman Sociality.' *An Irigaray Reader*. Whitford, M., ed. Oxford, Blackwell.

—— (1997). 'Equal to Whom?', *The Post-Modern God*. G. Ward, ed. Oxford, Blackwell.

Isichei, E. (1993). 'Does Christianity Empower Women? The Case of the Anaguta of Central Nigeria.' *Women and Missions: Past and Present: Anthropological and Historical Perceptions*. Bowie, F., D. Kirkwood et al., eds. Oxford, Berg.

Islamic Council (1980). 'Universal Islamic Declaration of Human Rights.' *Islam: A Challenge for Christianity* 1994 (3).

Jacobs, S.M. (1982). 'Their "Special Mission." Afro-American Women as Missionaries to the Congo, 1894–1937.' *Black Americans and the Missionary Movement in Africa*. Jacobs, S. M., ed. London, Greenwood Press.

James, R.M. (1996). 'The Church in Africa and Violence against Women.' *Violence against Women*. Wamue, G., and M. Getui, eds. Nairobi, Acton Publishers.

Jayawardena, K. (1986). *Feminism and Nationalism in the Third World*. London, Zed Books.

John Paul II (1979). *Redemptor hominis*. The Unofficial Pope John Paul II page http://www.knight.org/advent/Popes/ppjp02.htm.

—— (1980). 'Address to the Bishops of Zaire, Kinshasa.' *African Ecclesial Review* 22 (4).

—— (1981). 'Familiaris consortio. The Christian Family in the Modern World.' *Vatican Council II: More Post Conciliar Documents*: Volume 2, Austin Flannery, ed. 1982.

—— (1988a). *Christifideles laici: The Vocation and the Mission of the Lay Faithful in the Church and in the World*. London, Catholic Truth Society.

—— (1988b). *Mulieris dignitatem: On the Dignity of Women*. http://www.knight.org/advent/Popes/ppjp02.htm.

—— (1995a). *Ecclesia in Africa. The Church in Africa: Post Synodal Apostolic Exhortation of the Holy Father John Paul II*. Nairobi, Paulines Publications.

—— (1995b). *Letter to Women*. http://listserv.american.edu/catholic/church/papal/jp.ii/jp2wom95.html.

John XXIII (1959). *Ad Petri Cathedram*. *http://www.cin.org/ftpjohn23.html*.

Jules-Rosette, B. (1975). *African Apostles: Ritual and Conversion in the Church of John Maranke*. London, Cornell University Press.

Kagame, A. (1956a). *La philosophie bantou-rwandaise de l'être*. Bruxelles, Académie Royale de Sciences Coloniales.

—— (1956b) *Des prêtres noirs s'interrogent* (Rencontres, 47). Paris, Les Editions du CERF.

—— (1976). *La philosophie bantou comparée*. Paris, Présence Africaine.

Kato, B.H. (1975). *Theological Pitfalls in Africa*. Nairobi, Evangel.

Kaunda, K. (1973). 'Faith and Values.' *Letter to my Children*. London, Longman.

Kenyan Government Marriage Commission (1979). 'The Rejection of the Marriage Bill in Kenya.' *The Journal of African Law* 23 (2).

Kenyatta, J. (1938). *Facing Mount Kenya*. London, Secker & Warburg.

Kilbride, P.L., and J.C. Kilbride (1990). *Changing Family Life in East Africa: Women and Children at Risk*. London, Pennsylvania State University Press.

King, U., ed. (1994). *Feminist Theology from the Third World: A Reader*. London, SPCK.

—— (1996). 'Spirituality For Life.' *Women Resisting Violence: Spirituality for Life*. Mananzan, M.J., M.A. Oduyoye et al., eds. Maryknoll, NY, Orbis Books.

Kirwen, M.C. (1979). *African Widows*. Maryknoll, NY, Orbis Books.

Koso-Thomas, O. (1987). *The Circumcision of Women: A Strategy for Eradication*. London, Zed Books.

Küng, H., and J. Moltmann, eds. (1983). *Mary in the Churches*. Concilium 168. Edinburgh, T & T Clark.

Kupalo, A. (1978). 'African Sister's Congregations: Realities of the Present Situation.' *Christianity in Independent Africa*. Fasholé-Luke, E., R. Gray et al., eds. London, Rex Collings.

Labode, M. (1993). 'Anglican Mission Education and African Girls.' *Women and Missions: Past and Present*. Bowie, F., ed. Oxford, Berg.

Lagerwerf, L. (1990). 'African Women Doing Theology—a Survey.' *Exchange* 19 (1).

Lambert, H.E. (1956). *Kikuyu Social and Political Institutions*. London, OUP.

Landau, P.S. (1995). *The Realm of the Word: Language, Gender and Christianity in a Southern African Kingdom*. London, James Currey.

Larrson, B. (1991). *Conversion to Greater Freedom? Women, Church and Social Change in North-Western Tanzania under Colonial Rule*. Stockholm, Almqvist & Wiksell International.

Leakey, L.S.B. (1977). *The Southern Kikuyu before 1903*. London, Academic Press.

Lebeuf, A.M.D. (1963). 'The Role of Women in the Political Organisation of African Societies'. *Women of Tropical Africa*. Paulme, D., ed. Berkeley, University of California Press.

Lee, H. (1997). *Virginia Woolf*. London, Vintage.

Lennox, A., and D. Stewart (1985). 'Sisters are Doing it for Themselves.' *Recorded by Eurythmics*.

Lerranaga, I. (1991). *The Silence of Mary*. Santiago de Chile, St Paul's Media.

Livingstone, W.P. (1907). *Christina Forsyth of Fingoland: The Story of the Loneliest Woman in Africa*. London, Hodder and Stoughton.

—— (1923). *Mary Slessor of Calabar: Pioneer Missionary*. London, Hodder and Stoughton.

Lloyd, D.P., ed. (1966). *The New Elites of Tropical Africa*. Oxford, OUP.

Loades, A. (1990). 'The Virgin Mary and the Feminist Quest.' *After Eve: Women, Theology and the Christian Tradition*. Soskice, J.M., ed. London, Collins.

Lonsdale, J. (2002). 'Kenyatta, God and the Modern World.' *African Modernities*. Deutsch, J.-G., P. Probst and H. Schmidt, eds. Oxford, James Currey.

MacGaffey, J. (1987). *Entrepreneurs and Parasites: The Struggle for Indigenous Capitalism in Zaire*. Cambridge, CUP.

Maimela, S., and D. Hopkins (1989). *We Are One Voice*. Johannesburg, Skotaville.

Mananzan, M.J., M.A. Oduyoye, et al. (1996). *Women Resisting Violence: Spirituality for Life*. Maryknoll, NY, Orbis Books.

Marins, J., T. Trevisan, et al. (n.d. but 1985). *Basic Ecclesial Communities: The Church from the Roots*. London, CAFOD.

Marshall, R. (1992). 'Pentecostalism in Southern Nigeria: An Overview.' *New Dimensions in African Christianity*. Gifford, P., ed. Nairobi, AACC.

Martey, E. (1993). *African Theology*. Maryknoll, NY, Orbis Books.

Masamba, M.M., R. Stober, et al., eds. (1983). *An African Call for Life: A Contribution to the World Council of Churches Sixth Assembly 'Jesus Christ—the Life of the World.'* Nairobi, WCC.

Masolo, D.A. (1994). *African Philosophy in Search of Identity*. Edinburgh, Edinburgh University Press.

Mason, K.F. (1988). 'Co-Wife Relationships Can be Amicable as well as Conflictual: The Case of the Moose of Burkina Faso.' *Canadian Journal of African Studies* 22 (3).

Masson, J. (1962). 'L'Église Ouverte sur le Monde.' *Nouvelle Revue Théologique* 84.

Masters, W.E., and V.H. Johnson (1966). *Human Sexual Response*. Boston, Little, Brown.

Matthew, A. (1988). *Christian Mission, Education and Nationalism*. Delhi, Ananicka Prakashan.

Maxwell, D. (1997). 'Rethinking Christian Independency.' Henry Martyn Lecture, Westminster College, Cambridge, Unpublished.

Mbiti, J. (1969). *African Religions and Philosophy*. London, Heinemann.

—— (1970). *New Testament Eschatology in an African Background: A Study of the New Encounter between New Testament Theology and African Traditional Concepts*. London, OUP.

—— (1972). 'Some African Concepts and Christology.' *Christ and the Younger Churches*. Vicedom, G.F., ed. London, SPCK.

—— (1974). 'An African Views American Black Theology.' *Worldview* 17.

Mbiti, J.S. (1973). *Love and Marriage in Africa*. London, Longman.

—— (1975). *Introduction to African Religion*. London, Heinemann.

—— (1979). 'Christianity and African Religion.' *Facing the New Challenges: The Message of PACLA*. Cassidy, M., and L. Verlinden, eds. Kisumu, Evangel Publishing House.

—— (1991). 'Flowers in the Garden: The Role of the Woman in African Religion.' *African Traditional Religions in Contemporary Society*. Olupona, J., ed. New York, Paragon House.

Mbugua, J., ed. (1994). *Our Time Has Come: African Christian Women Address the Issues of Today*. Carlisle, Paternoster Press.

McCarl Nielsen, J., ed. (1990). *Feminist Research Methods: Exemplary Readings in the Social Sciences*. San Francisco, Westview Press.

Mikell, G. (1992). 'African Feminism: Towards a New Politics of Representation.' *Feminist Studies* 21 (2).

Millett, K. (1970). *Sexual Politics*. New York, Doubleday.

Moghadam, V.M., ed. (1993). *Identity Politics and Women: Cultural Reassertions and Feminism in International Perspective*. Boulder, Westview Press.

Molyneux, G. (1993). *African Christian Theology: The Quest for Selfhood*. San Francisco, Mellon Research University Press.

Moore, H. (1988). *Feminism and Anthropology*. Minneapolis, Minnesota Press.

Moore, H., Sanders, T., Kaare, B., eds. (1999). *Those who Play with Fire: Gender, Fertility and Transformation in East and Southern Africa*. London, The Athlone Press.

Morgan, R. (1996). *Sisterhood is Global*. New York, Feminist Press.

Mosala, B. (1986). 'Black Theology and the Struggle of the African Woman in Southern Africa'. *The Challenge of South African Black Theology*. Mosala, I.J., and B. Tlhagele, eds. Maryknoll NY, Orbis Books.

Mugambi, J.N.K., ed. (1989). *Jesus in African Christianity: Experimentation and Diversity in African Christology*. Nairobi, Initiative Publishing.

Mulago, V. (1956). 'L'Union Vitale Bantou. Principe de Cohésion de la Communauté chez les Bashi, les Banyanrwanda et les Barundi.' *Rythmes du Monde* IV.

—— (1965). *Un Visage Africain du Christianisme: L'Union Vitale Bantu face à l'Unité Vitale Ecclesiale*. Paris, Présence Africaine.

Murray, J. (1974). 'The Kikuyu Female Circumcision Controversy, with Special Reference to the Church Missionary Society's "Sphere of Influence."' Unpublished Ph.D. thesis. University of California, Los Angeles.

Muzorewa, D. (1975). 'Through Prayer to Action: The Rukwadzano Women of Rhodesia.' *Themes in the Christian History of Central Africa*. Ranger, T.O., and J. Weller, eds. London, Heinemann.

Mveng, E. (1983). 'Third World Theology—What Theology? What Third World? Evaluation of an African Delegate.' *Irruption of the Third World: Challenge to Theology*. Fabella, V., and S. Torres, eds. Maryknoll, NY, Orbis Books.

—— (1992). 'The African Synod: Prolegomena for an African Council.' *Towards the African Synod, Concilium* 1992/1.

Ndegwa, R. (1987). *Maids: Blessing or Blight*. Nairobi, Uzima Press.

Nederveen Pieterse, J. (1994). *Globalization as Hybridization*. The Hague, Institute of Social Studies.

Newsom, C.A., and S.H. Ringe, eds. (1992). *The Women's Bible Commentary*. London, SPCK.

Ngwenya, J. (1983). 'Women and Liberation in Zimbabwe.' *Third World, Second Sex*. Davies, M., ed. London, Zed Books.

Nicholson, L.J., ed. (1990). *Feminism/Postmodernism*. London, Routledge.

Niebuhr, H.R. (1952). *Christ and Culture*. London, Faber and Faber.

Nkrumah, J. (1959). *Ghana*. Edinburgh, T. Nelson.

Nold, L. (1974). 'None of Us Returns Home the Woman She was when She Came.' *Sexism in the 1970s: Discrimination Against Women: A Report of a World Council of Churches Consultation, West Berlin 1974*. WCC, ed. Geneva, WCC.

Nottingham, J. (1969). 'Establishing an African Publishing Industry: A Study in Decolonization.' *African Affairs* 68 (271).

Nthamburi, Z. (1987). 'The Ordination of Women into the Ministry of the Christian Church.' *African Ecclesial Review* 29 (3).

Nyamiti, C. (1984). *Christ as our Ancestor: Christology from an African Perspective*. Gweru, Mambo Press.

—— (1990). 'Church as Christ's Ancestral Mediation.' *The Church in African Christianity: Innovative Essays in Ecclesiology*. Mugambi, J.N.K., and L. Magesa, eds. Nairobi, Initiative Publications.

Nyerere, J.K. (1979). 'The Dilemma of the Pan-Africanist.' *Ideologies of Liberation in Black Africa 1856–1970*. Langley, J.A., ed. London, Rex Collings.

Obbo, C. (1980). *African Women: Their Struggle for Economic Independence*. London, Zed Books.

Obiego, C.O. (1984). *African Image of the Ultimate Reality: An Analysis of Igbo Ideas of Life and Death in Relation to the Chukwu God*. Frankfurt, Peter Lang.

Obuna, E. (1986). *African Priests and Celibacy: In a Culture Where A Man Without Children is A Waste*. Leberit Press, Rome.

O'Hara, S. (1979). *Dare to Live: A Portrait of Mother Kevin*. Dublin, Veritas Publications.

Okemwa, P.F. (1996). 'Cliterodectomy Rituals and the Social Well-being of Women.' *Groaning in Faith: African Women in the Household of God*. Kanyoro, M., and N. Njoroge, eds. Nairobi, Acton Publishers.

Okonjo, K. (1983). 'Sex Roles in Nigerian Politics.' *Female and Male in West Africa*. Oppong, C., ed. London, George Allen and Unwin.

Oliver, C. (1982). *Western Women in Colonial Africa*. London, Greenwood Press.

Omoyajowo, J.A. (1982). *Cherubim and Seraphim: The History of an African Independent Church*. New York, NOK Publications.

Opie, A. (1992). 'Qualitative Research: Appropriation of the "Other" and Empowerment.' *Feminist Review* 40 (Spring).

Ortega, O., ed. (1995). *Women's Visions: Theological Reflection, Celebration, Action*. Geneva, WCC.

Osakue, G., J. Okojie, et al., eds. (1992). *Women and Education: Proceedings of the Third Annual Women in Nigeria Conference*. Samaru Zaria, WIN Kanu State Branch.

Parker, M. (1995). 'Rethinking Female Circumcision.' *Africa* 65 (4).

Parratt, J. (1995). *Reinventing Christianity: African Theology Today*. Cambridge, Eerdmans.

Parvey, C.F. (1983). *The Community of Women and Men in the Church: The Sheffield Report*. International Consultation of WCC. Sheffield Conference: The Community of Women and Men in the Church. Sheffield, WCC.

Paul VI (1967). 'Sacerdotalis caelibatus: Encyclical Letter on Priestly Celibacy.' *Vatican Council II: More Postconciliar Documents* Volume 2. Austin Flannery, ed. Northport, NY, Costello.

—— (1969). 'Africae terrarum: Message to the Countries of Africa.' *32 Articles Evaluating Inculturation of Christianity in Africa*. Okure, T., and P. van Thiel, eds. Eldoret, Gaba Publications.

—— (1975). *Evangelii nuntiandi: Evangelization in the Modern World*. London, Catholic Truth Society.

Pedersen, S. (1991). 'National Bodies, Unspeakable Acts: The Sexual Politics of Colonial Policy-Making.' *Journal of Modern History* 63 (December).

Peel, J.D.Y. (1968). *Aladura: A Religious Movement Among The Yoruba*. Oxford, OUP.

Pemberton, C. (1992). 'Church and State Relations in Mobutu's Zaïre.' Centre for Development Studies/Department of Theology and Religious Studies. University of Leeds, Unpublished.

Perry, N., ed. (1988). *Under the Heel of Mary*. London, Routledge.

Pieris, A. (1983). 'The Place of Non-Christian Religions and Cultures in the Evolution of Third World Theology.' *Irruption of the Third World: Challenge to Theology*. Fabella, V., and S. Torres, eds. Maryknoll, NY, Orbis Books.

Pietila, H., and J. Vickers (1994). *Making Women Matter: The Role of the United Nations.* London, Zed Books.

Pirouet, L. (1982). 'Women Missionaries of the Church Missionary Society in Uganda 1896–1920.' *Missionary Ideologies in the Imperialist Era: 1880–1920.* Christensen, T., and W.R. Hutchison, eds. Aarhus, Aros Publications.

Pleck, E. (1983). 'Feminist Responses to "Crimes Against Women", 1868–1896.' *Signs* 8 (3).

Pobee, J S. (1992). *Skenosis: Christian Faith in an African Context.* Gweru, Zimbabwe, Mambo Press.

Pobee, J.S., and B. von Wartenberg-Potter, eds. (1986). *New Eyes for Reading: Biblical and Theological Reflections by Women from the Third World.* Geneva, WCC.

Post-Synodal Special Assembly (1994). *The African Synod: A Step Forward,* Carmelite Centre, Tangaza College, Kenya, Nairobi, Paulines Publications.

Rattray, R.S. (1930 (reprint 1983)). *Akan-Asante Folktales, Collected and Translated.* New York, ASM Press.

Reay, D. (1996). 'Insider Perspectives or Stealing the Words out of Women's Mouths.' *Feminist Studies* 53.

Robert, D.L. (1996). *American Women in Mission: A Social History of their Thought and Practice.* Macon, Mercer University Press.

Robertson, C. (1996). 'Grassroots in Kenya: Women, Genital Mutilation, and Collective Action, 1920–1990.' Signs 21 (3).

Ruether, R.R. (1979). *Mary—The Feminine Face of the Church.* London, SCM Press.

—— (1985a). 'A Feminist Perspective: The Interrelatedness of Oppression and Efforts for Liberation.' *Doing Theology in a Divided World.* Fabella, V., and S. Torres, eds. Maryknoll, NY, Orbis Books.

——, ed. (1985b). *Women-Church: Theology and Practice of Feminist Liturgical Communities.* New York, Harper and Row.

Russell, L. (1993). *Church in the Round: A Feminist Interpretation of the Church.* Louisville, Westminster Press.

—— (1994). *Human Liberation in a Feminist Perspective.* Philadelphia, Westminster Press.

Russell, L., I. Diaz, et al., eds. (1988). *Inheriting our Mothers' Gardens.* Philadelphia, Westminster Press.

Russell, L.M. (1992). 'Affirming Cross-Cultural Diversity: A Missiological Issue in Feminist Perspective.' *International Review of Mission* 81 (322).

—— (1996). 'Spirituality, Struggle, and Cultural Violence.' *Women Resisting Violence: Spirituality for Life.* Mananzan, M.J., ed. Maryknoll, NY, Orbis Books.

Saadawi, N.E. (1980). *The Hidden Face of Eve.* London, Zed Books Press.

Said, E. (1978). *Orientalism.* London, Routledge & Kegan Paul.

SCDF (1970). 'Nos virgines consecrandi: Introduction to the Rite of Consecration to a Life of Virginity.' *Vatican Council II: More Post Conciliar Documents.* Flannery, A., ed. Northport, NY, Costello. 1982.

—— (1976). 'Inter insigniores: Declaration on the Admission of Women to the Ministerial Priesthood.' *Vatican Council II: More Post Conciliar Documents.* Flannery, A., ed. Northport, NY, Costello.

—— (1979). The Book 'Human Sexuality.' *Vatican Council II: More Post Conciliar Documents.* Flannery, A., ed. Northport, NY, Costello.

Schmidt, E. (1992). *Peasants, Traders and Wives: Shona Women in the History of Zimbabwe, 1870–1939.* London, James Currey.

Schmidt, K.L. (1927). The Necessity of Christian Unity for the Presentation of the Christian Truth. *Faith and Order: Proceedings of the World Conference, Lausanne, August 3–21, 1927.* Bate, H.N., ed. London, SCM.

Schreiter, R.J., ed. (1991). *Faces of Jesus in Africa.* Maryknoll, NY, Orbis Books.

Schüssler Fiorenza, E. (1983). *In Memory of Her: A Feminist Theology of Christian Origins.* London, SCM.

——, ed. (1993). *Searching the Scriptures: A Feminist Introduction.* London, SCM.

—— (1994a). *Jesus: Miriam's Child, Sophia's Prophet: Critical Issues in Feminist Christology*. London, SCM.

——, ed. (1994b). *Searching the Scriptures: A Feminist Commentary*. London, SCM.

—— (1995). 'Ties that Bind: Domestic Violence Against Women.' *Voices From the Third World* 18 (June 1995).

Schwartz, N. (1985). 'Selected Aspects of Legio Maria Symbolism: A Case Study from a Village Community in East Alego.' Institute of African Studies, Nairobi, Unpublished.

SECAM (1978). *Catholic Bishops of Africa Speak: Family Life, Justice and Peace*. Onitsha, Nigeria.

Sen, G., and C. Grown (1987). *Development Crises and Alternative Visions: Third World Women's Perspectives*. London, Earthscan.

Senghor, L.S. (1964). *Poèmes*. Paris, Editions du Seuil.

Setiloane, G.M. (1979). 'Where are We in African Theology?' *African Theology En Route*. Maryknoll, NY, Orbis Books.

Setiloane, R.G. (1963). *Freedom and Anarchy in the Church*. AACC General Assembly, Kampala, AACC.

Shaw, C.M. (1995). *Colonial Inscriptions: Race, Sex and Class in Kenya*. Minneapolis, University of Minnesota.

Shaw, M. (1921). *Children of the Chief*. London, London Missionary Society.

—— (1988). *Toward a Theology of Inculturation*. Maryknoll, NY, Orbis Books.

—— (1994). 'Inculturation in Africa.' *The Tablet*. London. 23 April 1994.

Sithole, N. (1963). *African Nationalism and Christianity*. AACC General Assembly, Kampala, AACC.

Smythe, K.R. (1997). 'Mother or Mother House: The Life Story of a Fipa Catholic Nun.' *Africans Meeting Missionaries: Rethinking the Colonial Encounter*, University of Minnesota, 2–3 May 1997, Unpublished.

Söderblom, A. (1927). Christian Unity and Existing Churches. *Faith and Order: Proceedings of the World Conference Lausanne, August 3–21, 1927*. Bate, H.N., ed. London, SCM.

Spelman, E.V. (1988). *Inessential Woman: Problems of Exclusion in Feminist Thought*. Boston, Boston Press.

Stacpoole, A., ed. (1982). *Mary's Place in Christian Dialogue*. Slough, St Paul's Publications.

Stanton, E.C. (1895). *The Woman's Bible*. New York, European Publishing Company.

Stanton, H., ed. (1997). *Mary and Human Liberation: The Story and the Text*. London, Cassell.

Stock, E. (1899). History of the Church Missionary Society. London, CMS. I.

Strathern, M. (1981). 'Culture in a Net Bag: The Manufacture of a Sub-Discipline in Anthropology.' *Man* 16 (4).

Sundkler, B. (1961). *Bantu Prophets in South Africa*. London, SCM.

Sykes, S. (1984). *The Identity of Christianity: Theologians and the Essence of Christianity from Schleiermacher to Barth*. London, SPCK.

Synod of Bishops (1990). *Lineamenta. The Church in Africa and Her Evangelising Mission towards the Year 2000. 'You Shall Be My Witnesses' Act 1:8*. Vatican City, General Secretariat of the Synod of Bishops.

—— (1992). *African Synod: Instrumentum Laboris*. Nairobi, St Paul's Publications.

Tablet (1994). The Church in the World: African Synod hailed as 'historic event.' *Tablet*.

Tadesse, Z. (1988). Breaking the Silence and Broadening the Frontiers of History: Recent Studies on African Women. *Retrieving Women's History*. Kleinberg, S.J., ed. Oxford, Berg/UNESCO: 356–364.

Taylor, J.V. (1958). *The Growth of the Church in Buganda*. London, SCM.

Tempels, P. (1945). *La Philosophie Bantoue*. Elisabethville, Louvania.

The Month (1996). 'Special Issue on Mary.' *The Month* 257 (12).

The Way (1975). 'Mary and Ecumenism.' *The Way Supplement* 45.

Thiam, A. (1983). 'Women's Fight for the Abolition of Sexual Mutilation.' *International Social Science Journal* 35 (4): 747–756.

Thistlethwaite, S.B. (1990). *Sex, Race and God*. London, Geoffrey Chapman.

Thomas, L.M. (1996). '"Ngaitana (I will circumcise myself)": The Gender and Generational Politics of the 1956 Ban on Clitoridectomy in Meru, Kenya.' *Gender and History* 8 (3).

Torres, S. (1988). Dar es Salaam 1976. *Theologies of the Third World: Convergences and Divergences.* Boff, L., and V. Elizondo, eds. Edinburgh, T & T Clark.

Torres, S., and J. Eagleson, eds. (1981). *The Challenge of Basic Christian Communities.* Maryknoll, NY, Orbis Books.

Torres, S., and V. Fabella, eds. (1978). *The Emergent Gospel: Theology from the Developing World.* London, G. Chapman.

Trible, P. (1984). *Texts of Terror: Literary-Feminist Readings of Biblical Narratives.* London, SCM.

—— (1992). *God and the Rhetoric of Sexuality.* London, SCM.

Tshibangu, T. (1960). 'Vers une théologie de couleur africaine.' *Revue du Clergé Africaine* 2 (4).

Turner, H.W. (1967). *History of an African Independent Church: The Church of the Lord (Aladura).* Oxford, OUP.

Tutu, D. (1975). 'Black Theology/African Theology: Soul Mates or Antagonists?' *Journal of Religious Thought* Fall/Winter.

—— (1978). 'Whither African Theology?' *Christianity in Independent Africa.* Fasholé-Luke, E., R. Gray et al., eds. London, Rex Collings.

Umeagudosu, M.A. (1990). 'Gender Warfare in the Church: Debate on Ordination of Women in Igbo Christian Churches.' *Life, Women and Culture: Theological Reflections: Proceedings of the National Conference of A Circle of African Women Theologians.* Edet, R., and M.A. Umeagudosu, eds. Lagos, African Heritage Research.

UN (1975). *Fifth United Nations Congress on the Prevention of Crime and the Treatment of Offenders.* Geneva, New York, United Nations.

—— (1980). *Report of the World Conference of the United Nations Decade for Women: Equality, Development and Peace,* Copenhagen, New York, United Nations.

—— (1985). *Report of the World Conference to Review and Appraise the Achievements of the United Nations Decade for Women: Equality, Development and Peace,* Nairobi, New York, United Nations.

—— (1989). *Violence Against Women in the Family.* New York, United Nations.

—— (1994). *Preliminary Report to the Special Rapporteur on Violence against Women to the Commission on Human Rights,* New York, United Nations.

—— (1995a). *General Assembly Resolution on the Girl Child: Document 130.* The United Nations and the Advancement of Women 1945–1996, New York, United Nations Department of Public Information.

——, ed. (1995b). *Women: Looking Beyond 2000.* New York, United Nations Publications.

—— (1995c). *Report of the Fourth World Conference on Women, held in Beijing from 4 to 15 September 1995; the Beijing Declaration.* The United Nations and the Advancement of Women 1945–1996, Beijing, New York, United Nations Department of Public Information.

—— (1996). *The United Nations and the Advancement of Women 1945–1996.* New York, United Nations Department of Public Information.

Ununwa, U.R. (1995). 'Church and Politics in Africa: A Quest for Stable Democracy.' *African Christian Studies* 11 (4).

Utuk, E. (1997). *Visions of Authenticity: The Assemblies of the All Africa Conference of Churches, 1963–1992.* Nairobi, AACC.

van Allen, J. (1972). 'Sitting on a Man: Colonialism and the Lost Political Institutions of Igbo Women.' *Canadian Journal of African Studies* 6 (2).

van Binsbergen, W. (1991). 'Becoming a *Sangoma*: Religious Anthropological Field-Work in Francistown, Botswana.' *Journal of Religion in Africa* 21 (4).

van Wing, J. (1921). *Etudes BaKongo: Histoire et Sociologie.* Brussels, Goemaere: Bibliothèque Congo.

Vanneste, A. (1958). 'Une faculté de théologie en Afrique?' *Revue du Clergé Africaine*, May.

Vatican II (1964a). 'Ad totam ecclesiam: Decree on Ecumenism.' *Vatican Council II, The Conciliar and Post Conciliar Documents, Vol. 1*. Austin Flannery, ed. Northport, NY, Costello.

—— (1965a). 'Gaudium et spes: Pastoral Constitution on the Church in the Modern World.' *Vatican Council II: The Conciliar and Post Conciliar Documents*. Volume 1. Austin Flannery, ed. Northport, NY, Costello.

—— (1965b). 'Dei verbum: Dogmatic Constitution on Divine Revelation.' *Vatican Council II: The Conciliar and Post-Conciliar Documents*, Volume 1. Flannery, A., ed. Northport, NY, Costello.

Visser't Hooft, W.A., ed. (1949). *The First Assembly of the World Council of Churches*. London, SCM.

—— (1982). *The Genesis and Formation of the World Council of Churches*. Geneva, WCC.

Walker, A. (1983). *The Color Purple*. London, The Women's Press.

—— (1984). *In Search of Our Mothers' Gardens: Womanist Prose*. London, Women's Press.

Walker, A., and P. Parmar (1993). *Warrior Marks: Female Genital Mutilation and the Sexual Blinding of Women*. New York, Harcourt Brace and Company.

Wallace, A. (1957). *Religion: An Anthropological View*. New York, Random House.

Walls, A.F. (1970). 'A Christian Experiment: The Early Sierra Leone Colony.' *The Mission of the Church and the Propagation of the Faith*, Studies in Church History 6. Cambridge, CUP.

—— (1978). 'Black Europeans, White Africans: Some Missionary Motives in West Africa.' *Religious Motivation: Biographical and Sociological Problems for the Church Historian*. Baker, D., ed. Oxford, Blackwell.

—— (1995). 'Christianity in the Non-Western World: A Study in the Serial Nature of Christian Expansion.' *Studies in World Christianity* 1 (1).

Ward, K. (1976).'The Development of Protestant Christianity in Kenya 1910–1940.' Unpublished Ph.D. thesis. Department of History, Cambridge University.

Ware, H. (1979). 'Polygyny: Women's Views in a Transitional Society, Nigeria.' *Journal of Marriage and the Family* 41 (1).

—— (1983). Female and Male Life Cycles. *Female and Male in West Africa*. Oppong, C., ed. London, George Allen and Unwin.

WCC, ed. (1973). *Bangkok Assembly 1973: Minutes and Report of the Fourth Assembly of the Commission on World Mission and Evangelism of the World Council of Churches*. Geneva, WCC.

——, ed. (1975). *Sexism in the 1970s: Discrimination Against Women: A Report of a World Council of Churches Consultation 1974*. Geneva, WCC.

Webb, P. (1958). *Women of Our Company*. London, Cargate Press.

Weinrich, A.K.H. (1978). 'Western Monasticism in Independent Africa.' *Christianity in Independent Africa*. Fasholé-Luke, E., R. Gray et al., eds. London, Rex Collings.

Weinrich, M.A. (1975). An Aspect of the Development of the Religious Life in Rhodesia. *Themes in the Christian History of Central Africa*. Ranger, T., and J. Weller, eds. London, Heinemann.

Welbourn, F.B., and B.A. Ogot (1966). *A Place to Feel at Home: A Study of Two Independent Churches in Western Kenya*. London, OUP.

Williams, D. (1993). *Sisters in the Wilderness: The Challenge of Womanist God-Talk*. Maryknoll, NY, Orbis Books.

Wilmore, G., and J.H. Cone, eds. (1979). *Black Theology: A Documentary History, 1966–1979*. Maryknoll, NY, Orbis Books.

Wipper, A. (1975). 'The Maendeleo ya Wanawake Organisation: The Co-optation of Leadership.' *African Studies Review* 18 (3).

—— (1988). 'Current Research on African Women: Reflections on the Past Sixteen Years 1972–1988 and Future Challenges.' *Canadian Journal of African Studies* 22 (3).

—— (1995). 'Women's Voluntary Association'. *African Women: South of the Sahara*. Hay, M.J., and S. Stichter, eds. New York, Longman.

Wollstonecraft, M. (1985). *A Vindication of the Rights of Woman.* London, Dent.
Yuval-Davis, N. (1997). *Gender and Nation.* London, Sage Publications.
Zinn, M.B., and B.T. Dill (1996). 'Theorizing Difference From MultiRacial Feminism.' *Feminist Studies* 22 (2).

INDEX

abortion 97, 111
abuse 107, 133, 137, 155, 174
abusua 76, 78, 79, 88, 148, 179
Ackermann, Denise 23, 24
advocacy 3, 9, 13–14, 21, 26, 45, 91, 96, 159, 164, 166
Africa
economic concerns 65
African Christianity 14, 46, 50, 55, 58, 83, 113, 134
African Independent Churches 29, 87, 110
African Initiated Churches 7, 10, 31, 51, 57, 62, 69, 81, 83–85, 90, 94, 115–116, 121, 123
African Synod
Rome 1994 29, 57, 93–94, 96, 99, 101, 113, 121, 123, 143, 176
African Traditional Religion 7, 39, 51, 58, 67–72, 74, 77, 79–80, 84–85, 90, 94, 103, 115, 123, 143, 168, 175, 177
African-American women 7, 21, 29–30, 35–36, 50, 53–54, 60, 64, 79, 89
age set 78, 138, 152
agency 3, 94, 103, 105, 119, 123, 172, 175, 178, 180
agents of change 116, 123, 164
aggiornamento 94
All Africa Conference of Churches (AACC) 19, 34, 38, 45–49, 62–65, 68, 80, 86, 90, 101, 113, 159
Amin, Samir 181
Amoah, Elizabeth 8, 15, 17, 19, 37–38, 53, 126, 146, 160, 171–172
ancestors 71–72, 74–75, 78, 82, 96, 113–114, 170, 177
Anglican Womens Fellowship 16
apartheid 23, 44, 121
Appiah-Kubi, Kofi 49
Arbour, Frances 51
arranged marriage 85
Assaad, Marie 37
authority 16–17, 22, 63, 74, 77–78, 82, 86–87, 94, 99, 110–112, 119–120, 122–123, 128, 151, 153, 156–157, 171, 173, 179–180

autonomy 18, 47, 63, 78, 88, 122, 129, 132, 148, 157, 175, 183
Ayanga, Hazel 134, 136

Baarn Robert *The Life and Work of Women in the Church* 31
Baëta, Christian 70
Bahemuka, Judith 14, 143, 148
Balasuriya, Tissa 55
Bam, Brigalia 6, 33–36, 47, 53, 80, 171
Bantu philosophy 43
Barot, Madeleine 34
Baur, John 92
Bediako, Kwame 69, 71
Bible 14, 17, 25, 37, 48, 52, 54–55, 59, 61, 65, 70, 78, 85–87, 93–94, 100, 105, 108–109, 141, 154, 171, 176
Bimwenyi, Oscar 41
birthing 115, 118, 175, 178
Black consciousness 35
Black studies 15
Bliss, Kathleen 32
bodily integrity 130, 157, 160
Bonnke, Reinhard 85
Brandel-Syrier, Mia 23
bridewealth 95, 117, 135–136, 138, 180
Buganda 136–137
Bujo, Benezet 44
Burke, Sister Joan 92

Cameroon 8, 40, 42, 44, 52–53, 151
career women 89
Caribbean women 36
Carr, Burgess 45, 171
catechists 17, 24, 98, 104, 120–121, 152, 166
catholicity 79
celibacy 96–99, 105–106, 124
Chakko, Sarah 31–32
charismatic renewal 94, 104
childbearing 146, 178
childbirth 77–78, 82, 99, 154
childlessness 77–78, 142, 146, 179
children 32, 48, 53, 55, 64, 87, 93, 95–98, 103, 106–107, 111, 113–118,

STUDIES OF RELIGION IN AFRICA

SUPPLEMENTS TO THE JOURNAL OF RELIGION IN AFRICA

1. MOBLEY, H.W. *The Ghanaian's Image of the Missionary*. An Analysis of the Published Critiques of Christian Missionaries by Ghanaians, 1897-1965. 1970. ISBN 90 04 01185 4
2. POBEE, J.S. (ed.). *Religion in a Pluralistic Society*. Essays Presented to Professor C.G. Baëta in Celebration of his Retirement from the Service of the University of Ghana, September 1971, by Friends and Colleagues Scattered over the Globe. 1976. ISBN 90 04 04556 2
3. TASIE, G.O.M. *Christian Missionary Enterprise in the Niger Delta, 1864-1918*. 1978. ISBN 90 04 05243 7
4. REECK,D. *Deep Mende*. Religious Interactions in a Changing African Rural Society. 1978. ISBN 90 04 04769 7
5. BUTSELAAR, J. VAN. *Africains, missionnaires et colonialistes*. Les origines de l'Église Presbytérienne de Mozambique (Mission Suisse), 1880-1896. 1984. ISBN 90 04 07481 3
6. OMENKA, N.I. *The School in the Service of Evangelization*. The Catholic Educational Impact in Eastern Nigeria 1886-1950. 1989. ISBN 90 04 08932 3
7. JĘDREJ, M.C. & SHAW, R. (eds.). *Dreaming, Religion and Society in Africa*. 1992. ISBN 90 04 08936 5
8. GARVEY, B. *Bembaland Church*. Religious and Social Change in South Central Africa, 1891-1964. 1994. ISBN 90 04 09957 3
9. OOSTHUIZEN, G.C., KITSHOFF, M.C. & DUBE, S.W.D. (eds.). Afro-Christianity at the Grassroots. Its Dynamics and Strategies. Foreword by Archbishop Desmond Tutu. 1994. ISBN 90 04 10035 0
10. SHANK, D.A. *Prophet Harris, the 'Black Elijah' of West Africa*. Abridged by Jocelyn Murray. 1994. ISBN 90 04 09980 8
11. HINFELAAR, H.F. *Bemba-speaking Women of Zambia in a Century of Religious Change (1892-1992)*. 1994. ISBN 90 04 10149 7
12. GIFFORD, P. (ed.). *The Christian Churches and the Democratisation of Africa*. 1995. ISBN 90 04 10324 4
13. JĘDREJ, M.C. *Ingessana*. The Religious Institutions of a People of the Sudan-Ethiopia Borderland. 1995. ISBN 90 04 10361 9
14. FIEDLER, K. *Christianity and African Culture*. Conservative German Protestant Missionaries in Tanzania, 1900-1940. 1996. ISBN 90 04 10497 6

15. OBENG, P. *Asante Catholicims.* Religious and Cultural Reproduction Among the Akan of Ghana. 1996. ISBN 90 04 10631 6

16. FARGHER, B.L. *The Origins of the New Churches Movement in Southern Ethiopia, 1927-1944.* 1996. ISBN 90 04 10661 8

17. TAYLOR, W.H. *Mission te Educate.* A History of the Educational Work of the Scottish Presbyterian Mission in East Nigeria, 1846-1960. 1996. ISBN 90 04 10713 4

18. RUEL, M. *Belief, Ritual and the Securing of Life.* Reflexive Essays on a Bantu Religion. 1996. ISBN 90 04 10640 5

19. McKENZIE, P. *Hail Orisha!* A Phenomenology of a West African Religion in the Mid-Nineteenth Century. 1997.
 ISBN 90 04 10942 0

20. MIDDLETON, K. *Ancestors, Power and History in Madagascar.* 1999.
 ISBN 90 04 11289 8

21. LUDWIG, F. *Church and State in Tanzania.* Aspects of a Changing Relationship, 1961-1994. 1999. 90 04 11506 4

22. BURKE, J.F. *These Catholic Sisters are all* Mamas! Towards the Inculturation of the Sisterhood in Africa, an Ethnographic Study. 2001.
 ISBN 90 04 11930 2

23. MAXWELL, D., with I. LAWRIE (eds.) *Christianity and the African Imagination.* Essays in Honour of Adrian Hastings. 2001.
 ISBN 90 04 11668 0

24. GUNNER, E. *The Man of Heaven and the Beautiful Ones of God.* 2002.
 ISBN 90 04 12542 6

25. PEMBERTON, C.M. *Circle Thinking.* African Woman Theologians in Dialogue with the West. 2003. ISBN 90 04 12441 1